A NEW DEAL FOR QUILTS

JANNEKEN SMUCKER

International
Quilt Museum
UNIVERSITY OF NEBRASKA-LINCOLN

This publication accompanies the International Quilt Museum's *A New Deal for Quilts* exhibition, held between October 6, 2023 and April 20, 2024.

Major funding for this publication was received from:

Moda Fabrics International Quilt Museum Fund

Alan & Wilma VonSeggern International Quilt Museum Fund

Linda Pumphrey Fund for the International Quilt Museum

International Quilt Museum Fund for Public Programming and Outreach

Cooper Foundation

ISBN: 978-1-7352784-5-2
Library of Congress Control Number: 2023943892

Designed by: Ebbeka Design Co., Lincoln, Nebraska/Marin F. Hanson, IQM

Cover image: Maker unidentified, Broken Star, possibly made in Arkansas, 1930-1950 (International Quilt Museum, Ardis and Robert James Collection, 1997.007.0672).

Back cover images: Marion Post Wolcott, *Mr. & Mrs. Peacock, RR (Rural Rehabilitation) family (four years) and children in front of their home. Coffee County, Alabama,* April 1939. Farm Security Administration, Library of Congress; Russell Lee, *Quilt hung across doorway which separates living quarters of two families of white migrants. Berry pickers near Hammond, Louisiana*, 1939. Farm Security Administration, Library of Congress.

TABLE OF CONTENTS

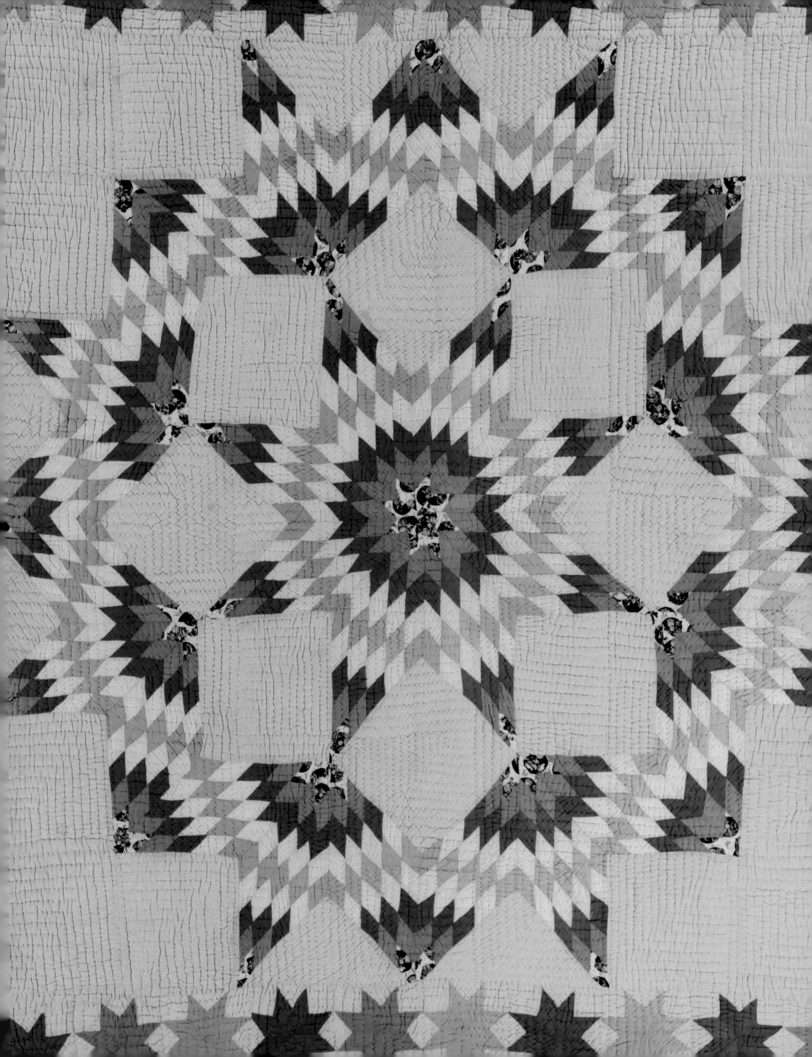

FOREWORD

During the initial months of the COVID-19 pandemic in 2020, the International Quilt Museum (IQM) team searched for ways to remain connected with our diverse audiences. We knew that regular periods of lockdown and quarantine meant people were feeling isolated from each other and from their favorite educational and cultural institutions. One way we reached out was through Textile Talks, a series of weekly online discussions and presentations—still ongoing today!—given by us and our textile-focused partner organizations. It felt so good to be helping create a sense of community during those hard and unsettled times.

It was during this period of uncertainty and apprehension that we began talking with Janneken Smucker, historian, quilt scholar, and longtime IQM collaborator, about the possibility of working together on an exhibition and companion book. Janneken had begun researching quiltmaking during the Great Depression of the 1930s, with a special focus on the U.S. government's New Deal policies as they related to quilts. At any given time, we would have been excited to work with Janneken, but during those unprecedented first months of the pandemic, her project seemed especially timely and compelling.

The Depression-era saying, "use it up, wear it out, make it do or do without," had suddenly become more applicable in the face of pandemic-triggered supply shortages, and the New Deal's sweeping efforts to lift up those in need echoed the superhuman exertions of health care workers in caring for COVID-19 victims. In both eras, quiltmakers were front and center in providing aid and comfort, whether through WPA-sponsored projects to make quilts for the poor in the 1930s or through the massive grassroots efforts to sew masks and personal protective equipment in 2020.

A New Deal for Quilts embodies a vital part of our mission at the International Quilt Museum: make quilt history relevant and captivating for the thousands of visitors who pass through our doors each year and who read our books or visit our website. Our partners in this important work are the many committed donors who provide financial support for time- and resource-intensive exhibitions and publications like *A New Deal for Quilts*. For them, we are incredibly grateful.

— Leslie C. Levy
Ardis and Robert James Executive Director
International Quilt Museum,
University of Nebraska-Lincoln

PREFACE AND ACKNOWLEDGMENTS

I began working on this project in earnest during my first and only sabbatical from West Chester University during the spring of 2020. Thankfully, I was motivated and dove into the work intently, digging into the research and beginning to draft chapters. And then the world changed irrecoverably in March. Surprisingly—as society shut down, the economy collapsed, and my liberated sabbatical turned into quarantining at home with my then third-grade daughter amid a global pandemic—I began to feel more connected to my subject. The scared, displaced, bored, anxious, lonely women and men who made and used quilts during the Great Depression seemed more familiar to me now. As the United States passed the largest governmental relief program since the New Deal, I understood more clearly how major it was for Congress to legislate into place unprecedented experimental initiatives. Yet here in the twenty-first century, some aspects of the New Deal that I was reading and writing about continued to feel completely foreign. As I remind my students regularly, "the past is a foreign country: they do things differently there."[1] *There* the government paid Americans to make quilts. The government paid artists to paint pictures of quilts. The government paid writers to interview other Americans about their quilts. The government paid out-of-work Americans to learn how to silk-screen so they could print patterns of quilts. In 2020, Americans began to make and love and obsess about quilts (along with sourdough), but the government did not seem to invoke crafting as part of its masterplan to lift morale and incomes the way that it did in 1936.

During the darkest months of the pandemic, like many other citizens around the world, my life changed suddenly and completely. And like many others, I experienced anxiety and depression. As I fought loneliness and boredom and sought activities other than doom scrolling as I waited for my child to return to school and vaccines to be tested, I turned to my scrap bag, piecing together the bits and pieces I had acquired from my own grandmother and mother, from flea markets and yard sales, from previous quilt projects and ones I never finished. And I turned to this manuscript, and it too helped guide me through the upheaval, uncertainty, and new routines that shaped my existence.

Needless to say, that sabbatical was not what I had imagined. I did not go on any of my grant-funded

research trips; going for long bike rides around Philadelphia was generally as far as I ventured. Instead, I benefited from an extraordinary network of women older than myself who are experts on American quilts and quiltmaking, and with their generosity, photocopied files showed up in my mailbox, while research notes and scanned primary sources appeared in my email. I sent drafts of my chapters to many of these experts, who fact-checked the patterns I discussed and pushed me for clearer evidence for my conclusions. The wisdom, wealth of knowledge, and absolute generosity of Merikay Waldvogel, Susan Wildemuth, Susan Salser, Julie Silber, Barbara Brackman, and Barbara Garrett enabled me to forge ahead and keep writing. I also welcomed tips from strangers who heard I was writing about quilts in the New Deal, telling me about one-off quilts in hidden collections or family accounts of quilting during the Depression. Thankfully, West Chester University, my home institution, implemented interlibrary loans that were sent to my home, and ILL coordinator Jen O'Leary packed many shipments, sending me the resources I needed.

During spring 2020 when everything was uncertain, I reached out to my dear friend and colleague Marin Hanson, Curator of International Collections at the International Quilt Museum (IQM), to ask for suggestions about where to pitch a book proposal about quilts: who would take me seriously, invest in the production and marketing, and understand the significant audience for books contextualizing quilts? She replied that I should pitch it to her, as the IQM now had its own publishing agreement in partnership with the University of Nebraska Press. My history with IQM and the University of Nebraska-Lincoln is such an important aspect of my career. The quilt center, as we used to call it back when I pursued my graduate degree in Textile and Quilt History, had opened up so many opportunities for me, launching me from

quilt hobbyist to a professional in the so-called quilt world. If it was an option to partner with my friends and colleagues at IQM, I wanted to do so. I am grateful to Marin, Curator of Collections Carolyn Ducey, Executive Director Leslie Levy, Curator of Exhibitions Camilo Sanchez, and the entire IQM team for their support of this project, not only this book but the accompanying exhibition of the same name. I wish I could walk through the exhibition with the late Ardis James, whose brilliance, creativity, and generosity the IQM community continues to miss.

Eventually, archives and museums reopened in limited capacities, and archivists and curators including Michele Willens at the Archives of the National Gallery of Art; David Sigler at the California State University, Northridge, Special Collections and Archives; Mary Worrell and Lynne Swanson at Michigan State University Museum; Jackie Schweitzer and Sara Podejko at the Milwaukee Public Museum; Michelle Frauenberger and Patrick F. Fahy at the Franklin D. Roosevelt Presidential Library provided me with resources, including some of the images herein. In addition, I received images and sources from the Minnesota Historical Society, the Museum of Art and Design, the Ohio History Connection, the Briscoe Center for American History, the North Carolina History Museum, Dallas Museum of Art, Janet Finley, Karen Finn and Susan Salser, John Foster, Merikay Waldvogel, the Metropolitan Museum of Art, the *Chicago Tribune*, Tarrant County College, the UCLA Library, Digital Maryland, the HathiTrust, Brent McKee of New Deal Daily, Indiana State Museum and Historic Sites, Harvard University's Schlesinger Library, the Indianapolis Museum of Art, the Museum of the City of New York, the National Gallery of Art, Shippensburg University Special Collections, the National Archives, the West Virginia Department of Archives and History, and the formidable collections of the Library of Congress. Further, newspapers.com, a division of

Ancestry.com, provided a timely and detailed glimpse into the 1930s, with its extensive searchable collection of newspapers large and small.

I am grateful to have received feedback on early drafts of parts of this work from Merikay Waldvogel, Susan Strasser, Joe Navitsky, Jess Bailey, Susan Salser, Charlie Hardy, and Barbara Brackman. And my most reliable and loyal reader of course is my mom, Barbara Smucker, a retired librarian who has read every chapter with her keen attention to detail. I presented early stages of this work at a number of venues, receiving external motivation and insightful feedback; these include the American Folk Art Museum, American Studies Association, the Daughters of the American Revolution Museum's symposium, the Project Threadways annual symposium, West Chester University's Sustainability Research and Practice Seminar, the World Congress of Home Economists, the annual meeting of the American Association of Family and Consumer Sciences, and as the guest know-it-all on the Six-Know-It-Alls' quilt history web series. I published an extended discussion of the Tennessee Valley Authority quilts in *Southern Cultures* ("Quilts, Social Engineering, and Black Power in the Tennessee Valley," Spring 2022). My students in the history department at West Chester University served as a community of fellow scholars, allowing me to share my day-to-day experiences as a historian tracking down sources, scrambling to meet deadlines, and wrestling with historical interpretation. WCU students—now alums—Anthony Cole, Madelyn Maychak, and Jessie Walsh provided specific assistance with various aspects of the project. Jamie Giambrone photographed me with results that made me feel more like me than I ever thought possible.

I'm not the first author to describe writing a book as a lonely act; it was all the more isolating when undertaken during varying degrees of social distancing. Thank you to colleagues near and far who have cheered me on; respected my need for time and bandwidth to write and think; and shared ideas, resources, and wisdom: Emily Aguilo-Perez, Eric Fourniér, Charlie Hardy, Bob Kodosky, Naomie Nyanungo, Tom Pantazes, Brent Ruswick, Jordan Schugar, Dean Jen Bacon, and the late and missed Hyoejin Yoon from West Chester University; Eleanor Shevlin and Kristin O'Neill of WordWorks, a program of WCU that provides copyediting and indexing; Amy Milne, Emma Parker, and Laura Hopper from the Quilt Alliance and Running Stitch; and fellow quilt experts whose work has inspired me and friendship has sustained me: Joe Cunningham, Roderick Kiracofe, and Julie Silber.

I'm grateful that as I end this project, I have a thriving community of friends with whom to celebrate the accomplishment. Many of these loved ones have served as a great distraction when necessary, and always provided encouragement and kudos at various steps along the way. Thank you to Devon Powers, Nicole Strunk, Frank Ianuzzi, Kiley Bates-Brennan, Krista and Steve Yutzy-Burkey, Kristine Kennedy, Joey McAteer, Laura Sider-Jost, Abby Bronstein, Heather Boyd, Jen Moses, Jeff VanOsten, Rick Sieber, quilt thought-leader Doug Boyd, my Zoom yoga pals, and my fellow cyclists on Wednesday Night Rides. Biweekly game night with my parents George and Barbara, my brother Matthew, and Carol, Finn, and Uly have provided a supportive and necessary routine. In the midst of this work, I fell in love with Jon Geeting, a fellow writer, thinker, and activist who believes in the power of government to improve our lives and inspires and supports me every day. And I've shared my experience writing a book with my remarkable, creative, brilliant daughter Calla, who has found her own writing voice. You're up next, kid.

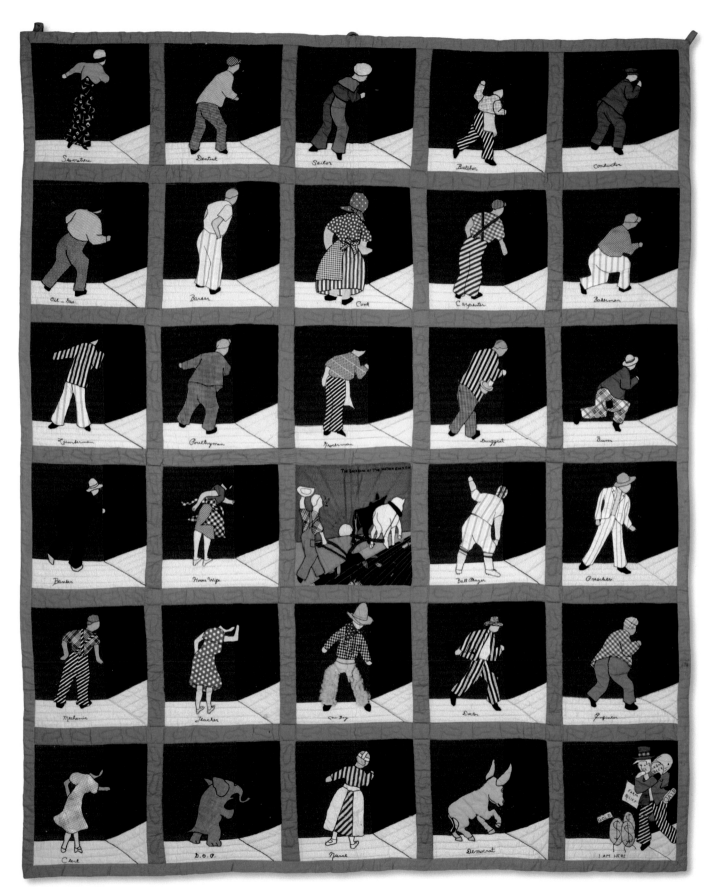

Fig. 0-1. Fannie Shaw, Prosperity is Just Around the Corner, *1930-32. Dallas Museum of Art, Texas, USAAnonymous Gift/Bridgeman Images.*

INTRODUCTION

Although President Herbert Hoover probably never said the exact words "Prosperity is Just Around the Corner," by 1932 this was a popular sentiment, with a hit song prominently featuring the prediction in its title. Quiltmaker Fannie Shaw was certainly familiar with the catchphrase when she made her intricate appliqué quilt in the early years of the economic downturn following the stock market crash of 1929. It featured common Americans peering around the corner awaiting economic relief: a housewife, banker, teacher, ball player, bum, and dozens of other representative figures hoping that better days are ahead. In a 1978 interview, Shaw recounted that she based many of these appliquéd blocks on real individuals, with the figure of the housewife representing herself and the adjacent farmer, her husband: "He didn't have no time to look around no corners. He just had to look straight down his row behind his old plow." She stitched the grocer, Einspizer, who she recalled "would let everybody he possibly could have their groceries on credit. He couldn't afford to do it really." In the lower right-hand corner, she appliquéd Uncle Sam arriving with farm relief, legal beer, and other aid. Fannie Shaw's quilt is clearly a prime example of creativity in the face of adversity, and while she may have been discouraged by Hoover's false optimism, she perceived in the American people a desire to unite and help each other through the Depression (fig. 0-1). She recalled "That ol' Depression was something, but you know, I never saw so much loviness [sic] in this country. It was one for all and all for one. Everybody loved. Everybody was scared and everybody was worried. All they owned to give each other was love."[1]

Shaw's masterpiece quilt was also one woman's political statement on what she expected of the federal government. Completed before Franklin Roosevelt was elected, replacing Herbert Hoover, she stitched a block featuring the GOP elephant. "Now, with this Republican there ain't much expression. Elephants, they just have the same look all the time," she later said.[2] She used Hoover's outlook as inspiration for the quilt: "Every time you picked up the paper or heard the radio he would talk about good times around the corner. He would make it sound so good. I wondered if I could make a picture of what he said and what he meant. I went to bed one night and couldn't get it off my mind."[3] Fannie Shaw was not the only quiltmaker who thought long and hard about the economic plight both she individually and Americans collectively were facing and what both the government and fellow Americans could do about it. And conversely, the federal government had quilts and quiltmakers on its mind.

During the recent years of the COVID-19 pandemic, Americans, and all global citizens, have faced a crisis unparalleled since the years of the Great Depression. With the rapid spread of the coronavirus and the lockdowns, closures, and economic impacts that

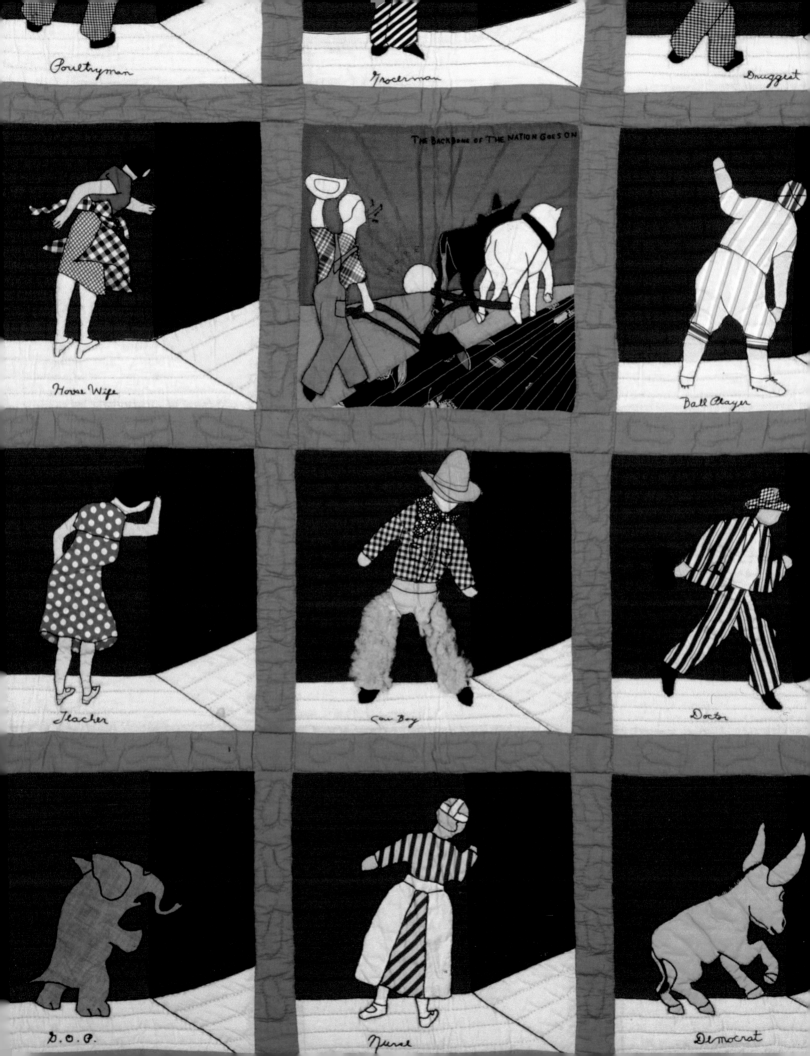

came with its initial spread, Americans waited with bated breath to see if the actions of the federal, state, and local governments, combined with the unity of purpose of the American people, could lift us out of a dire situation resulting from the COVID-19 pandemic. During the ensuing months of working and schooling at home in order to avoid in-person human interaction, many Americans turned to new hobbies, finding in baking, home renovations, and crafting necessary outlets for relief and escape. Making quilts seemed a better option than doomscrolling. As I began work on this book during my first sabbatical, I had my sewing machine and ironing board adjacent to my desk. A good friend with a knack for design texted me the PDF of the pattern she used to create masks for her family. She suggested I line the masks with quilt batting to provide a layer of stiffness, as she knew I would have some tucked away in my stash of sewing supplies. A study out of the University of Chicago agreed, stating, "One layer of a tightly woven cotton sheet combined with two layers of polyester-spandex chiffon—a sheer fabric often used in evening gowns—filtered out the most aerosol particles (80-99%, depending on particle size), with performance close to that of an N95 mask material. Substituting the chiffon with natural silk or flannel, or simply using a cotton quilt with cotton-polyester batting, produced similar results."[4] Soon patterns for making masks proliferated on the internet with homemade masks becoming the civically minded fashion statement of the spring, prior to studies determining that our homemade masks stitched from quilting fabric in fact offered only minimal protection from the virus and that medical grade N95s and KN-94s were required.

During the spring and summer of 2020, my Instagram feed, normally filled with both vintage quilts and new contemporary adaptations created by the legions of quiltmakers I follow, became peppered with the masks quilters made from their scraps of fabric, with hashtags like #millionmaskchallenge, #sewtogether, and #covidmasks. Today's quiltmakers, ranging from parents stuck working at home with their children out of school to celebrity quiltmakers forced to take a break from lecturing on the quilt circuit to the famed quilters of Gee's Bend, Alabama, all made masks for use in their home communities and nationwide.[5] This came as no surprise, as quiltmakers, including those living in Farm Security Administration (FSA) Migratory Labor Camps during the late 1930s, have again and again acted out their generosity with needle, thread, and cotton fabric. Quilters have long used their art to express empowering sentiments and to raise awareness of political, economic, and social justice issues, testifying to their support of the National Recovery Administration (NRA), Tennessee Valley Authority (TVA), and Works Progress Administration (WPA).

During the New Deal—the Roosevelt administration's legislative response to the Depression—quiltmakers created quilts on both an individual and collective level in response to the unemployment, displacement, and recovery efforts in the United States. In parallel, the government drew on both the symbolic heft and practical potential of quilts and quiltmaking in its relief and rebuilding projects. Governmental programs used quilts to symbolically communicate the values and behaviors individuals should embrace amid the Depression. New Dealers perceived the practical potential of crafts to provide women with skills to support their families; the government hired home economists to train women to make quilts in WPA Sewing Rooms, WPA Handicraft Projects, and in FSA Migratory Labor Camps and Planned Communities. The federal government's use of quilts and quiltmaking

Fig. 0-2. Russell Lee, Quilting in sharecropper's home near Pace, Mississippi. Background photo for Sunflower Plantation, Pace, Mississippi, 1939. Farm Security Administration, Library of Congress.

aimed to show how women could contribute to their families' betterment, generated empathy for poor and migrant families, and empowered Americans to create and use thrifty domestic objects closely associated with ideals of home and comfort.

Both the government and American quiltmakers symbolically drew on myths of colonial-era fortitude and self-sufficiency as a means of overcoming poverty. They imagined in the quilts and quiltmakers of early America an ingenuity of making do to create something beautiful and functional. These ideas stemmed from the nostalgia-fueled Colonial Revival of the late nineteenth and early twentieth centuries, which celebrated a romanticized version of the experiences of colonial-

era Americans, while altering the values with which contemporary Americans tried to live, as many looked longingly to the imagined simplicity of the pre-industrial past despite the rapidly modernizing society.

The ideals of colonial quilts that permeated mainstream society from the late nineteenth century through the 1930s were in fact *imagined* ones, ideals that were reinforced by ladies' magazines and farm newspapers alike offering quilt patterns inspired by old-fashioned designs and companies including Sears, Roebuck & Co. sponsoring quiltmaking competitions. But the symbolic meanings of quilts—closely connected to values of frugality and perseverance—were attributes now quite essential during the economic downturn.

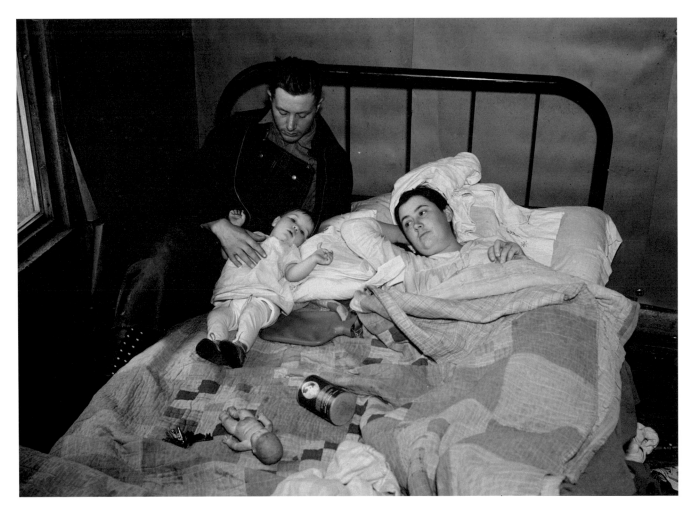

Fig. 0-3. Russell Lee, The Ingraham family who share a shack with another family near Alvin, Wisconsin. Mrs. Ingraham is sick in bed. Alvin, Wisconsin, *1937. Farm Security Administration, Library of Congress.*

By the time the Roosevelt Administration began combatting the Great Depression, the quilt had become an emblem of how to lift one's family out of poverty, piece by piece.

During the 1930s, quiltmaking was quite popular. The ubiquity of quilts within American society is visible in the photographs taken by Farm Security Administration photographers hired by the federal government to document and publicize the efforts of New Deal programs and record the experiences of everyday Americans. Quilts appear just as frequently in small-town homes as in shacks sheltering migrant workers (see fig. 0-2, 0-3). WPA-sponsored sewing and handicraft projects generated quilts that were distributed to the needy and to institutions such as orphanages and hospitals and as gifts to elected officials in gratitude. As the Federal Art Project and Federal Writers' Project documented American traditions, they preserved stories and images of old quilts. And quiltmakers dug into their scrap bags, used leftovers from making clothing, and repurposed sacks that held feed, sugar, or flour to make quilts to keep their own family members warm, and for distribution through federal and state relief programs. Following quilt patterns touted in newspaper columns as "economical" or making original works of art, quiltmakers expressed themselves through their stitches.

In 2020's "sheltering at home," Americans again turned to crafts: stitching quarantine quilts, following their favorite quilt celebrities in Instagram "quilt-alongs," and streaming video lectures on quilt history. And perhaps taking an unintentional cue from the New Deal's National Youth Administration, in which girls made medical and surgical supplies for hospitals, quilters made masks in great quantities.[6] During the vast economic interventions in 2020-21, the federal government allocated additional funding to the National Endowment for the Arts, providing funds for state and regional arts agencies to use for local funding and an additional seventy-five million dollars to support organizations and those they employed while their doors remained closed.[7] Perhaps with the continuing debates around an aspirational Green New Deal, we will again look to our past and find ways to draw on the values of art and craft as we find solutions to today's challenges.

The New Deal was comprised of the so-called alphabet soup of initiatives, legislation, executive orders, programs, and projects that tried to reshape the American economy and support struggling Americans during the Great Depression, with the Three Rs of "Relief, Recovery, and Reform." Some programs, like the Federal Emergency Relief Act (FERA) provided direct relief. Other programs—most famously the WPA—created government-funded jobs for the unemployed, or at least for the unemployed who were lucky enough to get those positions. Others provided systemic restructuring of the economy and employment, including the Social Security Act and the Fair Labor Standards Act, which live on today providing Social Security insurance payments and ensuring employers pay workers a minimum wage and overtime. The government aimed to improve infrastructure through major projects like the Tennessee Valley Authority, which provided electricity across a wide swath of the South, and in less visible ways, like the trails created by the Civilian Conservation Corps (CCC). And notably, Federal Project One, a division of the WPA, along with a handful of other initiatives funded arts and culture programming, employing artists, writers, historians, and other professionals. The many divisions and initiatives are often hard to distinguish, and their names, mandates, and authorities changed over time as did the administrators who managed them, with some acts and executive orders found unconstitutional and others discontinued for either practical or political reasons.

Historians generally split the New Deal into two phases: the First New Deal (1933-34) and the Second New Deal (1935-36). The First New Deal included a series of initiatives to reform and stabilize the banking system in the face of bank runs. It also provided jobs through the Public Works Administration (PWA) and CCC, a process called "priming the pump," which put money in Americans' pockets so they could spend and stimulate the economy. Here too were the first attempts at reforming and modernizing agricultural practices through initiatives such as the Agricultural Adjustment Act and the Resettlement Administration which helped struggling farmers and migrant laborers relocate. The short-lived National Recovery Administration and its Blue Eagle campaign aimed to establish fair practices for labor and industry, but was found unconstitutional by the Supreme Court in 1935 due to executive branch overreach; the National Labor Relations (aka Wagner) Act later replaced aspects of the NRA.

The Second New Deal addressed aspects of the first wave of legislation and executive orders that the Supreme Court had overturned, such as the NRA, and attempted to take more dramatic action, and as such was more controversial among Republicans and other taxpayers. Here we see the origins of many of the longstanding New Deal policies that continue to play important roles in Americans' lives, such as Social Security and the National Labor Relations Board. The Emergency Relief Appropriation Act of 1935 established the WPA, which employed millions of out-of-work Americans before the government dissolved it in 1943 in the midst of World War Two. The WPA's legacy endures through the many public works projects its workers created, such as roads, dams, school buildings, and recreational facilities, as well as through its arts and cultural programming that resulted in community arts centers, the American Guide Series, public art in schools and post offices, and, as discussed in chapter 5, the Index of American Design and the

Federal Writers' Project's American Life Histories. In 1937 the government replaced the Resettlement Administration with the FSA, the division responsible for providing loans to farmers and shelter to migrant workers, among other things. Enduringly, the FSA's Historic Division hired professional photographers to document the plight of Americans during the Depression. Many of the illustrations herein of women working on or posed with quilts are from this valuable documentary photography collection, now preserved at the Library of Congress.

Historians continue to debate whether the New Deal deserves full credit for lifting the American economy in the short term, as the build-up to World War Two shifted the government's focus and provided a different form of economic rejuvenation. But one thing is clear: the New Deal touched the lives of most, if not all, Americans during the Depression. We continue to experience its legacy in our daily lives, and the quilts created during this era can serve as a valuable, yet unexpected, entry point. The evidence of quilts' quiet but significant role is clear—in the government-created propaganda photographs, in the Federal Writers' Project interviews, in small-town newspapers, and in the quilts themselves made as part of the New Deal that reflect the lived experiences of the Great Depression.

In a similar spirit to how Fannie Shaw created her masterpiece quilt, *Prosperity is Just Around the Corner*, in the early years of the economic downturn, Mary Gasperik made *Road to Recovery* in 1939 as the relief, reform, and recovery efforts of the New Deal had begun to pay off (fig. 0-4, 0-5). Born Mariska Mihalovits in 1888 in Hungary, Mary immigrated to Chicago at the age of sixteen in 1905, where she lived in a Hungarian-American enclave in the neighborhood of Burnside in South Chicago. Although she had developed extraordinary needlework skills as a child living in Transylvania, she discovered American quiltmaking at

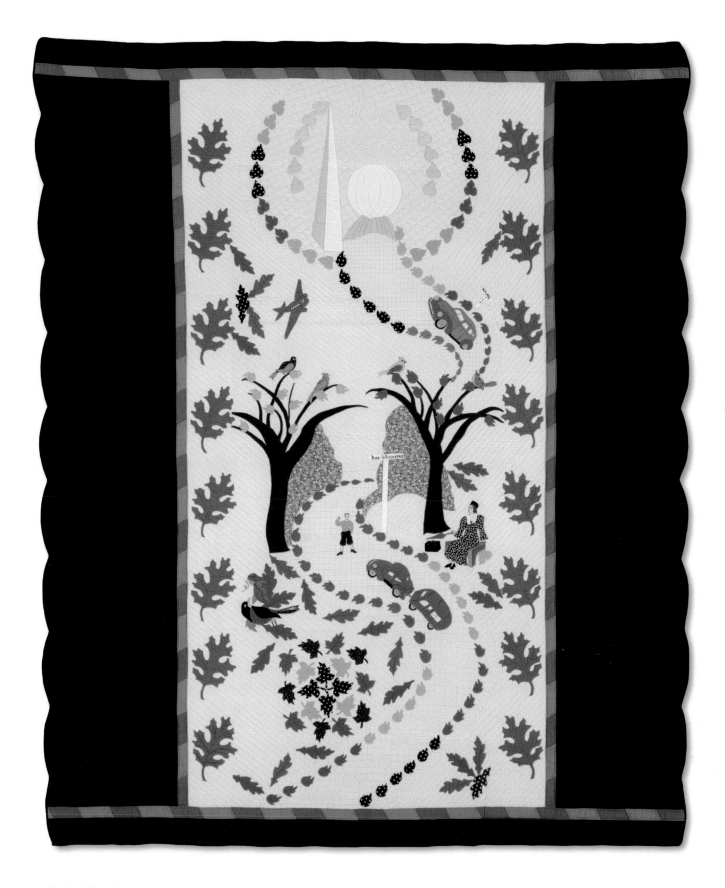

Fig. 0-4. Mary Gasperik, Road to Recovery, 1939. Courtesy of the grandchildren of Mary Gasperik. Hungarian immigrant Mary Gasperik learned how to quilt in her new hometown of Chicago, participating in the Tuley Park Quilting Club sponsored by the Chicago Park District. She made this quilt to submit to the 1939 New York World's Fair's quilt contest themed "Better Living in the World of Tomorrow." The quilt depicts a woman emerging out of the Great Depression.

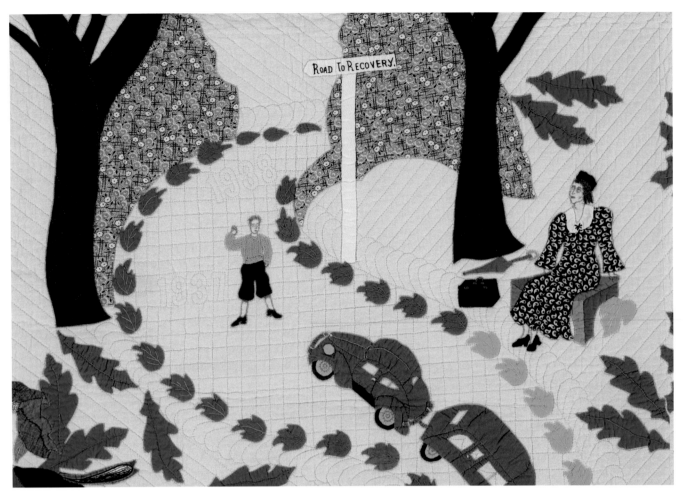

Fig. 0-5. Mary Gasperik, detail, Road to Recovery, *1939. Courtesy of the grandchildren of Mary Gasperik.*

an exhibit of entries to the Sears Century of Progress quilt contest held in conjunction with the 1933 Century of Progress World's Fair in Chicago. She soon became a prolific quiltmaker, joining the city-sponsored quilting club hosted at the local Tuley Park, part of the Chicago Park District. She began by adapting commercially published patterns, enlivening them with her own details and imagery, and often created original designs with elements inspired by patterns.[8] She made *Road to Recovery* to submit to a quilt contest themed "Better Living in the World of Tomorrow," sponsored by *Good Housekeeping* magazine and Macy's department store, held in conjunction with the 1939 New York World's Fair. Writing in Hungarian (translated by her daughter), Gasperik described the imagery in this quilt depicting

hope amid struggle: "This dear old lady is trying to bear the trials of poverty inflected upon her by the depression, and in passing along with the years, she must stop and rest to gather fresh courage to reach the 'World of Tomorrow.' Heedless of the traffic, only one thought persists in her mind, to attain her goal. The autumn leaves represent the poverty of the depression as it touched humanity. The birds are singing songs of encouragement. Beyond those mountains lies Recovery, the New York World's Fair of 1939."[9]

Gasperik's careful hand quilting marks the years of the Depression along her road to recovery: 1929, 1930, 1931, 1932, and so forth, ending with the text "NEW YORK WORLD'S FAIR 1939." Although she did not win

the World's Fair prize for this masterpiece of figurative appliqué—judges tended to favor more traditional quiltmaking—Gasperik's needlework and composition demonstrate her persistence, optimism, and courage, some of the very qualities that the administrators of the New Deal wished to instill in Americans. As Mary's granddaughter Susan Salser recounts, "Mary Gasperik learned how to be a modern American woman by making quilts."[10]

This book traces the ways Americans such as Mary interacted with quilts as part of the New Deal and how they expressed their own hopes and frustrations through stitches. The first chapter explores how romanticized notions of the colonial past shaped American perceptions of quilts during the 1930s. Quilts were fashionable objects that simultaneously reflected the necessary Depression-era practices of thrift and making do. Chapter 2 focuses on how the FSA's photography project presented quilts and quiltmaking within its large-scale public relations campaign, eliciting empathy by showing how displaced or impoverished families made and used quilts while showcasing the positive effects of the FSA and related governmental programs.

Chapters 3 and 4 analyze the governmental programs that provided instruction to women in how to make quilts. The WPA's Women's and Professional Division created sewing rooms and handicraft projects in which women without a husband or father supporting them could find work. Sewing rooms trained women to make quilts, resulting in the production of tens of thousands of bedcovers, along with the garments and mattresses that comprised the bulk of their output. Handicraft projects instructed women in more specialized patchwork and appliqué techniques, among other skills like block printing and bookbinding. Chapter 4

shifts focus to the home economists who facilitated quiltmaking and other home beautification and sewing techniques as part of the Department of Agriculture's Cooperative Extension Service and the FSA. Women living in the New Deal's many planned communities and migratory labor camps learned from the home economists staffing these federally funded outposts, each outfitted with a community sewing room.

In addition to promoting quiltmaking, the New Deal also sponsored initiatives that aimed to celebrate and preserve the history of quilts, even while drawing on some of the romanticized notions of colonial quilting. Chapter 5 explores how the Federal Writers' Project, the Index of American Design, and the Museum Extension Project—each subdivisions within the WPA—documented and disseminated knowledge of historical quiltmaking through oral testimonies, renderings of historical quilts, and reproductions of quilt patterns. Chapter 6 examines the outpouring of quilts made by American women and men as expressions of empowerment, frustration, and hope during the New Deal era, showcasing some of the remarkable quilts individually and collectively made and, at times, presented as gifts to New Deal administrators, including the Roosevelts. This volume concludes by considering both what was in fact "new" about quilts in the New Deal and identifying ways we can apply the lessons of New Deal quiltmaking to the challenges of our current era.

Fig. 1-1. *Illustration from* A Patchwork Quilt of Favorite Tales. *New York, M.A. Donohue & Co. 1933. Public Domain, courtesy of HathiTrust.*

CHAPTER 1
"THE WHOLE COUNTRY IS QUILT CONSCIOUS" [1]

When the stock market crashed in 1929, the United States was in the midst of what *Ladies' Home Journal* had thirty-five years before called a "Revival of the Patchwork Quilt."[2] This subset of the Colonial Revival—the architectural and home decorating movement inspired by romanticized perceptions of the American past—had resulted in quiltmakers crafting hundreds of thousands of quilts. Some were adaptations of "old-fashioned quilts" based on the thousands of quilt patterns published in magazines and newspapers. Some were contemporary in design, inspired by entrepreneurs who sold patterns, blocks, kits, and completed quilts. And nascent quilt historians speculated on the origins of American quiltmaking traditions, publishing popular books that celebrated the colonial practice of American quiltmaking. Along with renewed enthusiasm for quilts and quiltmaking—called the "Rage of the Hour" in 1933—Americans embraced the values perceived to be embedded in quilts, including creative reuse, thrift, and self-sufficiency, the same values that had become so essential to surviving the Great Depression.[3] For those of limited economic means, the American culture's nostalgia for the craft of quiltmaking, embodying both an adaptation of an imagined colonial style and ideals of fortitude and frugality, made particularly good sense.

When Carrie Hall and Rose Kretsinger wrote in their 1935 aptly title book, *The Romance of the Patchwork Quilt in America,* that "the whole country is quilt conscious," their observation extended beyond the great number of quilts being made, sold, and written about by colonial history enthusiasts and newspaper reporters alike.[4] Quilts permeated realms outside the domestic spheres of needlework and home decorating. Americans understood quilts' symbolic meaning, using the objects almost as a shorthand for "making do" amid trying times. By the 1930s, quilts were regularly used as a common metaphor, connoting the creation of something larger than the sum of its individual parts, even when those haphazard bits and pieces didn't necessarily fit together neatly. Already the language of quilting was stitched into the American vernacular, exemplified by a *New York Times* journalist describing the New Deal itself as a "patchwork quilt of work relief, permanent social reform, and resources development" while the *New York Herald Tribune* referred to the state guidebooks written by workers in the Federal Writers' Project as a "Patchwork Quilt of These United States." A sportswriter even characterized a baseball team's roster as a "crazy quilt infield and a patchwork outfield."[5]

Children, too, received indoctrination to the understanding that quilts—and the scraps from which they were made—were cherished and meaningful objects of American and family history. The beautifully illustrated children's book, *A Patch Work Quilt of Favorite Tales* compiled fairy tales, nursery rhymes, and adventure stories, including the introductory poem, "A Patchwork Quilt," in which a grandmother recounts the stories of the dresses she wore as a child that are now made into a colorful scrap quilt.[6] In 1937, the School District of Philadelphia offered a line drawing of an old fashioned quilting bee as a coloring sheet in its Bulletin for Teachers for grade 4, which provided source material for studying the "colonial people." Of the colonial woman, the Bulletin said, "The finished quilt satisfied some of her desire for household decoration, besides making possible the economical use of scraps of cotton, silk, linen, and woolen materials."[7] Children, growing up amid the economic downturn, learned through these object lessons that saving scraps and making do were desirable and necessary characteristics—indeed, something to take pride in.

Another curriculum promoted quiltmaking itself as an important skill for children to learn. A 1931 Ohio guidebook for teaching arithmetic to first and second graders proposed making a quilt, with the educational aim of introducing "the need for counting and measuring, through an actual situation" while also developing "a sympathetic interest in those less fortunate than themselves," as the resulting quilt would be given to a "needy child in the mining district." Accompanying the instructions were a number of math problems, including the question, "Two light patches and 2 dark patches are needed for one block. How many patches will be needed for

one block?" The lesson plan lists the "supplementary outcomes" as "neatness, self reliance, perseverance, cooperation, organization, thrift, courtesy, cleanliness, judgement."[8] Revealed in this activity's outcomes are the very values many Americans, including many government administrators, wanted to embrace during the Great Depression. And here they are linked explicitly with quiltmaking.

THE COLONIAL REVIVAL

The early quilt historians who wrote the first analyses of historical quilts and quiltmaking tried to link the contemporary quilting craze with what they theorized were the historical origins of quiltmaking. In books published with names such as *Quilts: Their Story and How to Make Them* (Webster, 1915), *Old Quilts and the Women Who Made Them* (Finley, 1929), and *The Romance of Patchwork Quilts in America* (Kretsinger and Hall, 1935), authors speculated—as they had few primary sources beyond the extant nineteenth-century quilts they collected—that quilts had been part of American households since the colonial era, typically recycled from scraps of fabric.[9] These early twentieth-century quilt scholars offered photographic reproductions of nineteenth-century American quilts as inspiration, sometimes providing patterns based on these old quilts. Further, some of them designed new quilt patterns and were active participants in the consumer culture of this new quilt industry that had sprung up before the Great Depression and continued unabated despite the economic downturn. Many American quiltmakers made quilts directly inspired by the examples in these books, creating "modern" adaptations of Pine Trees, all variations of Stars, and an array of floral appliqués.[10]

Fig. 1-2. Sarah Laughlin, Pink Dogwood, *probably made in Guernsey County, Ohio, dated 1927. International Quilt Museum, Ardis and Robert James Collection, 1997.007.0737. One of Marie Webster's many popular and widely circulating quilt patterns, Webster drew inspiration from nineteenth-century quilt styles and set them in contemporary formats and color palettes. Her popular 1915 book,* Quilts, Their Story and How to Make Them, *helped perpetuate romanticized ideas about colonial American quiltmaking, despite a lack of evidence.*

Popular literature about colonial times and old-fashioned quilts served as metaphorical guidebooks for how women during the Great Depression could take care of their families. Among the most popular and influential books was Marie Webster's *Quilts, Their Story and How to Make Them,* first published in 1915 and reprinted four times before 1930; Webster also lectured and presented quilt exhibitions across the country.[11] She directly linked her understanding of colonial quiltmaking practices with frugality, writing, "The pinch of hard times during the struggle for independence made it imperative for many well-to-do families to economize. Consequently, in many old patchwork quilts may be found bits of the finest silks, satins, velvets, and brocades, relics of more prosperous days."[12] She praised these early American quiltmakers, observing that "the comforts of the family depended upon the thrift, energy, and thoughtfulness of the women."[13] Her wildly popular quilt patterns had contemporary flair, even while exhibiting an influence of nineteenth-century high style appliqué quilts (fig. 1-2). During 1911 and 1912, *Ladies' Home Journal* published fourteen of her quilts in full color, and Webster soon started her own mail-order business supplying patterns to those eager to make their own versions. The popularity of her designs stretched into the Great Depression, even though they required large pieces for background fabrics rather than the sort of scrappy frugalness she promoted in her own book.

Ruth Finley, writing in *Old Patchwork Quilts and the Women Who Made Them,* concurred that "in mansion house and frontier cabin, from the Cavaliers of Jamestown to the Puritans of Plymouth, scraps of linen, cotton, silk and wool were jealously saved and pieced into patchwork quilts." Finley speculated that because these colonial era quilts were "pieced from materials that not infrequently had already seen their best days in the form of clothing," they had not lasted into the twentieth century, and for this reason she had no surviving quilts to support her claim.[14]

The old quilts photographically reproduced in popular early twentieth-century books, however, were neither colonial nor scrap quilts. These quilts were typically high-style quilts, many of them appliqué, with intricate quilting stitches, stuff work, and crisp unused fabrics that would have been quite fashionable at the time of the quilt's creation. Further, they were nineteenth and early twentieth-century creations, not "colonial" quilts. The same was true for the ornate contemporary patterns Webster and Rose Kretsinger designed and featured in their books. Modern inspirations that drew on the nineteenth-century versions, these quilts were neither scrappy nor thrifty but instead required large pieces of new fabric to create the pastel backgrounds. These quilt authors celebrated what they imagined as the frugality of colonial quiltmakers yet had no evidence to back it up.

Despite Finley's theory that "the practical bed-quilt, essential and within the economic means of all, was a universal form of needlework prior to 1750," late twentieth-century quilt historians conducting more rigorous scholarship have determined that "quilts were not common or ordinary articles in early colonial times. Far from it. They were both rare and expensive…. Quilts were not born of economic necessity or, at least primarily, as a practical means of keeping warm…. The 'need' for American women to make handsome quilts does not appear to be either economic or practical."[15] In the pre-industrial colonial era, textiles were among the most expensive of household belongings, typically imported from Europe. Only once industrialized American production made printed cottons accessible to those beyond the

upper classes did quiltmaking become a widespread activity.[16] Yet advocates of the Colonial Revival imagined colonial foremothers making do from scraps as a means to keep their families warm, part and parcel of their larger mythologizing of early America.

Quilt myths percolated throughout American culture in the early twentieth century; foremost among them was an enduring idea that centered on the thriftiness of America's quintessential women's craft. The "scrap-bag" myth posited that impoverished colonial-era women lovingly stitched together scraps of fabric to make quilts to keep their family members warm. Despite the lack of material evidence, the myth of quilts recycled from scraps had legs, and quilts became popularly understood as symbols of American women's fortitude in the midst of poverty, oppression, and other tribulations.[17]

FRUGAL FASHION

Belief in the early American scrap quilt was strong, whether it was based on myth or reality. In addition to embracing the "colonial" style of quilts, the mass media drew on the ideas espoused by the early quilt historians. Newspapers and magazines—along with the American government itself, as we shall see in subsequent chapters— encouraged American women to adopt the parsimony and resilience represented by quiltmaking. Just months before the 1929 stock market crash, an article titled "The Revival of an American Craft" suggested that "quilting was one of the few forms of self-expression that the wives of the American colonists were allowed. Tears and smiles were stitched into the intricate patterns that the pioneer woman evolved from discarded clothing and worn

household linen. Scraps of material were combined with consummate artistry in the old pieced quilts we treasure today."[18] A few years later, in the midst of the Depression, a 1933 Washington D.C. *Evening Star* column titled "Revival of Old-Fashioned Thrift" encouraged readers to use "discarded frocks" to create a Tree and Truth patchwork quilt, following a "custom of the early American days" when "thrifty housewives" recycled used dresses into durable quilts.[19]

Many newspapers similarly offered quilt patterns, often inspired by so-called colonial quilts, in columns written by quilt designers (or their pseudonyms), some syndicated nationally in smaller papers, allowing readers to mail order or simply copy any of the thousands of new patterns.[20] And despite the fact that few colonial era women had actually re-used old textiles in their quilts, Depression-era women did so in droves. Even *The New York Times* reported on the quiltmaking trend in an article titled "Quilt-Making Has a Revival," noting that "clothing which can no longer stand mending or remodeling is cut up for rugs or patchwork quilts," calling out the blue denim from worn-out overalls and the muslin from flour sacks.[21]

One of the leading newspaper quilt columnists appeared under the name Nancy Cabot, the pseudonym of Loretta Isabel Leitner Rising. Over twenty-five separate Nancy Cabot columns published in the *Chicago Daily Tribune* between 1933 and 1938 featured the word scrap or scrap-bag in the title, demonstrating the widespread understanding that quiltmaking and scraps went hand-in-hand. During this same timeframe, forty Nancy Cabot quilt patterns in the *Tribune* featured "colonial" in the column's title.[22] Marketers clearly understood that these value-laden

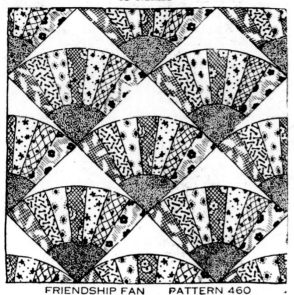

Fig. 1-3. "This Laura Wheeler Quilt is Economical to Make," Laura Wheeler Friendship Fan, Shreveport Journal, *September 10, 1936, and syndicated widely.*

cents in stamps or coin (coin preferred) for this pattern," allowing readers to mail order the physical pattern. But as quilt scholar Merikay Waldvogel observes, "readers could easily make quilts from the illustrated pattern that showed several blocks and gave the reader a good idea of the overall effect of the quilt."[23] A 1937 column featuring one of Laura Wheeler's pattern was titled "Here's Thrift," showing an appliqué pattern it referred to as a "scrap quilt."[24] Several Laura Wheeler columns urged quiltmakers to take pride in thriftiness, a sentiment that governmental initiatives echoed: "Into the scrap-bag you must go to take your pick of the most colorful pieces for this lovely quilt.... An economy quilt indeed and one you'll be proud to own!"[25] A pattern called "Pride of the North" was called "colorful and economical" while the feature's title demanded "Get out your scraps."[26] Although the copy for Laura Wheeler patterns did not typically make direct connections to colonial foremothers, the one featuring the pattern called "Grandmother's Pride" stated, "The very quilt that grandmother herself might have pieced! The chances are your cotton scraps are even gayer than those she used, which will make this scrap quilt an unusually gay one for you and your friends to make."[27] The text accompanying a pattern that Wheeler called "Friendship Fan" (fig. 1-3, 1-4)—predominantly a twentieth-century pattern rather than a colonial or nineteenth-century one—explicitly linked it to colonial romance, reading, "Handed down from colonial days, the Friendship Fan, made of scraps continues all its old-time popularity."[28] In the quilt patterns published through the 1930s, the values perceived to be embedded in the act of quiltmaking—even if based on the myth of colonial-era quilts—thrived.

buzzwords had resonance with newspaper readers who would in turn purchase the patterns.

Among the many quilt patterns published and sold through newspaper columns, Laura Wheeler designs were particularly popular because they encouraged the creative use of scraps, acknowledging explicitly that making a quilt in an economical way was desirable. These regularly occurring newspaper features promoted the purchase of complex contemporary quilt patterns while still being firmly enmeshed in the belt-tightening consumer culture of the 1930s. Wheeler's columns always ended by urging readers to "send ten

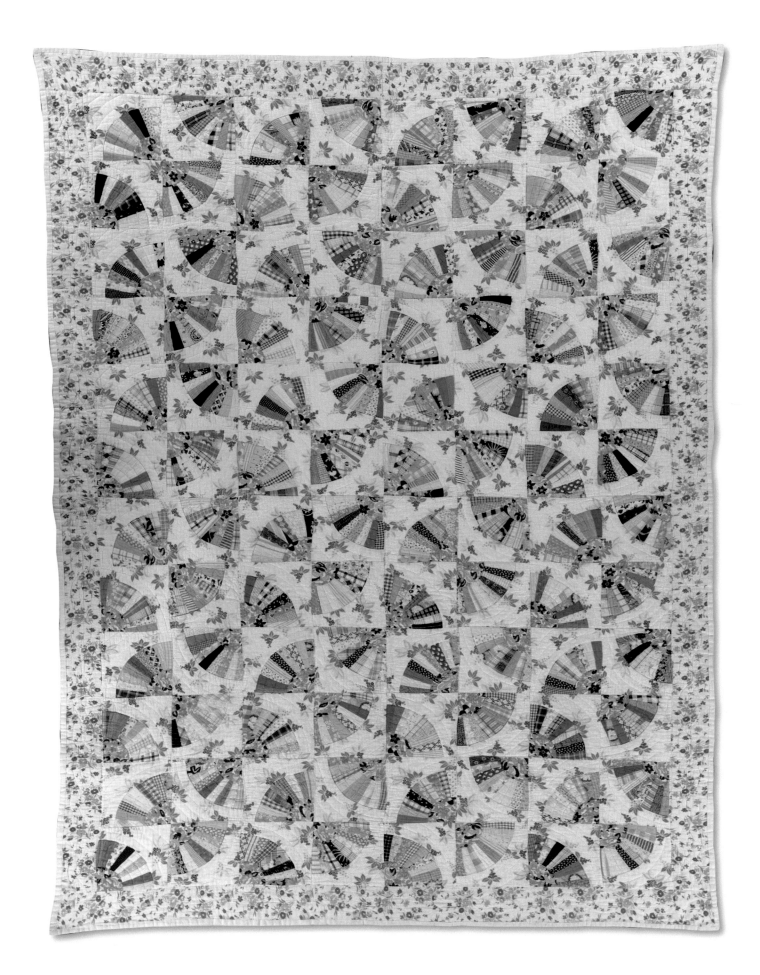

Quilts during this era were products of both consumer culture and a make-do culture. In this photograph of a child reading on a bed in a sharecropper's home, we see a version of the Friendship Fans pattern, perhaps drawn from Laura Wheeler's published pattern or another circulating source to which its maker had access (fig. 1-5). Friends and neighbors shared newspaper clippings and traded patterns cribbed from published sources, sometimes sketched onto repurposed paper. An inventive maker could have re-created the pattern through a reproduced image or from another quilt itself. She likely pieced the quilt on a sewing machine, which became widely available on the consumer market since after the U.S. Civil War and was the most common means of stitching together quilts in the twentieth century, even in homes like this one with few modern amenities. The government had purchased this sharecropper cottage in 1937, part of an experiment to turn a former plantation of 6,700 acres where 40 African American and 60 white sharecropper families lived and worked into a farm cooperative community called La Forge Farms in southeastern Missouri. As such, the family who lived in this house now had access to shared resources, like a community center in the newly built school, and Farm Security Administration loans for purchases such as sewing machines. Women in La Forge operated a cooperative store that sold dry goods (fig. 1-6), perhaps the source of some of the fabric for this quilt, although in the 1930s industrious quilters often made good use of other repurposed materials such as sacks from feed or flour and bits leftover from making clothing.[29]

In addition to photographic evidence like we see here, the many existing quilts reflect the great number of quiltmakers who adapted the widely

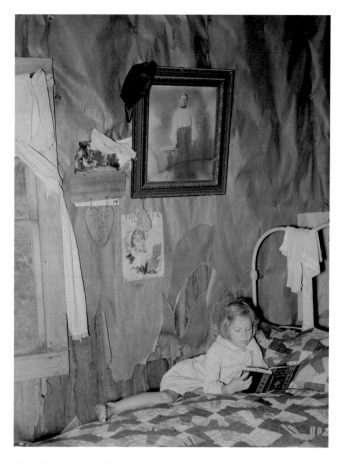

Fig. 1-5. *Russell Lee,* Southeast Missouri Farms. Child of sharecropper reading on bed in living room, *1938. Farm Security Administration, Library of Congress. On the bed is a Friendship Fan or Grandmother's Fan pattern in use.*

circulating patterns and advice that promoted quilting as a simultaneously "colonial" and thrifty activity.[30] Yet because of the prominent role mass media had in the dissemination of quilt patterns, the hundreds of thousands of quilts made with commercially published patterns or from kits resulted in many homogeneous designs.

Characteristic of the quilts from the Great Depression are ones in patterns that made ingenious use of

Fig. 1-4. Maker unidentified, Grandmother's Fan, *possibly made in the Midwestern United States, 1920-1940, International Quilt Museum, Ardis and Robert James Collection, 1997.007.0036. Perhaps made from the Laura Wheeler "Friendship Fan" pattern in fig. 1-3, this quilt features economical use of scraps, including feed sacks. Such use of a great mix of uncoordinated prints was common among quilts made during this era, encouraged by the renewed emphasis on thrift as well as the fashion for mixing and matching, exemplified by the popular Fiesta dishes. In this way, quilts could be, to quote Barbara Brackman, both "frugal and fashionable."*

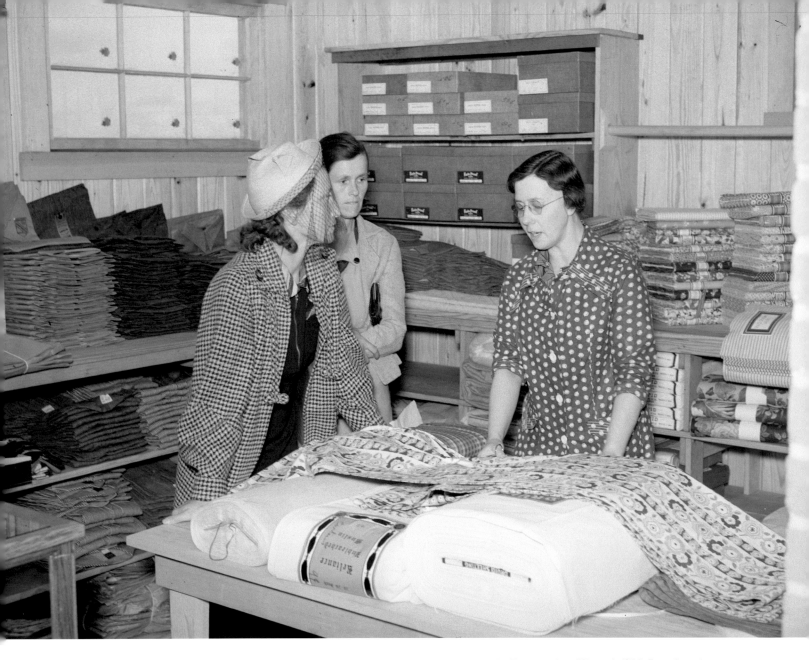

Fig. 1-6. Russell Lee, Southeast Missouri Farms. Examining yard goods in cooperative store. La Forge project, Missouri, *1938, Farm Security Administration, Library of Congress.*

scraps, including those published in the newspaper columns of Nancy Cabot, Laura Wheeler, and other syndicated columnists. Some quintessential Depression-era patterns were published repeatedly, like Grandmother's Flower Garden, Dresden Plate, and Double Wedding Ring.[31] Although scraps were indeed a necessity for some quiltmakers, for others, it was fashion. Quilt historian Barbara Brackman likens scrap quilts to popular china settings of the same era, like Fiestaware, makers of which encouraged

mismatched colors. Brackman further notes that Sears Roebuck and other mail-order companies sold boxes of printed cotton scraps along with patterns for making Double Wedding Ring and Grandmother's Flower Garden quilts. Magazines advertised bundles of "factory cut-aways"—the odd-shaped fabric pieces leftover at factories that produced clothing.[32] Even quiltmakers without their own scrap bags could execute quilts that displayed the values and aesthetics of frugality and reuse.

Co-existing with the colonial revival scrappy style quilts promoted by newspapers and magazines was a tradition that paid no attention to published patterns. Southern rural women, both Black and white, developed haphazard improvisational quiltmaking techniques that paid no mind to commercially circulating patterns (see fig. 1-7).[33] Although twenty-first-century curators and collectors have celebrated African American quiltmaking traditions as existing separately from those of white Americans, stylistic distinctions have much more to do with region and socio-economic status. Indeed, without known attribution, it is nearly impossible to know the race of a quiltmaker, no matter how improvisational the design or creative the use of scraps. As the next chapter demonstrates, in Depression-era photographs of rural quiltmakers of both races, we see an array of designs, some inspired by commercially available patterns and some original creations. As such, scrap quilts took many forms, sometimes adhering to more formal Colonial Revival aesthetics and sometimes pieced in asymmetrical and improvisational designs. Race plays a significant role in the New Deal and the resulting quilts, as subsequent discussion in this book reveals, yet a quilt's style alone does not identify the race of its maker.[34]

A cheerful pastel pieced Broken Star quilt (fig. 1-8) shows how a quiltmaker could execute a Colonial Revival-inspired pattern, while drawing on the Depression era values of thrift and reuse. The pattern, inspired by a nineteenth-century favorite made available during the 1930s to consumers as a kit with die-cut pieces, was published and named "Broken Star" in a 1925 issue of *Capper's Weekly*, a farm magazine from Kansas, and later offered as a free pattern inside rolls of Mountain Mist quilt batting.[35] Attributed to rural Arkansas, close examination of this particular quilt reveals the maker's reuse through the repurposing of a feed or flour sack. On the quilt's back is a faded printed label.[36] The integration of dual-use packaging—cloth bags that once held feed, flour, sugar, or other staples—into quilts has become synonymous with the thrifty ingenuity of the Great Depression, and as chapter 4 discusses, was promoted by governmental home economists and cotton trade groups alike. The reuse of sacks, typically dyed or bleached to remove the labels (which often stubbornly remained, as did this one), is a prime example of how farmwomen, and younger girls, like Bernice "Tootsie" Schultz Mackey, creatively made do with what they had, even as they participated in the quilt revival by executing quilts in fashionable commercially published patterns.[37]

As a young woman, Mackey (1916-2002) began work on her Oriental Poppy quilt (fig. 1-9), a Rose Kretsinger design published in *The Romance of the Patchwork Quilt in America* (1935). Mackey had ordered the pattern for ten cents from *Farm Journal,* where it was published in 1940. Although she executed this high-style design which Kretsinger had adapted from a late nineteenth century quilt, she bleached feed sacks to use for the white background fabric and backing fabric, combining it with newly purchased fabric that she used for the appliqué floral motif. Making a Colonial Revival style quilt from recycled cloth combined the popular aesthetic with the practical frugality twentieth-century Americans imagined was embedded in old quilts.[38]

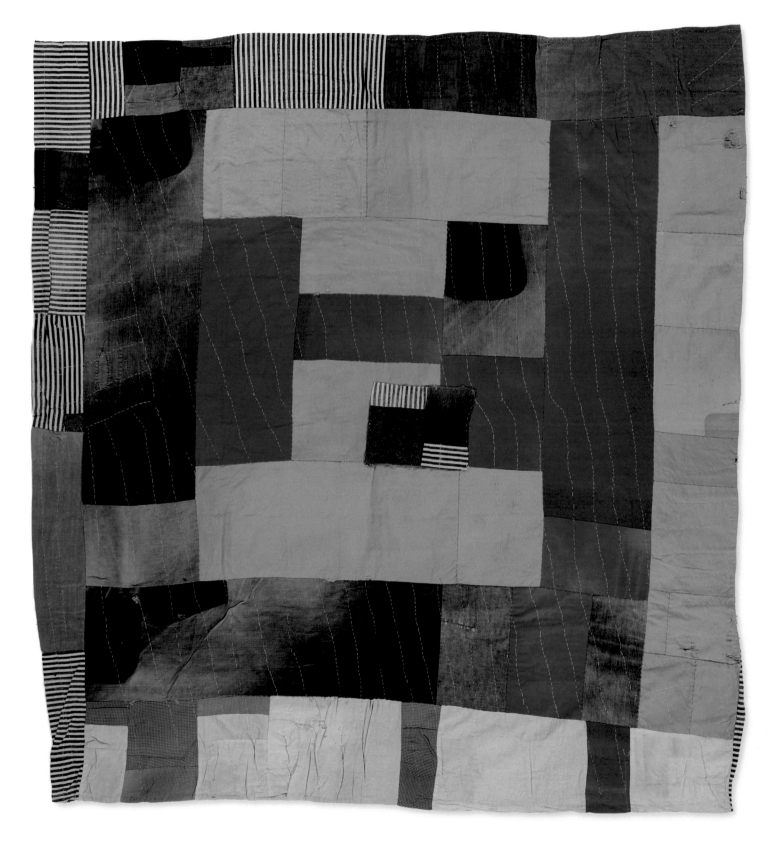

Fig. 1-7. Catherine Somerville, Britchy Quilt, *probably made in Pickinsville, Alabama, 1930-1950. International Quilt Museum, Robert and Helen Cargo Collection, 2000.004.0116. Rural women in various geographic enclaves made quilts out of worn work trousers. In the Deep South, where Catherine Somerville lived, they called them "britchy" quilts. In the twenty-first century, these improvisational quilts have gained fame and recognition as hallmarks of African American quiltmaking, although women of all races made similarly bold scrap quilts. According to the census, in 1940, Somerville (1910-1991), a Black woman, lived with her mother Henrettia in a rural, unincorporated crossroads called Spring Hill, outside of Pickinsville, Alabama, and was listed as a farm laborer.*

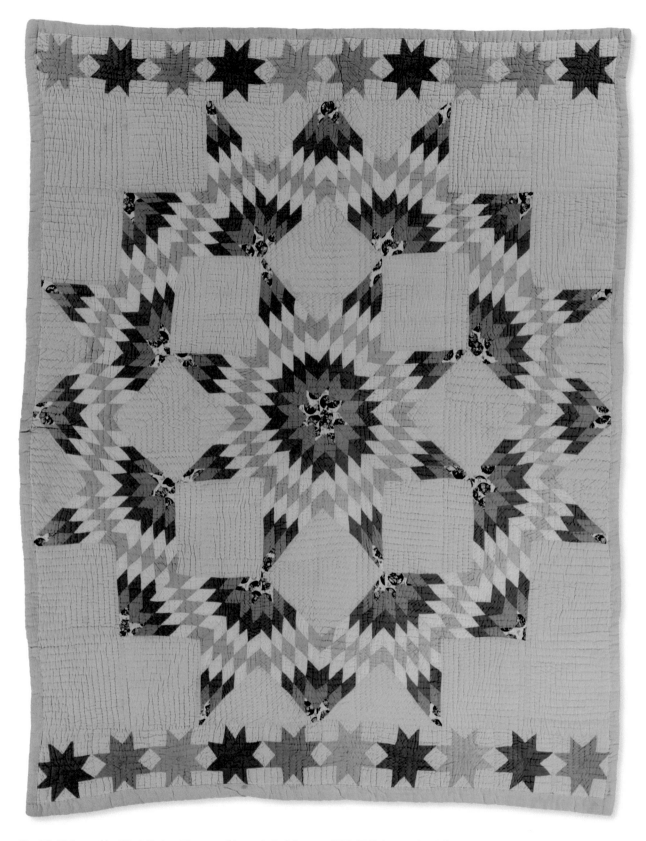

Fig. 1-8. Maker unidentified, Broken Star, *possibly made in Arkansas, 1930-1950. International Quilt Museum, Ardis and Robert James Collection, 1997.007.0672. This cheerful pastel pieced Broken Star quilt shows how a quiltmaker could execute a pattern with clear inspiration from the literature celebrating "colonial"-style while also being thrifty. The pattern, a favorite during the 1930s that consumers could purchase as a kit with die-cut pieces, was published and named "Broken Star" in a 1925 issue of* Capper's Weekly, *a farm magazine from Kansas, and later offered as a free pattern inside a roll of Mountain Mist quilt batting. Attributed to rural Arkansas, this version has a faded printed label on the quilt's back revealing its maker's reuse of a feed or flour sack.*

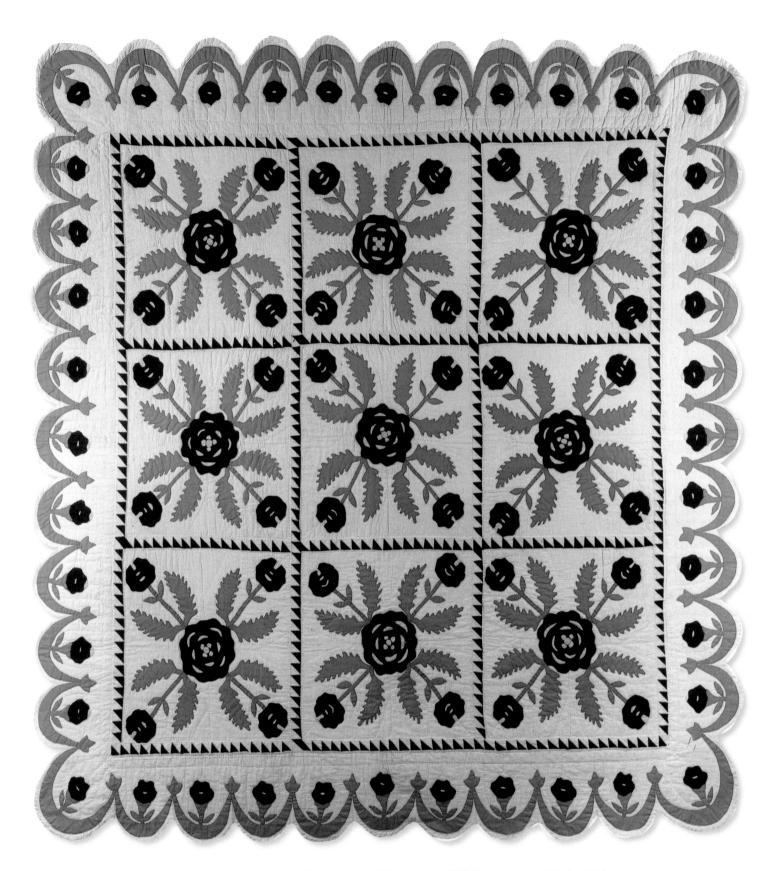

Fig. 1-9. Bernice "Tootsie" Shultz Mackey, Oriental Poppy, *Huntland, Tennessee, c. 1940. Image courtesy Merikay Waldvogel.*

Fig. 1-10. Russell Lee, White migrant mother piecing a quilt. Harlingen, Texas, *1939. Farm Security Administration, Library of Congress.*

THRIFTY QUILTING

Colonial Revival fashion—and its related values—coupled with Depression-induced thrift is exemplified by the woman shown piecing a quilt in Russell Lee's 1939 photograph from his visit to south Texas (fig. 1-10). As the following chapter explores, many evocative Farm Security Administration (FSA) photographs feature quilts and quiltmakers, serving as valuable evidence of quiltmaking practices while also delivering a distinct New Deal message. Captioned "White migrant mother piecing a quilt. Harlingen, Texas," we

unfortunately do not know how FSA photographer Lee may have posed the picture—if he found this young woman in the midst of her work, if he asked her to sit and stitch, or if any of these items were used in the composition as props.

The phrase "migrant mother" gained resonance when Lee's colleague Dorothea Lange carefully composed a series of photographs at a pea pickers' camp in California in 1936, which resulted in a

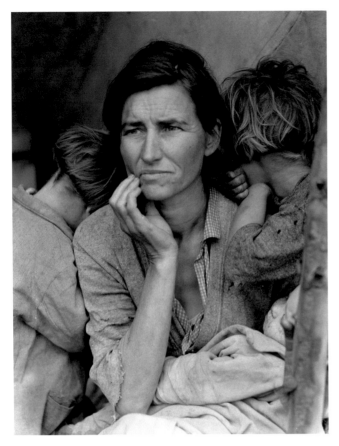

Fig. 1-11. Dorothea Lange, Migrant Mother *or as originally captioned,* Destitute pea pickers in California. Mother of seven children. Age thirty-two. Nipomo, California, *1936. Farm Security Administration. Library of Congress.*

widely published portrait of a woman and her young children that evoked empathy for the plight of poor displaced families, and soon became known as *Migrant Mother* (fig. 1-11).

Lee's photograph draws on the same theme, here depicting a young mother in Texas wearing fashionable stockings and shoes and a housedress in a cheery printed fabric, perhaps her best one. She's sitting on a make-do bed on the floor, on which we can see two pieced quilts, with a bubble gum box filled with scraps of fabrics beside her. She's at work on a complicated pattern, piecing sixty-degree angles into a Lone Star or other large central motif, one of the patterns made popular by the Colonial Revival.[39] Notably, this is handwork. By the 1930s, sewing machines for

home use had been on the market for decades, and quiltmakers had readily embraced them since the years after the Civil War. Certainly, a migrant mother may not have had access to a sewing machine, although the FSA supplied some impoverished women with sewing machines through its credit program and in the community centers in the migratory labor camps it operated (see chapter 4).[40] The handwork, though, harks back to the imagined pre-industrial colonial past, as does the woman's box of scraps. Was she one of the "quilt conscious" Americans Rose Kretsinger and Carrie Hall described? Whether consciously or not, this woman embraced the 1930s' spirit of thrift and reuse, likely not because of its colonial charm but because thrift made sense, as demonstrated by her repurposed bubble gum box, the rolls of quilts on the floor, and the threadbare rug on the ground. For those of limited economic means, such thrift exemplified by repurposing scraps of fabric was practical, even if it was inspired by American culture's romanticizing of the craft of quiltmaking. Quiltmakers like this migrant mother may have perceived the craft as old-fashioned yet resourceful whether or not they connected it to the mythologized colonial Americans who sacrificed in the previous century.[41]

In this way by the 1930s, romanticized understandings of quilts had transitioned from myth into living practices of women who now embraced a mentality of reuse, thrift, and self-fortitude in their day-to-day lives out of necessity, while adopting the fashion trends promoted through commercially published patterns. Russell Lee's migrant mother digs into her scraps, using whatever resources she has, to make her family's lives warmer and cheerier, just as the imagined colonial quiltmakers did. This was a value permeating American society during the Great Depression, and it also was an ideal the federal government wished to promote in its recovery initiatives, as the many photographs captured by Lee and his colleagues discussed in the next chapter reveal.

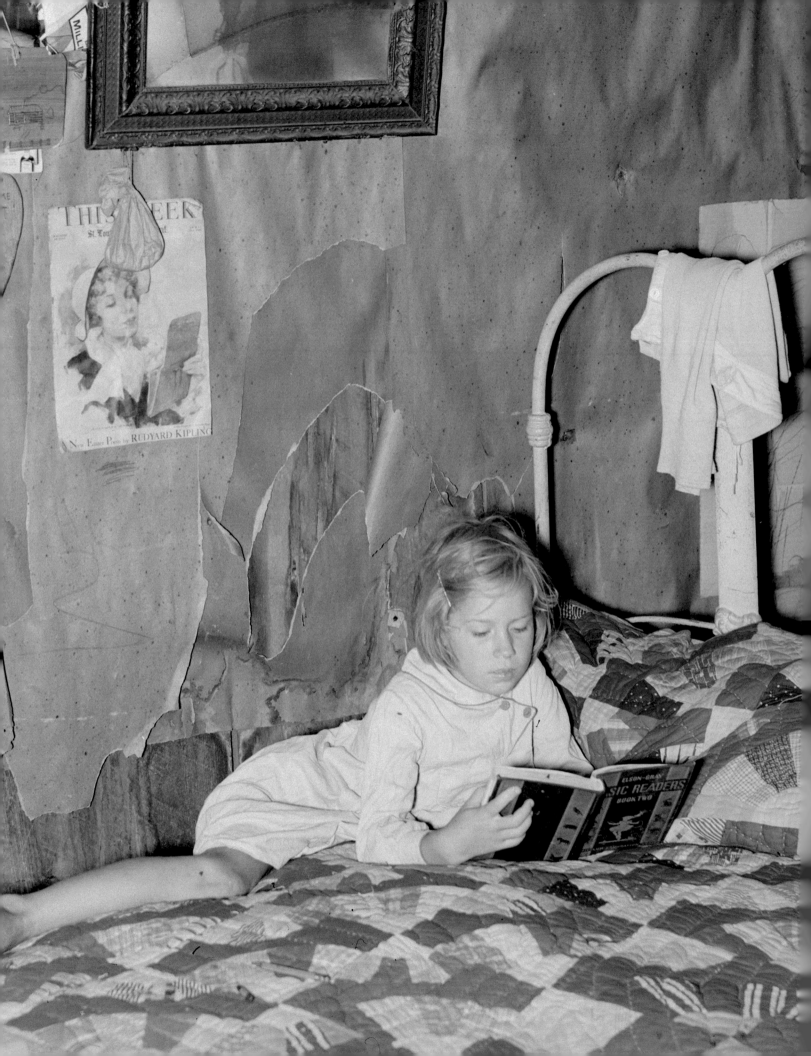

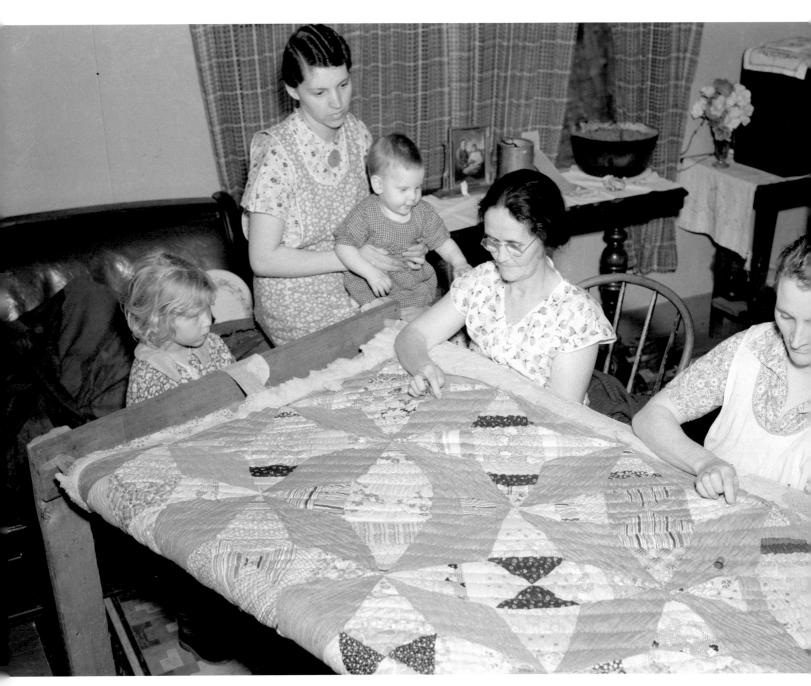

Fig. 2-1. Russell Lee, *A quilting party in an Alvin, Wisconsin, home, 1937.* Farm Security Administration, Library of Congress.

CHAPTER 2
VISUAL RHETORIC

Family members of multiple generations sit around a quilt frame, with a baby in a mother's lap while a toddler stands at the edge of the frame, staring intently at the grandmother as she slides her needle through the layers of the quilt. The quilt's pattern—published as Rocky Road to Kansas by the Ladies Art Company—is perfect for using up scraps, and close examination reveals an abundance of florals and stripes, not dissimilar from the dresses and aprons worn by the women and children pictured in this Wisconsin home (fig. 2-1).

It appears as a typical 1930s scene, characteristic of a family pulling together to overcome hard times, making something beautiful and useful from leftover fabrics, that will both lift their spirits and keep the family warm at night. Yet one detail in this domestic photograph is amiss: the women have their needles in the quilt where there are already clear lines of running stitches holding together the three layers of the bedcover. From the angle of the camera's lens, the quilting appears complete, not in process.

This photograph, one of over ninety featuring quilts taken by Russell Lee (1903-1986), a photographer employed by the New Deal's Farm Security Administration (FSA), is carefully crafted. Lee clearly posed the women and children in the Wisconsin

home, as he likely did with many other of the quilt-related photographs he shot while working for the FSA's Historic Division. In some photos, quilts are merely incidental, part of the domestic setting—including many of the shots he took of migrants sick in bed, curled up under quilts. But again and again, Lee composed photographs of women at work on quilts or with finished quilts, making clear links between his compositions and the messaging the FSA pursued. Perhaps Lee was swept up in the quilt revival—the "rage of the hour."[1] Or perhaps he knew that quilts could be effective elements of compositions created to communicate the desired message of the FSA photography project. He was not alone in photographing quilts; renowned FSA photographers Dorothea Lange, Marian Post Wolcott, Arthur Rothstein, John Vachon, Jack Delano, and Marjory Collins each took quilt photographs.

American collective memory of the Great Depression has been shaped by the photographs taken under the auspices of the FSA. Appearing initially in governmental reports, the popular press, and in widely attended World's Fair exhibitions during the Depression and its aftermath, FSA photographs appeared decades later in museum exhibitions, textbooks, and documentary films, becoming a common way Americans visualized the 1930s.[2] Many

individual photographs, like Dorothea Lange's *Migrant Mother* (fig. 1-11), have become iconic images of this era. Yet creating this visual record for posterity was not the project's primary objective. In 1935 when the Resettlement Administration (RA, the precursor to the FSA) sent its first photographers out to document impoverished Americans primarily in rural settings, its goal was to demonstrate the need for federal support of struggling Americans.[3] Some of the division's photographers explicitly sought to use the photographs to spur improvements in the lives of those impoverished by the Depression; in the words of photographer Marion Post Wolcott, they had "a social consciousness definitely... they were all interested in the plight of human beings and in the programs of the New Deal."[4] In addition to the immediate goal of spurring action, the project's director, Roy Stryker, had a personal aim of assembling a collection of photographs depicting American life, in his words, "showing America to Americans."[5] After fighting in World War One, Stryker studied economics at Columbia University under the direction of his mentor Rexford Tugwell, who later was part of Franklin Roosevelt's "brain trust," the administrators and advisors who helped shape the New Deal. When Tugwell, at FDR's direction, created the RA in 1935, he invited Stryker to join the team. In this capacity, Stryker managed the photography project. At its core, the FSA

photography project was a massive public relations campaign aimed at convincing both Congress and the American people that the FSA, along with other New Deal programs, was necessary.

The administrators of the FSA, like those of the New Deal as a whole, exhibited conflicting ideologies that resulted in goals and values that were not necessarily consistent or aligned. A main FSA objective was to make "destitute farm families ... more independent" by fostering the "ideals of self-reliant individuals," drawing on the archetype of the yeoman farmer and the primacy of individual home and farm ownership.[6] Essentially, the FSA was established to provide credit to small farmers, including sharecroppers, so that they could continue to earn a living within a changing economy with increased modernization of farming and a move toward urbanization. The FSA implemented this through what it called "rural rehabilitation," which entailed the reformation of farming practices with the help of agricultural experts, coupled with governmental loans.[7] While rural rehabilitation aimed toward self-sufficiency, another FSA strategy, resettlement, typically took on a form of collectivism, with federally sponsored planned communities for farm families or migrant laborers and direct intervention from governmental experts (see chapter 4).

Unlike other New Deal art programs, the FSA photography project was not a "make-work" project benefitting the common good, that aimed to both raise morale and keep families afloat financially. Instead, this project employed some of the nation's best photographers, especially those trained in the documentary practice of capturing real life with veracity, creating authentic representations of the destitute and eventually expanding to a mission of documenting American ways of life, including the progress made thanks to New Deal programs later in the 1930s and into the 1940s. The FSA disseminated the most powerful of its 150,000 negatives through major magazines and newspapers, wire services, museum exhibits, traveling exhibits, congressional reports, government pamphlets, specialized periodicals, and picture books.[8] With its specific political objectives—namely showing both the need for New Deal programs and their positive impact on those hit hard by the economic downturn—the photographs aimed to elicit empathy for the plight of small-town Americans, farmers, migrants, displaced laborers, sharecroppers and tenant farmers. And its photographers captured many pictures of quiltmakers.

Other scholars have thoroughly documented the intentionality of FSA photographs. These professional photographers set out with an agenda shaped by their allegiance to the goals of the New Deal as well as their personal philosophies grounded in motivations to create social change amid suffering. Scholars of visual rhetoric have combed through negatives, discovering ways that the FSA photographers carefully crafted poses to achieve peak emotional impact, sometimes working from shooting scripts developed by Roy Stryker, the project's director.[9] Over 200 FSA photos feature quilts: women (and sometimes men) posing with quilts; people in the midst of quiltmaking; and quilts in use in domestic settings, frequently in the living quarters of the impoverished. The FSA photographers no doubt found quilts and quiltmakers during the late 1930s and early 1940s, as the so-called quilt revival was thriving. But why did the photographers choose to snap these shots of quilts and quiltmakers? While only a sliver of the large number of photos taken by FSA photographers, the quilt photographs share many qualities and communicated specific messages about how to lift one's family out of poverty. These photos drew on nostalgic myths of the colonial era described in the previous chapter by using quilts as symbols of making do and self-sufficiency; they humanized the subjects living in dire conditions by showing them interacting with quilts in ways that created warm domestic spaces; they depicted the cooperative nature of quiltmaking and the mythologized quilting bee to promote the FSA's communally minded agenda; and they showed the skill of quiltmaking as one that represented the positive impact of New Deal programs on individuals and communities. Quiltmaking, symbolic of the sorts of domesticity that may have been lost with a transformation from an informal, rural structure to the highly formal planning promoted by the FSA, softened the blow of this form of modernism that accompanied New Deal programs.

The FSA photographers were communicators, primarily using visual rhetoric—communication through visual elements such as images. In doing so, they combined their evocative photographs with notes and captions to explicitly link quilts to the values of the New Deal. They narrated the photos—sometimes almost through storytelling—by conveying important aspects of how they wanted contemporary viewers to interpret them.[10] Captions were central to the agenda shared by the FSA photographers; historian Linda Gordon notes that Dorothea Lange (1895-1965) "explicitly rejected the notion that 'a picture is worth a thousand words.' Without words she thought, photographs could be universalized, turned into icons" and removed from their context.[11] Russell Lee's captions called viewers' attention to the hard knocks endured by his subjects.

Fig. 2-2. Russell Lee, Mrs. Shotbang with Her Four Children She Delivered Herself. Husband Broke His Foot Early This Spring. About Time Baby Was to Be Born They Ran Short of Coal and Bed Clothing, Mrs. Shotbang Had to Take Care of the Newly-Born Baby and the Rest of the Family, Cutting Fence Posts for Fuel. The Family Almost Froze; No Mattresses on the Beds This Past Winter, Only Quilts over the Hard Springs, *1937. Farm Security Administration, Library of Congress.*

His description of Mrs. Shotbang, for example (fig. 2-2)—a very young mother, with a very hard life—narrated his composition of small children alongside quilts covering the bare springs of her bed, speaking to the dire need for governmental assistance: "Mrs. Shotbang with her four children she delivered herself. Husband broke his foot early this spring. About time baby was to be born they ran short of coal and bed clothing, Mrs. Shotbang had to take care of the newly-born baby and the rest of the family, cutting fence posts for fuel. The family almost froze; no mattresses on the beds this past winter, only quilts over the hard springs." Lee's story accompanying his 1937 photo results in the picture speaking more than visually; his intent is for the viewer to have empathy, or at least sympathy, for the plight of this young North Dakota woman, with her make-do use of quilts as evidence for fortitude. Lee's wife, Jean, accompanied his shooting trips and typically took notes and wrote captions. She often was able to make the women being photographed feel at ease, by asking about recipes and other domestic activities, and perhaps this caption with its evocative language is a result of her efforts.[12]

Not all captions speak so directly to the quilts and their meanings, however. Some FSA photographers provided much less commentary with their photos. Of his Greensboro, Alabama, photograph featuring the walls of a tenant farmer's home lined with old calendar sheets and pages from newspapers, which served as a backdrop for a portrait of a stoic elderly woman sitting in a chair in front of two beds covered in utilitarian patchwork quilts, Jack Delano (1914-1997) simply wrote, "Mulatto ex-slave in her house near Greensboro, Alabama" (fig. 2-3).

Fig. 2-3. Jack Delano, Mulatto Ex-Slave in Her House near Greensboro, Alabama, *1941. Farm Security Administration, Library of Congress.*

As the 1941 photograph was taken almost eighty years since emancipation, Delano's caption ballparks her age and implies the hardships she had lived through. Yet the quilts—not referenced in the caption—serve as an essential part of the composition, which feels part collage, with the squares and triangles of fabrics on the quilts echoing the papered walls.[13] These quilts are made from scraps, not using the ubiquitous published patterns available in newspapers and magazines; in doing so the quilts communicate the woman's ability to creatively piece together bits and pieces in order to get by, sustaining herself over generations.

While the quilt revival celebrated the romanticized quiltmaking practices of European colonial forebearers, it alternatively could have praised woman like this, born into slavery, who made quilts in their own vernacular, drawing on a mix of inspirations and traditions, and ignored by the colonial revivalists.[14]

The rest of this chapter focuses on the kinds of messages the FSA quilt photos conveyed: quilts as emblems of thrift and self-sufficiency; quilts as make-do objects that demonstrated poverty, cultivated empathy, and showed the need for

New Deal programs; quiltmaking as a communal practice that fit the FSA agenda of developing cooperative communities; and quiltmaking as a learned skill exemplifying the benefits of governmental interventions.

SELF-SUFFICIENCY & THRIFT

In practice, the FSA's rural rehabilitation agenda focused on efforts that would result in poor rural farmers becoming increasingly self-sufficient. At the local level, the FSA sent farm and home supervisors to guide farm families in improving their subsistence farming instead of focusing on cash crops, such as cotton. Supervisors heavily promoted food preservation, giving loans for clients to purchase appliances including pressure cookers. Supervisors also encouraged families to produce nonedible products at home, including constructing furniture

from salvage materials.[15] If a family purchased a sewing machine from the FSA's *Household Furniture and Domestic Equipment* catalog, the FSA promised to arrange sewing instruction to the client without additional cost.[16] With these goals in mind, it is easy to understand how quilts—home-produced objects made from salvage materials—served as useful symbols of the FSA's goals of thrift and self-sufficiency.

One of the strategies employed by FSA photographers was to capture quiltmakers in the midst of their work—a deliberate effort to showcase the self-sufficient act of quiltmaking: piecing together something beautiful and functional seemingly out of nothing. In her 1939 photograph (fig. 2-4) in Coffee County, Alabama, Marion Post Wolcott (1910-1990) posed Mrs. L.L. LeCompt at her sewing machine, likely the model available through the FSA's catalog, with examples of her handiwork—both clothing and

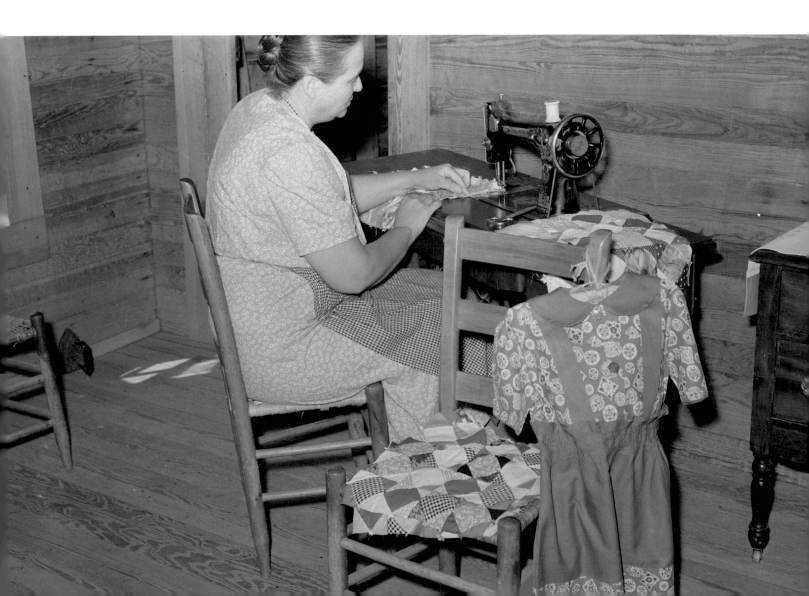

patchwork—staged on a chair as props nearby. "She does all the family sewing," Wolcott wrote in the photo's description, calling out the self-sufficiency of her subject.[17] The LeCompts were an FSA client family, what the government called the citizens whom the division helped. Among FSA's programs was a federally issued Standard Rural Rehabilitation Loan, which averaged between $240 and $600 (from $5,000 to $12,000 in today's money) from 1937 to 1940 and was designed to assist high-risk farm families. In exchange, FSA farm and home-management supervisors made routine visits to FSA client families to provide advice and assistance in implementing budgets and using new tools like sewing machines.[18] Another photo Wolcott took of Mrs. LeCompt featured a new stove, purchased through the loan program (fig. 2-5). The theme of self-sufficiency continues in that shot, with the farmwife standing over the stove stirring a pot while the pressure cooker jiggles along beside it. These photos, and the many others Wolcott took during her 1939 swing through Coffee County, show the FSA programs in action and, in doing so, promoted how governmental support had made these families more self-sufficient and able to maintain home and farm.

Wolcott took a series of photographs of the Peacock family, another client family who, according to Wolcott's caption, had at the time of the photos been part of the Rural Rehabilitation program for four years. She used quilts hanging on the porch of the Peacocks' home as the backdrop for a family portrait (fig. 2-6): the three boys and father wear overalls, while the mother and daughter appear in clean, cheery dresses, posed on the front steps of their wooden farmhouse. Two of the five quilts hanging on the porch have their patchwork fronts showing. The quilt on the far left appears to be a Nine Patch variation, while the one to the right of the

family features a Pinwheel variation. The other quilts show long lines of quilting stitches, while another patchwork quilt rests on a chair behind the family.[19] In this series of photos of a "rehabilitated" family, Wolcott also pictured shelves of canned food and a nutritious family meal in progress, with the caption "Through help and supervision of home and field supervisors, diet and health of many RR (Rural Rehabilitation) families have been greatly improved. The Peacock family (RR

Fig. 2-5. *Marion Post Wolcott,* Pressure cooker on Mrs. L.L. LeCompt's new stove bought through FSA (Farm Security Administration) loan. Coffee County, Alabama, *1939. Farm Security Administration, Library of Congress.*

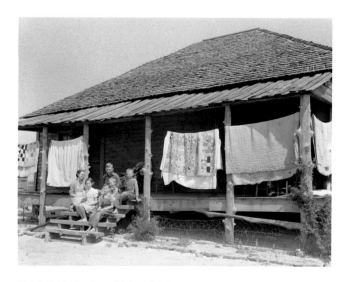

Fig. 2-6. *Marion Post Wolcott,* Mr. & Mrs. Peacock, RR (Rural Rehabilitation) family (four years) and children in front of their home. Coffee County, Alabama, *April 1939. Farm Security Administration, Library of Congress.*

Fig. 2-4. *Marion Post Wolcott,* Mrs. L.L. LeCompt stitching quilt squares together. She does all her family sewing. Coffee County, Alabama, *1939. Farm Security Administration, Library of Congress.*

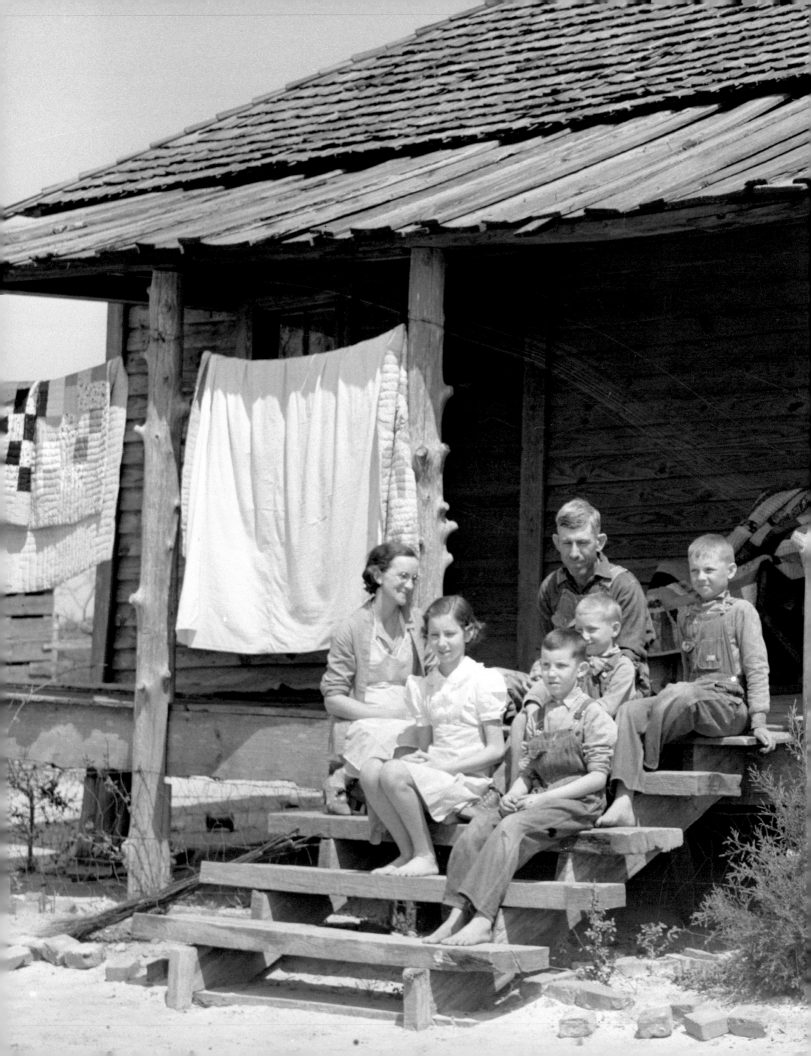

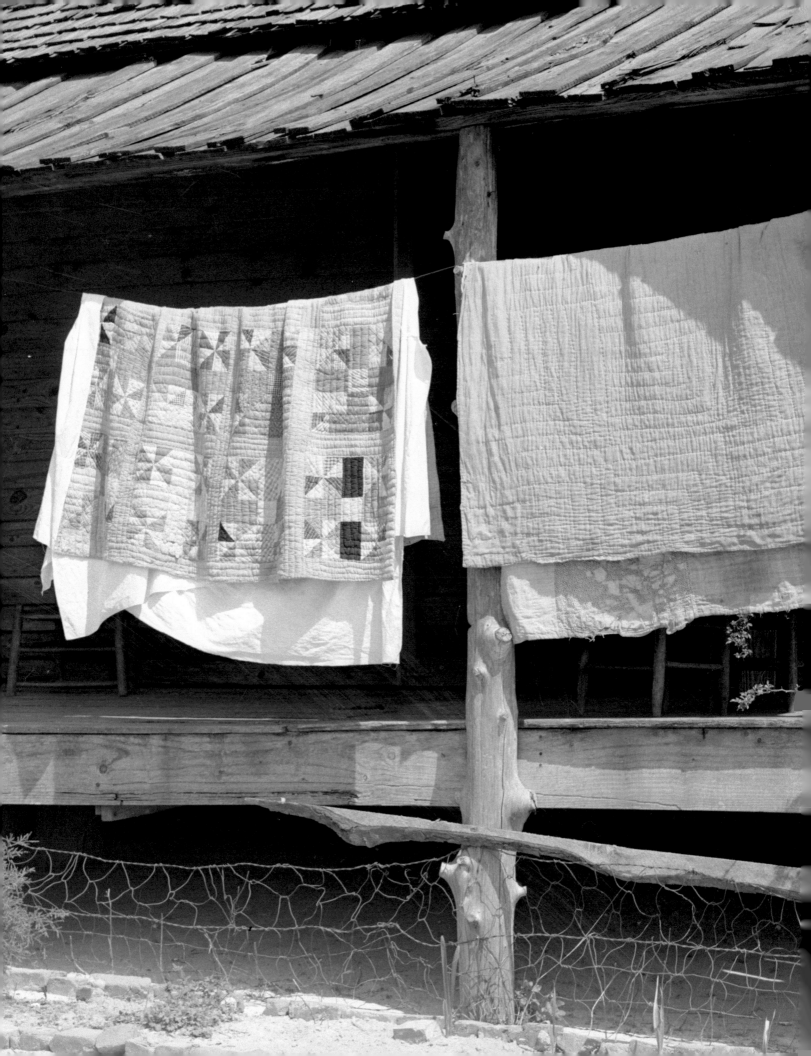

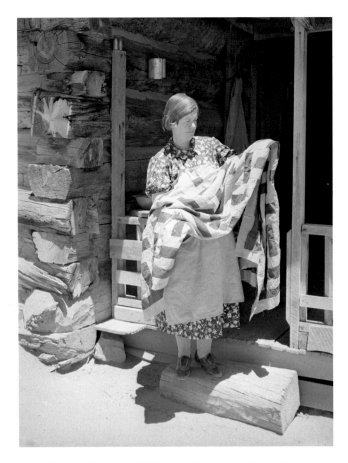

Fig. 2-7. Russell Lee, Mrs. Bill Stagg exhibiting a quilt made from tobacco sacks which she ripped up, dyed, and pierced *[sic].* Nothing is wasted on these homesteading farms. Pie Town, New Mexico, *1940. Farm Security Administration, Library of Congress.*

four years) had for dinner (noon meal): sausage, cabbages, carrots, rice, tomatoes, cornbread, canned figs, bread pudding and milk."[20] This caption credits the FSA supervisors with governmental interventions that led to greater self-sufficiency. The quilts in the family portrait serve as more than just a decorative backdrop. These make-do objects pieced from scraps—some clearly threadbare—in the same series of photos featuring rows of canned food and other objects suggestive of resilience show Wolcott's efforts to symbolically use objects around the Peacocks' home to demonstrate the government's success in cultivating self-sufficiency in this family's life. Wolcott portrays the family as "worthy poor," industrious rather than lazy, a family the government should spend tax dollars helping.

In 1940, Russell Lee, at the direction of the photography division's director, Roy Stryker, ventured to Pie Town, New Mexico, to conduct what Stryker called a small-town study, an assignment that similarly targeted the worthy poor. Stryker sought to capture the regional differences of what he described as the "American institution" of the small town, including its "agricultural methods, living standards, crops, clothing, folkways, local government, architecture, climate, etc."[21] Stryker wanted to emphasize the positive aspects of rural life, images that could be "powerful antidotes to the malaise of Depression America" by showcasing the "traditions of rugged individualism and community cooperation."[22] Stryker developed a shooting script for use in documenting small-town America with an emphasis on the home. While shooting scripts made no mention of quilts, sewing, or other needlework, quilts—a quintessential piece of domesticity—certainly embodied the values Stryker wished to capture in the FSA's documentation of small-town America.

Lee captioned one photograph (fig. 2-7), "Mrs. Bill Stagg exhibiting a quilt made from tobacco sacks which she ripped up, dyed, and pierced [sic]. Nothing is wasted on these homesteading farms. Pie Town, New Mexico."[23] His words accompanying the image celebrated the quiltmaker's ingenuity and thrift, characteristic of the perseverance the Roosevelt administration wished to cultivate in Americans nationwide. He has posed her, quite appropriately, in front of a log home, another potent symbol of the self-sufficiency of rugged Americans, such as these so-called homesteaders. The log cabin, however, likely was no longer in use, as residents of Pie Town typically had replaced these temporary homes with "second-generation structure[s]"; yet Lee knew that log cabins

represented ingenuity in the face of adversity and he did not waste film photographing newer homes.[24]

Mrs. Stagg's scrap quilt was one of five Pie Town quilts Russell Lee photographed in 1940. In addition to the quilt recycled from tobacco sacks, Mrs. Stagg posed for two rare color photographs with an embroidered state bird quilt, patterns for which appeared in a variety of magazines and syndicated newspaper columns beginning in the 1930s (fig. 2-8).[25] One of these photos again featured the log cabin as a background; the other had the quilt hanging on a clothesline. Lee used the clothesline to photograph three additional quilts, including Mrs. Stagg's appliquéd butterfly quilt, her unfinished Grandmother's Flower Garden variation quilt top, and a friendship quilt top with embroidered signatures. In the background of each of these photos appears a dry landscape with scattered trees and a wooden fence. A wood constructed building also appears behind the clothesline. Unlike the scrap quilt made from tobacco sacks, the rest of these quilts are typical of the commercially circulating patterns from the era; they exhibit a wide array of calico prints, plaids, and stripes, characteristic of the sorts of fabric pieces a housewife might pull from her scrap bag. Perhaps Mrs. Stagg was most proud of these quilts that followed fashionable trends, rather than the one assembled from tobacco sacks. It's difficult to know whether Russell or Jean Lee would have discerned the differences in style—some quilts as modern and fashionable and some as make-do. We do know some FSA photographers took several frames with a sitter in part to warm them up and make them feel comfortable.[26] Without question, these are posed photographs, intended to showcase the quilts themselves and evoke the symbolism of these hand-made objects. A likely

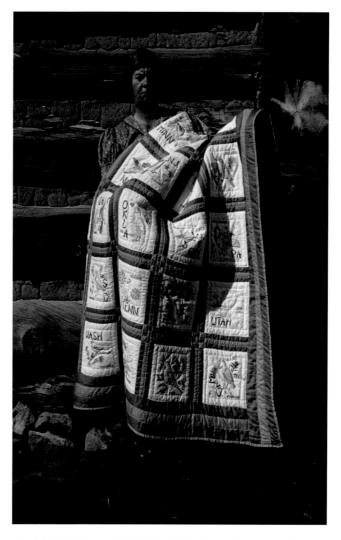

Fig. 2-8. Russell Lee, Mrs. Bill Stagg with state quilt, Pie Town, New Mexico, 1939, Farm Security Administration, Library of Congress.

scenario for this series of photographs involved the Lees asking to see Mrs. Stagg's quilts; she obliged and the photographer gradually made his way to his ultimate composition featuring the quiltmaker posed with quilt in front of a log cabin.

These quilt pictures make up only a small amount of Lee's Pie Town photographs, which also include depictions of community activities. Among those are over twenty from a square dance held in a home. Lee makes note of one of the features of the room adapted into the dance floor: the quilting frame suspended tight to the ceiling overhead.[27] In several of the photos, the

Fig. 2-9. Russell Lee, Figure in a square dance. Pie Town, New Mexico. Notice the quilting frame overhead, 1939. Farm Security Administration, Library of Congress.

quilting stitches are quite visible and, from one angle, the scrappy eight-pointed stars pieced from printed fabric appear where the quilt has been rolled (fig. 2-9). These shots convey the community socialization aspect sought by Stryker and Lee in the small-town studies, while simultaneously emphasizing the resourcefulness of these pioneers.

POVERTY AND MAKING DO

The FSA photographers intended to both document the plight of those most severely experiencing the Depression and to raise awareness about their poor living conditions, what scholar Cara Finnegan has referred to as the social justice agenda of the FSA photography section.[28] While some photographers used quilts to convey perseverance, other photographs explicitly tried to depict the dire conditions in which migrants, tenant farmers, and other impoverished Americans lived. *Migrant Mother* (fig. 1-11) epitomizes this approach to using photos to demonstrate the need for governmental intervention and foster sympathy among lawmakers and middle- and upper-class Americans alike.

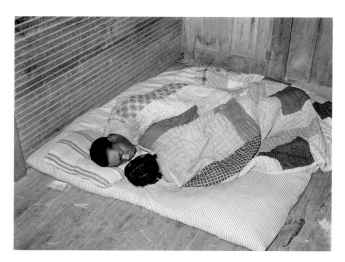

Fig. 2-10. Russell Lee, Negro couple, intrastate migratory workers, sleeping on the floor. Near Independence, Louisiana, *1939. Farm Security Administration, Library of Congress.*

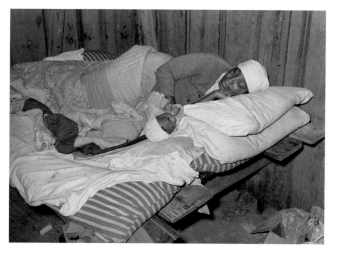

Fig. 2-11. Russell Lee, Negro mother and baby in bed in the house furnished them while working in the strawberry fields near Independence, Louisiana, *1939. Farm Security Administration, Library of Congress.*

Quilts, when depicted as make-do objects and emblems of poverty, helped communicate the dire challenges many faced during the Great Depression. Russell Lee captured dozens of photographs of impoverished sharecropper and migrant families' living spaces, including many shots of beds, often featuring patchwork quilts in various states of wear. Lee's focus is not the quilts specifically, yet he clearly had great interest in the domestic spaces in which workers lived, and as such, quilts appear over and over. Despite the rough, sometimes temporary living conditions, quilts demonstrated that these were domesticated, comforting spaces, not merely places to sleep. By showing how families and individuals repurposed quilts and sometimes used them to shreds, photographers suggested some of the symbolism inherent in scrap quilts.

In 1939 Russell Lee visited the berry growing region north of New Orleans in Louisiana; in addition to capturing photographs depicting the hard field labor—including children at work—Lee took many pictures of the living conditions of these migrant workers, both whites and African Americans. Lee's focus on interior living quarters, while arguably invasive of the workers' privacy, demonstrates his interest in showing the dire conditions migrant

families faced. In some ways quilt and other bedding are intimate objects, with their associations with private and familial domestic moments: sleep, sex, childbirth, and expressions of warmth and comfort. An African American couple lies on a stuffed mattress on the floor of their quarters, with a graphic scrap quilt draped across their bodies (fig. 2-10). Another shows a baby nestled under a quilt beside its mother in bed (fig. 2-11). Lee's compositions of these intimate moments may leave the viewer uncomfortable. Did Lee pose his subjects in these intimate ways, as if sleeping? Or did he disregard their privacy and take these frames without their consent, as the subjects slept? A wider shot of a full room in what Lee calls "quarters of Negro berry pickers" (fig. 2-12) reveals at least nine individuals, all seemingly awake, and as such suggests that Lee posed them in this series of intimate domestic scenes, narrowing his frame from the wider angle in order to portray private moments. His conscious or subconscious motivations are difficult to decipher, yet his overall thesis is that despite poverty, these workers found comfort in their makeshift interior spaces. The quilts in these photographs do the work of showing that in defiance of the precarity of their living spaces, laborers create the comforts of "home" even when living in transitory situations.

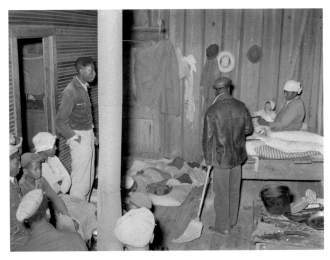

Fig. 2-12. *Russell Lee*, Scene in quarters of Negro berry pickers near Independence, Louisiana, *1939. Farm Security Administration, Library of Congress.*

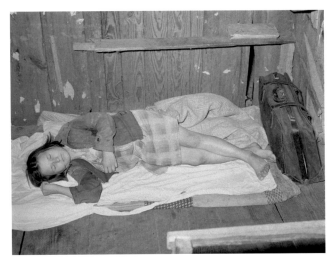

Fig. 2-13. *Russell Lee*, Daughter of migratory berry picker taking a nap on her bed on the floor. Near Ponchatoula, Louisiana, *1939. Farm Security Administration, Library of Congress.*

Lee's argument carries through in photographs that remind viewers that these are not permanent houses, and instead are improvised dwellings. His photograph (fig. 2-13) of a white teenage girl on a pile of folded up quilts on the floor, serving as a makeshift mattress, demonstrates that quilts not only contributed to the comfort and warmth of these shelters but were versatile objects. In another dramatic composition, a child peeks out from behind a tied Grandmother's Fan comforter being used to separate the living quarters of two families (fig. 2-14), showing how workers used

quilts for more than just bedding within their living quarters. The quilts here present a dual message of survival and comfort.

The FSA public relations message—that these migrants needed governmental support—is not heavy handed in Lee's interior photographs featuring quilts, but the surroundings in which the migrants live speak volumes. Quilts—domestic objects that provided warmth, comfort, and beauty—served as the perfect means to convey how these migrants persevered. Further, the quilts softened these harsh living spaces by showing viewers how even within temporary dwellings, the inhabitants could have beloved patchwork bedcovers at hand to warm bodies and souls. Displaced migrant mothers may not have had the space, supplies, or leisure time to piece quilts, and as such, the displaced quilts—now in shacks, tents, and other temporary worker housing—served as reminders of earlier times of abundance and comfort.[29]

Eliciting empathy toward impoverished Americans was a primary purpose of the FSA photographers as they crisscrossed the nation documenting how Americans lived during the Depression, humanizing their plight through realistic photographs, albeit often posed, that showcased the "problems of the time." Jack Delano recalled that the photographers "all had a respect for human beings and we were hoping that in our pictures we were saying something decent about the dignity of mankind, the dignity of human beings."[30] Again and again, FSA photographs reveal individuals in dire straits persevering with great dignity. To be sure, the poverty and make-do attitude may have been overemphasized and accentuated, perhaps even staged at times, as photographers aimed to slant their pictures to convey the FSA agenda.[31]

Fig. 2-14. *Russell Lee*, Quilt hung across doorway which separates living quarters of two families of white migrants. Berry pickers near Hammond, Louisiana, *1939. Farm Security Administration, Library of Congress.*

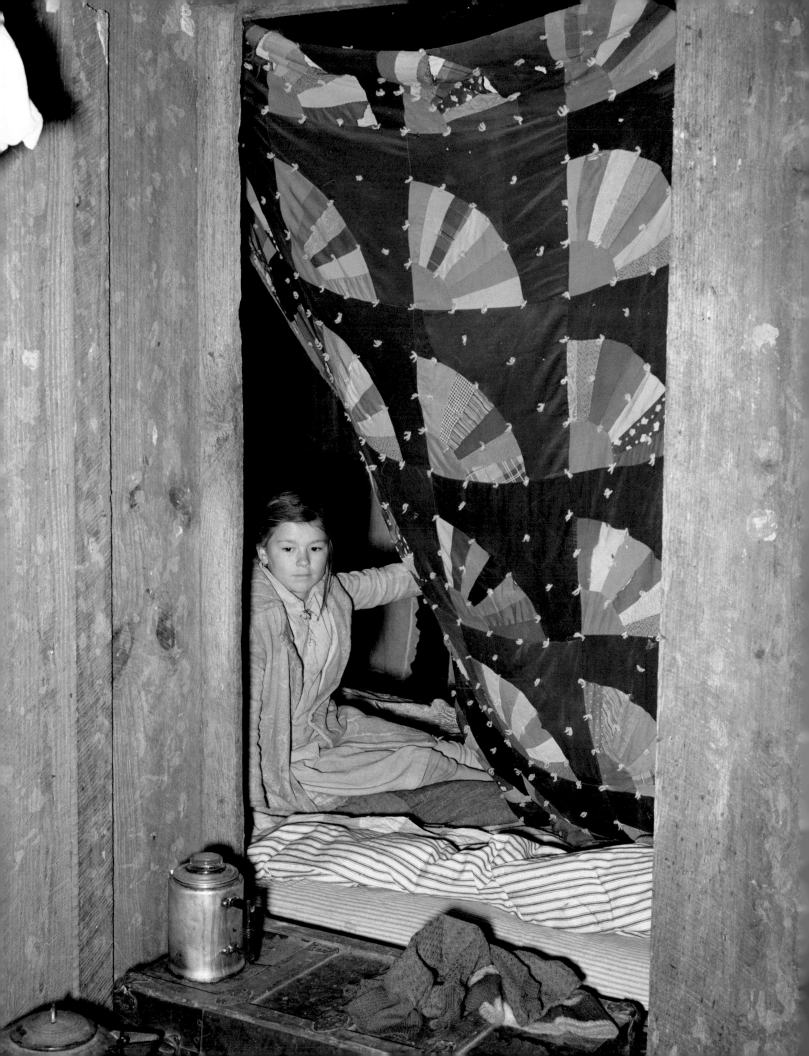

Jack Delano captured a haunting shot of a woman at work on her quilt in a smokehouse (fig. 2-15). While many migrant farmers were displaced and resettled due to the harsh environmental conditions of the Dust Bowl combined with the economic collapse, families near Hinesville, Georgia, living in three villages—Clyde, Taylors Creek, and Willie—were displaced when in 1940 the federal government acquired land to create Fort Stewart, constructed by the Civilian Conservation Corps, during the build-up to the United States' entry into World War Two. According to a Department of Agriculture estimate, the camp's construction displaced more than 1,500 families, many likely African Americans such as this woman quilting in her smokehouse, as Delano's photographs document.[32]

Using deliberate composition—meat hanging on hooks along the top of the frame, the subject with a stoic, dignified expression—the photo showcases American resiliency in the face of adversity. The white displaced farmers on the West Coast thoroughly documented by Dorothea Lange and fictionalized by John Steinbeck were commonly understood to deserve federal assistance, but in contrast, the displaced African Americans in the Jim Crow South had gained less sympathy from lawmakers, media, and some white Americans and were perceived as migrants by choice.[33] Delano aimed to counter this perception, and took photos across the southeast of displaced African Americans, in the spirit of a muckraker aiming to call attention to the plight of these overlooked families, in this case pushed out by the federal government itself.[34] Framing the woman in the open doorway of her smokehouse, Delano presents her as confined by her circumstances. Yet just as the use of quilts in temporary shelters domesticated them, here too the quilt in its frame, with ropes that allow it to be stored on the ceiling, emphasizes that this is the woman's home.

Delano's composition makes the woman appear to be piecing together scraps to create a utilitarian bedcover.

A close look at the quilt, however, reveals a more complicated narrative. The smokehouse quilter is stitching a pattern often known as a Baptist Fan into what appears to be a printed patchwork cloth, factory-produced yardage designed to look like a pieced quilt. Telltale signs of what today's quilters commonly call "cheater cloth" are the lack of lines from seams, the consistency in the arrangement of the printed triangles (in marked contrast to the many scrap quilts in other FSA photographs that are typical of the 1930s), and the precise points where each triangle meets another.[35] This is not recycled fabric squares but rather is new yardage printed to look like an intricately pieced quilt. Cheater cloth has long been a popular means of creating the appearance of patchwork without any of the work.[36] At first glance, the printed patchwork cloth does not make much sense in these circumstances, as the woman waiting for a new home probably did not have the expendable income to buy several yards worth of new fabric for the purpose of making a quilt, although such material was available in the Sears catalog for eight or nine cents a yard.[37] The photo also prompts the questions: Did Delano recognize that this was not the kind of frugal quilt depicted in so many other photographs? And why was this woman quilting in a smokehouse, not a practice otherwise documented in quilt history? There is no explicit reason to believe Delano staged this photograph, and a quilt frame with cheater cloth would be an unlikely prop for him to add to a composition.

Quilt historian Barbara Brackman hypothesizes that instead of making do by piecing together bits and pieces to make a traditional quilt, the cheater cloth suggests that the woman in the photo may be making a

Fig. 2-15. *Jack Delano,* Woman who has not yet found a place to move out of the Hinesville Army camp area working on a quilt in her smokehouse. Near Hinesville, Georgia, *1941. Farm Security Administration, Library of Congress.*

Fig. 2-16. Dorothea Lange, Grandmother from Oklahoma with grandson, working on quilt. California, Kern County, 1936. Farm Security Administration, Library of Congress.

quilt for the consumer market, participating in the quilt industry in order to earn income. Delano's agenda of humanizing and raising awareness of African American migrants is well documented, and the photo along with its caption, "Woman who has not yet found a place to move out of the Hinesville Army camp area working on a quilt in her smokehouse. Near Hinesville, Georgia" suggests that this composition was designed explicitly for viewers to contemplate the meaning of home amid upheaval.[38] He may not have noticed or cared that she used printed patchwork, ignoring the possibility that she may have been making a quilt for sale.

Another pair of photographs (fig. 2-16, 2-17) similarly uses quilts to evoke home for one of the most iconic

symbols of transplant: the so-called Okie—a person who migrated from Oklahoma or from neighboring states to California to escape the environmental damage of the Dust Bowl. Dorothea Lange's well-publicized photographs of migrants, and later through the plight of the Joad family depicted in Steinbeck's *The Grapes of Wrath* (1939), made the families working in the agricultural fields of California well-known to many Americans.[39]

In February and March of 1936, Lange took over 200 photographs of migrant workers and facilities in the camps in Kern County—including thrown together Hoovervilles (makeshift encampments named after Herbert Hoover, the president at the time of the stock

market crash), cabins owned by the large corporate farms, and in new federal camps (see chapter 4 for more on these camps). She photographed the tents and temporary shelters, the cotton and pea pickers working in the fields, children and old women, and many migrant mothers in addition to her iconic shot of Florence Thompson, the unnamed Migrant Mother of her most famous photo.[40]

In addition, she took two photographs of a woman with quilts, whom she called in her captions a "grandmother from Oklahoma." In one, the woman sits at a quilting frame with her grandson in a wooden structure. The frame has rope attached to it, so it can be hoisted to the ceiling in order to have flexible living space. The room is all-purpose, with sheets as a makeshift room divider in a corner to create a small private space. A ramshackle shelf indicates that the space also serves as the kitchen, with pans and a coffee pot teetering. The ceiling is open to the rafters, to which the quilt frame is tied. Paper covers some of the walls, while the rest are exposed wood. The grandmother and grandson quilt by the limited light coming through the window. The quilt's pattern is one that often serves as an album for signatures stitched or inked onto the cloth. In the second photo, Lange has posed the woman at an exterior door to what is presumably the same structure. Here she holds a completed Dresden Plates quilt—a classic and widely circulating pattern from the era—with an array of calicos forming wheels stitched to a solid-colored ground with contrasting sashing separating the quilt blocks. The woman's face is nearly expressionless, but perhaps we can detect a slight bit of pride amid her stoicism, as the quilt drapes over her outstretched arm. She wears small round glasses and fur-lined slippers, along with a polka dot top with a wide butterfly collar. All indications suggest

she is not a new arrival; she has settled in and has the supplies, time, and space to quilt.

The Oklahoma grandmother is likely not at the nearby Arvin Federal Migratory Labor Camp known colloquially as Weedpatch. Lange captured these photos just six months after the camp was established, and this wooden structure appears more substantial than the tents many federal camp residents lived in by February 1936, according to camp reports from that year.[41] Lange perhaps posed this woman in her temporary housing as a way of evoking the grit of the migrant families who pushed their way west, but prominently featured the quilt to domesticate and soften the rough housing conditions. Not only had this woman survived the Dust Bowl, but her finished Dresden Plates quilt and the one in process in the quilting frame suggest her resiliency, as well as leisure time required to make quilts.

Presumably migrant families did not bring quilting frames with them, nor would they have set them up in makeshift housing in tents. However, quilting frames like the one pictured here, could be easily assembled from long lengths of lumber or salvaged wood. Once the federal camps were built, which Lange characterized as "a democratic experiment of unusual social interest and national significance," they usually

had quilting frames in community centers or sewing rooms, as chapter 4 discusses in more detail.[42]

The photographs of this grandmother contrast starkly with many of Lange's other photos featuring dilapidated homes of pea pickers and other tent dwellers—including several photos in which quilts and other bedcoverings serve as part of the shelter itself.[43] Scholars have suggested Lange in particular made her personal politics clear in her photos—she and her husband were strong advocates of New Deal engineering, particularly cooperative agricultural programs. Her photos, more than those of any of the other FSA photographers, aimed to raise the visibility of the problems faced by the migrants, and in the words of visual rhetoric scholar Cara Finnegan, Lange believed that "her photography could play an important role on behalf of social justice, particularly for California's poor."[44] Lange wanted to show both the need for and successes of government intervention in the lives of migrant families.

COMMUNAL QUILTMAKING

In the early years of the New Deal, some federal administrators aimed to develop experiments in cooperative living and farming. The FSA also sponsored cooperative loans for its clients to collectively purchase livestock and farm machinery.[45] Through such programs, the New Deal promoted a mentality in which Americans were stronger when they banded together, rather than went at it alone, what historians have called a cooperative ethos.[46]

A romanticized version of collectivism took the form of a quilting bee, a nostalgia-fueled embodiment of a community coming together to make the work both more efficient and more pleasurable. Quilting bees, quilting frolics, or simply quiltings, as they were often called, emerged as a performative reenactment of perceived colonial values during the sanitary fairs that raised money for the Union Army during the Civil War

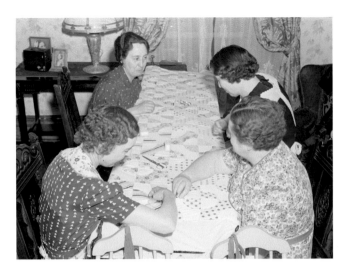

Fig. 2-18 John Vachon, Making a quilt in Scranton, Iowa, home. The ladies will give the quilt to a needy family, *1940. Farm Security Administration, Library of Congress.*

and late-nineteenth-century World's Fairs. Work parties including quiltings certainly did exist in early America, although nostalgia for those pre-industrial days made the myth more potent than the reality. Already in the mid-nineteenth century—as early as 1830 by one newspaper account—women referred to such bees as "old-fashioned quilting part[ies]."[47]

Quilting bees made good sense during the Depression, as the women, and sometimes men, stitching together could support one another, lifting each other through the trials and tribulations of the Depression. Carrie Hall and Rose Kretsinger's sentimental 1935 description of the quilting bee of the pioneer days noted that "the social, gossipy interchange of neighborhood news did not interrupt the swiftly flying fingers of those expert quilters, but seemed rather to add to their agility."[48] With such idealized understandings of group quilting, it is no surprise that again and again FSA photographers presented women working in groups on quilts.

Cooperative quiltmaking took various forms. Some federally sponsored planned communities used surplus cotton to make quilts, working under the direct auspices of an FSA or WPA project. Others, like the Moravian sewing circle in Lititz, Pennsylvania,

Fig. 2-19. Dorothea Lange, Farm women of the 'Helping Hand' club display a pieced quilt which they are making for the benefit of one of their numbers. Near West Carlton, Yamhill County, Oregon, *1939. Farm Security Administration, Library of Congress.*

photographed by Marjory Collins, used their quilting to generate money to support the church.[49] Photographers took pictures of various quilting clubs that made quilts to benefit those in need, such as the quilting bee John Vachon (1914-1975) photographed in Scranton, Iowa (fig. 2-18), captioned, "The ladies will give the quilt to a needy family."[50] Some groups, often called Helping Hand Clubs or similar names, comprised farmwives associated with a farm cooperative or New Deal planned community.[51] As described in more detail in chapter 4, federally funded cooperative homestead communities, like Granger Homesteads in Iowa, promoted craft making as a virtuous educational activity for children and adults alike and provided community space for women's clubs to meet and work on quilts.[52] Photographs of quilting bees—a form of collectivism that hardly any American would frown upon—were an easy way to celebrate and publicize

positive aspects of one of the more controversial aspects of the FSA.[53]

In Yamhill County, Oregon, Lange took a series of photographs of women identified in the caption as the farm women of the Helping Hand Club (fig. 2-19).[54] In her field notes, Lange described how these women—"wives of the members of the West Carlton [Oregon] chopper cooperative"—met once a month in one of their homes to quilt (here "chopper" refers to a type of forage harvester used to chop plants to make silage to turn into livestock feed, which one of Lange's captions calls an "ensilage cutter"). Lange reported that this particular quilt was for one of the women who was expecting a new baby. The group raffled a previous quilt for seventeen dollars, funds held by the Helping Hand Club "for something that may come up."[55]

Fig. 2-20. Dorothea Lange, Seven of the eight farmers shown with their cooperatively owned ensilage cutter on the Miller farm, where they are working filling the silo. West Carlton, Yamhill County, Oregon, *1939. Farm Security Administration, Library of Congress.*

In this same community, in addition to taking photos of the quilters, Lange took several pictures of a group of farmers who had bought an ensilage cutter cooperatively (fig. 2-20).[56] Cooperative farming, like quilting bees, represented a mentality Lange and her husband, agricultural economist Paul Taylor, supported: working together to lift the common good. The couple strongly believed in cooperative farming and wanted to promote the successes of the FSA in providing credit to make this possible. An FSA loan supported the purchase of this cooperative's "chopper," which the farmers moved from farm to farm with the whole group working collectively to process and store the silage.[57]

These photographs no doubt also harked back to imagined notions of pre-industrial communities in which neighbors looked out for one another, without the need of government assistance, a sort of yeoman farmer utopia. In this mythical agrarian world, the farmers' wives surely made quilts as the men plowed fields, with these families' work ethics and morals on a higher plane than those residents of the chaotic urban industrial world.[58] Lange's observations about both the Helping Hand Club and the cooperative farm implements could have doubled as evidence in quilt authority Marie Webster's 1915 nostalgic description of the lives of pioneer quiltmakers; she wrote, "without friendly cooperation, the lot of the pioneer would have been much more difficult than it was."[59] Webster's sentiments were shared by the New Dealers who developed the homestead community program and other governmental interventions, detailed later.

SUCCESS OF GOVERNMENTAL INTERVENTION

Although FSA photographers promoted their social justice agenda along with fulfilling Stryker's goal of creating a documentary record of American life for posterity, their primary task remained publicizing the successes of the Farm Security Administration's programs. Here too, photographers featured quilts in their compositions to support the FSA's public relations campaign.

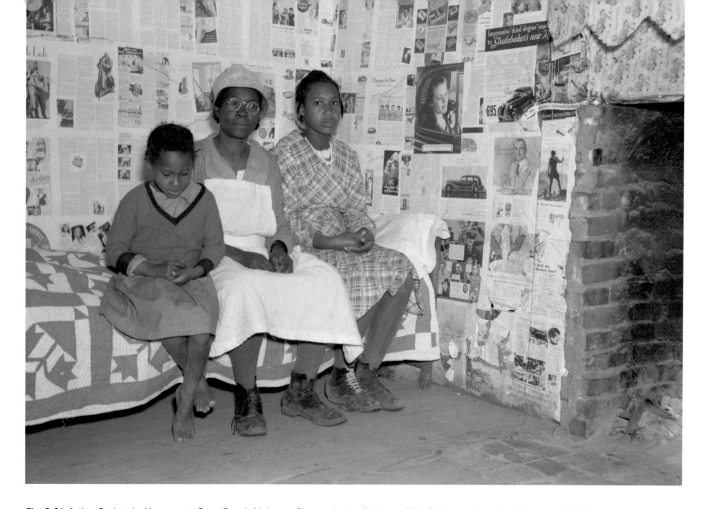

Fig. 2-21. Arthur Rothstein, Negroes at Gees Bend, Alabama. Descendants of slaves of the Pettway plantation. They are still living very primitively on the plantation, *April 1937. Farm Security Administration, Library of Congress. Rothstein captioned his photos* Gees Bend *rather than the more common spelling of Gee's Bend.*

Two separate visits by FSA photographers to Gee's Bend, Alabama—from April 1937 and May 1939—serve as a before/after FSA intervention series. Now one of the most famous quiltmaking communities in the United States, Gee's Bend, Alabama, first received national public attention during the New Deal. Following some initial small loans from the Federal Emergency Relief Administration (FERA) in 1934, in 1935 the Resettlement Administration had begun providing agricultural loans and home economics training to this isolated community, tucked in the bend of a river and nearly inaccessible due to an unreliable ferry. When in 1937 Congress was considering new farm tenant legislation, Roy Stryker sent Arthur Rothstein (1915-1985) in search of a tenant farmer community to document, in order to show the harsh

conditions of tenancy. Compelling photographs would demonstrate the need to legislators and the general public. Rothstein heard about Gee's Bend through a journalist who was writing about the community, so he set out in April 1937 to take photos in Gee's Bend.[60]

Among the photos Rothstein took are three featuring a young Jennie Pettway, another young girl, the quiltmaker Jorena Pettway, and quilts. In one photograph, the three females of distinctly different ages sit lined up on the edge of a bed covered with a Carolina Lily quilt (fig. 2-21). The walls of the room are covered in newspaper and magazine pages, with advertisements for Studebakers, rubber tires, facial lotions, and sleep remedies in a patchwork quilt of makeshift wallpaper. In a second picture, taken on the

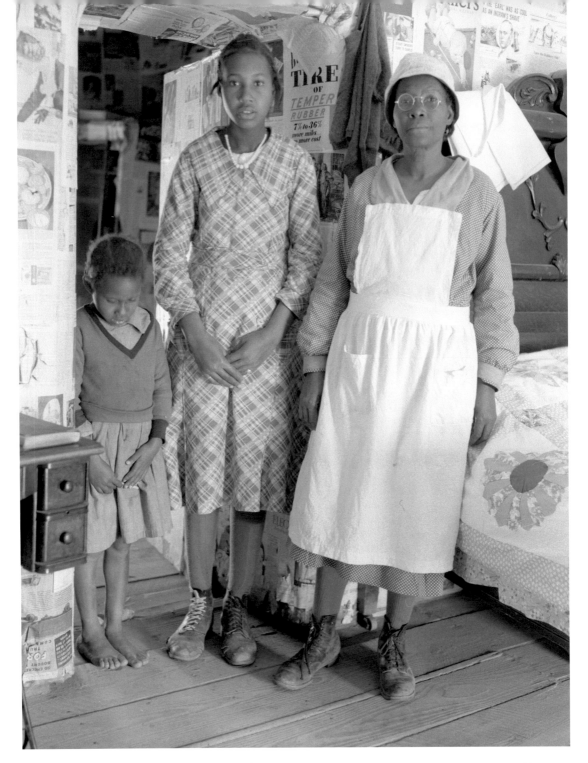

Fig. 2-22. Arthur Rothstein, Inhabitants of Gees Bend, Alabama, *April 1937. Farm Security Administration, Library of Congress. Rothstein captioned his photos Gees Bend rather than the more common spelling of Gee's Bend.*

opposite side of the room (fig. 2-22), the three Pettways stand in a doorway between a sewing machine table and a bed, on which a quilt top in a Dresden Plates pattern is displayed. The same unquilted top appears in a third shot (fig. 2-23), with the two girls posed holding it up as Jorena sits at the sewing machine;

Rothstein's caption reads "Sewing a quilt, Gee's Bend, Alabama," even though the action is staged.[61]

An August 1937 *New York Times Magazine* article featuring some of Rothstein's photos did not include these pictures with quilts, as it focused

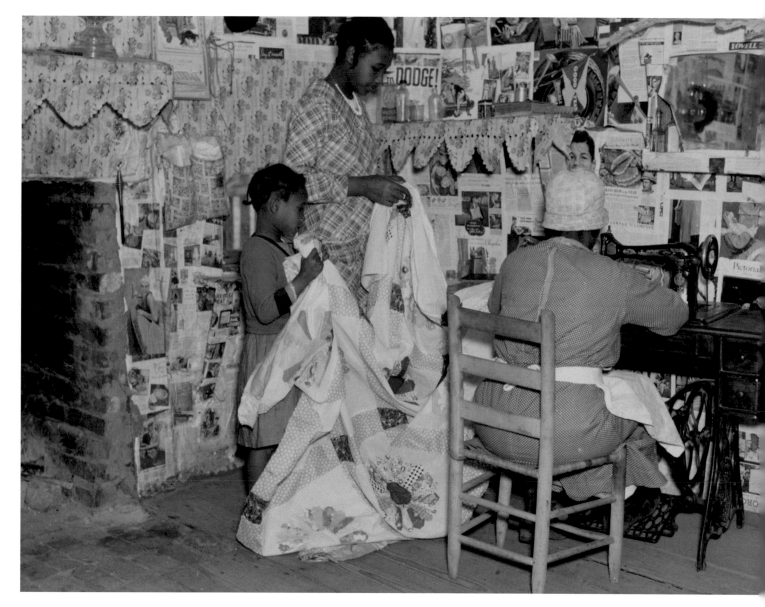

Fig. 2-23. Arthur Rothstein, Sewing a quilt. Gees Bend, Alabama, *April 1937. Farm Security Administration, Library of Congress. Rothstein captioned his photos Gees Bend rather than the more common spelling of Gee's Bend.*

on improvements to the farm economy brought with RA loans and with the 1937 FSA purchase and subdivision of the Pettway plantation and two adjacent farms.[62] Gee's Bend now had mules, equipment feed, fertilizer, and plenty of help from the federal government. At that point in 1937, the Resettlement Administration (soon to be FSA) had purchased the Pettway plantation and two adjacent parcels, comprising around 10,000 acres, and was preparing to divide the land into five-acre parcels with houses and outbuildings to be sold with low interest

RA loans with adjacent 95-acre fields leased to 100 Gee's Bend families. The goal was to end the tenancy cycle and create small self-sufficient farms. The RA was also slated to build a cooperative medical center, along with a community center, school, general store, gristmill, and cotton gin. The article emphasized that Gee's Benders had long done many things cooperatively, reporting, "They have been doing it all their lives, doing it because so many of them are kin and because they all like and trust one another."[63]

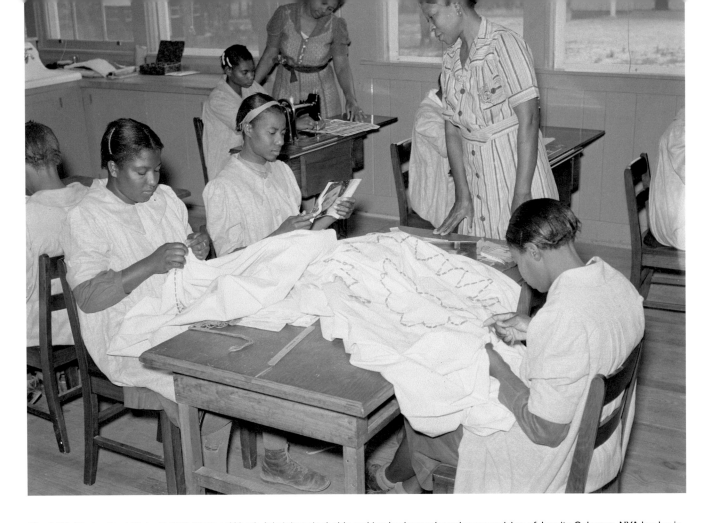

Fig. 2-24. Marion Post Wolcott, NYA (National Youth Administration) girls making bedspreads under supervision of Juanita Coleman, NYA leader, in school home economics room. Gee's Bend, Alabama, *May 1939. Farm Security Administration, Library of Congress.*

In May 1939, just over two years after Rothstein took his series of photographs in Gee's Bend, Stryker sent Marion Post Wolcott back on assignment to take "after" photographs documenting the changes the FSA funding had brought to the community. Wolcott joined the FSA photography team later than many of its other members and as such was tasked with much of this documenting of "the positive side of the FSA Program and work that was being done" as she explained in an interview.[64] Gee's Bends Farms, as the cooperative resettlement project was called, had opened its medical clinic in 1937 and its new school in October 1938.

In contrast to the quilt photos Rothstein took in 1937, which were in a home with makeshift furnishings,

Wolcott's quilt photographs are in the new school's home economics room. Teenage girls working under the auspices of the National Youth Administration (NYA)—a New Deal agency that provided work and education opportunities for 16- to 25-year-olds— sat at sewing machines and at tables appliquéing and embroidering bedspreads for babies and other needlework projects. NYA supervisors Juanita Coleman, Thelma Shamburg, and Mrs. Spragg assisted the girls in their work. While these photographs may be just as posed as Rothstein's, they present a very organized, well-resourced project, in a brand-new building—no newspapered walls in sight (fig. 2-24, 2-25).[65] The NYA supervisors guided the girls, just as Rothstein's photos suggested that Jorena Pettway was teaching the two girls to quilt.

Fig. 2-25. Marion Post Wolcott, A display of sewing and needle work made by NYA (National Youth Administration) girls in school home economics room. Gee's Bend, Alabama, May 1939. Farm Security Administration, Library of Congress.

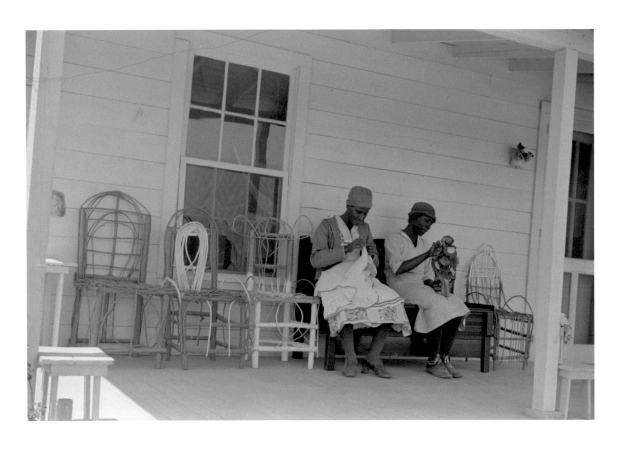

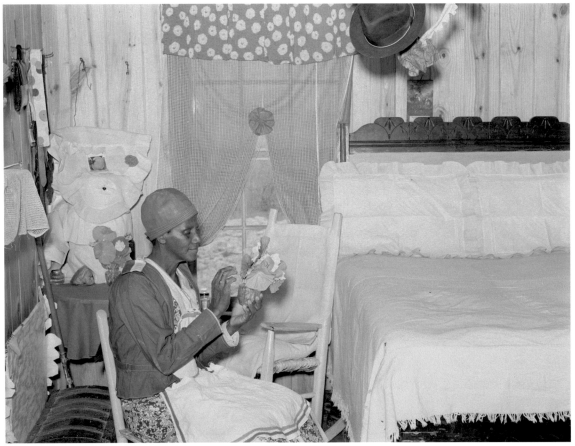

During this trip Wolcott took additional photos of Jorena Pettway. Here she was no longer in the home with crumbling brick and make-do wall coverings but now in what appears to be a new house—likely the new dwellings the FSA built as part of Gee's Bend Farms—with wooden walls, a big front porch, and paned glass windows. The home, with its cozy furnishings and sunlit rooms, contrasts sharply with the log cabins Rothstein photographed in Gee's Bend two years earlier.[66] Wolcott's captions speak to Pettway's self-sufficiency, one of the primary values the FSA resettlement projects wished to promote.[67] Following the New Deal party line, she wrote: "Jorena Pettway and her daughter making chair cover out of bleached flour sacks and flower decorations from paper. She also made the chairs and practically all the furniture in the house. Gee's Bend, Alabama" (fig. 2-26) and "Jorena Pettway making flower decorations for her home. She has made practically all her own furniture and her own bedspreads and chair covers from flour sacks, etc. Gee's Bend, Alabama" (fig. 2-27).[68] Wolcott's photos from this trip to Gee's Bend suggest two perspectives on quiltmaking that aligned with FSA values. First, governmental programs like the NYA's home economics classes Wolcott photographed could provide vocational training while lifting morale. Second, the government could provide structures and systems, such as the new homes and community building that were part of Gee's Bend Farms, that could allow residents to flourish and increase their self-sufficiency.

DOCUMENTING AND PERSUADING

The FSA photographers had multiple, sometimes conflicting purposes as they pursued their work. They were documentarians, trying to capture with veracity the lifestyles and values of American life, even as it was in the midst of a significant transition, compounded by dire economic needs. But the photographers were also activists, using their art to create compositions designed to persuade legislators and ordinary Americans that many fellow citizens were in need of the governmental programs created by the New Deal. They wanted to show how the FSA and related programs had a positive impact on the lives of farmers and migrant families. Quilts were not an essential component of how they communicated; quiltmaking was just one popular activity and quilts were just one commonplace object with homes, whether temporary shelters or more permanent housing. But the frequent employment of quilts as props and setting indicate how useful both the act of quiltmaking and quilts as objects were to the messages the FSA photographers aimed to communicate. Quilts were part of everyday life, but they also carried with them symbolic heft, and the photography project employed that symbolism to great effect.

Fig. 2-26. Marion Post Wolcott, Jorena Pettway and her daughter making chair cover out of bleached flour sacks and flower decorations from paper. She also made the chairs and practically all the furniture in the house. Gees Bend, Alabama, *May 1939. Farm Security Administration, Library of Congress.*

Fig. 2-27. Marion Post Wolcott, Jorena Pettway making flower decorations for her home. She has made practically all her own furniture and her own bedspreads and chair covers from flour sacks, etc. Gee's Bend, Alabama, *May 1939. Farm Security Administration, Library of Congress.*

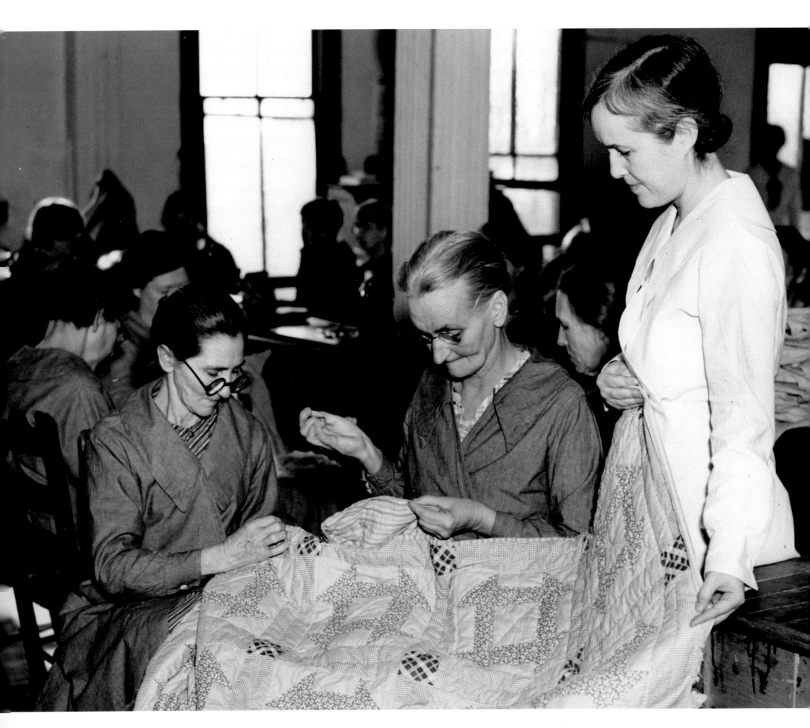

Fig. 3-1. Mrs. Lizzie Chambers and Mrs. Mary Collier piecing quilts while Mrs. Octa Self, forelady of the quilting project directs the pattern they are to follow. *1936. Records of the Work Projects Administration, National Archives, (69-MP-3-21-550.)*

CHAPTER 3

"FOR UNSKILLED WOMEN WE HAVE ONLY THE NEEDLE" [1]

A Works Progress Administration (WPA) photograph of forty-six-year-old Octa Self posed with two older women, Lizzie Chambers and Mary Collier, huddled over a patchwork quilt in process in the Churn Dash pattern, documents one of the common ways that women heads-of-household were able to earn a meager living during the Great Depression (fig. 3-1). The WPA's records refer to Self as "the forelady of the quilting project." [2] Born Adna Octavia Dryden in 1890, by 1930 Self was a single mother of five children living with her parents in Lawrence, Tennessee. By that time, Self's former husband had relocated to Birmingham, Alabama, leaving Octa and the children a state away. As a needy and unemployed single mother without a husband to support her, Self met the requirements for employment in the WPA's Women's and Professional Division, and likely because she had worked several jobs outside the home—including as a telephone operator and bookkeeper in a doctor's office—she was deemed a suitable supervisor for the WPA. [3]

Tennessee's "women's program of the WPA"—like similar initiatives operating in many states under the WPA's Women's and Professional Division—consisted of a variety of projects intended "to give work to needy mothers, wives, or other women with dependents in urban and rural communities of Tennessee." Most of the work projects involved sewing or weaving in some capacity; as a WPA administrator observed, "for unskilled women we have only the needle." [4] The Nashville *Tennessean* reported in 1935 that, "In Nashville sewing machines are already whirring, hand looms are moving back and forth, scissors are snipping, needles darting in and out, all being guided by capable feminine hands. These are the sewing projects." [5] Each of the fifty women employed by the WPA quilting project in Rock Island, Illinois, received fifty-five dollars a month for their work in 1935. Needy families then received the resulting quilts. [6] These were the two primary goals of WPA-funded quilting projects: jobs and vocational skills for women in need and quilts for families on relief as a means of bringing warmth and beauty to their homes.

The New Deal sewing initiatives also had a third goal, summed up by a Richmond, Virginia, journalist: the "development of a pride in skill and useful work, a delight in artistry of making beautiful things from common and homely products—in short, a contribution to those human satisfactions that make happiness." [7] In

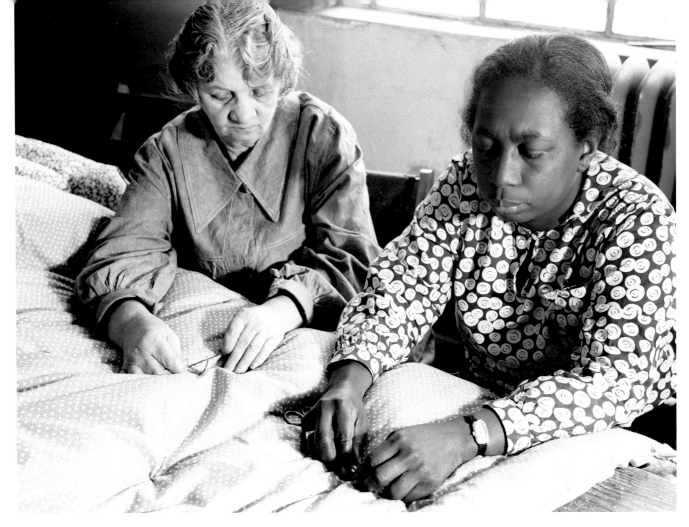

Fig. 3-2. Andrew Herman, Quilting, 10th Ave & 36th St., Federal Art Project, Works Progress Administration Sewing Room, 1937. Museum of the City of New York.

this way, the federal programs aimed to shape values, attitudes, and behavior through the projects. WPA quiltmaking projects thus could function as a vehicle for instilling values the government administrators deemed needy workers were lacking, including work ethic, good taste, and transferable skills such as thriftiness and adaptability.

Quiltmaking and other traditional women's arts—as this journalist called them—spinning, weaving, and lacemaking—were a distinct form of relief project. Women working in WPA sewing rooms generated millions of garments, mattresses, and bedding articles, often using surplus commodity cotton and cloth woven from the same. Yet the ready-to-wear garment and mattress industry executives and trade organizations complained to the WPA about this arrangement because the government gave away these goods, disrupting the market with oversupply. Quilts, in contrast, especially decorative patchwork ones, did not have a giant industry to compete with and posed less of a threat to the conventional economic order. Commodity cotton, in abundant supply through many of the Depression years, could be used to fill quilts as well as mattresses, and the government encouraged projects that made use of this oversupply. Quilts also were a ready means to use the abundance of scraps leftover from other WPA sewing room projects like garment making. As such, quilts were a less controversial product of the WPA sewing rooms, as most private industry complaints centered on their impact on the garment-making sector.[8]

Government funded initiatives facilitated quiltmaking as a livelihood in several ways. Although Federal Emergency Relief Administration (FERA) and later WPA sewing rooms produced garments in substantial numbers, many of them also included quiltmaking. While some sewing rooms made quilts from scraps left from other sewing, others—including the massive racially integrated operation in New York City at 10th Avenue and 36th Street (fig. 3-2) and the small town one in Catlettsburg in northeast Kentucky (fig. 3-3)—generated utilitarian whole cloth (without a decorative pieced or appliquéd top) quilts and comforters as part of their regular output. And initiatives like Milwaukee's well-documented WPA Handicraft Project produced decorative goods, including quilts for nurseries, orphanages, and hospitals. These federally funded quiltmaking initiatives encouraged women to view quiltmaking as a marketable skill rather than merely a leisure activity or old-fashioned craft, despite the

reality that few jobs in the private sector existed that could take advantage of these skills. An official WPA training guide even instructed that sewing rooms decidedly not be set up to resemble "quilting bees,"—the romanticized tradition of sharing socially-productive work. Instead the WPA promoted industrial workspaces in which women could learn new skills for the job market.[9] When employed by the WPA or its youth-oriented counterpart, the National Youth Administration (NYA), women and girls gained skills intended as transferable to cottage industries, factory sewing, or producing piecework at home to sell at local fairs and markets. It is difficult to assess the success of the New Deal in meeting this outcome, yet by examining the goals and the processes put in place in WPA sewing rooms and handicraft projects, we can gain a sense of why the government viewed quilts (along with related sewing and crafts) as an important part of its relief and recovery strategy.

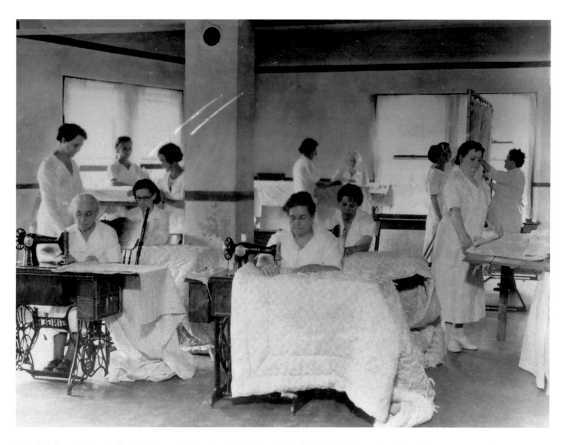

Fig. 3-3. Boyd County, Catlettsburg, Kentucky. 6/15/36, project #899 - Sewing project showing women making comforters, *1936. Courtesy of the National Archives.*

QUILTMAKING IN WPA SEWING ROOMS

In November 1935 as part of the WPA—the massive newly created federal agency tasked with providing federally funded jobs to millions of out of work Americans—the Roosevelt administration established sewing rooms intended to provide wages to so-called unskilled women. The WPA, part of Roosevelt's "Second New Deal," replaced FERA, which had given grants to local and state governments designed to operate relief programs. The WPA, in contrast, created federal projects to employ those in need in partnership with local sponsors. The government intended for WPA jobs to provide wages while also lifting the morale of those struggling through the Depression. As a 1938 WPA pamphlet explained, "There are only two basic ways in which unemployment relief can be given—doles or jobs. Give a man a dole and you save his body and destroy his spirit. Give a man a job and pay him an assured wage, and you save both the body and the spirit."[10] Most projects employed men to work on infrastructure construction, such as roads, dams, and parks. In addition to these public works projects, the WPA established its Division of Women's and Professional Projects to provide employment for women heads of household and white-collar workers. Although earlier governmental- funded sewing rooms had existed under the auspices of FERA, the WPA sewing room program soon employed the largest number of women in the WPA.[11]

Sewing rooms made up the largest non-construction industry in the WPA, comprising 5 percent of all WPA jobs in 1938, with 10,259 rooms across the nation. According to 1936 statistics, 245,000 women worked in sewing rooms, 20 percent of them as professional skilled seamstresses, with the remainder of women tasked with gaining new skills. Historian Elna Green notes that sewing rooms were "something of a dumping ground for women who had few industrial skills, often little work experience, and probably little future in the industrial work force." Women with employable husbands were not eligible.[12] Although the federal government administered the division, local

Fig. 3-4. "Girls inspect Work project," Cincinnati Enquirer, March 7, 1940.

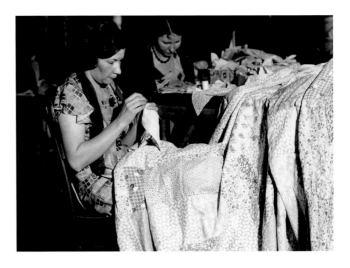

Fig. 3-5. Women at work on quilts on sewing project, New Albany Indiana, c. 1936. Courtesy of the National Archives.

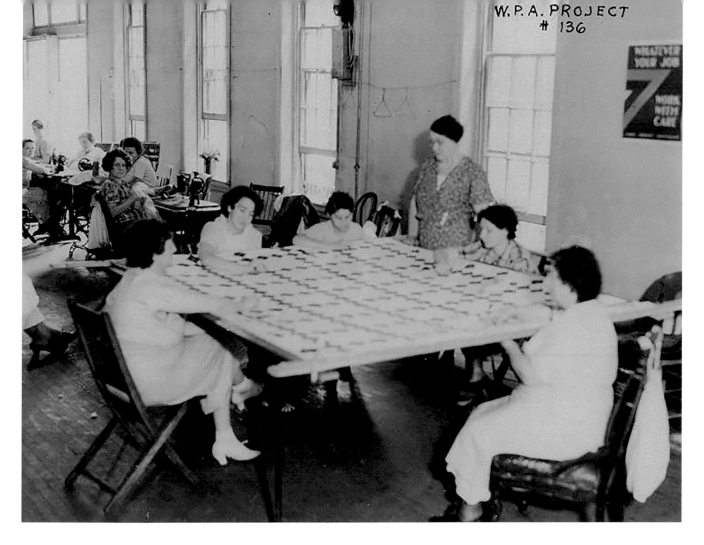

Fig. 3-6. Works Progress Administration of Maryland, Division of Operations. Washington County. White women engaged in a sewing project, at Hagerstown, *1935, Enoch Pratt Free Library / Maryland State Library Resource Center.*

supervisors decided what articles any given sewing room produced. Usually quilts were not the sewing rooms' primary product, but often workers created them from the leftovers after garment making, such as this String Quilt pictured in the *Cincinnati Enquirer* (fig. 3-4), along with rugs, rag dolls, and other toys.[13] In some sewing rooms, including one administered by the NYA (the young people's division of the WPA), workers made quilts out of secondhand clothing, as that was deemed more cost efficient than "renovating the used garments."[14]

Evidence of patchwork quilts made in WPA sewing rooms largely comes from photographs of the work itself and from descriptions, often cryptic, in WPA

reports and local newspaper articles. Given the vague nature of the term "quilt" without further context, photographs provide the best sense of what types of bedcoverings sewing rooms produced. In an image from a sewing room in New Albany, Indiana, a white woman sits with needle and thread, a one patch quilt comprised of roughly six-inch square blocks draped across her lap. A photo from a WPA training center in Hagerstown, Maryland, shows five white women seated around a quilting frame with a quilt in the Single Irish Chain pattern, with a sixth woman standing as if supervising; other women work at sewing machines in the background (fig. 3-6). An image from Robbinsdale, Minnesota, depicts sunlight coming in from paned factory windows, while women sit hunched over at

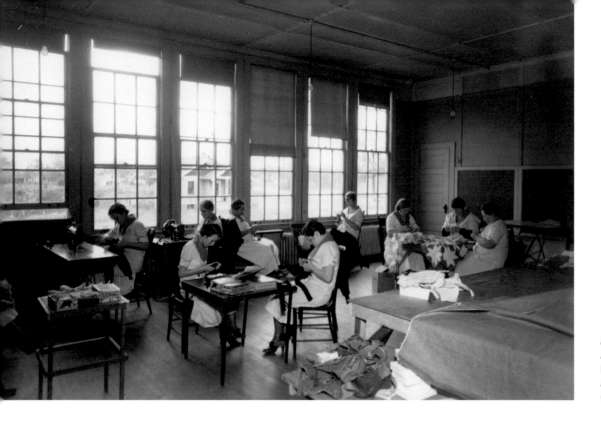

Fig. 3-7. Works Progress Administration sewing project, Robbinsdale, Minnesota, c. 1938. Minnesota Historical Society-Gale Family Library.

sewing machines and at their handwork, including a pieced star quilt (fig. 3-7). Two additional photographs from Minnesota sewing rooms (fig. 3-8, 3-9) show women in uniforms—white dresses with contrasting collars, along with white headbands that read "WPA"—while pieced quilts in frames lean against the walls.

Local newspapers covered the WPA projects, sometimes reporting on the numbers of women employed and the output of production, sometimes offering descriptions of the quilts themselves, the workmanship, or the techniques and processes employed. For example, in 1936 the Idaho Falls *Post-Register* reported on seventy-two women "working diligently in the local WPA sewing and quilting room" on seventeen sewing machines and quilting frames around the room, where the "workmanship on the quilts is said to be excellent."[15] A 1935 article documented the quilting output of the Woodside, Queens, quilting project, which employed 200 women:

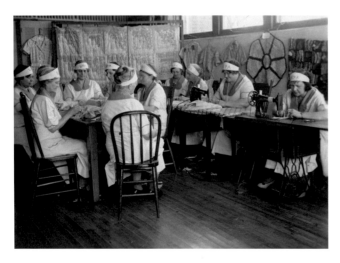

Fig. 3-8. Sewing center, St. Louis Park, Minnesota, c. 1938, Minnesota Historical Society, Gale Family Library.

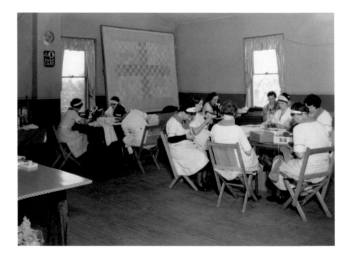

Fig. 3-9. Sewing project, Golden Valley, c 1936, Minnesota Historical Society, Gale Family Library.

"Using material furnished by the Federal Surplus Board, the group, recruited from home relief rolls, in nearly a year have turned out 127,000 quilts. These were made from 800,000 yards of material furnished by the Board." Another article on the Woodside project added that "the quilts have a filler of half wool and half cotton. They are made in the old-fashioned way, tied with wool knots in nine-inch squares with two rows of stitching on the outer border."[16]

Although most accounts of WPA productivity do not indicate details about specific quilts, New Jersey's 1935-1936 report on the work of its newly formed Women's and Professional Division of the WPA offers a few such glimpses, as well as statistics regarding production of quilts. New Jersey itemized the number of workers and output in each of its 167 sewing rooms. Thirty-five of these, including some that called themselves "Quilt Factory," "Comforter Room," or "Quilting Room," specifically listed quilts and comforters as part of their production (many others simply listed a category of "household goods," which likely included various bedcovers). These sewing rooms combined to produce at least 3,736 comforters and 3,355 quilts from November 1935 through July 1936, in addition to hundreds of thousands of garments, with nearly 1,200 workers employed. In some instances, the report added specific details about individual quilts, such as this report from Neptune, New Jersey: "Besides making the regulation plain quilts, many interesting designs have been carried out by the individuals. One quilt that was most unique was made in crib size, was placed on exhibit at Washington. The idea was secured from a childs' [sic] quilt over 100 years old; each block representing a letter of the Alphabet with an article appliquéd on each. Another small quilt

Fig. 3-10. Quilt making at the sewing project, *St. Paul, Minnesota Historical Society, Gale Family Library.*

Fig. 3-11. Andrew Herman, Quilt, 10th Ave. & 36th St., *1937, Federal Art Project. Museum of the City of New York, 43.131.4.20*

Fig. 3-12. Federal Emergency Relief Administrative Quilt, *c. 1934, Lafayette, Indiana. Indiana State Museum, 71.2018.093.000.*

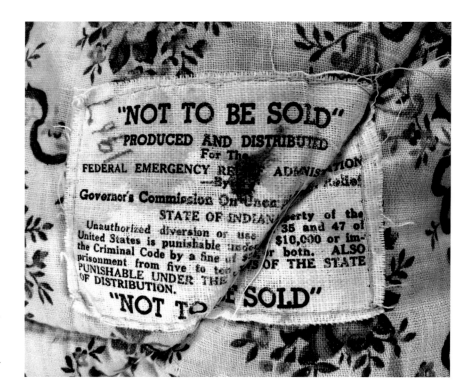

Fig. 3-13. Detail, Federal Emergency Relief Administrative Quilt *from Fig. 3-12. Tag reads "'Not to be Sold,' Produced and Distributed for the Federal Emergency Relief Administration by Governor's Commission on Unemployment Relief State of Indiana." Indiana State Museum. 71.2018.093.0001.*

had three large kittens worked out in tying twine. The workers in the room gave each one a name, they represented W.P.A.: one was William; second Peter and the third, Alexander."[17] The report referred to other quilts simply as "patchwork," which likely distinguished them from the "regulation plain quilts" that likely were the whole cloth comforters many WPA sewing rooms produced.

This type of quickly assembled whole cloth comforter, typically tied or tacked, and sometimes machine quilted, made good sense for bedcoverings distributed to families on relief, particularly when the government supplied surplus cotton yardage. The WPA Quilting Project in Marshfield, Wisconsin employed five women who made eight to ten comforters a day, suggesting the speed with which these could be assembled. The women made each quilt from a three-pound batt of cotton "covered with regular comforter prints"—likely printed cotton calico.[18] The sewing room in Alloway, New Jersey—called a "Quilt Factory" with seventeen quiltmakers, two electric sewing machines, and fifteen

quilting frames—produced 175 "cotton comforters" in three months in 1936, which the State Emergency Relief Administration (the state entity that received FERA grants to allocate locally) distributed to needy families.[19] A sewing room in Frederick, Oklahoma, reported that it made one quilt every two hours on the second floor of Frederick's city hall, which had been converted into a sewing room.[20] The quilt pictured in figure 3-12 is a rare example of a surviving utilitarian bedcover produced in a New Deal sewing room, with its machine stitching holding together the thick layers and a label indicating that the piece was not to be sold (fig. 3-13).

In addition to the rapidly produced utilitarian comforters, sewing rooms also provided women with opportunities to make quilts worthy of exhibition. Some rooms sent their prized quilts to Washington, D.C., for an exhibition of WPA-produced goods from around the country, one of the ways the WPA tried to convince American taxpayers and legislators that the government-funded projects were worthwhile. Local

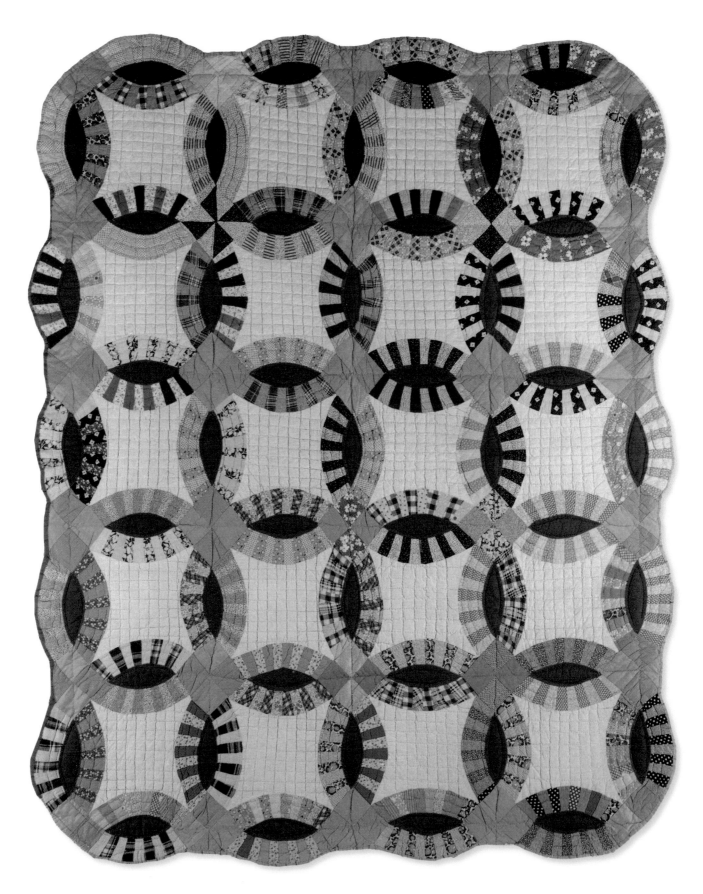

Fig. 3-14. Georgia Thomas Mize, Double Wedding Ring, *Sevierville, Tennessee, 1934. Image courtesy Merikay Waldvogel.*

exhibits also showcased sewing room products. In Clinton, Missouri, in 1936, representatives of several local sewing rooms brought quilts to display to the public, including "three clever nursery quilts," one vividly described by *The Clinton Eye* as featuring a "green print with two white ducks facing each other, bills and feet in yellow."[21] At the WPA Pageant in Camden, New Jersey, girls employed through the NYA held a fashion show that also included an exhibition of "novelties," including patchwork comforters, that "show the uses even scraps of material are put to."[22] An estimated 550,000 people attended the WPA exhibition at the New Jersey State Fair in Hamilton in 1936, at which women demonstrated how to use electrical sewing machines while quilts and other sewing products were on display.[23] The Niagara Community Center in Niagara Falls, New York, had a sewing room employing all African American workers; a report noted that "a few of the women specially qualified are making quilts of very artistic design. So splendidly has this quilting been done that Mrs. Pearson thinks she may be able to use some of them for exhibition purposes. The design of the quilts is on the whole excellent and very artistic."[24]

Although many WPA employees produced quilts as part of their paid work, some women also brought home the bits and pieces left from garment making at the end of the day to produce their own quilts at home. The Scottsbluff, Nebraska, newspaper reported on this development, stating, "the women save almost every little piece of material and use it, usually for quilts."[25] Georgia Mize from Knoxville, Tennessee, recalled that her sister brought home "some awful pretty scraps" from Knoxville's WPA sewing project where she worked. Mize made a Double Wedding Ring quilt from these scraps, backing it with white flour sacks (fig. 3-14).[26]

Sewing rooms aimed to employ those in need, develop new job skills, and distribute garments and bedding to the needy, all while lifting morale. Did WPA sewing rooms meet these goals? The financial help was key to those fortunate to work in sewing rooms, but the work opportunities and pay were inconsistent.[27] In its 1935-1936 report, the New Jersey division of Women's and Professional Projects profiled a widow working in a sewing room it called "Mrs. Z." who had been on the Emergency Relief Rolls (the "dole") as part of FERA. Never having used a sewing machine previously, Mrs. Z. stated, "I have not felt as free from the stigma of having to accept aid, as I have these past three weeks.... I am able to send my children's shoes to be mended because I have a dollar in my pocket...."[28] Another woman on relief, twenty-eight-year-old Laura May Jones from Charlotte, North Carolina, whose husband had tuberculosis, recalled earning "$36 a month on WPA, piecing quilts for the poor," until the project was closed only six weeks into the job, leaving her without work.[29] Janie Solomon worked as an inspector in a WPA sewing room earning just shy of thirty dollars a month; yet she needed to support four children, including a baby, and a husband unable to work due to arthritis rheumatism. Her family's rent was sixteen dollars a month, and Solomon said she "can't really manage on what she gets" and was grateful for the WPA provided garments the family received. She said, "I thank the Lord I can sew" for if not, "I wouldn't have the job I've got now."[30] Such was not the case for Flora Colbox, a widowed young woman, because she lived with her parents: "The W.P.A. won't put me on in the sewing-room, as long as Pa has a job in the mills. I'm plumb wore out trying to get a W.P.A. job."[31]

Women in WPA sewing rooms did have opportunities to learn new skills, with some projects explicitly set up as instructional spaces: for example, the Passaic,

New Jersey, sewing room had "floorladies ... instruct classes of 30 women."[32] Some women spent an hour of their day on "merit books," in which they practiced various techniques, such as buttonholes, hems, and various fancy stitching, in order to demonstrate their proficiency in learning new skills.[33] The Union City, New Jersey, sewing room reported that 90 percent of its women were "inexperienced and had never used a machine"; thus the skilled seamstresses were assigned to teach the "rudiments of sewing" to the "unskilled workers."[34] In Woodside, Queens, some women making quilts "had to be taught the work" while "others had home experience."[35] The sewing room in Gloucester City, New Jersey, specifically employed twenty-five elderly women with physical limitations—what the WPA called "physically handicapped women"—to make patchwork quilts from scraps from the industrial sewing project in the same building that produced undergarments.[36] "Mrs. Z." from New Jersey wrote, "I never held a needle in my hand before, and after this short period of training, I have been taught how to make a complete garment. I know that I shall save a great deal of money by making all our clothing."[37] Reports and testimony do not speak specifically to the skills learned by making quilts in sewing rooms, nor do they mention the "soft skills" of showing up for work on time, punching a timecard, working well with others, and developing a work ethic, abilities that may have been new to women who had not previously worked outside the home. Some WPA sewing rooms did offer training in "self-improvement" classes in topics such as hygiene, baby care, and first aid, with an emphasis on thrifty practices that they could apply to homemaking.[38]

Despite the goal of providing women with new skills so that they could acquire jobs in private industry, an analysis of the number of sewing room workers compared to workers in needle trades in private industry found that "women were less successful than men in finding work in private enterprise" and that "it would be improbable that women workers of the sewing-room projects were easily employable in private industry."[39] One of the WPA's own economists observed that, "Although women have learned to do excellent work as seamstresses, the commercial possibilities of their acquired skills are not great."[40] An Atlanta newspaper article reported that 10 percent of the women employed by WPA had been able to move off relief rolls and into industry jobs, calling the WPA jobs a "stepping stone to better jobs."[41] Yet historian Martha Swain notes that during the New Deal, social workers and economists critiqued sewing rooms as a sort of bait and switch "that misled project workers into thinking that legitimate employment lay ahead or that marketable skills were being learned."[42] This perspective easily applies to quiltmaking; although flourishing cottage industries existed in parts of the country, particularly Appalachia, it was difficult to earn one's livelihood making quilts. A Richmond, Virginia, journalist noted that limitation of the specialized WPA handicrafts: "If many women were trained for such skilled and artistic work, their products would far exceed the demand for them, and oversupply would defeat the rehabilitation aims of projects that seek to provide means of self-help."[43]

As the numbers of quilts tallied in state WPA reports and local newspaper articles reveal, the sewing rooms certainly produced and distributed quilts at high volumes. In its first six months of operating sewing rooms, Pennsylvania's State Emergency Relief Board, which sponsored the commonwealth's sewing rooms, distributed 6,000 comforters to families in need.[44] The thirty women working in the sewing room in Gloucester, Oklahoma, produced four quilts a day (among their

output of an average of eighty articles daily).[45] A photograph in the January 25, 1937, edition of *The Kansas City Star* showed a bustling room full of women hovering over quilt frames, knotting and stitching together the layers of bedcovers. The photo's caption read, "A scene in the WPA sewing project ... where 1,200 women went back to work ... to rush quilts and comforts for flood sufferers in Southeastern Missouri.... The women hoped to complete 500 quilts and comforts by the time the consignment is to leave on trucks tonight."[46] Tennessee WPA sewing rooms similarly sent goods, including nearly 500 quilts, to victims of the Great Flood of 1937 that affected the Ohio Valley region.[47] In January 1936, New York's Commodities Distribution Division of the Emergency Relief Bureau distributed a whopping 14,000 WPA quilts.[48] Such data, while still somewhat anecdotal, suggests that over the course of the WPA (1935-1942), workers made hundreds of thousands of quilts for distribution.

In defending sewing rooms from the many letters of complaint sent to the White House and WPA headquarters and other forms of lobbying from garment manufacturers, WPA director Harry Hopkins wrote that the sewing rooms provided "tremendous rehabilitation in terms of morale and skills."[49] Such sentiments were echoed throughout official WPA reports. The report from East Rutherford, New Jersey, detailed that "the morale of the women in their work on this project has been of a high degree due to the progress they themselves made in the art of sewing."[50] Union City, New Jersey, reported that the women in its sewing room were "regaining confidence and moral courage" while helping with the nation's economic recovery.[51] In her assessment of the sewing rooms, home economist Catherine Cleveland wrote, "Many women—unskilled, underprivileged, often maladjusted—have learned to do useful work which

has given them a real place in the community and opened up a better way of living."[52] Eleanor Roosevelt took particular interest in championing the sewing rooms, valuing craft production both for its products and ideology; she often visited them when touring New Deal initiatives across the country. In 1936 she observed: "What interests me most are the people carrying on these projects. I had opportunity to meet them clear across the continent and their enthusiasm and belief in their work is really fine to see. It is not the kind of spirit you see in people who are working because they received a certain amount of money at the end of each week. There is a fire in them, I think, through the feeling that they are really working to better conditions for their fellow beings."[53]

Despite these ringing endorsements in official governmental reports and from the First Lady herself, the workers' perspectives may have differed. "I would rather be dead than know that I had to go back there to work the way it was run," said Mrs. Louis about her experience in a Florida sewing room; although she did not elaborate, she said "my work in the WPA sewing room was just awful."[54] Other women working in sewing rooms complained about poor ventilation, sanitation, insensitivity from supervisors, and in some sewing rooms, required uniforms that women felt stigmatized them as impoverished WPA workers. A prime complaint regarding sewing rooms was the inconsistent availability of work that left women dependent on the paychecks sporadically without an income.[55] Clearly, these work conditions were not ideal, but for many, it was one of their only options of getting by financially, and there were benefits beyond their salaries.

Even amid complaints, women in sewing rooms forged community, one of the most essential assets

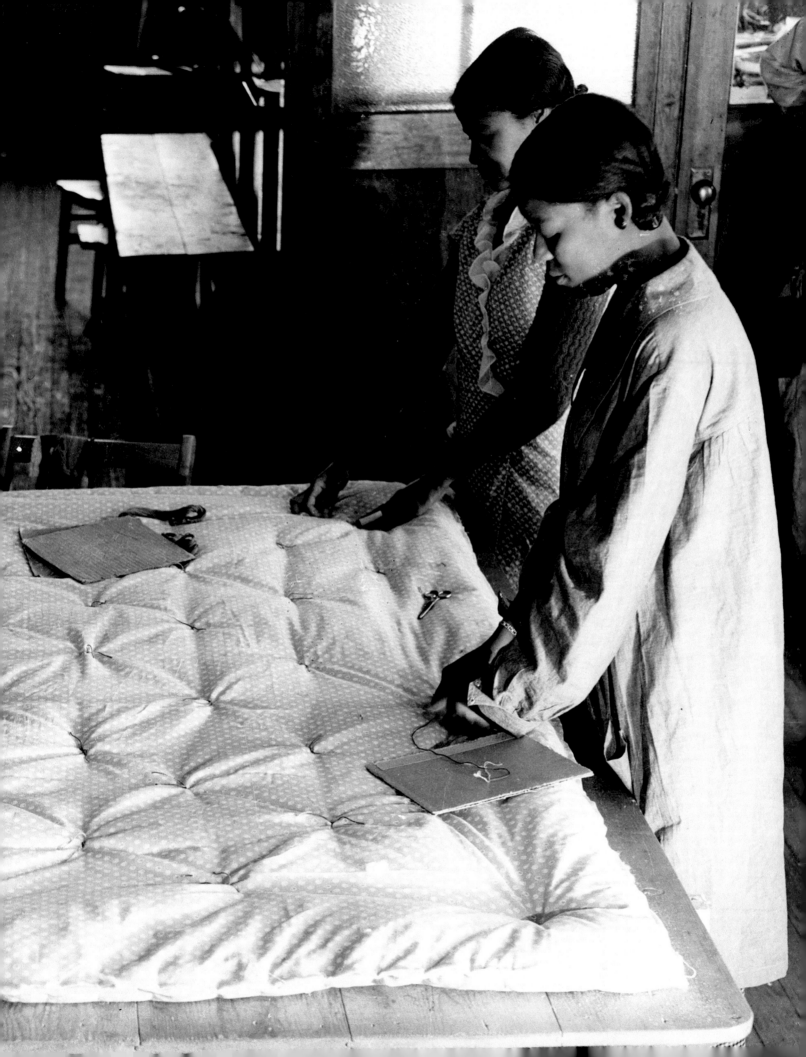

for managing through the Depression, which led to a spirit of mutual aid, with women "tak[ing] pleasure in helping each other, exchanging flower and vegetable cuttings and recipes of every kind," according to a WPA work report.[56] Such camaraderie also empowered women in some sewing rooms, including ones in Tampa, to organize and stage a walkout due to work conditions and fluctuating federal funding that resulted in inconsistent work hours and layoffs.[57] Despite conditions that were far from ideal, WPA sewing rooms ultimately served as what historian Elna Green calls a "lifeboat for many women."[58] And many were quite grateful. Eugenia Martin, an African American woman who lived in Atlanta and worked as a floor woman on a sewing project, recounted, "I enjoyed it much…. I am glad I have had the opportunity to work on WPA, first because it has provided me a livelihood and second for the experience I've gotten, which I wouldn't have gotten otherwise."[59] Another woman wrote to Eleanor Roosevelt of her employment in a Tampa sewing room: "It is meaning so much to me [sic], and I appreciate it more than I can express."[60]

WPA HANDICRAFT PROJECTS

Operating separately from sewing rooms, WPA handicraft projects similarly employed women in need, but with a distinct emphasis on artistic craft production rather than on industrial textile output. Handicraft projects also differed from the various initiatives of the Federal Art Program designed to employ trained artists or craft makers, and instead employed a small group of skilled makers to supervise unskilled workers

from the relief rolls—often older women who did not have specific skills deemed useful for work on other WPA projects.[61] Handicraft projects, also part of the WPA's Women's and Professional Projects Division, aimed to "revive handicraft that is being forgotten in a commercial age and to train talented workers to create markets for their work."[62] By 1938, forty-three states had handicraft projects, with around 35,000 workers engaged on these projects nationwide, although the largest, most well-known, and most emulated was that of Milwaukee.[63] Quilts were just one of the many crafts produced within various states' projects; projects also included weaving, toy and doll making, block-printing, furniture making, and other crafts, all indicative of what one journalist perceived as a "rosy future" for "domestic handmade goods."[64]

The WPA's interest in handicraft related to a growing "home crafts movement" that predated the Great Depression, exemplified by Eleanor Roosevelt's well-documented enthusiasm for the handicraft revival. In 1927, prior to her time as First Lady, Roosevelt partnered with two friends to incorporate Val-Kill Industries, which produced handmade reproductions of colonial furniture, marketing their traditional craftsmanship and good design. In operation through 1936, Val-Kill sold its goods in galleries and department stores, appealing to a higher end consumer.[65] In the midst of the Depression, Roosevelt shifted her craft focus to Appalachia, where federally sponsored subsistence homesteads and planned communities aimed to revitalize impoverished communities, as discussed in detail in the following chapter. Crafts

were part of Roosevelt's focus, yet already played a significant role among those who had been promoting a craft revival in the region through Berea College, the Southern Highland Handicraft Guild, Penland School of Crafts, and other endeavors.[66]

In Milwaukee, Harriet Clinton, the county supervisor of the WPA's Women's and Professional Division, sought a work project to employ women on the relief rolls who were deemed "unskilled." In 1935, 2,600 Milwaukee women applied to the U.S. Employment Agency in search of work to support their families. Clinton knew about the craft initiatives in Appalachia that aimed to promote social welfare through handicraft production.[67] She tapped Milwaukee State Teacher's College art education instructor Elsa Ulbricht to develop and direct the project. Both Clinton and Ulbricht envisioned it as an alternative to the industrial sewing operations that were standard in many WPA sewing rooms and often resembled sweatshop factory work.[68] Like the federally funded sewing rooms, the government mandated that the Handicraft Project could not compete with industry by selling its goods on the retail market. So rather than distribute the products as a relief effort like the sewing room sponsors did with quilts, comforters, and garments, it contracted with public institutions such as orphanages, nursery schools, and hospitals. The project provided these facilities with toys and home furnishings—including bedcovers, window treatments, and upholstery—while the institutions paid the cost of the supplies and materials. The sponsoring partner—initially the Milwaukee State Teacher's College in 1935 (now University of Wisconsin, Milwaukee) and, beginning in 1937, Milwaukee County—paid for the cost of the workspaces, and the federal government paid the workers as part of the WPA's so-called make work efforts.[69]

Ulbricht's vision for the Milwaukee Handicraft Project (MHP) drew on ideals of the Arts and Crafts Movement, which in its British origins was a response to the Industrial Revolution and encouraged a return to the unity of craftsman and designer in the production of home goods, with an emphasis on natural forms and functionality. The American adaptation of the Arts and Crafts Movement, led by Gustav Stickley, offered a simplified version of the English design ideals without the same intricate level of detail, characterized by the clean simple lines of Stickley's Mission furniture and naturalistic forms in textiles and pottery.[70] MHP also drew inspiration from the Appalachian craft initiatives, such as the Southern Highland Handicraft Guild, that aimed to train women deemed to have few employable skills in crafts they could use to help support their families.[71] Ultimately MHP's focus was on "good design"—emphasizing that an object's aesthetics were equally important to its craftsmanship, that even so-called unskilled workers could execute this work, and in doing so the taste standards of both the workers and the users of the crafted projects would be elevated.[72]

To help supervise the project, Ulbricht initially sought out trained artists, but most were already employed by the Federal Art Project—the wing of the WPA that employed artists to execute murals, posters,

Fig. 3-15. *Milwaukee Handicraft Project, Project coverlets and wall hanging, WPA nursery school, Milwaukee, c. 1938. WPA Joint Photographic Unit.*

and other graphic arts, ran Community Art Centers, and implemented the Index of American Design (see chapter 5), so she recruited among her own students and recent graduates. Mary Kellogg Rice, the project's art director and one of Ulbricht's former students, recalled that the project started with simple tasks like braided rag rugs. At this point, most skilled seamstresses on relief rolls had already gone to work in the WPA sewing rooms. As such, Rice and other project supervisors developed basic craft projects that enabled women who had previously not known how to thread a needle to contribute.[73] Some women used scissors to cut out illustrations and articles from donated magazines and wallpaper samples to fill scrapbooks for distribution to educational and

recreational institutions. Others learned how to weave on looms. And eventually, when one of the Milwaukee WPA nursery schools wanted to update its "dull gray comforters," several of the designer-foremen—what MHP called the trained supervisors who created the designs and taught the workers how to execute them—developed cheerful appliqué patterns that would add a colorful and whimsical touch as covers on top of the gray comforters.[74]

After MHP produced colorful patchwork spreads for the local WPA nursery school (fig. 3-15), the state director of nursery schools commissioned quilts for all the Wisconsin schools, with administrators in Iowa and Kansas following suit.[75] Milwaukee County

General Hospital's children's ward deemed coverlets on hospital beds impractical and instead opted to have the appliqué designs placed on moveable screens that could be placed in between beds. Local kindergarten teachers similarly requested that the appliqués be adapted as curtains for their classrooms. The county's home for dependent children requested appliquéd coverlets for its 600 beds, along with curtains, prompting Harriet Clinton to note that "600 quilts... will go far in persuading that institution and similar ones, that color and beauty are the heritage of even institutionalized children."[76]

The newly created "quilt department," as it was called in an undated report, employed 75 workers in addition to the designer-foremen.[77] In total the project offered twenty-five to twenty-eight distinct quilt designs, and additional appliqué screens, wall hangings, and curtains, with designs conceived and adapted by designer-foremen Julia Loomis and Dorothy Phillips.[78] Neither woman had prior experience making quilts and, as such, consulted Ruth Finley's *Old Patchwork Quilts and the Women Who Made Them* as well as published quilt patterns, including ones that circulated in syndicated newspaper columns.[79] They produced watercolors of their proposed designs, which demonstrate how the initial prototypes differed from the finished quilts, sometimes in color, sometimes in intricacy.[80]

The resulting coverlets—which quilt scholar Merikay Waldvogel notes are of an unusual size (forty inches by sixty inches) because they were intended to cover the tops of beds and not fall over the edges—are executed in clean, simple designs following MHP's interpretation of Arts and Crafts philosophy. For example, a stylized horse featured a sleek curved line connecting the

horse's legs, rather than a complex rendering of a realistic animal (fig. 3-17). Yet some of the appliqué motifs were deceptively hard to execute, indeed challenging for novice stitchers, with their small, irregular shapes.[81]

The Cherry Tree quilt (fig. 3-18), one of the original cot coverlet designs for nursery schools, exemplifies a design inspired by traditional quilt patterns of the nineteenth century executed in a modern setting that may have been hard to stitch. The bluish green percale of the leaves was a popular hue among quiltmakers during the 1930s, and its use updated the chemical green of the mid-nineteenth-century appliqué quilts from which this design clearly draws inspiration. Rather than make quilts as a means of creatively using up scraps from other projects, as some of the WPA sewing rooms described above did, Rice recalled that MHP purchased new color-fast percale in a palette of solid colors expressly for making appliqués.[82]

Fig. 3-16. WPA worker machine stitching on an applique quilt, c. 1936-1938. Courtesy of Milwaukee Public Museum, H49622-30.

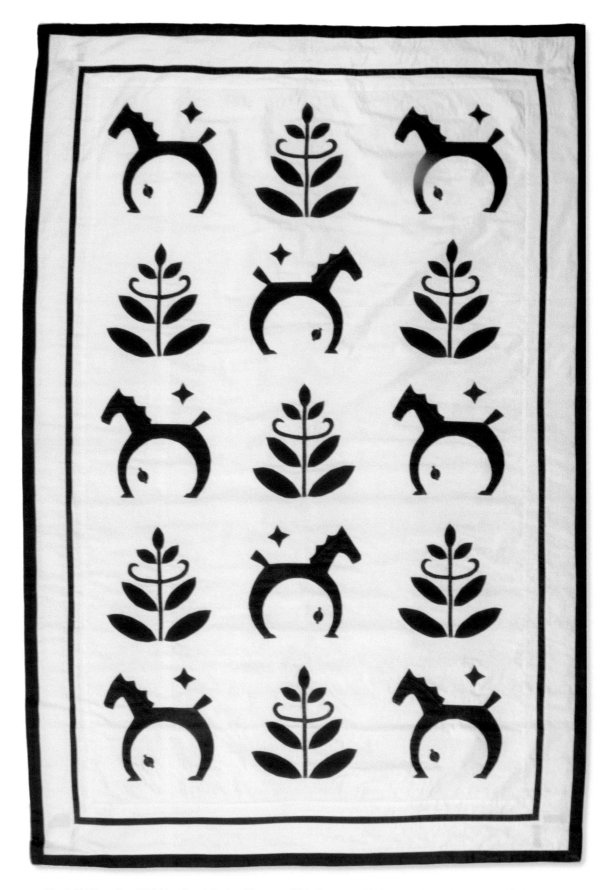

Fig. 3-17. Milwaukee WPA Handicraft Project, Horse, c. 1938. Courtesy of Milwaukee Public Museum, H56565-Horse.

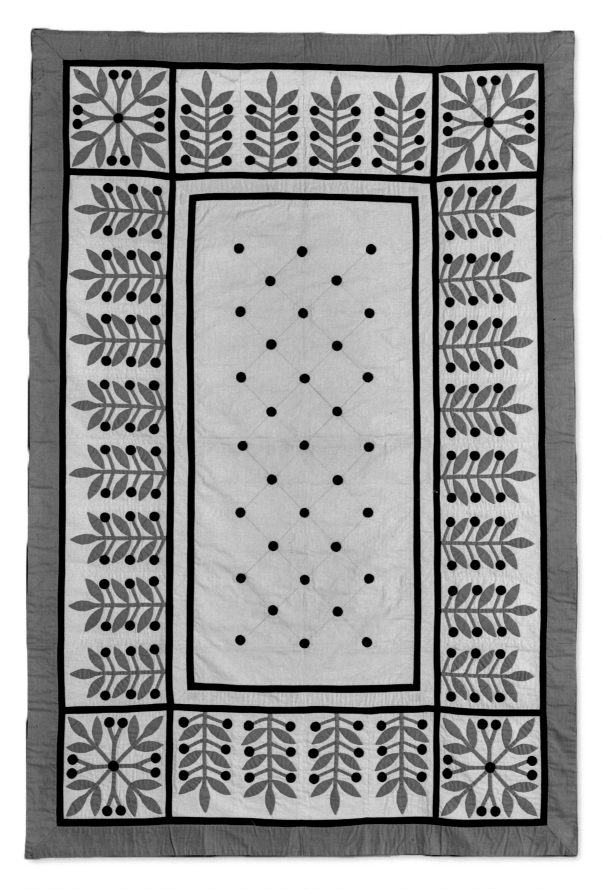

Fig. 3-18. *Milwaukee Handicraft Project,* Cherry Tree Quilt, *Julia Loomis, pattern designer. Indianapolis Museum of Art at Newfields, Eliza M. and Sarah L. Niblack Textile Fund, 39.45.*

Fig. 3-19. Hand appliqué in process as part of the Milwaukee WPA Handicraft Project, Milwaukee Public Museum, H49622-9.

In an interview much later, Julia Loomis, one of the primary quilt designers, admitted that they often made patterns overly challenging to execute with details like mitered corners in the borders; "we were very fussy, and time and labor were abundant," she explained.[83] The small, curved pieces required expert hand appliqué skills (see fig. 3-19) and this technique may not have held up to rigorous use in institutional settings. The stitchers who worked on the extant Cherry Tree coverlet in the Indianapolis Museum of Art's collection executed it with invisible hand appliqué stitches, with the appliquéd stems, leaves, and cherries outlined with hand quilting stitches. Art director Rice stated that eventually

the appliqué unit switched from hand appliqué to a more efficient and durable machine appliqué technique, noting that this method necessitated "more simplicity in the design for a complicated motive [motif] could not be produced successfully."[84] The borders framing the cherry design are machine stitched. The lower left corner (fig. 3-20) reveals the difficulty in perfectly aligning the forty-five-degree seam to create the precise mitered corner. Tiny prick holes in the fabric adjacent to the stitched seam show that the stitches from a first imprecise effort at the mitered corner were removed and redone, indicative of the challenging geometry necessary to achieve this feature. Loomis recalled to Waldvogel

Fig. 3-20. Milwaukee Handicraft Project, detail of mitered corner, Cherry Tree Quilt, *Julia Loomis, pattern designer. Indianapolis Museum of Art at Newfields, Eliza M. and Sarah L. Niblack Textile Fund, 39.45.*

that one of the women working in the appliqué division became quite skilled in stitching mitered corners and eventually did all of them.[85] Work on the coverlets, quilts, and appliquéd screens and curtains was generally handled like this: as piecework, with individual workers handling a specific step, rather than completing an appliqué from start to finish.[86]

Cherry Tree is one of the four original cot coverlet designs that MHP produced, along with Fish, Sailboat, and Circles. Eventually, MHP offered these designs and eleven others as quilts that could come with optional batting in the following sizes: nursery (forty by sixty inches) for $1.25, three-quarters size (sixty by ninety inches) for $2.45, and full size (eighty by ninety inches) for $3.25.[87] Rice recounted that various MHP crafts, including quilts, were shipped to all forty-eight states.[88]

Although the Cherry Tree quilt drew on the quiltmaking style of the previous century, other Milwaukee handicraft designs were quite novel, sharing little resemblance with either historical or contemporary quilts. An appliqué wallhanging listed as "Bird and Beast" in the 1939 MHP catalog, described as

"Unbleached sheeting ground; special peacock blue, navy, rust, sulphur appliqué" and priced at $2.50, is likely the same design as a coverlet documented by the Wisconsin State Quilt Project. Its owner at the time of its 1980s-90s documentation was a former Wisconsin grade-school teacher who purchased several quilts from her school when they were no longer in use; she called it "Wild Geese and Deer" (fig. 3-21).[89] It features a symmetrical design comprised of alternating rows of appliqué motifs, starting with simple peacock blue circles stitched onto a rust ground, then rust-colored geese in flight tipped with navy blue beaks and tails, then two rows of an abstract snaking rust line bisecting a sulfur yellow stripe framed with blue fabric bordering a stylized stem and leaf design in rust. Two rows of the "beast"—a rust-colored deer or unicorn featuring fine navy detailing for the horn, tail, and hooves—alternate with a zigzag design flanking an appliquéd row of flowers and crosses. The bottom half of the coverlet (or wallhanging as it may be) is a mirror image of the top rows of appliqué.

The flattened figurative and abstract motifs in the Bird and Beast appliqué look much more like something one would find on an Arts and Crafts style block print

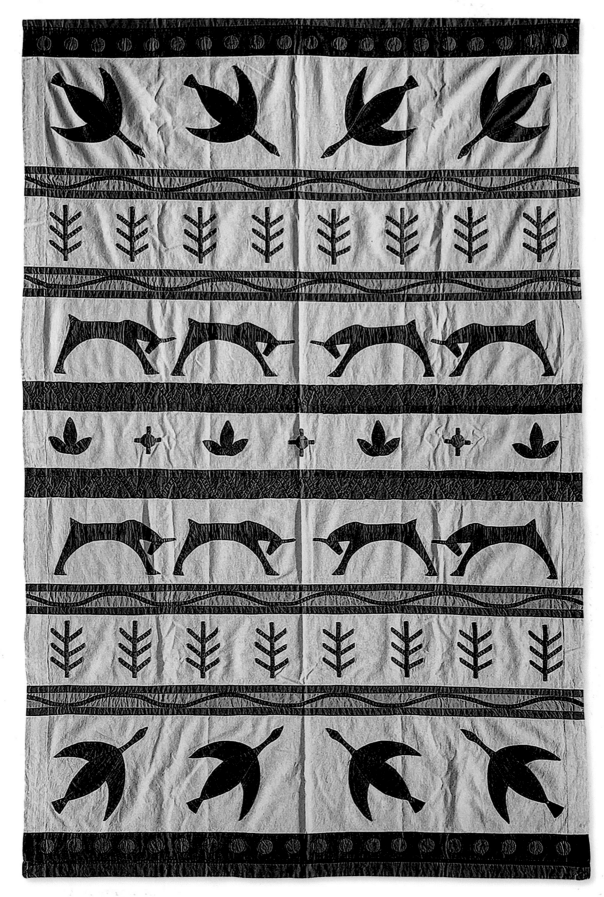

Fig. 3-21. Milwaukee WPA Handicraft Project, Bird and Beast, c. 1938-9.

rather than on an appliquéd quilt. The creatures are simplified forms, resembling other stylized Art Deco artwork from the era yet upon inspection, not simple to execute. The appliquéd details are quite small and would have required expert dexterity with needle and thread, further evidence supporting the theory that the designers were more concerned with the aesthetic qualities than the ease of creation, even if the project's stitchers were supposedly "unskilled." With time and labor abundant, as Julia Loomis recalled, MHP emphasized what it referred to as "good design" rather than factory-volume output. As Valerie Davis and Jackie Schweitzer observe in their analysis of the project, MHP designers "may have viewed the production of complicated sewing projects as a way [to] provide many hours of work for the highest number of workers."[90]

During its heyday, other state WPA administrators regarded the Milwaukee project as a model, with a federal official noting that its "organization is most efficient and their design is very good."[91] Unlike quilt projects aimed at producing quilts solely as warm bedcovers to give to the needy, this one had the objective of producing well-designed goods with "commercial possibilities," and indeed the products were in demand by public institutions across the country. MHP even sent two of its designer-foremen to Iowa to start and administer a handicraft project in that state. The WPA home office in Washington DC requested exhibitions of MHP products, which further extended the reach of the model for crafting objects for institutional use. Berea College, known widely as a hub of craft education, hosted an exhibition, as did the Western Art Convention when it met in Toledo, Ohio, while other crafts from the project were on view at the Art Institute of Chicago, Indianapolis Museum of Art, and in department store displays.[92]

As evidence of the project's growing reputation, visitors flocked to see the workers in action, including Eleanor Roosevelt, architects Frank Lloyd Wright and

Eliel Saarinen, Ruth Reeves (the textile designer who helped conceive of the WPA's Index of American Design, discussed in chapter 5), industrial designer Russell Wright, Bauhaus artist Lazlo Moholy-Nagy, and a number of educators from across the country. Politicians and governmental administrators also visited. MHP maintained support for its efforts by creating buy-in for the project through positive press coverage, well-received exhibitions, and clear messaging about its objectives.[93] Rice, however, viewed the rave reviews as secondary to the empowerment of the women working on the project: "Words of praise expressed by the visitors directly to individual workers reinforced in these women their newly found self-esteem and their pride in work well done."[94]

Rice and other administrators viewed this goal of changing the lives of MHP's workers as a priority. Many of the workers were immigrants, most of them Polish, with ages ranging from eighteen to their sixties. Many only had elementary education, and most had only limited work experience outside the home. African American women, with limited employment opportunities even in the best of times, comprised more than half the workforce, with the project directors insistent that Black workers would be fully integrated into the project and work side-by-side with their white counterparts, a rare policy for government-subsidized relief work.[95] In 1944, an observer wrote that MHP workers "were the ones whom industry, education and society had discarded as useless and here they were before our very eyes creating quality products."[96] But it wasn't merely new work skills along with the improvement of morale in the midst of the Depression that Elsa Ulbricht set as a goal; she wrote in 1944 that the project provided "an excellent opportunity for disseminating culture and raising the standards of taste in the community."[97]

At times, this attitude of imparting the cultural values of the upper class on lower-class women

from the relief ranks resulted in a paternalistic approach to MHP's operations. From the start the project was conceived to specifically employ "unskilled" workers because out-of-work skilled women had largely found jobs already on other WPA projects, including in sewing rooms, art projects, and white-collar projects through the Division of Women's and Professional Projects.[98] MHP employed personnel not on the relief rolls— trained art educators who Ulbricht described as "young, enthusiastic, and energetic,"—to supervise the workers. Ulbricht's attitude presumed a hierarchy in which the "unskilled" workers had no taste or discrimination of their own, even though many came with their own experiences and traditions, whether as transplants from the Great Migration or from waves of European immigration. She recounted in a 1964 interview that she perceived the workers assigned to MHP as "the kind of people that hadn't had to do much thinking" even though many of them were heads of household who by necessity had to be problem solvers with creative ingenuity, despite their lack of resources. She concluded that the workers "learned so many things that they could use that they had never had an opportunity to because they were just indigent people."[99] From this perspective, some of the most significant skills learned were ones, as Rice noted, frequently referred to as "soft skills," such as the ability to "adjust to a regular schedule, to work cooperatively in a group and to develop simple skills and to gain confidence in their ability to learn new things."[100]

Rather than promote these transferable work skills, the project's marketing materials emphasized how it imparted good design, stating that "it gave to approximately 3,000 people an opportunity thru their work to associate with articles of taste and discrimination hitherto unknown to them."[101]

Ulbricht surmised that the 5,000 workers who contributed work to the MHP eventually "got some culture" and "an introduction to the fine things of everyday life."[102] Harriet Clinton, director of the WPA Women's Division in Milwaukee, perceived the reach of the products' good design as impacting not only the workers, but also those in the orphanages, nursery schools, and hospitals who eventually used them, noting specifically that the "600 quilts ... will go far in persuading [the Milwaukee County Home for Dependent Children] and similar ones, that color and beauty are the heritage of even institutionalized children."[103]

Ultimately MHP did have a significant reach, and as a model WPA initiative, its legacy has survived through anniversaries, exhibitions, and the inclusion of its products in museum collections and publications, including this one. As with many New Deal projects, our perceptions are primarily colored by the remembrances of the administrators, supervisors, and others in positions of power, rather than the lives of the women who did the work.

BOONDOGGLE OR DRUDGERY?

What do we make of these so-called unskilled women who produced hundreds of thousands of WPA quilts? Praise for the various WPA sewing projects that produced quilts came from luminaries such as Eleanor Roosevelt and WPA administrators responsible for justifying the enormous budget that kept these and other WPA programs afloat, all while certain taxpayers and members of the media considered them a boondoggle. Classifying the unemployed women working on these projects as unskilled and only capable of wielding needles exemplifies both the classism and sexism of the era.

Yet because the many women stitching quilts in the evocative WPA photographs throughout this chapter remain anonymous to us, it is challenging to assess whether the New Deal administrators' perceptions of these programs had the lasting results on the quiltmakers that they articulated. New Deal legislation has had enduring impacts on American life in prominent and subtle ways, from post office murals to Social Security. For those living through the Great Depression, the New Deal also had the power to provide hope for the future by providing a place to show up and find moral and mutual support, such as a sewing room or a handicraft workshop.[104] Temporary relief jobs in these workplaces may not have resulted in new industrial vocations as promised, especially those like a Pensacola sewing room where the supervisor hoped to revive the art of spinning by wheel, an obsolete technology by 1937. Quiltmaking too may not have created transferable skills, but the quiltmaking fostered by WPA programs did help keep this art form alive through the Depression years.

Although we look back from the twenty-first century at Depression-era quilts with rose-colored glasses, imagining the cheery scrap quilts women in sewing rooms produced from fabric leftover from garment making as what Merikay Waldvogel called "soft covers for hard times," the women stitching away at them may not recall WPA quiltmaking so fondly.[105] Those who pieced together WPA quilts did so not out of love or leisure but because they needed whatever minimal pay they could get. As the nation recovered during the decades following World War Two, quilting's popularity ebbed. Some of the Depression-era quiltmakers who made quilts for pay or necessity likely relished the chance to buy a chenille bedspread from a department store rather than stitch bedcovers as a hobby. Quiltmaking's decline through the mid-century may indeed stem in part from a desire to leave behind the drudgery of making quilts while on the relief rolls.

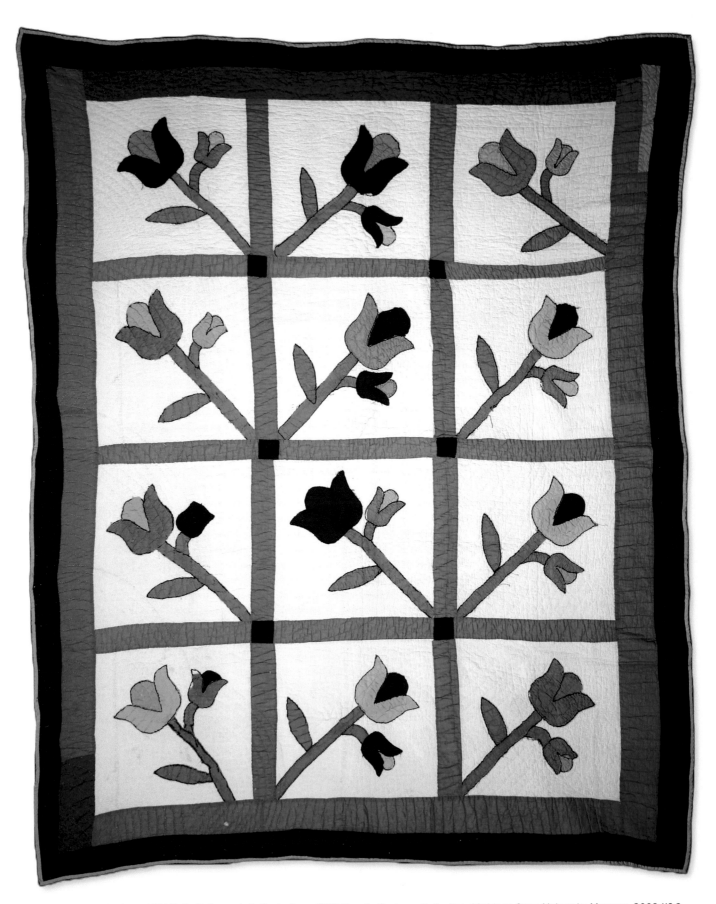

Fig. 4-1. Minnie Benberry, WPA Tulip Quilt, *made in Kentucky, c. 1936, Cuesta Benberry Collection, Michigan State University Museum, 2008:119.3.*

CHAPTER 4
HOME ECONOMICS

Minnie Benberry, who lived in western Kentucky during the Depression, recalled a governmental worker coming to visit the African American farm families scattered across the region, armed with a quilt pattern. When the women from the region "gathered in the spring at the churchyard to quilt their tops they were surprised that they each had used the same pattern," unaware that the federal worker had distributed a tulip pattern to "everyone for miles." These Black quiltmakers—Minnie Benberry, Maudeline Wimbleduff, Ivy Stone, and others—gave the pattern the name "WPA Tulip Quilt," (fig. 4-1) as they associated it with the governmental program that distributed it.[1]

Cuesta Benberry, Minnie's daughter-in-law and a noted quilt historian, later recounted this story, emphasizing that the governmental worker was employed by the Works Progress Administration (WPA), which may indeed have been the case. Many Americans used "WPA" as the catchall for governmental relief programs and workers during this era, a shorthand for the whole New Deal, even though the New Deal comprised countless programs varyingly administered at the local, state, and federal levels.[2] The WPA's work centered on putting Americans to work on various projects

that would benefit the public, such as road and bridge building and the ubiquitous sewing rooms described in the previous chapter. The Farm Security Administration (FSA) and its precursor, the Resettlement Administration (RA), both sent governmental employees hired as expert home economists to visit, assist, and educate rural families, as did the U.S. Department of Agriculture's Cooperative Extension Service.

Experts like the federal worker who visited Minnie Benberry worked in a variety of capacities as home economists tasked by the government with providing rural women with advice on how to keep up their homes in the midst of an economic downturn, which for many farm families had begun well before the stock market crash of 1929. These governmental experts promoted gardening, canning, nutrition, home beautification, rational consumption, and home sewing, among other things, as ways to "help the families to make a going concern of the farming enterprise."[3] And among the domestic sewing tasks home economists promoted was quiltmaking, both individually and in quilting groups—whether in rural farmhouses, in temporary FSA (or, initially, RA) Migratory Labor Camps, or in one of the 100 planned communities

created by New Deal programs such as the Division of Subsistence Homesteads (DSH). These typically rural women made quilts with the advice of home demonstration agents and FSA supervisors, sometimes through organized homemakers' groups including the home demonstration clubs sponsored by the U.S. Department of Agriculture's Cooperative Extension Service or Adult Education courses sponsored by the WPA. Women's motivations for quiltmaking in either domestic or community contexts included the desire for warm bedcovers, home beautification, a creative outlet, earning money from selling the goods, and opportunities to socialize with other women in the community. These impetuses overlapped with the government's interest in quiltmaking; New Deal home economists prioritized home production over reliance on the consumer market (or at times, participation in the market as a producer), thrift in the form of reuse, and home beautification through tasteful handicrafts.

The New Deal, with its changing administrative divisions and varying levels of local and federal control, both conformed to local conventions, including racial hierarchies, and disrupted them. Rural Americans, some of whom had been displaced as industries shuttered and some of whom voluntarily migrated to the West Coast in search of labor, had to interact with federal authorities despite skepticism toward the government and its agencies. For Black families, the unequal resources available to them coupled with systemic and individual racism resulted in relief programming that did not always reflect the equity the federal government espoused. These same federal divisions that at times provoked suspicion also provided struggling Americans with loans to purchase sewing machines or access to shared community buildings housing sewing machines and quilting frames. By providing quilt knowledge and resources, home economists and other federal workers created outlets to craft, use, and share quilts, which are among the most symbolically and physically comforting of

objects. Home economists knew that quilts had the potential to make challenging, unfamiliar, and often precarious circumstances feel like home.

During the so-called Progressive Era that preceded the onset of the Great Depression, home economics developed as a profession, characteristic of the early twentieth-century impulse toward professionalizing many aspects of American society. Home economists had the objectives of promoting efficiency, hygiene, and good taste among housewives while also not only encouraging them to be producers through gardening, canning, and home sewing but also training them as "rational consumers" through participation in the consumer economy in ways that were within their means. Home economists urged women to purchase efficient appliances like pressure cookers and some factory-produced goods like glass jars and factory-woven cloth.[4] These home economists were distinct from the rural farmwives they attempted to train as they were typically college educated, single, and outsiders to the communities to which they were assigned to work.[5] According to a 1936 report, 80 percent of the 1,300 home economists the RA employed as supervisors had degrees in home economics from accredited colleges or universities, with many of them holding master's degrees. While "practically all of them have lived on a farm or a ranch," their educational background no doubt set them apart from many of the rural families they served, creating a power dynamic in which the outside expert imparted advice on the relatively unschooled housewives.[6]

As the economic downturn limited families' ability to participate in consumer society, home economists emphasized thrift, reuse, and home production as complements to purchasing goods at market.[7] One academic home economist recommended that home supervisors working on federal rehabilitation projects "must guide the family to make rather than buy.... She guides the women and girls of rural rehabilitation

There are Difficulties

Starrville 4-H club girls of Smith county made quilts.

but Encouragement

Fig. 4-2. "Starrville 4-H club girls of Smith County made quilts," in Girls' 4-H Club Work in Texas by Onah Jacks, College Station, Texas: Extension Service, 1938. Courtesy of HathiTrust Digital Library.

families to experience and appreciate the joy and strength which come from creating and making something out of their own resources."[8] Quiltmaking, exemplary of the values and skills espoused by this advice, was part of the arsenal of home crafting that home economists encouraged during the New Deal.

HOME DEMONSTRATION WORK

The federal Smith-Lever Act of 1914 predated the New Deal but became all the more essential during the Great Depression. Smith-Lever created the Agricultural and Home Economics Cooperative Extension Service, through which land-grant and agricultural colleges and universities could receive federal matching funds to send experts—agricultural extension agents and home demonstration agents—into rural communities to provide advice on the best ways of running a farm, including, for the women, "the elementary principles of home making and home management."[9] Agricultural extension and home demonstration agents visited families in their homes and communities, often facilitating instruction through Home Demonstration Clubs and community meetings. Smith-Lever also established the national 4-H program (fig. 4-2) for rural youth to be involved in agriculture and home economics, although local 4-H clubs had existed since 1902.[10]

During the Depression, home demonstration agents extended their role to aid farm women in relief and recovery, with particular advice on how to live within one's economic means.[11] This objective was a significant pivot for the profession, since in the booming years of the 1920s home economists had, among other things, focused their efforts on consumption, including by working with utility companies to promote the use of new electrical appliances designed to limit the drudgery of housework and showing housewives how they could

use new modern, factory-made products.[12] As historian Melissa Walker notes, with the onset of the economic downturn the extension service "responded by shifting its focus from consumption to survival."[13] Dorothy Dickens earned a master's degree in Home Economics from Columbia University and was Mississippi's leading home extension service worker during the Depression era. She viewed sustainable home production as the appropriate role for rural housewives, rather than participation in the consumer economy, and as such asserted that "the sewing machine is to the clothing budget what the milk cow, the garden, and the orchard are to the food budget."[14] As historian Ted Ownby notes, home demonstration agents like Dickens who worked in the rural South "urged sewing and thrift." Farm women, unlike many of the women in small towns and cities who worked in the WPA sewing rooms described in the previous chapter, likely had some experience with home sewing, although not all may have owned a sewing machine, depending on their families' resources. Home demonstration agents viewed home sewing in moralistic terms since it contributed to a self-sustaining household while acting on a Protestant work ethic; further, home sewing could mitigate what some home economists considered the potentially damaging effects of shopping for fashionable clothing and home décor that were beyond one's means.[15]

While home demonstration agents devoted lots of time to the home production of clothing, their focus on frugality applied equally well to home beautification in the form of quilts. One of the emphases of the home demonstration program was teaching farm women ways to improve their homes through the introduction of home decorating, including through the use of handmade crafts, which historian Ann McCleary suggests resulted in "Colonial Revival imagery" that supported the extension service's "vision of farm woman as producer, like the colonial woman, making what she needed for her home."[16] This approach was not merely aesthetic but also functioned as part of the extension agents' "thrift campaign" that encouraged demonstration club members to make things by hand, avoid lavish consumption, and reuse and repurpose materials when possible.[17]

A wealth of literature written by fellow home economists, proponents of home crafting, and representatives of the cotton industry supported this emphasis on reuse, providing recommendations for how to economically repurpose materials to make things of use and beauty for the household. In 1939, Marion Spear, one of the pioneers of the emerging field of occupational therapy and an advocate for the therapeutic aspects of craft making, published a three-volume series called *Waste Materials;* in volume two, Spear focused on textiles, with the table of contents a rundown of various cloth and fiber products—"Burlap sacks, Old cloth, Sheets, Blanket Strips, Cotton underwear," and so forth—with each chapter leading to an illustrated description of what to do with these products. In the section on how to reuse "Scraps of gingham," Spear suggested that "the irregular shaped pieces may be used for patch work, the larger blocks being cut first, leaving the smaller pieces for the smaller and more complicated designs. Scraps from which a circle the size of a fifty-cent piece may be cut are worth saving, for a most intricate quilt may be made from circles of this size that are basted onto tiny hexagonal pieces of paper."[18]

The Textile Bag Manufacturing Association provided tutorials for how to repurpose dual use packaging—flour, sugar, and feed sacks printed to appeal to farmwives—to make children's bedcovers and comforter covers in addition to a whole array of garments, sometimes even printing quilt patterns or patchwork elements, as on the backside of the Shawnee's Best Flour sack (fig. 4-3, 4-4). The cotton industry had good reason to promote such reuse: if cotton replaced fibers such as jute imported from

Fig. 4-3. Shawnee's Best Flour Sack, 1930-1940. International Quilt Museum, Paul Pugsley Collection, Gift of the Robert and Ardis James Foundation, 2016.074.0078.

Fig. 4-4. Shawnee's Best Flour Sack (verso), 1930-1940. International Quilt Museum, Paul Pugsley Collection, Gift of the Robert and Ardis James Foundation, 2016.074.0078.

India, there would be a domestic market for millions more bales of cotton, which would help the struggling cotton farmers.[19]

And this is where the government also intervened by encouraging projects that used commodity cotton as a means of stabilizing the economy. As with other

commodity crops, the price for cotton had plummeted in the first years following the 1929 crash, and the Roosevelt administration had responded with a series of measures, including the Agricultural Adjustment Act (AAA) of 1933, which incentivized farmers to plow under crops and produce less, intervening in the invisible hand of supply and demand. During the

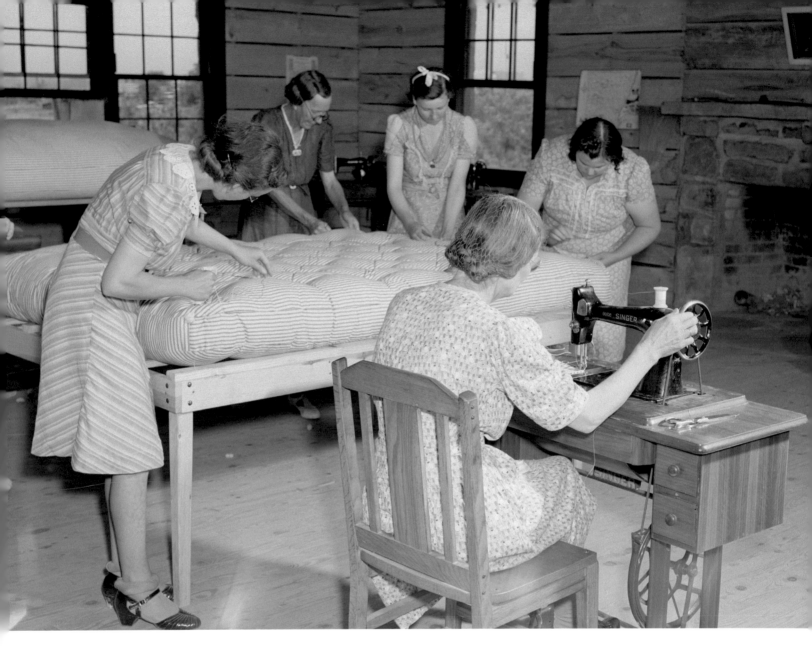

Fig. 4-5. Marion Post Wolcott, Farmers' wives working in mattress-making unit. Community service center, Faulkner County, Centerville, Arkansas, *1940. Farm Security Administration, Library of Congress. The FSA helped the farm families in this area create this community center, where, among other things, the client families worked together to make mattresses.*

summer of 1933, farmers removed 10,497,000 acres of cotton from production, doubling the price to ten cents per pound from five cents in 1932.[20] Despite the efforts of the AAA and the federal government's encouragement of cotton farmers to diversify their crops, a significant surplus of cotton existed, and the government initiated various plans to sell or otherwise use the excess, including through export and programs such as "the Mattress Plan," which aimed to turn cotton surplus into bedding.[21]

Through various locally administered cotton mattress projects like the one pictured in figure 4-5, the federal government tasked home demonstration agents with teaching women to make mattresses and comforters for their families from the surplus, resulting in 220,000 cotton mattresses and 100,000 comforters produced by rural women during 1940-1942 alone. For many participants, these mattresses were the first they had owned, having slept on shuck- or straw-filled sacks. With each mattress estimated to

use at least fifty pounds of cotton, it was an efficient means of using the surplus while improving the lives of impoverished rural families.[22] Mary Evelyn Russell Lane of Louisville, Tennessee, recalled that her local home demonstration agent trained women in how to use surplus commodity cotton to make mattresses. Then her mother-in-law salvaged the scraps of cotton from mattress making and carded it—combed it into straight fibers—in order to fill quilts that she had pieced from chicken feed sacks. "I had several of the quilts made out of [surplus cotton]," she reminisced in an oral history interview: "Brown domestic on the bottom, and sometimes chicken feed sacks on both [sides] and the chicken feed sacks pieced on top and then the cotton in the middle."[23]

The manufacture of such dual-use cotton sacks was another initiative promoted by the Bureau of Agricultural Economics, a division of the Department of Agriculture. It advocated the switch from imported jute burlap to domestically grown cotton for the use in sack packaging because of the abundance of commodity cotton. In 1933, Secretary of Agriculture Henry Wallace encouraged women to make dresses out of sugar and feed bags.[24] These efforts trickled down to the relief programs of the early New Deal. For example, the Georgia Emergency Relief Administration—the state level division of FERA— taught home economics classes for girls, showing them how to make articles from cotton sacks.[25] At this point, sacks were typically white cloth, printed with a brand name, like the one in figure 4-3; resourceful women learned to dye them using either commercially produced or homemade natural dyes to turn cloth into various color shades.[26] As a means of further promoting the use of cotton bags in order to help cotton growers, in the 1930s cotton sack manufacturers began printing the sacks with the intent that creative housewives would select the sacks they found the most attractive in order to reuse them in home beautification and clothing projects

Fig. 4-6. Printed feedsack, 1935-1940. International Quilt Museum, Paul Pugsley Collection, Gift of the Robert and Ardis James Foundation, 2010.042.0021.

(fig. 4-6).[27] Home economists in turn promoted the economic reuse of dual-purpose sacks to their clientele, and quilts were naturally a common result (see fig. 4-7 and 4-8).

In Mississippi, home demonstration agents specifically encouraged African American women to "economize, avoid extravagance, and be content with few goods." Likewise in Tennessee, Black home demonstration agents encouraged their rural African American clientele to "buy mill ends from textile mills at fifteen to thirty cents per pound," with one woman making thirty garments from remnants she purchased for just $1.05. A 1932 extension service report celebrated that Black women in Mississippi

Fig. 4-7. Maker unidentified, Seven Sisters, made in the United States, 1930-1940. International Quilt Museum, Paul Pugsley Collection, Gift of the Robert and Ardis James Foundation, 2019.074.0003. The maker used dual purpose sacks to create this quilt.

Fig. 4-8. Maker unidentified, Four Patch Variation, made in the United States, 1935-1945. International Quilt Museum, Paul Pugsley Collection, Gift of the Robert and Ardis James Foundation, 2019.074.0005. The maker used dual purpose sacks to create this quilt.

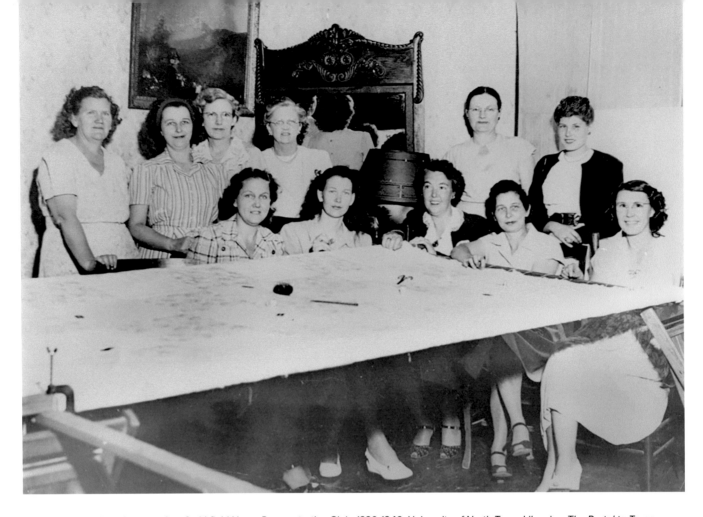

Fig. 4-9. Unidentified photographer, Smithfield Home Demonstration Club, 1930-1940. University of North Texas Libraries, The Portal to Texas History, Tarrant County College NE, Heritage Room. Most likely, the younger woman standing on the far-right side with black cardigan, belt, and upswept hair is the demonstration agent.

had created 9,925 quilts, along with hundreds of thousands of other garments and home goods, from sugar and flour sacks.[28] Another report detailed the outpouring of articles one 4-H girl made by reusing sacks, itemizing the dresses, undergarments, and bedding she produced for mere pennies, guided by the local African American extension service agent in segregated South Carolina.[29]

Home demonstration clubs, one of the primary activities of the extension services, predate the Depression, but proved to be an essential form of community building, resource and knowledge sharing, mutual aid, and supplemental income during this period. When families living in cities relocated to rural areas due to a lack of jobs, they learned from club members how to garden, can, and sew.

Mattress making was another significant outlet for club members. And club members made quilts both individually and collectively, while hosting quilt exhibitions and contests, as well as making quilts to raffle as fundraisers. In Oklahoma, many clubs met bimonthly, with one meeting for business and a second one for quilting and sewing projects.[30] Home demonstration agents supervised and organized the clubs, including submitting reports to the sponsoring universities and to the government. Agents provided club members with quilt patterns, just as the federal worker gave the Tulip pattern to Minnie Benberry and other women in her community (see fig. 4-9).[31] Some demonstration agents encouraged club members to apply their home crafting skills toward earning additional income to support their families by selling their wares at "curb markets" or through other means.

Fig. 4-10. Detail, Album Quilt, block reads "Margarett Nelson, Co. Ext. Agt." Referring to the Extension Service's Home Demonstration Agent assigned to Cass County, Missouri. Image courtesy John Foster.

Selling quilts and other home-produced objects was indeed a common way for women to attempt to earn money during the Depression. In the rural South, some African American home demonstration agents encouraged their Black clientele to bring in extra income from, among other things, the sale of quilts.[32] Indeed, quilt historian Barbara Brackman has found that many women during the Great Depression made quilts not as hobbyist home crafters, but to sell to help support their families.[33] In Tennessee, every county demonstration agent during the 1930s and early 1940s provided instructions in handicrafts, and a marketing director helped promote the sale of local crafts, seeking to standardize products to suit potential consumers.[34] Mrs. Albert Farlow and her widowed daughter Flora, whom the WPA sewing room would not employ because she lived at home with her gainfully employed father, sold quilts for three dollars apiece, making two a week.[35] Another widow, Mary J. Lockard of New Port Richey, Florida, even pitched a Blue Eagle quilt she had made to Eleanor Roosevelt in a 1935 letter, asking the First Lady if she was interested in buying it for her grandchildren as "a remembrance of their grandfather's administration," telling her that she made her living from making quilts.[36] Mrs. Lonnie Ray of Clearwater, Florida, also wrote to Roosevelt, offering to sell her "beautiffull [sic] quilts" so that she would have money to see a doctor for her goiter.[37]

Such contributions to farm and family income were often supplemental, rather than primary, called "pin money" or "egg money," yet whatever the actual dollar amount, women's participation as producers in the economy was both empowering to them

individually as well as essential in keeping their rural families afloat.[38] Historian Kathleen Babbitt even found that "a woman's income from crafts could literally make or break a farm business during these difficult years." In New York state, home demonstration agents were initially reluctant to promote craft making as a source of income but relented as demonstration club members clamored to hone their skills in rugmaking, basketmaking, and other traditional arts like quiltmaking. The "expert" home economists began to see this as an opportunity to instill values of good taste in order to meet a higher standard and have better market appeal—and to make craft making more scientific and rational—rather than have rural women turn to the traditional methods of crafting.[39] One home demonstration agent reported that "Rural women have little opportunity to see beautiful art treasures ... in museums or the homes of wealthy urbanites.... Therefore, guidance is wanted where one might expect spontaneous natural skill and taste," referring to the farm women as at the "'kindergarten stage' of design appreciation."[40] Just as the designer-foremen working in the Milwaukee Handicraft Project wished to impart good taste on its largely immigrant and African American workforce, so too did extension workers wish to encourage in housewives a "high standard of good taste and appreciation of color and design."[41]

Building a reliable market for rural women's crafts was challenging, as studies from both New York and Virginia indicate. In New York, the extension service created a Rural Women's Markets division that established markets near urban centers. In Staunton, Virginia, the rural club members helped create a successful curb market to sell their produce and wares, lobbying Staunton's city councilmembers in order to have a dedicated market space. Only home demonstration club members were able to sell their goods at this outdoor curb market, which moved

to a church basement when there was inclement weather.[42] Some home demonstration agents provided guidance on how to best run these small businesses, such as advice on bookkeeping and other financial requirements. In some cases, African American women were not permitted to participate in local markets; this was the case in rural Tennessee where the extension service only assisted white women, and not their Black counterparts, in creating this entrepreneurial outlet.[43] Although quilts were just one of the many possible crafts and products women might sell at these venues, they exemplified the kind of ware that could be made either for home use or for sale, depending on the club member's motivation.

MAKING QUILTS IN NEW DEAL COMMUNITIES

To our twenty-first-century minds, one of the hardest to fathom New Deal initiatives may be the various planned community programs established by the federal government. Operated by a shifting mix of federal administrations, the government funded the creation of around 100 communities that dispensed with the individualism that has so often defined the United States' culture and economy in favor of a form of collectivism that was to define "a new, organic society, with new values and institutions."[44] These experimental planned communities—defined explicitly as pilot projects—were characterized by shared community spaces and individual family homes in a setting that combined aspects of both rural and urban living, with families typically having a plot of land for subsistence farming.[45] In addition, many of the communities had cooperative associations that were eligible to receive governmental loans and grants. Cooperatives managed agricultural products and services, healthcare, and an array of industries including sawmills, hatcheries, canneries, greenhouses, and even light mills and factories. Although these structures proved to be controversial among free

market policymakers and others critical of New Deal collectivism, and were eventually repudiated and disbanded, quiltmaking and other forms of craft production had a welcome home within these planned communities during their existence.[46]

Roosevelt's administration established the Division of Subsistence Homesteads in 1933 during the first wave of New Deal legislation, with an objective of creating planned communities, not for the destitute but for those struggling to get by on modest wages. The government intended for them to be paths toward self-sustaining communities, with each family initially living on a small plot of land provided by federally allocated start-up funds. These families were subsequently able to purchase their own small homestead. The Division aimed to relocate families who, to use the government's analysis, did not want to be on relief but sought a "new start, a new opportunity to provide for themselves and to live in decent houses located in respectable communities."[47] These experimental communities took various forms, with the primary three classified as Industrial, Stranded, and Rural. Industrial homestead communities like Lake County Homesteads near Chicago or the African American community of Aberdeen Gardens near Newport News, Virginia, comprised the vast majority of Subsistence Homesteads and were adjacent to urban areas. They aimed to resettle industrial workers close to places of employment, with families each having a plot of land to grow much of their own food through subsistence agriculture; these homes were available through low-interest government loans of $3,000. This price point catered to those who, according to the government, "on the one hand, are above the sheer relief level, but who, on the other hand, lack the savings and the income to enable them to obtain financing from private sources."[48] The government intended for these projects to pilot how part-time wage work combined with part-time subsistence farming could be a model for survival. By providing families with decent housing, the project was "designed to help families to become self-supporting, and to humanize living conditions."[49]

Stranded communities, like the ones in Cumberland Homesteads in Tennessee and Tygart Valley Homesteads in West Virginia, drew from the relief rolls in mining and lumbering regions where the Depression had shuttered local industries, leaving residents "stranded." Residents in these communities had no opportunities for employment and were largely reliant on part-time farming and dependent on relief unless the government was able to persuade viable industries to relocate to the region. Initially just two communities, the division also established Rural communities in which families engaged in cash crop production.[50] In 1935, the DSH folded and the newly created RA subsumed it, creating additional planned communities, many of them cooperative farms or other agricultural communities, like the one in Gee's Bend, Alabama (see discussion in chapter 2). In addition, the RA's Division of Suburban Resettlement created "garden cities" including Greenbelt, Maryland. Locally organized corporations under the administration of the WPA operated a few additional communities, including Dyess Colony in Arkansas (where Johnny Cash spent part of his childhood) and Pine Mountain Valley (a favored community of FDR adjacent to his vacation home in Warm Springs, Georgia). In a subsequent reorganization, the U.S. Department of Agriculture's Subsistence Housing Project took over all of these initiatives. All told, there were ninety-nine planned communities of various types orchestrated by the changing administrative bodies.[51]

Many of the communities explicitly tried to revive handicrafts as part of their missions, an approach promoted by Eleanor Roosevelt and other New Deal administrators. Handicrafts, they thought, could be a vital part of economic recovery and "could invoke a community spirit, and could lead to a restored pride in workmanship, a pride that seemed so lacking in assembly-line America."[52] In 1936, University of Wisconsin home economist Abby Marlatt observed that during the Depression emerged "a revival of creative work in the arts and crafts responding to the need of both men and women to create with their hands if they are to continue a sane and happy life."[53] Mrs. Roosevelt sought to revive craft production as both a creative outlet for the working poor and as a means of countering the focus on machine production that industrialization had brought about. She personally encouraged women to pursue such crafts as hobbies or to use them to bring in added income to poor families.[54] Weaving played a larger role than quilting in these homestead enterprises, perhaps because it was deemed a skill transferable to for-profit industry, particularly in Appalachia, and the settlements could operate small-scale weaving workshops. New Deal historian Paul Keith Conkin observes that "probably for the first time in history, government employees traveled about the country with titles such as Associate Adviser in Weaving." As such, many subsistence communities, even if they did not have an official weaving industry, had workshops filled with looms and lessons in weaving.[55]

Following the Agricultural Extension Service's model of providing home demonstration agents to assist rural housewives, the government assigned at least one home economist to each New Deal planned community to organize women residents and provide them with advice about efficiently managing their

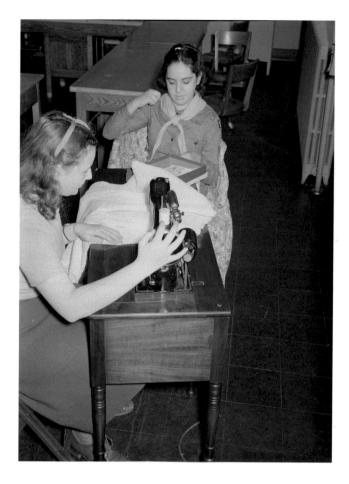

Fig. 4-11. Arthur Rothstein, *Home economics class. Greenbelt, Maryland.* April 1939. Farm Security Administration, Library of Congress.

households.[56] Some of these experts also taught formal classes in home economics, which included quiltmaking, such as the class pictured in figure 4-11 in the garden community of Greenbelt. A 1942 report on the DSH program noted that "every woman on the projects has had a chance to learn about the most modern ways of canning and preserving foods, preparing balanced meals, furnishing rooms, and sewing."[57] In addition, the various forms of communal living in these planned communities enabled informal group quilting activities held at community centers and in clubs that met in homes.

Not only did home economists stationed in planned communities assist families with setting up home

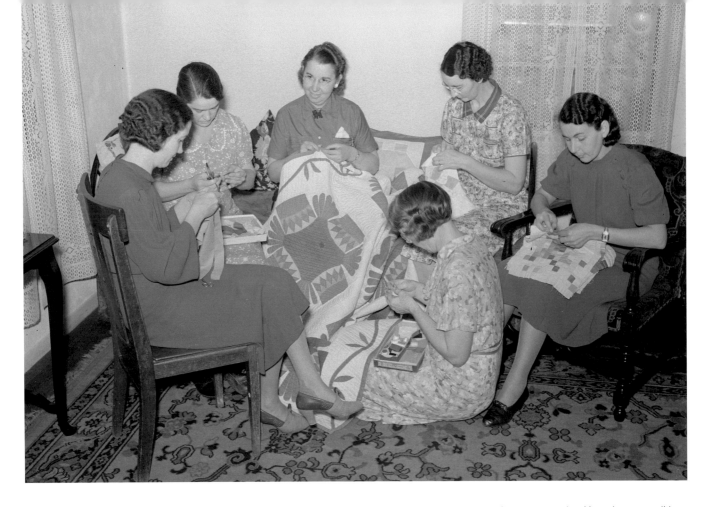

Fig. 4-12. Marion Post Wolcott, Housewives in Tygart Valley, West Virginia, have weekly group meetings in home economics. Here they are quilting. *Farm Security Administration, Library of Congress.*

budgets and home management plans, they organized women's clubs in a similar vein to those initiated by home demonstration agents. In fact, some communities had extension service agents on staff while other home economists took extended leaves of absence from the extension service so they could work for the federal programs overseeing the communities.[58] A photograph from Tygart Valley (fig. 4-12) depicts the scene of a women's club meeting in a home. Marion Post Wolcott's caption reads, "Housewives in Tygart Valley, West Virginia, have weekly group meetings in home economics. Here they are quilting."[59] Like other FSA photographs, it is unclear how staged this tableau may have been, but it nevertheless depicts women engaged in various steps of the handwork associated with making quilts. Tygart Valley Homestead in West Virginia resettled families left stranded when the coal mines and lumber industry suffered during the

Depression. As in other homestead communities—most notably Arthurdale, West Virginia, a favorite community of Eleanor Roosevelt—it had a formal weaving center in addition to other light industry as part of its mandate to provide work for residents.[60]

Quilting, in contrast, was a handicraft that fell into the category of applied arts, rather than light industry, yet some subsistence homestead communities similarly embraced it. For some women quilting was likely more of a communal leisure activity, with women gathering to socialize around a quilting frame as they did in the photograph from Granger Homesteads (see fig. 4-13). Marie Irwin, the home economist for Cumberland Homesteads in Tennessee, another stranded community, organized the women's clubs there. She perceived group quilting "as a good way for women to get to know

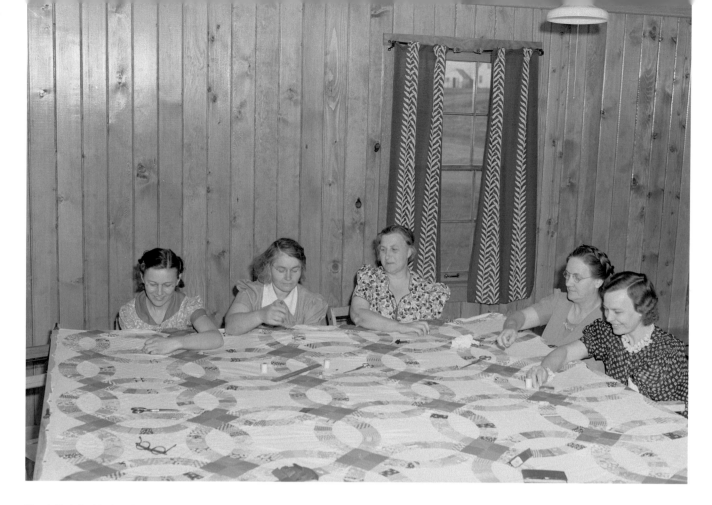

Fig. 4-13. John Vachon, Members of the women's club making a quilt. Granger Homesteads, Iowa, 1940. Farm Security Administration, Library of Congress.

one another."[61] Suburban Greenbelt also had sewing and quilting groups for girls and women and hosted quilt contests as part of its annual Town Fair. A local observer wrote in the *Greenbelt Cooperator* that such events allowed the community's residents to "show with justifiable pride our own creations; and we acknowledge, with genuine appreciation, the justice of our neighbors' pride in their creations.... A well grown garden, a well made quilt, a well made cake, a beautiful exhibit."[62] In many ways the women's clubs and handicraft contests in planned communities were very similar to the existing extension services model that encouraged friendly competition among participants through contests and exhibitions.[63]

Women who lived in various types of subsistence communities found opportunities to participate in commerce as producers. In some communities,

individual women tried to sell quilts, rather than create them as an organized collective industry. A woman in the Tygart Valley Homestead repurposed Gold Medal Flour sacks into clothing, selling to both fellow residents and to those outside the community. This same woman also earned money as a midwife, helping deliver most of the babies born there before 1940. Those who learned to weave in Tygart's workshop also sold their wares from their homes or from the workshop itself.[64] Evidence of selling both home-sewn and woven goods suggests that perhaps quiltmakers did the same.

In addition to organizing clubs, exhibits, and contests, home economists in planned communities created opportunities for more formal home economics education.[65] Such was the case in Flint River Farms in Macon County, Georgia, a farm community planned

by the RA and opened by the FSA in 1938. Flint River was one of thirteen all-Black farm communities the federal government created in the rural South, where segregation still ruled despite the federal government's pledge for equal access to relief programs.[66] Locals debated about where this particular community should be established, with some white citizens opposed to its creation due to fear that land values would decline and that African Americans working as sharecroppers on neighboring farms would be "dissatisfied with wages from private landowners," among other reasons.[67]

The hub of this settlement was the Flint River Farms Community Center where youth attended school from first through twelfth grades in an environment the FSA claimed was "better than any the county had known for Negroes before." In addition to instruction in typical academic subjects like math, reading, science, and history, the school had home economics and other vocational training, where girls specifically learned homemaking skills including gardening and canning. The home economics teacher also offered evening classes for adults. Marion Post Wolcott's photograph (fig. 4-14) and its accompanying caption reveal the home economist's focus on thrift and reuse, noting "Everything they make ... utilizes materials of local origin as cornshucks, cane, flour and meal and feed sacks." Although the women seated on the porch appear to be engaged in other handwork, a patchwork quilt has prominent position in the foreground.[68] FSA home supervisors, as this division called its home economists, offered such training in creative reuse of cotton sacks in other planned communities as well.[69]

Fig. 4-14. Marion Post Wolcott, Home economics and home management class for adults, under supervision of Miss Evelyn M. Driver (standing in white uniform). Everything they make including the small handmade looms, utilizes materials of local origin as cornshucks, cane, flour and meal and feed sacks, etc. Flint River Farms, Georgia, May 1939. Farm Security Administration, Library of Congress.

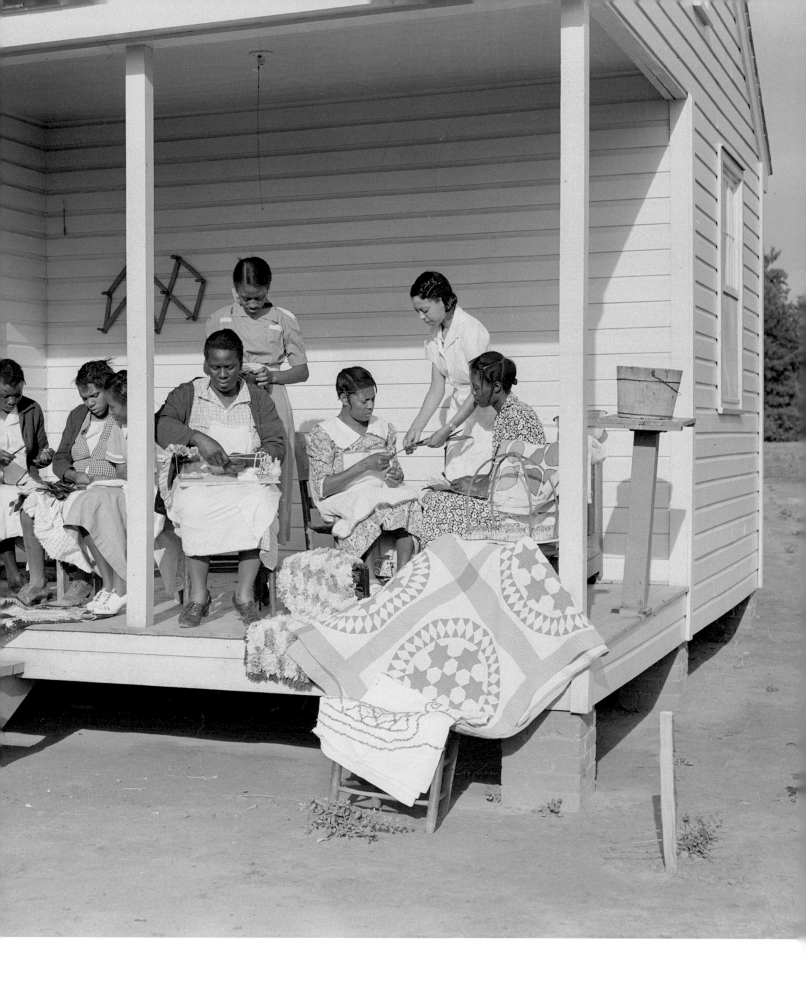

QUILTS MAKE HOMES IN TEMPORARY MIGRANT CAMPS

With so many Americans displaced, and many others long engaged in migratory agricultural work, the FSA established temporary Migratory Labor Camps to shelter these families, many of whom were of Mexican or Asian descent, in addition to the so-called Okies and Arkies who journeyed west in search of work. In 1942, the FSA reported that eighty-five camps existed nationwide providing homes to an estimated 89,000 individuals, with some camps classified as mobile that moved with the harvest season. While some camps existed on the East Coast in Maryland, New Jersey, North Carolina, Virginia, and Florida, the bulk were in the Southwest, Northwest, and West Coast in Arizona, California, Idaho, Oregon, Texas, and Washington. Conceived by the more radical wing of the federal New Dealers, the FSA camps aimed to provide migrant workers with more than mere emergency relief by supplying reliable housing, education, medical care, and other resources that, in the words of historian Verónica Martínez-Matsuda, "[fostered] farmworker solidarity" and "opportunities necessary to better shape their world." She notes that the FSA regarded these camps as a great "experiment in democracy" in which farmworkers of all ethnicities and races were empowered to "realize a more substantive, participatory, and inclusive sense of U.S. democracy than what existed."[70] Although the camps were ostensibly temporary, architects designed them with centralized community centers in order to provide shared space for schools, recreation, and entertainment, as well as to foster "solidarity through cohabitation and cooperation" in an effort to "combat migrants' individualistic attitudes," according to Martínez-Matsuda.[71] Much of this participatory citizenship—attending camp council meetings and serving as elected officials, planning and attending numerous community events, publishing camp newsletters—took place in the camps' community buildings, where among other activities, residents made quilts.

Despite the transient nature of camp life, here too, women made quilts with guidance, equipment, and materials provided by home economists. Like other planned communities, camps often had expert home economists on staff to provide education and support to families, particularly to the women who worked the fields while also raising children and otherwise attempting to maintain family cohesion. In addition to their beauty, quilts symbolized comfort and home, no doubt fueling the camp residents' desire to make, exhibit, and share quilts, along with the very practical purpose of serving as bedcovers. FSA photographs from the camps as well as the newsletters published by camp residents provide evidence of quiltmaking and its significance to camp life.

Community centers were at the heart of the camps. In addition to hosting medical clinics, nursery schools, and weekly dances, among other things, community centers typically housed a home economics room with sewing machines and quilting frames. In the Arvin Migratory Labor Camp outside of Bakersville, California, known colloquially as Weedpatch and on which the fictional migrant camp in John Steinbeck's *The Grapes of Wrath* is based, WPA employees led classes on quilting and sewing and gave canning demonstrations. A 1936 visitor to Weedpatch found the sewing room "taxed to capacity ... every afternoon."[72] Weedpatch's *Tow Sack Tattler* reported in 1941 that "there has been quite a lot of quilting for the last week."[73] Mrs. Clyde Lovell shared in the Yuba

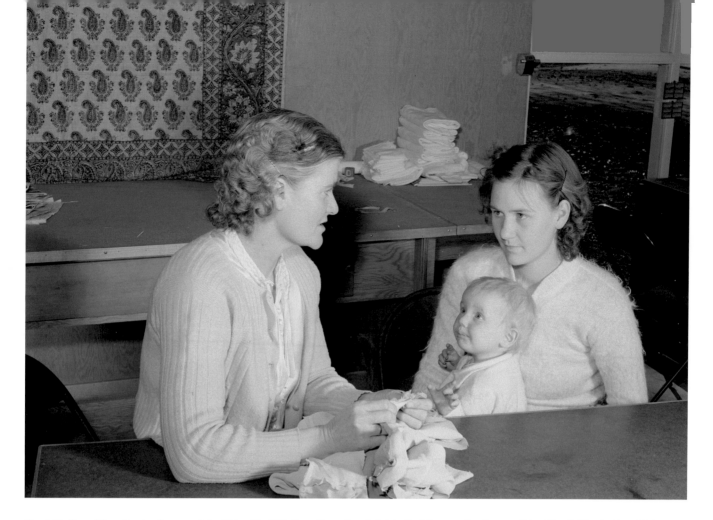

Fig. 4-15. Russell Lee, Sewing Lesson at the Yuba City FSA (Farm Security administration) farm workers' camp. Yuba City, California, *Dec 1940. Farm Security Administration, Library of Congress.*

City camp's newspaper that "we have good chance to sew, make quilts, matressis [sic], furniture, and rugs."[74] Newsletters from other camps echoed this testimony, with the home economist at the Shafter Farm Workers Community reporting that four girls, including an eleven-year-old, were working on quilts, but they needed more sewing machines and donations of fabric pieces from fellow residents to replenish their scrap basket.[75]

Some of the camps' home economists offered instruction in a variety of home hygiene and domestic arts. Both the Yuba City and Marysville, California, FSA camps' community buildings had sewing rooms with available sewing machines, with home economists on staff holding classes in mattress- and quiltmaking, among other things (fig. 4-15). In the

Yuba City camp's home economics center, camp residents made mattresses and quilts as part of a home management program under the direction of the camp's home economics supervisor, using surplus commodity cotton provided by the government. They made 117 mattresses and fifty-two quilts in May 1942 alone; unfortunately, we do not know what these quilts looked like, other than the few captured by FSA photographers. Although the camp offered a variety of adult education courses, hands-on ones like quiltmaking proved to be among the most popular because they offered skills that would immediately improve camp life.[76]

Quiltmakers in Migratory Labor Camps focused on quilting not only as a leisure activity but as a form of mutual aid. The Home Makers Club at Shafter made

Fig. 4-16. Russell Lee, FSA (Farm Security Administration) farm workers' community. Carding surplus cotton which will be used for quilts, *1942, Woodville, California. Farm Security Administration, Library of Congress.*

Workers Community similarly made quilts for "families who needed cover," producing forty-eight quilts as part of its Comfort Project in 1942. That same year, FSA photographer Russell Lee visited Woodville, taking pictures of a woman at work at a quilting frame and others carding surplus cotton to fill the quilts, the process of brushing the fibers with wire to align them (fig. 4-16, 4-17). The camp's newsletter reported that "we have been slow on the quilts because we have had difficulty keeping cotton carded."[81]

Opportunities to make quilts in the camps' community buildings also served as ways to build a sense of community and to create feelings of "home" among turbulent living and working conditions, which was a vital asset to migrant families. Just as at county fairs and other venues across the country, Yuba City's quiltmakers held contests to win prizes for the best quilt; one resident shared that she was "disappointed that she had not win [sic] the prize for finest quilt offered at the Fourth of July Festival Display held in the camp in 1942." An observer noted during a 1942 visit to Yuba City that the walls of one camp family's metal shelter were decorated with "multicolored quilts."[82] Within these temporary camps filled with residents in search of more stable and permanent living situations, making, using, and sharing quilts could symbolically allow them to feel at home within their communities, while providing a source of warm bedding and an enjoyable craft activity.

THE PATERNALISM OF HOME ECONOMICS EXPERTS

In addition to resettling displaced families in various planned communities, the FSA—and its precursor, the Resettlement Administration—also provided knowledge, loans, and supplies to farm families who stayed in place—often southern sharecroppers or tenant farmers, including many African Americans—

"comforts" and mattresses and then held a drawing to determine which families would get them.[77] At the Marysville Camp, women formed Good Neighbors and Happy Hour Clubs, where women stitched quilts to give to newcomers to the camp, along with organizing other activities to make migrant families feel at home in their new surroundings.[78] Clubs at other camps made quilts to raffle to raise proceeds for other mutual aid efforts, such as Christmas toys. The Ladies Club at Shafter displayed one of its raffle quilts at the camp library and sold raffle tickets for five cents.[79] This camp's Welfare Club also had a system for families to "check-out" and "turn in" quilts, just like one would do with books at the library.[80] The Woodville Farm

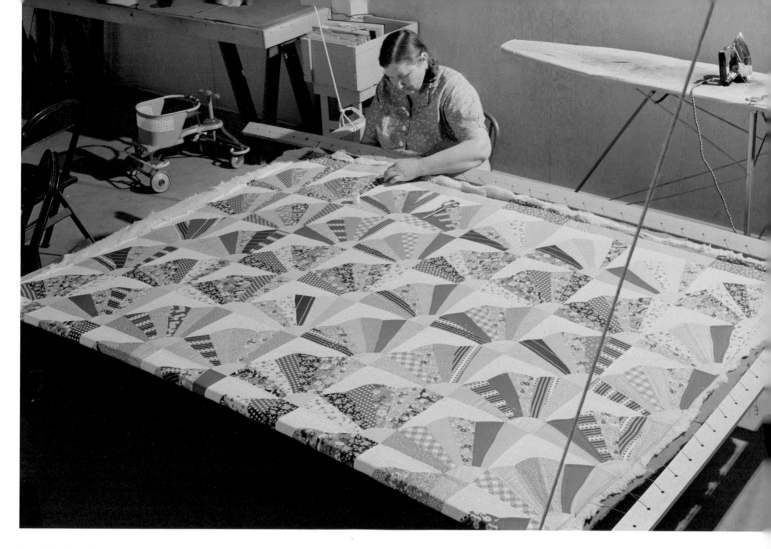

Fig. 4-17. Russell Lee, FSA (Farm Security Administration) farm workers' community. Agricultural worker quilting in the sewing room. *April 1942, Woodville, California. Farm Security Administration, Library of Congress.*

who were unable to break the cycle of poverty that characterized the tenant and sharecropping systems. FSA supervisors assisted these farm families—called "rehabilitation clients"—who benefitted from low-interest FSA loans in order to purchase modern farm supplies and household equipment like pressure cookers and sewing machines.[83] These FSA client families had to adhere to certain requirements; in Greene County, Georgia, for example, farm families qualifying for loans had to commit to establishing a home garden, raising livestock, canning surplus produce, and developing and implementing a home and farm plan with the guidance of their FSA supervisor.[84] As historian Clifford Kuhn notes, supervisors promoted independence among their clients, yet did so through close monitoring and

paternalism that was often at odds with the self-sufficiency the FSA espoused.[85]

Advice to home economists working in rural rehabilitation programs noted disparagingly that "the home economist must see the family as it is"—in debt, in poor health, "frustrated, discouraged, apathetic ... without interest in cleanliness and sanitation ... content to sit at home in idleness." This expert, writing in the academic *Journal of Home Economics,* went on to suggest that "it is the duty of the home economist to develop with the family ... a homemaking program which will ... build a more satisfactory home life." Such sentiments suggest that by default these home economists approached their clients as inferior, in need, but perhaps not welcoming of, the

expert advice they had to offer. The writer observed that the home economist may find the family with "a woeful lack of clothing and household goods; ugly, dismal, bare houses and surroundings" combined with "apathy and lack of knowledge."[86] From this point of view, government-employed home economists were not just advisors but also tastemakers and moralizers. Although their intentions may have been good, the hierarchies inherent in the relationship of home economists providing instruction to those they deemed inferior, whether economically or racially, likely rubbed some clients the wrong way.

Like the Agricultural Extension Service's home demonstration agents, FSA supervisors also facilitated women's clubs, like the Clark Hill Club in Coffee County, Alabama, where Velma Patterson led a session at an FSA client family's home (fig. 4-18). This scene, captured by FSA photographer Marion Post Wolcott, shows four women and girls sitting on a bed wearing rolled stockings and calico dresses, with others surrounding them in chairs. A second photo from this series shows another angle. All participants at the meeting occurring in this far southern region of Alabama are not surprisingly white, as many New Deal projects were locally administered and deferred to local custom in terms of segregating white and Black relief recipients, adhering to the doctrine of "separate but equal." Many southern states appointed "Negro advisors" and established "Negro divisions" to administer segregated services. Despite African Americans constituting 24 percent of the South's population, they made up only 12 percent of extension service staff, meaning that fewer Black women were able to take on these federally funded professional positions and that fewer Black families were served by home economists of their own race.[87] In Tennessee, the extension service director believed that African American farm families should be "served by 'their own kind,'" yet refused to use New Deal funding set aside

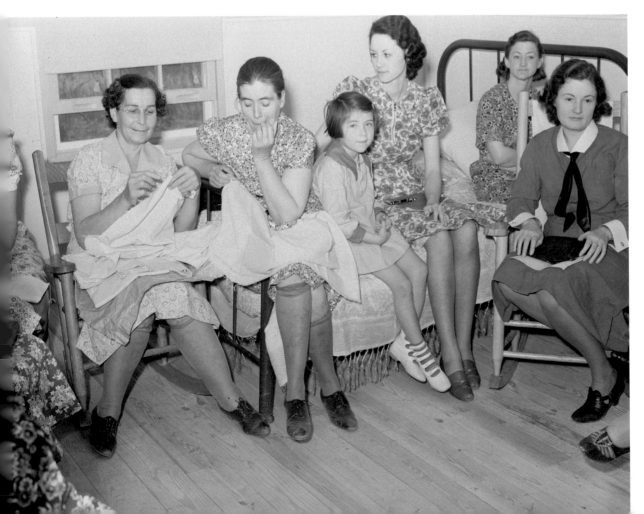

Fig. 4-18. Marion Post Wolcott, At a meeting of the Clark Hill Club, conducted by Miss Velma Patterson, vocational field worker from Elba, at the home of FSA (Farm Security Administration) project family, J.A. Veasy. The women discuss materials for clothing and curtains. Coffee County, *April 1939. Farm Security Administration, Library of Congress.*

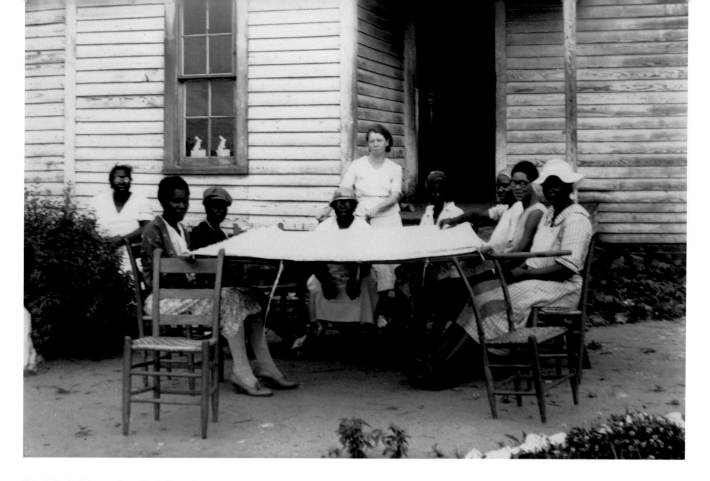

Fig. 4-19. Quilting project; Rock Crest School, Chambersburg TWP., Iredell Co., N.C. *May 30, 1935. Resettlement Administration, Rural Rehabilitation. Courtesy of the Franklin D. Roosevelt Presidential Library and Museum.*

to increase the number of Black extension workers. Some local county governments refused to fund the Black home extension program. As a result, Tennessee extension services catering toward African Americans were dependent on funding from the state's one historically Black land-grant college and from private charitable funding, resulting in one Black agent serving thirty counties, in contrast to white home agents who served just one county.[88] In South Carolina, once Black women received training as demonstration agents, "no black farm woman could be a client of a white home demonstration agent, and black home demonstration agents did not serve white women."[89] Further, African American home economists did not have the same opportunities to learn new skills as their white counterparts did due to entrenched segregation in higher education, and they sometimes went out of state to land grant universities where they would be welcome to attend professional development.[90] As

such, the pervasive and systemic racism of the South resulted in unequal distribution and quality of services, fewer African American home demonstration agents, and belittling and paternalistic treatment of Black families on relief.[91]

Photographic evidence of racial paternalism from home economists working with the FSA and WPA shows that on some occasions a white home economist served as the agent or instructor to groups of African American women, a power dynamic that may have resulted in projects such as quilting feeling imposed, rather than as a friendly social club situation. Analysis of photographs documenting white home economists overseeing Black quiltmakers suggests this could be a potentially uneasy relationship. In an image of an outdoor quilting (fig. 4-19), eight African American women sit in chairs, some wearing hats perhaps to protect from the sun. The seated women gaze with

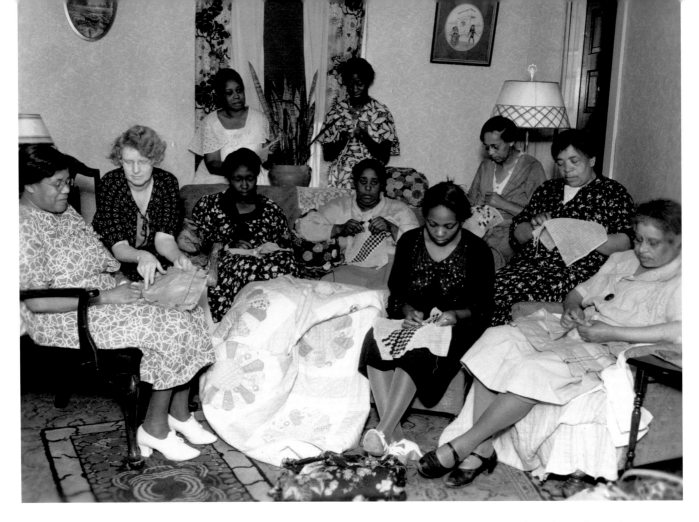

Fig. 4-20. Ohio Federal Writers' Project, Butler County Emergency School sewing project, *1936. Courtesy of the Ohio History Connection.*

flat expressions at the camera. Only one has a hand on the quilt as if engaged in the process of quilting. The sole white woman stands at the back of the frame, assuming a position of authority. Little is known about the context of this 1935 photograph, other than the brief official caption, reading "Resettlement Administration; Rural Rehabilitation; 'Quilting project'; Rock Crest School, Chambersburg TWP., Iredell Co., N.C."[92] The Division of Rural Rehabilitation operated under the auspices of FERA, a precursor to the WPA, and shared similar goals to the DSH but created few planned communities, instead typically providing loans to individual farmers to help them purchase livestock and equipment. This was likely the case for Chambersburg, as no planned community was established in this North Carolina county.[93] As historian Clifford Kuhn notes, many white home supervisors had little experience interacting with African Americans and in turn, many rural Black families in the South "held a deep skepticism about the government and white people."[94] This skepticism comes through in the expressions of the women seated around the quilt frame in Rock Crest School.

Another photo (fig. 4-20) from Middletown, Ohio, shows Thenie Latham, a white woman employed as an educator by the WPA, surrounded by eight African American women in a domestic setting, with Latham providing guidance in needlework, including quilting, represented by the finished Dresden Plates quilt draped in the foreground of the scene. The photo appears posed rather than candid, in that some of the women have gathered behind the couch, standing or sitting on windowsills, in a way likely not conducive

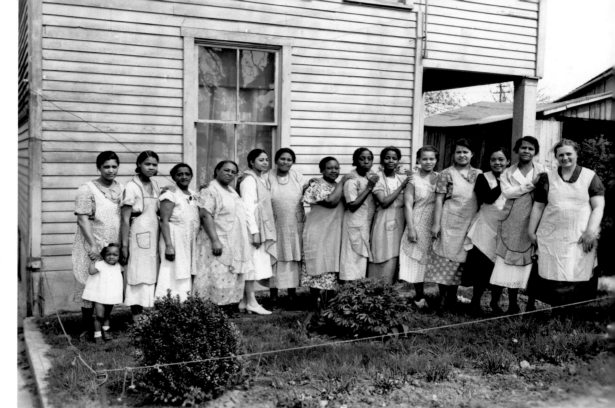

Fig. 4-21. Ohio Federal Writers' Project, Mrs. Viola Smith, Teacher. Class in Homemaking- Cooking, Food Values, Meal Planning, Sewing, Quilting, Basketry. This class wrote a play and dramatized it in Stewart High School. From the proceeds they purchased materials to make aprons and dresses so they might learn more about sewing, designing and finishing garments, 1936. Courtesy of the Ohio History Connection.

to hand sewing. The caption reveals this lesson in needlework was part of Butler County's Emergency School, a program run by the WPA out of Miami University of Ohio. Another image (fig. 4-21) from the Emergency School shows a row of aproned African American women with teacher Viola Smith, who ran a class in homemaking providing instruction in "Cooking, Food Values, Meal Planning, Sewing, Quilting, Basketry."[95] Here, too, African American women were learning the "expert" ways from a white woman, with the home economist's status and education level likely exacerbating a racial power dynamic that existed in its own forms in the North.

During the last several decades, quilt scholars have discussed whether quilts made by African American quilters have any particular characteristics, debating if aspects of quilt design, such as improvisation or symbolism, came from their African heritage.[96] Cuesta Benberry—the daughter-in-law of Minnie, who made one of the WPA Tulip quilts that opens this chapter—demonstrates that African Americans have made quilts of all types and that it is impossible

to know the race of a maker by a quilt's appearance or technique.[97] Yet the role of educated white home economists in disseminating quiltmaking knowledge, including commercially available patterns, to African American women complicates what we know about quilt design preferences. Some Black women may have adapted their own quiltmaking traditions—many of which are well-documented in the Federal Writers' Project narratives described in chapter 5—at the prompting of home economists employed by various divisions within the federal government. Quilt design has never taken a clear and linear path, with many makers employing techniques and traditions from multiple lineages, and the case of quilts produced by African Americans during the New Deal is no different. Women like Minnie Benberry in Western Kentucky or the teenage girls of the National Youth Administration who took courses in Gee's Bend's home economics room (fig. 4-22) developed their own preferences, adapting what they determined was useful from the home economists while maintaining personal taste and community conventions, at times code-switching among quilt genres.

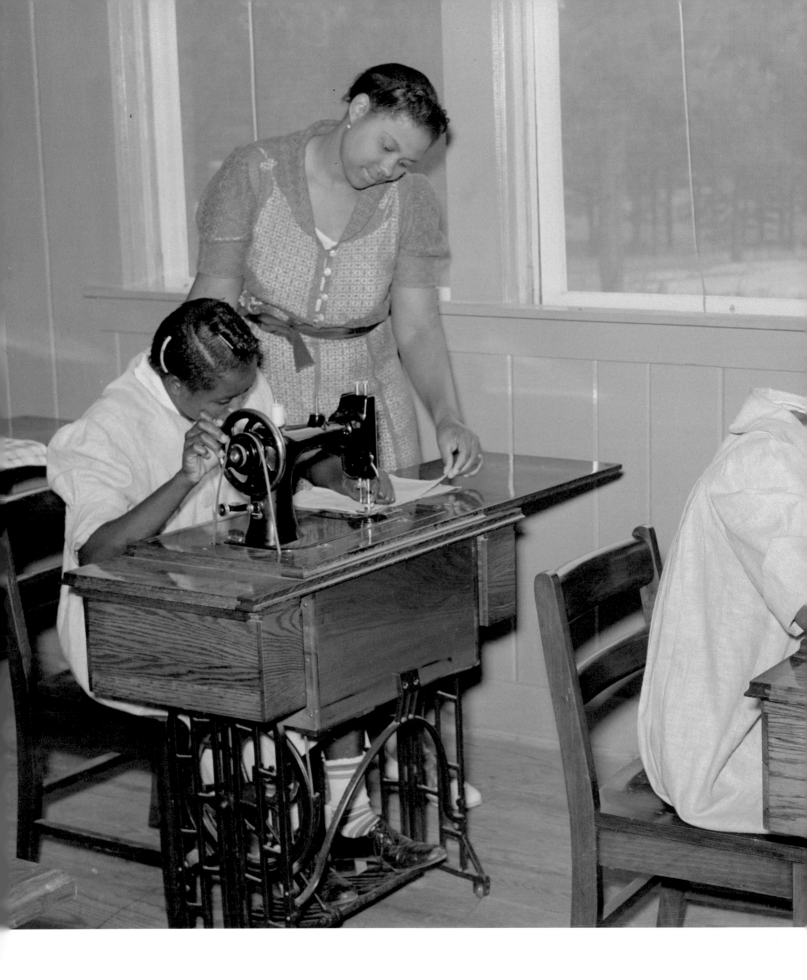

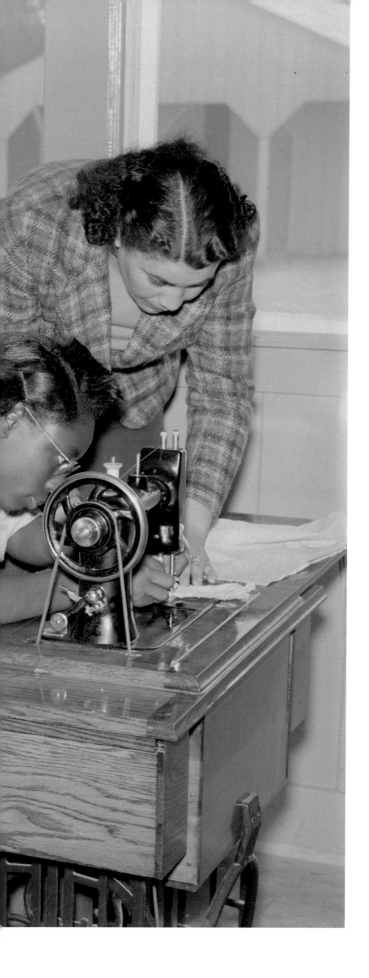

DISSEMINATING VALUES

The federally employed home economists who shared their wisdom in various environments—WPA sewing rooms, Farm Security Administrative camps, planned communities, home demonstrations clubs, and 4-H meetings—played vital roles in disseminating knowledge about canning, home sewing, nutrition, home beautification, and marketing home- and farm-produced goods. Many of the values we now associate with the Great Depression, such as a frugal spirit of reuse, may have been part of an ideology learned by struggling Americans in the face of the limited resources and low morale brought about by economic conditions. Home economists provided that instruction. Although quiltmaking was just one of the many skills promoted by home economists, its close connection with those values we associate with the Depression—perseverance, thrift, and home production—make it a perfect example of how New Deal programs helped Americans develop tangible ways of coping with the upheaval of the downturn.

Fig. 4-22. Marion Post Wolcott, Thelma Shamburg and Mrs. Spragg (or Sprague), NYA (National Youth Administration) state supervisor, helping Catherine Plumer and Sallie Titus at sewing machines in school economics room. Gee's Bend, Alabama, *1938. Farm Security Administration, Library of Congress.*

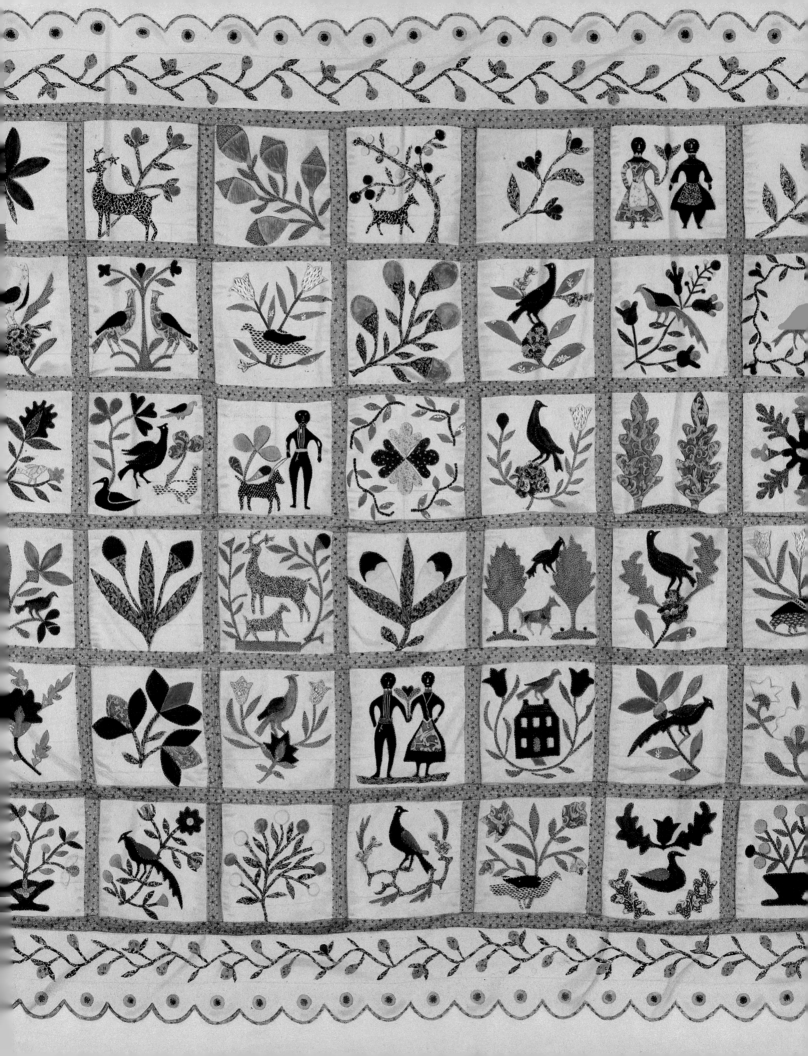

CHAPTER 5
A USABLE PAST

Dorothy West (1907-1998, fig. 5-1), an out-of-work African American writer living in New York City during the 1930s, was an active participant in the Harlem Renaissance, where writers such as Langston Hughes and Zora Neale Hurston referred to her as "the kid" due to her relative youth. After starting the literary magazine *Challenge* in 1934, she, like many others, turned to federal relief programs in the midst of the Great Depression when times grew desperate. In this capacity, she worked for the Works Progress Administration's (WPA) Federal Writers' Project (FWP), while also publishing short stories in publications including the *New York Daily News.* On September 21, 1938, West arrived in the five-bedroom Harlem apartment of Mayme Reese, at that time a fifty-seven-year-old woman, originally from South Carolina, who had moved north as part of the Great Migration of African Americans from the rural South to the urban North. West described Reese as the "color of roasted almonds, gray hair, black eyes (wears glasses). Large Woman; speaks with a trace of what is called the Geechie (Gullah) dialect. Has a sense of humor and is interested only in movies and the

Fig. 5-1. Portrait of Dorothy West in her New York City apartment. West is seated on a couch, holding a pad of paper on her lap, c. 1935. *Image courtesy Schlesinger Library on the History of Women in America, Radcliffe Institute, Harvard University.*

church as outside activities." Although Reese's life in Harlem may have been limited to church and movies, her life in South Carolina was steeped in quilting, as she recalled to Dorothy West in 1938.[1]

As part of the FWP's Folklore Project, West asked Reese to recall leisure activities. Mayme, or as the 1930 census listed her, Mammie, remembered attending "quilting parties at least twice a year" where three or four ladies would sit on opposite sides of a quilting frame and "you'd decide before how you were going to make the stiches. If you were going to have a curving stitch, you'd sew one way. If you were going to quilt block fashion, you'd sew that way." The "men-folks" would have to fend for themselves on these occasions, eating cold food, and if they complained "we'd remind 'em 'bout keeping warm in the winter." Reese said she might sew together scraps for a year in order to piece a quilt. "Depending upon how many quilts you needed a year or just wanted to make, there'd be that many quilting parties for ladies who were intimates," she recalled. In the fall, the women took their best quilts—"the prettiest color, the prettiest pattern and the best stitches"—and entered them in the county fair exhibit where they might win a five dollar prize. Contemplating these days from her younger years in South Carolina, Reese nostalgically said, "Things like that were nice. Sometimes I wish I could go back to that kind of life for awhile but times have changed so. They won't ever be like that again. But I guess it's just as well. Nowadays, there are other things to occupy people's minds."[2]

Mayme Reese's account recorded by West is one of several ways the New Deal's WPA documented traditional quilting practices. Americans working at some of the highest levels of federal government had determined that it was important to record and preserve the folkways of the past, as these practices reflected a sort of American romantic nationalism. Romantic nationalism had become a more commonly understood concept in Europe during the nineteenth century and took the form of celebrating national and folk identity as an inspiration for artistic expression.[3] In the 1930s, many Americans understood quilts as quintessentially American objects that reflected both the values of the past and encouragement for the present, and as such they fit perfectly into the federal government's vision of romantic nationalism. Although a wide variety of quilt styles coexisted in the 1930s, the imagined quilts of the colonial and pioneer past loomed large in the American imagination. Many New Deal workers—including the cultural critics, folklorists, writers, and artists who worked on these documentation projects—adopted Colonial Revival ideologies that promoted romanticized, and sometimes incorrect, ideas about the past in an effort to instill pride and courage in Americans struggling amid the Great Depression.[4] The Colonial Revival, which peaked between 1880 and 1940 and drew inspiration from the American centennial, celebrated a simpler American past as an antidote to increasing urbanization and industrialization. By the economic downfall of the 1930s, Colonial Revival participants, including quilt enthusiasts like Ruth Finley, author of *Old Patchwork Quilts and the Women Who Made Them* (1929), perceived that those historic practices could inspire perseverance in struggling Americans.[5]

Along with interviews conducted by writers like Dorothy West, the Index of American Design (IAD) and the Museum Extension Project (MEP) also documented historical quilts and quiltmaking. These subprojects of the larger Federal Art Project established in 1935, itself part of the WPA, provided jobs to white-collar

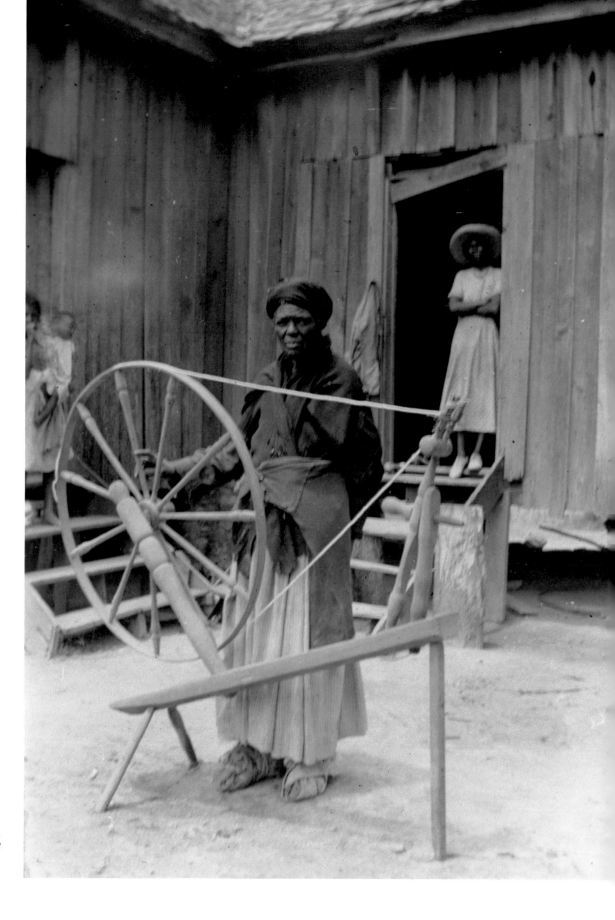

Fig. 5-2. Lucindy Lawrence Jurdon, Age 79, *Federal Writers' Project, c. 1936-1938, Library of Congress. WPA photographers took photographs of some of the narrators the FWP interviewed, including Jurdon, a formally enslaved individual from Alabama, posed here with a spinning wheel.*

workers, especially artists and writers. But their aims were more complex than simply putting Americans to work and money in their pockets. They turned to the American past with the objective of creating an inspiring model for the present and a resource for the future; in short, they searched for a usable past that celebrated imagined simpler times and the "folk" that inhabited them.[6]

Each of these subprojects, however, approached the concept of folk traditions in a distinct, and, at times, contradictory way from the others. The IAD and MEP perceived quilts as educational objects—formally, by distributing quilt patterns to Pennsylvania schools, and informally, through reproducing IAD renderings of quilts in museum exhibits and magazine articles. While the understanding of quilts as models of resourcefulness amid dire economic conditions was widespread by the 1930s, the IAD and MEP emphasized highly decorative "best quilts" owned by Americans of means, rather than the humbler variety depicted in Farm Security Administration (FSA) photographs analyzed in chapter 2 or made with scraps in WPA sewing rooms. By drawing on Colonial Revival ideologies, these two projects couched quilts as objects of the past, which could serve as valuable inspiration in the present, rather than as an ongoing vibrant tradition. In contrast, the FWP captured quiltmaking as both a living practice and one from the past on which to draw, less concerned with the quilts as objects of the past than with celebrating quiltmaking as part of a vibrant and continuing American tradition.

For example, the silk-screen printed quilt patterns created as part of Pennsylvania's Museum Extension Project (MEP), with names like "Dolly Madison Star" and "Yankee Puzzle," harkened back to an imaginary colonial ideal of American quiltmaking, rather than the craft tradition that thrived during the 1930s. The quilt history recorded in the FWP, however, particularly the so-called ex-slave narratives conducted with formerly enslaved individuals, includes many more anecdotal details about quiltmaking that emphasize community, thrift, and making do and, unlike the IAD or MEP, explicitly sought out the experiences of African Americans. Further, the IAD administrators did not make an effort to explore folk art forms as living traditions, and instead wanted them to exist in the past to be used as design inspiration that cultivated cultural nationalism.

Documenting the past allowed Americans to look to pre-industrial models of how to overcome hardships, and among the many forms of cultural heritage New Deal programs showcased, historical quilts and quiltmaking traditions were deemed distinctly American and, as such, appropriate conveyors of the Depression-era values of resilience and thrift. While quilts certainly did not originate in the United States, by the 1930s they clearly were considered among the most quintessential of American objects. But symbolically, quilts, as well as other folk traditions documented by New Deal programs, tied twentieth-century Americans struggling to get by to an earlier era of self-sufficiency and making do—showing those plodding through the Great Depression a way to survive. Although these documentation projects provided Americans in the 1930s and those of us living in the future with rich resources regarding the quiltmaking traditions of the past, these projects' primary objective was to employ those most in need of income, with the side benefit of lifting the morale of those out of work. Like the rest of the WPA, these projects intended to provide sustenance in the present

and hope for the future in the form of useful work projects—in this case, by looking to the past.

THE FEDERAL WRITERS' PROJECT

The WPA employed around 6,500 out-of-work white-collar workers, including journalists and writers like Dorothy West, in the Federal Writers' Project (FWP), paying them about twenty dollars a week.[7] In addition to its objective of providing work and necessary income, the FWP explicitly aimed to document American folklife—much to the consternation of New Deal critics who viewed funding such initiatives as a boondoggle. Unlike some New Deal initiatives, the FWP did not shy away from documenting the diversity of Americans, including African Americans who had grown up in chattel slavery.[8] The Ex-Slave Narratives project, as it was frequently called, had its origins under the auspices of the Federal Emergency Relief Administration (FERA), which predated and was replaced by the WPA in 1935. African American sociologist Charles Johnson conceived of this initiative to have the federal government fund the collection of interviews with formerly enslaved individuals as part of the FWP, with the goal of studying racial mores, or what he called "racial folkways," including folktales, music traditions, ceremonies and rituals, and other leisure activities. In part, the project aimed to document African American life before the last generation who grew up in slavery died. It resulted in a body of work that helped define African American culture and history into the next century, demarcating and debating what it meant to be a Black American.[9] With the goal of collecting national and regional folklore, the FWP hired musicologist and folklorist John A. Lomax to head up the division. Under his direction, the FWP developed a life-history approach to collecting folklore,

implemented in both the Ex-Slave Narrative Collection and the companion Folklore Project.[10] Led by folklorist Benjamin Botkin, it focused on showcasing the ethnic diversity of Americans, interviewing individuals about their everyday experiences in work, family, and leisure.[11] These interviews, however, are not objective accounts of the past. Most were not audio recorded and scholars have shown that some out-of-work creative writers may have embellished their narratives, and some narrators may have reflected on their past experiences with rose-colored glasses.[12] Despite these limitations, the project remains a valuable means through which Americans learned about—and continue to learn from—our collective pasts.

Although the Ex-Slave Narratives and Folklore Project initiatives did not have a specific mandate to document the history of quiltmaking, both Lomax and Botkin had a deep interest in collecting evidence of the diverse so-called folk traditions of the United States, which included quiltmaking. Many narratives indeed reference quilting practices, and this documentation is one of the best avenues for understanding some of the contexts of African American quiltmaking, especially quilting practices during slavery. Lomax provided the interviewers with a questionnaire, although he encouraged them to let their narrators speak freely on any topic. Questions included those on many topics about life during slavery, including food, clothing, discipline, work, and education. Lomax also encouraged interviewers to solicit details about leisure time activities and life in the slave quarters, subjects that likely yielded the answers that speak about quilts.[13] Later, Lomax's team revised the questionnaire to also include questions asking the narrators about their thoughts on emancipation, freedom, and life after slavery.[14]

After Sadie Hornsby of Athens, Georgia, interviewed eighty-seven-year-old Georgia Baker in 1938 for the FWP, she wrote up a cheery narrative based on Georgia's recollections, which nostalgically described life during slavery on Alec Stephen's plantation. As was the practice and policy of the FWP, now critiqued as drawing on ugly and racist stereotypes, Hornsby wrote in a first-person voice that tried to mimic Baker's accent, essentially attempting to write in dialect.[15] Lomax developed this standardized written version of dialect, intending to make the regional speech patterns readable to white audiences, while preserving what Lomax and his team deemed the authenticity of Black speech patterns. Scholar Lauren Tilton asserts that this approach "flattened regional variations into a single speech style intended to represent all black oral traditions across the United States."[16] Hornsby's account of Georgia Baker's quilting memories reads: "No, Mam, dere warn't no special cornshuckin's and cotton pickin's on Marse Alec's place, but of course dey did quilt in de winter 'cause dere had to be lots of quiltin' done for all dem slaves to have plenty of warm kivver, and you knows, Lady, 'omens can quilt better if dey gits a passel of 'em together to do it."[17]

This account of quiltmaking practices during slavery, as well as others, emphasizes the values the federal government promoted during the New Deal—here, the ability to overcome hardship through a collective spirit. Without the dialect, this passage reads: "No, Ma'am, there wasn't no special corn shucking and cotton picking on Master Alec's place, but of course they did quilt in the winter, because there had to be lots of quilting done for all them slaves to have plenty of warm covers, and you know, lady, women can quilt better if they get a passel of them together to do it."[18] When

considered as a means of looking toward a usable past, the account promoted the advice that Americans could band together as a "passel" in order to help one another out.

In a 1937 interview conducted by Marjorie Jones in Asheville, North Carolina, Fannie Moore, who grew up enslaved in South Carolina, recalled her mother working in the field all day and piecing and quilting all night; she sometimes stayed up into the dark evenings assisting her mother with the process. Moore's mother made quilts for her family and also for the white enslaver's family.[19] The account from James Bolton of Athens, Georgia, as told to Sarah H. Hall, notes that enslaved women who were too old to work in the fields made quilts "outen old clothes," which they slept under while lying on mattresses made out of cotton sacks, stuffed with straw.[20]

While problematic for the power dynamics between the often white federally employed writers and the elderly, typically illiterate African American narrators, the collection is a vital source of firsthand documentation of life during slavery. Much of what historians know about the social lives of enslaved individuals has been derived from this invaluable collection, including what we know about quilting and quilts on plantations.[21]

The Folklore Project narratives did not have this same kind of power dynamic as the interviews with formerly enslaved individuals. The out-of-work writers conducting the interviews and the interviewees recounting folk practices often had much in common, including living on relief in the same town, and often viewed each other as equals.[22] These FWP workers had specific instructions to ask about so-called folk practices, which included quilting, and the answers

reveal some of the ways quilts were important cultural objects during this era, not solely in the past.

An account recorded with Mrs. Albert Farlow and her widowed daughter Mrs. Flora Colbox in Asheville, North Carolina, reveals the importance of quilts not simply as a cozy craft, harkening back to earlier times, but as a livelihood, or at least a supplement to a family's income. The women revealed in their interview with WPA worker Anne Stevens in 1938 that they made quilts not for warmth but for money: "When they furnish all the materials and do all the work, which includes the quilting, they collect three dollars a quilt. But a detailed enumeration proves that the material alone costs two dollars and a half." They went on to recount making a Wedding Ring quilt for Mrs. Colbox's niece and that the two women generally make two quilts a week. "'I used my quilt money to buy shoes and cotton cloth for two dresses,' summoned up Mrs. Colbox," wrote Stevens in the narrative. Lolly Bleu, a Florida woman interviewed in 1938 by Barbara Berry Darsey, similarly made quilts to sell, noting that "it always makes me feel bad to part with one of them.... I don't want to sell them anyway except when we just need the money so bad."[23] Another narrator described raising ninety dollars for the local church by taking donations in exchange for putting signatures on a quilt.[24]

Other narrators interviewed by FWP workers vividly described the communal and festive nature of making quilts. Ella Bartlett of Brookfield, Massachusetts, remembered attending a very hot "quilting" (the more common term for quilting bees), on the occasion of her friend Henrietta Daggett's engagement in July, at which she was "wilted." She recalled how large Henrietta's quilt was and the complexity of its Sunflower pattern: "I never saw so many pieces in a pattern ... Some of the pieces were from dresses... The older women could tell you just who had 'em, how they was made and everything about 'em. One woman found a piece of her wedding dress." Louise Bassett, the FWP interviewer, concluded the interview by asking if Miss Daggett liked her quilt. Bartlett answered, "She loved it, she kept it for years. I've seen it dozens of times and every time I've seen it I've always felt like openin' a window or something, no matter if it is a cold day I begin to feel warm all over, it's July again. You know I think it's such a pity that folks don't quilt any more."[25] Lula Bowers from Hampton County, South Carolina, similarly recalled "a big Quiltin' Party and dance! ... They'd quilt all day and dance all night." She noted that she had seven quilts when she was married, including "the old time Nine-patch and the Seven Sisters" as well as an Open Rose, Rose and Bud, and Album quilt. She also remembered that her family buried quilts during "the Confederate War" to protect them when the "Yankees" came to burn houses down.[26] Kate Flenniken, eighty-years-old at the time of her 1938 interview with W.W. Dixon, also remembered quilting parties after the harvest of crops in the late summer, with "sometimes as many as four quilts ... being made at the same time." She noted the process of stitching squares together, attaching the quilt linings [backs] to the quilting frames, and rolling up the frame as they made progress stitching the layers together.[27]

The FWP subprojects sought out these nuanced details of folk culture, encouraging its workers to solicit such vivid descriptions of how traditions and practices fit into daily life. The narrators interviewed for the project—the so-called folk—shared memories of quiltmaking that were both grounded in the past and thriving in the present. The quilts and processes described in these interviews were not relics of an

imagined colonial or pioneer past but were living traditions: ways to create beauty for the home, to socialize as a community, and to earn money during economically challenging times. The New Deal programs shared and promoted these values, perceiving that Americans needed community-oriented traditions to lift their spirits during the tumult of the Depression. B.A. Botkin aimed for the narratives to create a "composite and comprehensive portrait of various groups of people in America."[28] Botkin's vision was grounded in the present, as he aimed "to show a living culture and understand its function in a democracy," referring to the folklore project as "the greatest social experiment of our time."[29] Quiltmaking, on its surface, may seem to have little to do with creating citizens within a thriving democracy, yet quilts were a shared American passion that wealthy Colonial Revivalists like Abby Rockefeller embraced just as much as impoverished Mrs. Farlow and her

daughter Flora. What could be more democratic than objects lovingly pieced together by Americans with a shared sense of purpose? Another Federal Art Project initiative, however, homed in on the traditions of well-to-do Americans of the past.

INDEX OF AMERICAN DESIGN

During the Great Depression, women often found their quilt inspiration in their bags of fabric scraps or in the pages of a local newspaper that featured quilt patterns. Yet administrators in the Federal Art Project aimed to employ out-of-work artists to create a more systematic catalog of inspirational quilts and numerous other folk-art objects through the Index of American Design (IAD). Rather than take black-and-white photographs of weathervanes, toys, furniture, metalwork, and quilts, the IAD tasked unemployed artists seeking work relief to paint lifelike watercolor renderings of objects in a

Alois E. Ulrich

form of hyperrealism reminiscent of trompe l'oeil. The results of this project are a vast archive of over 18,000 paintings of folk, decorative, and commercial art pieces painted by close to 1,200 out-of-work artists, now in the collection of the National Gallery of Art.[30]

Conceived as a means to record a "quintessentially American style" and the "spirit of American design," the IAD charged artists with documenting American folk arts and crafts, with the administrators' dream of creating a widely circulated record of American design that contemporary artists could draw upon, rather than continue to turn to exclusively European precedents, in order to answer the question plaguing many cultural critics: "Have we an American design?"[31] Project planners imagined that portfolios reproducing the watercolor paintings would be available through public libraries and community art centers, and that through this distribution system, the artists

and designers of the future would have a distinctly American inspiration. In doing so, IAD and other Federal Art Project initiatives that documented the American past promoted what scholars have called a cultural or romantic nationalism.[32] Although the publicly accessible portfolios of screen prints from the IAD never transpired on the scale the IAD organizers had hoped for, paintings from the project were widely exhibited and published in books and periodicals.[33] This impulse to document American design fit with a growing interest in American folk art, fueled by artists and collectors searching for the precursors to modernism in the carvings, metalwork, textiles, and paintings of the eighteenth and nineteenth centuries.[34]

Constance Rourke, an author and critic who the Federal Art Project hired as the lead editor for the IAD, "advocated a unified national culture based on a mythical American folk."[35] But as historian Jerrold

Hirsch explains, this united version of America in which everyone rallied together for a harmonious future was ultimately a conservative interpretation of both where Americans had come from and where the nation was heading, a vision that ignored the very real conflicts and divides that existed in the United States.[36] Quilts fit in to this concept, as they embodied mythologized and romantic ideas about creatively piecing together scraps of fabric to create a beautiful whole. This "whole" was decidedly nationalistic, with its aim of creating a culture and aesthetic distinct from European origins, what cultural critic Van Wyck Brooks called "new Americanism."[37] It made sense for the federal government to similarly support a distinct American culture, as this shared history—reflected in folk art objects including quilts—could unify Americans in their efforts to overcome the economic downturn.

Yet rather than show an American tradition of making do amid adversity, the IAD reflected a record of American design that corresponded to a "dead" tradition of the past that was predominantly enjoyed by privileged white Americans, mostly from the East coast, and predominantly high style. The fancy quilts that project administrators such as Rourke selected for the project shared little in common with the scrappy make-do ones that became more common during the Great Depression. This emphasis on nineteenth-century quilts made by Americans with resources, rather than living folk traditions, may have emerged due to the perspective and worldview of those who created and administered the project.

The vanguard group of cultural movers and shakers who envisioned the IAD—including Rourke, textile designer and American Union of Decorative Artists and Craftsmen (AUDAC) member Ruth Reeves, and head of the New York Public Library's Picture collection, Romana Javitz—were based in New York City, the nation's art capital.[38] As such, the IAD pilot project began there and was able to draw on the wealth of objects in the city's museums, including prominent collections at the Metropolitan Museum of Art and the Brooklyn Museum. Further, many wealthy collectors of folk and decorative arts lived near the city, and the project could employ the numerous commercial artists and other white-collar cultural workers living in the city who were out of work during the Depression. The New York City project then served as a model for thirty-four state projects and a District of Columbia project. Each state's IAD project had local supervisors who networked with local museums, university art departments, historical organizations, and other civic groups to identify folk art collections, sending surveys of objects back to the IAD headquarters in Washington, D.C., where Rourke and her staff selected which objects to render. Regular press coverage, sometimes accompanying exhibitions of completed renderings, attracted additional private owners and collectors who contacted the Index to nominate their own pieces for inclusion.[39]

Of the more than 18,000 paintings of objects now in the National Gallery, almost 700 of them feature quilts or details of fabrics from quilts. This subset presents a useful case study in why the Federal Art Project wished to create this permanent record, as well as the choices its organizers made in selecting objects. Local project directors selected quilts for inclusion in projects based in California, Delaware, D.C., Florida, Illinois, Kentucky, Louisiana, Maine, Maryland, Michigan, Minnesota, Missouri, New Hampshire, New Jersey, New York, Ohio, Pennsylvania, Tennessee, Texas, Utah, Virginia, and Wisconsin.[40] Despite this seeming geographic diversity, over half of the quilt renderings

were completed in New York (102) and Pennsylvania (286). Additional quilt paintings included sixty-nine from California (with a Southern California project and a statewide one), forty from New Jersey, thirty-two from Kentucky, thirty from Florida, twenty-three from Delaware, twenty-two from DC, and nineteen from Utah. The remaining states represented in the IAD had anywhere from three to thirteen quilts. This array had a heavy mid-Atlantic slant, with many of the California quilts also coming from points further East and many of the Florida quilts coming from the North. Utah's rendered quilts were primarily from Mormon pioneers, including multiple paintings of blocks from ceremonial quilts hanging at the Utah State Capitol building. Half of the quilts that artists rendered in D.C. were from the Smithsonian Institution. This leaves a noted absence of renderings of quilts from the South, aside from those in the Kentucky project, three from Tennessee, three from Texas, and two from Louisiana.[41] Similarly, the Midwest and West are underrepresented.

This uneven geographic distribution is not a result of the availability of quilts across the United States, but instead reflects both the logistics and goals of the IAD. The federal government's primary goal for the Federal Art Project as a whole was providing employment to out-of-work artists.[42] As such, projects were concentrated in areas where there were many unemployed commercial artists—particularly East Coast cities and Los Angeles—whereas areas of the South and West did not have many out-of-work trained artists eligible for federal relief projects.[43] With artists located primarily in urban areas, and limited budgets available to send them to more remote locations, the IAD selected objects to render that were closer at hand, including many from museums and private collections. Holger Cahill, director of the Federal Art Project, also recounted political and cultural animosity toward various art projects—including the IAD—in some areas of the Midwest and South, particularly when northern administrators attempted to initiate the projects.[44] The IAD limited its object selection to those from the colonial era through 1900, and eliminated most Native American objects from consideration, because Cahill thought including them would expand the project's scope too broadly and that those objects could be documented as part of the federally funded Indian Arts and Crafts Board.[45] The project did not explicitly exclude African American made objects, although because many such artifacts remained in the South, there were few opportunities to render them.[46] Project organizers focused their choices on fine examples of decorative arts—what Rourke called "aristocratic forms"—while also celebrating what Rourke called "homely products" like the patchwork quilt, which she asserted were produced of "need, combined with thrift," despite the many high-style examples in the Index that told otherwise.[47]

Quilts, of course, could be high-style examples of aristocratic forms or, in contrast, quite humble. No doubt both varieties often represented what National Gallery curator Virginia Tuttle Clayton calls the "spirit of American design."[48] Yet most of the quilts showcased by the IAD were indeed the more elite examples belonging to those with resources in the form of leisure time and materials, rather than the make-do quilts stitched by the many women shown in FSA photographs or pieced from scraps leftover in WPA sewing rooms. The vast majority of quilts represented in the IAD were still in family hands, with the provenance and ownership of previous generations often documented on the objects' datasheets now archived at the National Gallery. These quilts were family heirlooms, likely considered treasured "best quilts," which may not have exhibited much wear

Fig. 5-3. Charlotte Winter, Sunburst Quilt, *c. 1938, Index of American Design, National Gallery of Art. 1943.8.2578. At the time of this painting, Florence Peto owned the quilt, attributed to Mary Totten, the same maker as the quilt painted in figure 5-4.*

or use. Other quilts were owned by collectors like Peggy Westerfield (née Grace Hartshorn, 1885-1974), wife of New York Stock Exchange executive Jason Westerfield. She owned several of the quilts rendered by the Maine division of the IAD, the state where she and her husband restored historic homes, and eventually donated antiques in her collection to Colonial Williamsburg; Museum of Fine Arts, Boston; the Brooklyn Museum; and other institutions.[49] A Kentucky IAD datasheet described Mrs. C.L. Pemberton of Elizabethtown, Kentucky, the wife of a livestock dealer who owned five of the thirty-two quilts

documented by the Kentucky project, as "a collector of quilts and of luster for her personal pleasure not a dealer in a commercial sense of the word" and referred to a book she hoped to publish on quilt patterns.[50]

Florence Peto, a knowledgeable expert on quilts who served as an informal consultant on the IAD, did publish a book with patterns based on quilts in her private collection and ones she identified for inclusion in the IAD. Peto met with Esther Lewittes, a supervising artist of the New York City IAD who is listed on numerous IAD quilt datasheets as the

Fig. 5-4. Mary Berner, Patchwork and Appliqué Quilt, c. 1936, Index of American Design, National Gallery of Art. 1943.8.2579. The original quilt is now known as Mary Totten's Rising Sun and is in the collection of the Smithsonian National Museum of American History, attributed to either Mary Totten or Mary (Betsy) Totten. After it was rendered, Florence Peto arranged for it to be given to the Smithsonian in 1938.

researcher. Lewittes and Peto together tried to date and give geographic attribution to quilts, poring over photos and documentation.[51] At least one of the quilts in Peto's personal collection, in a pattern known as Sunburst, appears in the Index (fig. 5-3), and in Peto's 1939 book, *Historic Quilts*. In addition to Sunburst, her book includes photographs of several other quilts rendered in the Index.[52] Beginning in the 1930s, Peto lectured widely with a flip chart of over fifty quilt patterns, appeared on WNYC radio broadcasts produced in conjunction with the IAD, exhibited her own quilts and lectured at the 1939 New York World's Fair (also sponsored by the IAD), and consulted with several East Coast museums on quilt acquisitions.[53] In 1938, Peto orchestrated the gift of Mary Totten's Rising Sun quilt to the Smithsonian, a highly ornamental quilt documented with four separate renderings in the IAD (fig. 5-4) and featured as the frontispiece in *Historic Quilts*.[54] Peto discovered both this quilt and the Sunburst quilt—each attributed to Totten—by knocking on doors in Staten Island in the 1930s, asking residents if she could see their quilts.[55]

Size of Quilt 94" by 94".

In addition to quilts in private hands, over fifty of those rendered by IAD artists were from museum collections. In the first several decades of the twentieth century, some museums, including the Metropolitan Museum of Art, had begun acquiring quilts, displaying some on beds as part of their "American Wings"—the period rooms featuring the elite decorative arts of early America—but not necessarily as works of art in their own right. The IAD includes an ornate early nineteenth-century hexagon mosaic quilt the Metropolitan Museum of Art acquired in 1923 (fig. 5-5, 5-6)—the earliest pieced American quilt in its collection, along with a figurative chintz quilt the Met subsequently acquired in 1938, which artist Margaret Concha had painted for the Index in 1936. The Brooklyn Museum has twenty-seven quilts from its collections in the Index—a remarkable number, since many art museums did not begin acquiring quilts in great quantities until the 1970s. In 1934, shortly before the IAD began its work, the Brooklyn Museum had reconceived of itself as an art museum, rather than as a catchall museum of arts and sciences. With this shift, curators reclassified the quilts and other textiles in its collection from "tangible examples for the (often hands-on) study of social and cultural mores" and included them in its art collections, although they were not hung on walls vertically like paintings at that time.[56] The Smithsonian Institution, as well as the New York Historical Society and the Louisiana State Museum, collected quilts with important historical documentation that IAD editors selected for inclusion in the project. One of the two Louisiana quilts has an ink inscription to General Zachary Taylor from the "Ladies of the Danville Working Society as a slight testimony of their admiration for one not less distinguished for his clemency and forbearance than for his valour and patriotism, 1848."[57] A Baltimore Album quilt in the Index was owned by John and Abby Rockefeller, of Standard Oil wealth, who founded Colonial Williamsburg in the late 1920s and were prominent folk-art collectors.[58]

At least 115 of the rendered quilts are in the style commonly called "red and green appliqué," with flora and fauna designs stitched onto a white ground, a common motif for mid-nineteenth-century quilts that were often kept as "best" quilts and received infrequent use.[59] The IAD features four Baltimore Album quilts, the epitome of nineteenth-century high-style, ornamented quilts. Thirty-one renderings include signature quilts—signed or inscribed blocks—and sometimes paintings of individual blocks. Another significant subset of renderings (twenty-eight) features Crazy Quilts, the Victorian, late-nineteenth-century parlor throws stitched from velvets, satins, and other dressmaking fabrics, embellished with whimsical embroidery stitches. Fifteen more renderings are of whitework quilts, fancy whole cloth quilts often with elaborate stuffed quilting. Fourteen are hexagon mosaic quilts, like the one in figure 5-5, from early in the nineteenth century.

When we think of the great American quiltmaking traditions today, connoisseurs and enthusiasts alike recall the brooding colors and geometries of Amish quilts, the improvisation and rhythms of African American quilts, the cheery late-nineteenth century Pennsylvania German quilts, and the resourceful inventiveness of southern quilts made by both rural African American and white quiltmakers. The Pennsylvania division of the IAD, under the leadership of Frances Lichten, documented thousands of Pennsylvania German (also called Pennsylvania "Dutch") decorative arts, but only a couple of the quilts represented in the Index hailed from rich traditions of southeastern Pennsylvania, including Lancaster County, which by the late twentieth century was known

Fig. 5-5. Elizabeth Van Horne Clarkson, Honeycomb Quilt, c. 1830. The Index of American Design documented this quilt with the rendering in Fig. 5-6. Metropolitan Museum of Art.

Fig. 5-6. Elizabeth Valentine, Patchwork Quilt, c. 1936, Index of American Design, National Gallery of Art, 1943.8.433.

as the "quilt capital" of the country due to its Amish and Mennonite quiltmaking traditions.[60]

A maker's racial background is notoriously hard to discern from a quilt itself, and likely there are quilts made by African Americans in the IAD, despite the project's geographic limitations and emphasis on the high-style traditions of European Americans. The details provided by the datasheets give few indications regarding makers' ancestry and racial background. The National Gallery now presumes that a figurative appliqué sampler quilt documented in New York City was made by a free Black quilter living in New York. The quiltmaker used a distinct technique of embroidering features onto black cloth to create the human figures; this method along with its figurative design and scalloped edge make this quilt very similar to another quilt signed "Sarah Ann Wilson Aug 1854" (now in the collection of the Art Institute of Chicago) that historians believe was created by the same maker, although the present location of the quilt represented in the IAD is unknown (fig. 5-7). With Wilson's common name and the frequent use of Black stereotypes during the nineteenth century, it's impossible to know for sure if this maker was indeed African American.[61]

Several other African American-made quilts documented as part of the IAD are similarly shrouded in mystery. The Tennessee project evidently created renderings for three quilts, yet the National Gallery does not have these paintings in its collection. One of the datasheets for a missing painting includes the note, "These quilts were made on the home place in Sparta, Tennessee, with the help of slave women, who gathered the herbs and shrubs in the woods for the dye-pots." Sadly, we do not have the renderings to pair with this important detail hidden on an archival datasheet.[62] Adolph Glassgold—the IAD's national coordinator who oversaw rendering

techniques, regularly met with and discussed work with artists, and critiqued (and occasionally rejected) paintings—reflected in 1946 that "'slave-made' products would be significant additions to the Index," regretting their absence.[63]

Despite the Great Depression's emphasis on creative reuse and making do, exemplified by the numerous scrap quilts created during this era, few in the IAD represent that genre of quiltmaking. In part, this is a result of limiting the project to folk-art objects made prior to 1900 and limiting those made by African Americans.[64] There are exceptions in the IAD, however, that exemplify the humbler historical scrap quilting practice. Unsurprisingly, some of these are from the Kentucky project, a state rich in quiltmaking history with strong traditions in rural parts of Appalachia, in thriving cottage industries in cities, in Shaker communities, and by both white and Black quiltmakers. Unlike renderings of quilts from the Northeastern states of New York, New Jersey, and Pennsylvania, the Kentucky project selected quilts pieced in simple geometric patterns, like Four Patch and Log Cabin. As historian Jerrold Hirsch notes, the traditions recorded by the Kentucky IAD remained alive and well during the 1930s, and evidence of their thriving existence appears in other New Deal initiatives, including the FWP and FSA photographs. Those projects provided living context for the aestheticized IAD renderings, with their clean, sharp lines of objects floating in space without context of creation or use.[65] In Kentucky, unlike many other spots nationally, traditions like quiltmaking were celebrated not only as relics of the past but as revived crafts sponsored by organizations such as Berea College and the Hindman Settlement School, as well as in smaller cottage industries, that could provide economic opportunity to the region by selling traditional folk art to urban consumers. However, the IAD evidently did not build relationships with Berea or Hindman, choosing instead to focus primarily on

Fig. 5-7. Arlene Perkins, Appliqué Bedspread, c. 1941, Index of American Design, National Gallery of Art, 1943.8.2589.

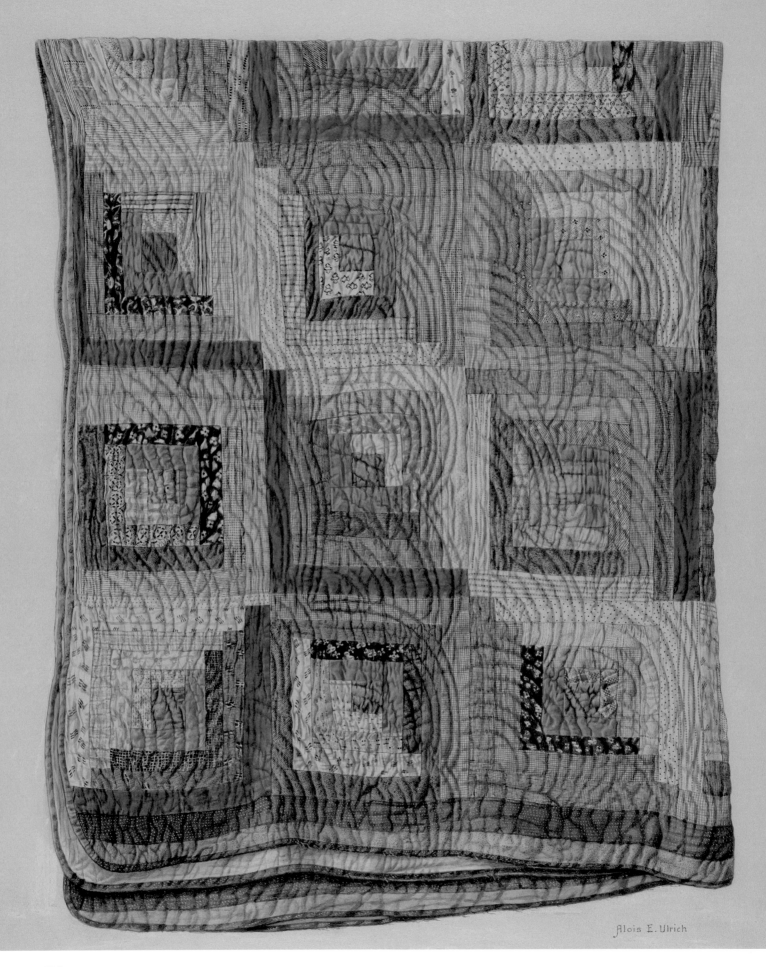

Alois E. Ulrich

Kentucky's Shaker communities and quilts in family and private collections.[66]

Kentucky WPA artists painted renderings of some scrap quilts, including several pieced in the Log Cabin pattern, which reveal both the tremendous skill of the artists who painted them—taking anywhere from two to ten weeks to complete—and the inventiveness of the objects' original makers. Two pieces, each executed by one of the nine artists who painted quilts in the state, reflect distinct approaches to showcasing patchwork in the IAD. The National Gallery notes that with few exceptions, "biographical information is sparse or unavailable for most of the artists who participated in the Index of American Design."[67] As such, we can only piece together minimal details from public records.

Alois Ulrich emigrated from Switzerland around the year 1879 at the age of eighteen and by 1900 was living in Louisville, at which time his occupation was listed as "portrait painter." The 1907 Louisville City Directory called him a "designer." By 1930 the federal census listed him as an artist employed in the field of commercial artistry. In 1924 he published a novel titled *Money Mad: An American Novel by an American Citizen.* He sang tenor in the local Concordia Singing

Society; he wrote an angry letter to the editor in response to raised bus fares; and in 1935, he worked as an assistant painter for a mural for the new Federal Building in Louisville, part of the U.S. Treasury's Public Works of Art Project.[68] From 1935 to 1938, Ulrich painted seventeen objects for the IAD; in addition to four images of quilts, he executed renderings of seven coverlets, two tools, one rug, one bonnet, and two wooden objects. His quilt details are among some of the finest in the IAD, with very naturalistic treatment of the quilting stitches themselves and actual wear to the fabric. His detail of a Log Cabin quilt (fig. 5-8) pieced in soft shirting fabrics, calico prints, and muted solids achieves the hyperrealism of trompe l'oeil. His execution of the cascading curved quilting pattern commonly known as Baptist Fans and the folded layers of the quilt hanging one on top of another exemplify his skill. He presents the quilt as one you would wish to curl up with, one that many previous users had already used in such fashion. The quilt itself was owned by Mrs. C.L. (Ora) Pemberton (born 1886) who had five of her quilts documented in the Index, although this was the only of those quilts that had descended in her own family, made by her mother Mrs. R.E. (Helen) Rorie (or perhaps Rosie, born c. 1866). According to census records, Ora's mother was born in Arkansas. As such, this worn

Fig. 5-9. Elbert S. Mowery at work on the Index rendering shown in Fig. 5-10, 1938. National Gallery of Art, Washington, DC, Gallery Archives. RG44D, Records of the Index of American Design, Original Project (WPA) Images - Exhibitions, Staff, and Publicity. 44D16_94270_02.

Log Cabin represents the southern, rural tradition of quiltmaking, otherwise nearly absent in the IAD.[69]

One of Ulrich's IAD colleagues, Elbert Mowery, also contributed seventeen renderings to the IAD, including eight depicting quilts (see fig. 5-10, 5-11), along with two woven coverlets and pictures of various Shaker objects. Mowery left even less of a paper trail than Ulrich, perhaps appearing in census and military draft records as "Albert" Mowery, although it is difficult to

know if these governmental documents indeed refer to this artist. The WPA did take his photograph at work on a painting of a block patch quilt, with a board in his lap holding his paper, a fine brush in his right hand, and a cigarette in his left, with his palette and ashtray sitting on an adjacent folding chair (fig. 5-9). In contrast to Ulrich's soft, tactile renderings, which looked like they were textiles themselves, Mowery's quilt paintings were crisper and feel less like quilts and more like the types of modernist abstract art that were common in

Fig. 5-10. Elbert S. Mowery, Patchwork Quilt, *c. 1938, Index of American Design, National Gallery of Art. 1943.8.787.*

Fig. 5-11. Elbert Mowery, Silk Quilt, c. 1941, Index of American Design, National Gallery of Art, 1943.8.367.

the 1930s, like Piet Mondrian or Fernand Leger. His zoomed-in hyperrealist detail of a silk Log Cabin quilt—distinctly unlike the worn cotton one Ulrich painted—does not look like a quilt at all and instead appears as a modernist abstraction. His attention to detail rivals that of Ulrich, as his brushstrokes captured the individual fabric weaves. But the two men's results are starkly different. This individual expressive touch, despite the task of painting in order to capture an object with fidelity, makes the project results so magical, and showcases the layers of meaning within the IAD. These two paintings each represent a quilt of the same pattern but are individually executed by skilled artists who each brought their distinct interpretive visions to the project.

Although paintings produced by artists such as Ulrich and Mowery reveal their artistic vision for quilts, the researchers who documented the objects also played an important role in how contemporary viewers perceived these pieces of folk art. The IAD's researchers—otherwise out-of-work Americans paid through the WPA—consulted the Colonial Revivalist quilt historians' publications to date, name, and provide historical and cultural context for quilts the IAD documented. These early quilt historians—Marie Webster, Ruth Finley, Rose Kretsinger, and Carrie Hall—had summoned their foremothers to look back nostalgically on a time when women stitched together scarce scraps of textiles to make beautiful, warm bedcovers. The IAD published a bibliography for its researchers to consult as they chose objects, listing Webster's *Quilts,* Finley's *Old Patchwork Quilts,* and Hall and Kretsinger's *Romance of the Patchwork Quilt,* along with books by Eliza Calvert Hall and Carrie Sexton, as the go-to resources for researching old-fashioned bedcoverings. This is, of course, no surprise, as these were indeed the available publications about

quilts in 1936.[70] Also unsurprisingly, these authors' Colonial Revivalist interpretations of quilts and quiltmaking permeates the IAD's selection of quilts and the bits of historical context found within the datasheets recorded for each object. For example, the datasheet for a rendering of a cheerful pieced and appliquéd baskets quilt in the Brooklyn Museum collection noted, "Ruth E. Finley in 'Old Patchwork Quilts,' p. 41 speaks of a similar one made on Long Island before 1810."[71] In doing so, the IAD perpetuated inaccurate assumptions about quilt history (to no fault of Finley or the IAD researchers), as more recent quilt scholarship suggests the style of the Baskets pattern in this quilt indicates a late-nineteenth-century date, as this Baskets pattern was not in circulation or use in 1810.[72] And more to the point, the IAD adopted and disseminated Colonial Revival ideology that mythologized white foremothers, while erasing the contributions of impoverished and Black quiltmakers.

Despite the IAD's desire to create widely circulating portfolios showcasing the renderings, the project never achieved this outcome. Eventually, the project published several books with highlights from the IAD, but it failed to become the design resource its organizers had imagined. Perhaps this was due to the project's limitations. By looking nostalgically to the imagined past rather than connecting the folk-art objects to living, thriving traditions that embodied New Deal values, the Index continued to promote quilts as old-fashioned relics. Maybe if the IAD had documented the many living quiltmakers—like the ones described in the following chapter—the Index could have more fully connected the romanticized past to the present, showcasing quiltmaking as a relevant and timely cultural expression that spoke to the present situation rather than one solely from the past.

MUSEUM EXTENSION PROJECT

Another means of documenting the nation's quilts as a way of looking to the past to improve the present occurred as part of the commonwealth of Pennsylvania's Museum Extension Project (MEP), which emerged out of the WPA's Division of Women's and Professional Projects. The government charged this division with developing relief programs for women and white-collar workers.[73] In contrast to the sewing rooms and handicraft projects that aimed to train those deemed to not have marketable skills, the MEP employed many educated workers, including artists, educators, clerks, stenographers, architects, librarians, carpenters, electricians, seamstresses, and other artisans and craftspeople.[74] The MEP's mission was to "prepare historical and educational objects, charts, models, and exhibits for use as visual aids to education," supplying those resources to schools, museums, and libraries across the state.[75]

Pennsylvania was the first among twenty-five states to create an MEP, with other states emulating its programming. The commonwealth's WPA administrators described its dual purpose as "providing work for the needy and also creating and distributing thousands of items to schools and institutions of the state to be used as visual aids in objective teaching."[76] During the early twentieth century, progressive education theory emphasized the importance of visual aids in education, and Pennsylvania was a leader in developing and promoting this pedagogy, with a robust museum education program that partnered with schools by providing visual resources. Inspired by the extension services offered by land grant universities and public libraries, museums also developed extension services, loaning collection objects and other educational resources to schools.[77]

Building on this existing momentum and infrastructure, the MEP, sponsored by Pennsylvania State College (now University) instituted a wide-ranging program of providing free resources for permanent use in schools. The Pennsylvania MEP catalog—which school administrators and teachers could use to order the project's resources—offered an array of free materials, including a slew of dioramas depicting life during different eras, fish plaques, color plates of historical and ethnic costumes, and puppets that promoted good hygiene, among other items.[78] In 1937, the project produced 2,600 scale models of Independence Hall to mark the 150th anniversary of the U.S. Constitution, which the MEP distributed along with the script for an original short play, *A Modern Newsboy at the Constitutional Convention.*[79] In total, the Pennsylvania MEP employed around 1,200 workers annually, producing over a million and a half visual aids for distribution to schools.[80]

Item 46-PQ-1 in the 1940 Pennsylvania MEP catalog was "Patchwork Quilt Plates"—largescale screen-printed quilt patterns—weighing in at four pounds, for calculating shipping costs. The detailed description read, "A series of 30 plates of old patchwork quilt designs, taken direct from quilts. These plates are working drawings and are so designed that actual patterns may be cut from them. Instructions for assembling and a short history of the design are on each plate." The catalog presented a numbered list of thirty quilt patterns, including appliqué patterns like Pineapple, Rose of Sharon, and Love Apple and pieced repeat block patterns with such names as Rocky Glen, Ducks and Ducklings, and Pinwheel.[81]

When considered in the context of the other visual aids for education produced by the MEP, these quilt patterns—like dioramas, costume plates, and miniature replicas of historical furniture—were created and distributed as a means of teaching schoolchildren in Pennsylvania about past ways of living.[82] Unlike most other visual aids created by MEP, however, the quilt patterns were not mere illustrations of past traditions but could double as patterns for schoolchildren to create their own quilts inspired by historical designs. The Pennsylvania MEP also created weaving samples based on woven coverlets, but these textiles stood as examples of the craft rather than a how-to guide with instructions for reproducing your own. Quilts, unlike coverlets or the many ethnographic and historical costumes illustrated on MEP plates, were accessible objects that could be produced within schools in the 1930s, requiring fabric, needle and thread, scissors, and basic sewing skills. The manual accompanying the quilt pattern portfolio, titled *Colonial and Pioneer Patchwork Quilts*, included directions for how to assemble each block.

In 1990, when Barbara Garrett—a member of a southeastern Pennsylvania's Variable Star Quilters, a quilting group with a penchant for history—purchased a set of the quilt patterns at an estate sale auction, the Variable Star Quilters began investigating its origins. They discovered that the portfolio of quilt patterns drew heavily on another 1930s quilt resource: Colonial Revivalist Ruth Finley's *Old Patchwork Quilts and the Women Who Made Them*.[83] Despite the MEP's claim that the patterns were based on physical quilts, each pattern was actually drawn from a black-and-white plate or pattern diagram in Finley's now classic book.[84] In addition to instructions for assembling the blocks, the manual included an introductory essay and charming descriptions of each pattern's origin, echoing Finley's emphasis on the olden days (even if most of these quilts were in fact misdated by decades, placing them after the end of the colonial era) as a source of inspiration for the present.[85]

The project's introductory essay was titled "History and Romance in Quilts" and, as the Variable Star Quilters determined, was heavily plagiarized from Finley's text.[86] While offering romantic notions of how many quilts young women needed in their dower chests (twelve everyday quilts and a best one worked by her own hands), the text suggested that contemporary women—rather than the schoolchildren who were the primary audience for MEP visual aids—might also find interest in quilting as a leisure activity. "As a hobby it has wonderful possibilities; a collection of old patchwork squares in lovely materials appeals to women, young and old alike," the manual stated. "The modern-primitive artist can derive much inspiration from study of the early patchwork designs," it continued, encouraging contemporary quilters to turn to the imagined colonial and pioneer past.[87]

The Variable Star Quilters' analysis found that many of the pattern templates were unworkable, printed in too small a scale to be useful, with confusing and awkward instructions in the accompanying manual. In short, they determined that "if the directions were followed as given in the manual, the inexperienced quilter would achieve a sense of frustration," which suggested to them that "the writers were neither quilters, nor needleworkers."[88] Although a handful of full pattern sets exist in archives and a few incomplete sets have also emerged, the Variable Stars Quilters theorize that the portfolio was put together quickly with only minimal distribution.

Fig. 5-12. Chimney Sweep, *from Pennsylvania Museum Extension Project, c. 1939, Shippensburg University Library Special Collections.*

Despite drawing on Finley's ideas about nineteenth-century quilts, the resulting silkscreen printed plates are 1930s modernist creations, printed in the popular colors of the day—Nile Green, powdery blue, Easter egg shades of orange and pink. A characteristically Art Deco typeface printed each pattern name, any known geographic attribution, a date for the original quilt, and a stamp stating "W.P.A. State Wide Museum Extension Project Pennsylvania, So. Langhorne" (see fig. 5-12, 5-13). Of the thirty plates, nineteen of them are based directly on black-and-white photos of quilts in Finley's book, while nine are from black-and-white line diagrams in the same. The remaining two plates—Crazy patchwork and a Barn

Raising variation of the Log Cabin pattern—have no specific illustration in Finley's text, although these were widely popular and adaptable styles in the late decades of the nineteenth century.[89]

As the Variable Star Quilters noted, the MEP workers likely used the black-and-white photographs featured in Finley's book to create their vibrant color plates, so rather than trying to create replicas of the old quilts—as was the IAD's objective—these plates adapted nineteenth-century quilt patterns with contemporary flair. For example, MEP's Plate No. 16, Chimney Sweep (fig. 5-12), features the muted aqua tone commonly called Nile Green in the background, a shade not

Fig. 5-13. Basket of Tulips, *from Pennsylvania Museum Extension Project, c. 1939, Shippensburg University Library Special Collections.*

produced in the nineteenth century. The plate shows an appliquéd floral motif in the corner treatment, just as the black-and-white photo in Finley's Plate 72, but rather than use the ubiquitous red and green fabrics common on appliqué quilts of the mid-nineteenth century—as noted in Finley's caption—the MEP plate shows the appliqué in reverse, with the flowers silhouetted in Nile Green, referred to as "Apple Green" in the manual.[90]

Despite this very modern interpretation of the pattern, the commentary in the manual firmly connects it to the romance of the previous century. "This popular old quilt-pattern was suggested to the early quiltmaker by the construction of the oldest type of house chimney," the description read, paraphrasing Finley while grounding the design in the colonial era. "Before the American Revolution, the center chimney ceased to be used because it took up too much space," the text continued.[91] The instructions for the Basket of Tulips pattern similarly harken back to the colonial era, citing a date of 1750 as the origin for quilt blocks set "on point" as diamonds rather than as squares. Here the manual draws on notions of thrift and making do while also paraphrasing Finley's mythologized understanding of colonial quiltmakers: "The making of both quilts and hooked rugs appealed to the thrifty-minded women of the period because scraps of material, new and old,

could be utilized to produce beautiful decorations for the home." The instructions go on to give advice to the thrifty quiltmaker of the Great Depression: "A delightful, inexpensive effect may be secured through the use of home-dyed unbleached muslin." This plate employed the favored contemporary colors of "pinky orange," "peacock blue," and "light green."[92]

Unlike the IAD, the MEP did not have a large bureaucratic footprint guiding its decisions, with federal administrators in Washington, D.C., sometimes rejecting watercolor renderings of poor quality or the local choices of which folk-art objects to document. The Pennsylvania MEP, the largest and first of its kind, was administered in Harrisburg but had sixteen district offices and seven individual workshops scattered around the state, each taking on its own specialties, resulting in a number of local projects. By 1939, the WPA required local matching funds in order to receive federal dollars, which also contributed to more localized control compared to other federally funded projects.[93] The South Langhorne division, which silkscreened the quilt patterns, was sponsored by the Associated Businessmen of South Langhorne.[94] This division employed eight workers in its silk-screen department in 1940, among fifty-seven workers total, with the MEP paying handicraft workers such as this fifty-three cents per hour.[95]

The MEP's quilt manual and patterns aimed to explicitly show Americans in the late 1930s how they could aspire to be more like the colonial quiltmakers who came before them, translating the nineteenth-century patterns into a colorful, engaging—if unworkable—contemporary form. But did schools or libraries actually order and use the plates? Only a handful of known sets of the full portfolio exist, including copies at the Reading Public Library, the State Museum of Pennsylvania, Shippensburg University, and one now in the archives in the National Gallery of Art. Partial copies with some plates missing also exist, including the copy that Barbara Garrett purchased at an estate sale, which had handwritten names on each of the various patterns. Genealogical research revealed that most of the identifiable individuals were each born in the mid- to late-1940s and were pictured in Norristown, Pennsylvania, high school yearbooks from the early 1960s. Perhaps these children used the quilt patterns in school, with each block assigned to the student named on the silk-screened plates.[96]

Contemporary defenders of the MEP as a whole praised the use of visual materials in education, calling them "part and parcel of the modern methods used in progressive education."[97] A high school principal in Gap, Pennsylvania, declared that the MEP "is making tremendous advance in the preservation of past and present modes of living in the United States."[98] Despite its high regard among educators, with many New Deal programs shifting focus to the looming war effort, in 1940 the MEP redirected to defense training, using its workers' modelmaking skills to produce aircraft for training purposes and its printmaking to create mechanical drawings and posters for the defense industry. Yet by that time, millions of visual aids were already dispersed to schools across Pennsylvania, with many more in the other states with similar projects. The entire WPA dissolved in 1943.[99]

THE USEFULNESS OF THE PAST

The Federal Writers' Project's recorded memories of quilting parties and the money earned from making quilts, the watercolor paintings of quilts in the Index of American Design, and the silkscreen printed patterns of the Museum Extension Project each looked to the past in an effort to inspire resilience in those living through the Depression. Often, the projects' leaders manifested Colonial Revival ideologies that resulted in a romantic cultural nationalism. These projects aimed to document the past by employing Americans desperately in need of income to create resources fellow citizens would continue to draw on in the future. During the Great Depression, these projects were part of the vast and controversial efforts of the WPA's "make-work" efforts. Their more enduring legacy lies in the ways they documented cultural traditions during an era of rapid change in which Americans adapted and combined folk practices with modern efficiencies.

Of these projects, the FWP's oral histories have had the most enduring legacy, serving as an instrumental resource documenting life in the 1930s as well as the experiences of the past, including valuable information about the lives of previously enslaved individuals. Although quilts and quiltmaking are just one of hundreds of practices and traditions discussed in these narratives, the ubiquity of quilts within these descriptions suggests the importance of the craft within the memories of those who were interviewed. Quilt historians of recent decades have turned to the narratives to learn, among other things, about the quiltmaking practices of enslaved Americans, using the recollections to more accurately discuss how quilts were made and used within the institution of slavery.[100]

The IAD, in contrast, aimed to be a resource from which contemporary and future artists would draw inspiration rather than a record of the past. In reality, however, it too served as historical documentation, creating a vast visual record of material culture from the eighteenth and nineteenth centuries that adhered to Colonial Revival impulses toward old-timey charm. It's hard to determine if contemporary artists and designers in fact looked to the watercolor renderings of historical quilts as inspiration. But late-twentieth-century quilt enthusiasts drew inspiration from the project itself, running state quilt documentation projects and hosting quilt days during which anyone who owned quilts could have theirs photographed and documented for posterity. These records are now housed in state or university archives, with many of them aggregated in an online database with a name reminiscent of the IAD: the Quilt Index.[101]

The relatively unknown MEP may have had its greatest impact during the New Deal era and subsequent years during which the visual aids were in use. With local school budgets slashed due to the economic downturn, educational resources like the millions of objects produced by the MEP provided a needed boost to the curricula of under-resourced schools, including some 6,000 rural one-room schools in Pennsylvania alone. In addition, those working on the MEP gained new skills in fabrication, illustration, and in the case of the quilt patterns—the new technology of silk-screen printing.[102] For each of these projects, the immediate successes were in giving paychecks and hope to unemployed Americans. It is more difficult to assess the less tangible goal of looking to a usable past for constructive advice about how to live in both present and the future. Yet quilts, comforting objects symbolically associated with creative reuse and fortitude in the face of adversity, were valuable instruments in those processes.

Fig. 6-1. "Old Fashioned Quilt for White House," International News Photos, March 17, 1933. Courtesy of Janet Finley.

CHAPTER 6
COVERS FOR THE NATION

Two months after Franklin Roosevelt's inauguration, a brief mention in the *Pasadena Post* read, "A quilt made up of more than 3000 pieces of cloth and named 'The Steps to the White House,' has been completed by Esther and Juliet Romeo of this city. The quilt was sent to Mrs. Franklin D. Roosevelt at the White House in Washington."[1] The quilt was a very conventional one for the era, a Grandmother's Flower Garden, rather than a new pattern commemorating the White House. Perhaps due to what was then the novelty of sending quilts to the White House, a wire service picked up the story and added the following details, along with a photograph of the sisters: "Having heard that Mrs. Franklin D. Roosevelt is one of the Nations [sic] foremost old fashioned quilt collectors, Esther and Juliet Romeo of Poicoima [sic] are forwarding one of their finest hand-made quilts to the new First Lady of the Land. The Romeo girls are recognized authorities on the old fashioned coverings and have the greatest collection in the country."[2]

The reporter who covered this brief feature story likely did not know one way or another if the Romeos were indeed experts, and no additional evidence suggests that they indeed were. But the newspaper evidently considered the sisters' gift to Mrs. Roosevelt and her well-documented love of quilts and other handmade objects as newsworthy and of interest to readers. After all, the "whole country is quilt conscious," as quilt experts Carrie Hall and Rose Kretsinger had claimed.[3]

American women generated countless quilts during the Depression years, many of which have survived, while others were used up. The ubiquitous patterns of the 1930s—like the Grandmother's Flower Garden and Double Wedding Ring pictured in the wire service photo with the Romeo sisters (fig. 6-1)—made up a significant portion of quilts. Scrap quilts pieced together without patterns—like the one hanging behind the sisters—made up another portion. And then there were quiltmakers who used their craft to make statements, in a tradition of political and activist quiltmaking that stretches back to the women who stitched in support of the abolitionist movement and the Woman's Christian Temperance Union.

Perhaps surprisingly, quilts have long been apt vehicles for expressing empowerment, whether political allegiance, support of a social cause, or distinct personal sentiments. As an acceptable form

for women's expression, stitching one's politics into a quilt was a culturally appropriate way to communicate allegiance to a cause. Quilts, especially those made as gifts or otherwise publicly presented, could attract attention to contemporary issues. Quiltmakers did all of these things during the New Deal. Fannie Shaw did this in the early years of the Depression before the New Deal was enacted with her quilt *Prosperity is Just Around the Corner* (fig. 0-1), while Mary Gasperik expressed her feelings about the end of the Depression in her 1939 quilt *Road to Recovery* (fig. 0-4), each described in the introduction to this book.

QUILTS SUPPORTING THE NEW DEAL

With its so-called alphabet soup of agencies, the New Deal presented numerous opportunities for quiltmakers to show support for specific governmental efforts. The earliest New Deal quilts reflected their makers' support of the National Recovery Administration (NRA), formed in the early days of the Roosevelt administration with the National Industrial Recovery Act (NIRA), the first major recovery legislation passed as part of the New Deal. Businesses that signed on to the blanket code rules of the NRA—minimum wage, maximum workweek, and the right for workers to collectively bargain—were allowed to display the NRA's Blue Eagle emblem, and consumers were encouraged to boycott those who did not. Beginning in late July 1933, firms adhering to the code could put Blue Eagle posters and stickers in their windows and use the logo in their own marketing materials. Individual consumers could also sign a "Statement of Cooperation" pledging to support businesses who opted in to the NRA code. Soon, the Blue Eagle was everywhere, with seventy million cards, stickers, and posters printed and shortages of the logo causing anxiety among businesses who did not wish to be boycotted.[4] In particular the Roosevelt administration targeted women as consumers who

Fig. 6-2. *"NRA Inspired This Quilt,"* Lancaster New Era, September 4, 1933.

could be persuaded to be loyal to the Blue Eagle; an August 1933 NRA press release stated: "If the women who control the purse strings of the nation use this mighty instrument of mass buying power to support the Blue Eagle, they can [help] to achieve security for themselves and build a better and happier America."[5]

With such mass interest in displaying the Blue Eagle, it did not take long for quiltmakers to show support by brandishing the logo on their bedcovers; some adapted published patterns while many created quilts of original design. In September 1933—just one month after NIRA's passage—Needlecraft Service, Inc., the publisher of the widely circulating

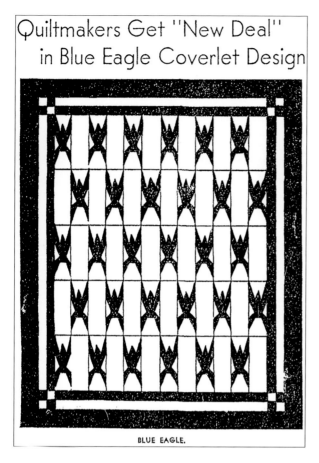

Fig. 6-3. Nancy Cabot's *Blue Eagle pattern,* Chicago Daily Tribune, *Oct 8, 1933.*

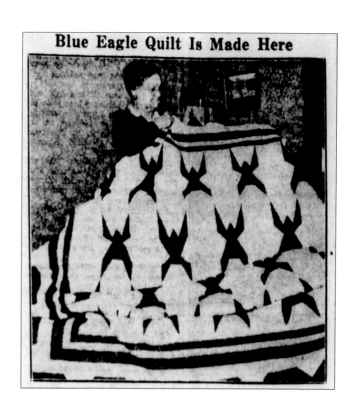

Fig. 6-4. *"Blue Eagle Quilt is Made Here,"* The Pantagraph, *March 6, 1934.*

Laura Wheeler patterns, syndicated its White House Steps pattern (fig. 6-2) to newspapers across the country. The column text stated that the pattern was inspired by the NRA because "the NRA movement has centered the eyes of the entire country on the White House." This pattern did not figuratively or symbolically depict the Blue Eagle logo—it was a fairly typical geometric pieced quilt pattern—but soon, many quilts did, including some extant pieces now in museum collections as well as those celebrated in the pages of other local newspapers in the mid-1930s.[6]

Prolific quilt pattern columnist Nancy Cabot (the pseudonym of Loretta Isabel Leitner Rising)

published her NRA Blue Eagle pattern in the October 8, 1933, edition of the *Chicago Daily Tribune* (fig. 6-3). Cabot's Art Deco patchwork design does not attempt to figuratively recreate the Blue Eagle logo posted in advertisements and shop windows. Rather, the column stated that the pattern evokes eagles "as they soar upward."[7] While Cabot's syndicated column was widely read, it's unknown how many quiltmakers may have taken her advice and adopted her original commemorative design. One quilter, Miss Katharine Mantle of Bloomington, Illinois, executed the pattern and was photographed in the local newspaper posing with the completed quilt (fig. 6-4), which *The Pantagraph* stated took her three months to complete.[8]

What inspired Mantle to make this quilt or the many other makers responsible for NRA quilts? Unlike other logos, like those for a business or a sports team, the NRA Blue Eagle had a very specific meaning. It was a badge that one had to earn, either by complying with the NIRA requirements, or as a consumer, by signing a Statement of Cooperation pledging to patronize employers who adhered to the rules. Those names of individuals and businesses were then displayed as an "Honor Roll" at the local post office. It was patriotic, but it also had greater connotations than simply waving a flag. When the government encountered shortages of the stickers and posters, businesses feared they might face blowback, despite having complied with NRA requirements.[9] Did Americans stitch quilts to hang in business windows as substitutes for the logo? Since women were responsible for purchases in many families, the government perceived that they played a special role in the NRA's success. Hugh Johnson, a member of Roosevelt's "brain trust" stated that "when every American housewife understands that the Blue Eagle on everything that she permits into her home is a symbol of its restoration to security, may God have mercy on the man or group of men who attempt to trifle with this bird."[10]

One maker of an NRA quilt was decidedly not a housewife. A February 1934 article in *The Cincinnati Enquirer* titled "Even the Men Quilt" featured an image of a well-executed quilt with thirteen appliquéd blocks each in the design of the NRA logo (fig. 6-5). The newspaper recounted that A.E. Marthens—a sixty-three-year-old grocer, according to census records and the Cincinnati City Directory—"proudly displays this needlework of current history which he copied from the patriotic symbol on his NRA membership card hung in his store window." Mr. Marthens used a buttonhole stitch for his appliqué and featured the

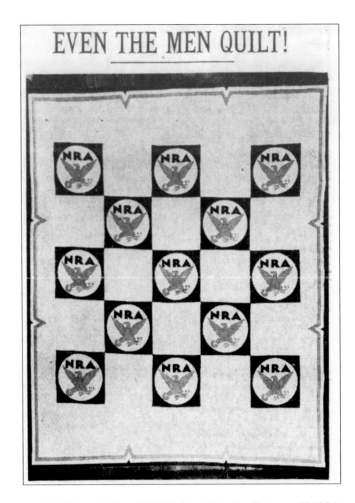

Fig. 6-5. *"Even the Men Quilt!"* Cincinnati Enquirer, *February 23, 1934. Newspaper photograph of quilt made by A.E. Marthen, grocer.*

NRA logo in the quilting of the alternating setting squares. The article mentions that his only previous quiltmaking experience was helping his wife finish a quilt sixteen years earlier and that he stitched at his masterpiece during lulls in between customers. The reporter no doubt appreciated the novelty of a male quilter, while also making the connection between "events ranging from the colonial period to current problems, testing the mettle of our statesmen." The *Enquirer* celebrated his work with the closing line: "Like the early needleworkers whose quaint historical designs are now museum pieces, Cincinnati's first man quilter has stitched his name and the date of his completed work in the right-hand corner of this

NRA quilt."[11] Marthens, as a grocer hoping to attract consumers who supported the NIRA guidelines, used his quilt as an added signifier of his loyalty to the program. But his reasons for choosing a quilt as his medium remain unknown.

The Yonkers, New York, *Herald Statesman* featured an image captioned "The New Deal All Sewed Up!" of Mrs. A.J. Bridgeman's Blue Eagle quilt, an original design complete with "diminishing dollars" radiating out from the eagle at the bedcover's center. Each block included the quilted letters, "NRA," with stars of hope featured in the corners. Despite what appears to be an exuberant quilt professing support for the program, the March 1935 article accompanying the photo noted, "the quilt is the product of no partisanship but rather the result of aesthetic and domestic preoccupation" and that when it was displayed at the local church, its tag proclaimed that the quilt "did not imply approval of the New Deal."[12] Perhaps this disclaimer was a matter of timing: in the spring of 1935 the Supreme Court considered the constitutionality of the NIRA, ultimately ruling in May that the Act violated the constitutional separation of powers. The nation had become lukewarm to the Blue Eagle prior to this point, with businesses less frequently featuring it in their advertising by the fall of 1934.[13] Mrs. Bridgeman's allegiance to the cause may have similarly dissipated. The article suggested a few of her motivations, stating, "Mrs. Bridgeman originated it only because she has found quilting one of the happiest of hobbies—inexpensive, fascinating and, she says an interest not requiring ability.... Its maker firmly believes that quilting offers many women the escape they seek from the troubles and confusions of the present day."[14]

The total volume of quilts made to commemorate the NRA is unknown, although in addition to the newspaper references, several are now in prominent public and private collections.[15] The variety of styles of these NRA quilts—most seemingly original designs—suggests that there was little top-down design influence inspiring these quilts. Indeed, when Ella Martin—a coal miner's wife from Mercer County, West Virginia—wrapped her NRA quilt in brown paper to mail it to the White House as a gift for President Roosevelt in December 1933, she included in her letter, "I believe this is the first quilt of this kind to have been made."[16]

Martin's correspondence with the White House also sheds light on one woman's motivations for making the quilt. Upon completing her quilt featuring forty-eight appliquéd Blue Eagle blocks, one for each state, with the state abbreviation and the words "We Do Our Part" embroidered in red adjacent to each eagle (fig. 6-6), Martin wrote from her home in West Virginia to ask the White House how she should send the quilt. She called the quilt a "cover for the nation" and said she wanted to give it to the president "out of appreciation of the National Recovery Act, and what it means to the people, and as an expression of confidence in the NRA." She followed up with her congressman, John Kee, seeking his advice about how to ensure that the quilt made it to the White House. In this note Martin said, "I am a woman of the common people.... If in any way you will be so kind as to convey the idea to Mr. Roosevelt that along with the broader meaning of the quilt, it means real sacrifice from the hands of the donor, I shall be very grateful to you."[17] Ella clearly wanted the president to know the actual time she had labored over her Blue Eagle quilt, and, perhaps symbolically, wanted to also convey the dire conditions she and many fellow Americans faced in these early years of the Depression. To her, the stiches in the quilt equated with the larger sacrifices many Americans endured. In January 1934, Roosevelt wrote the following thank-you note to Martin

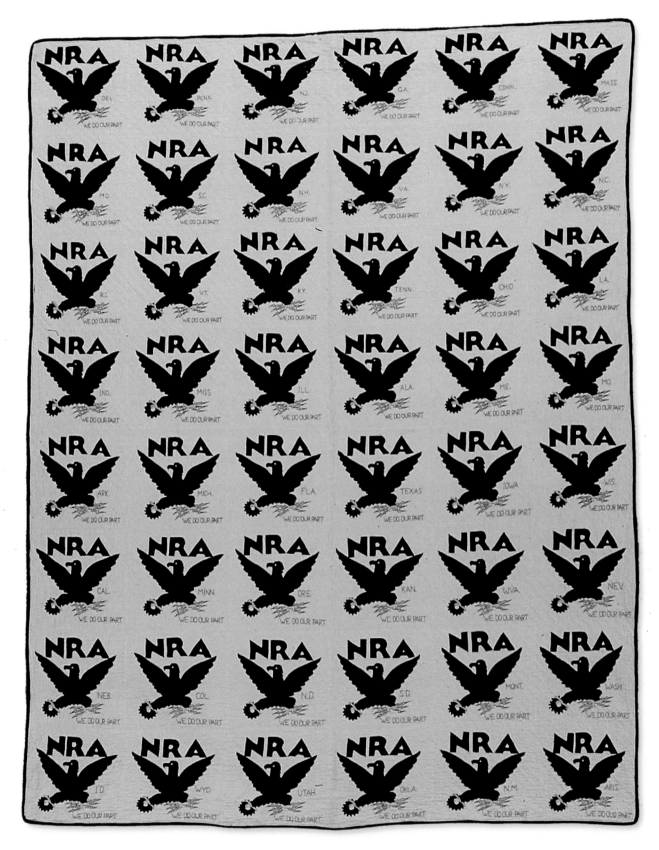

Fig. 6-6. Ella Martin, We Do Our Part, 1933, Montcalm, West Virginia. West Virginia Department of Archives and History.

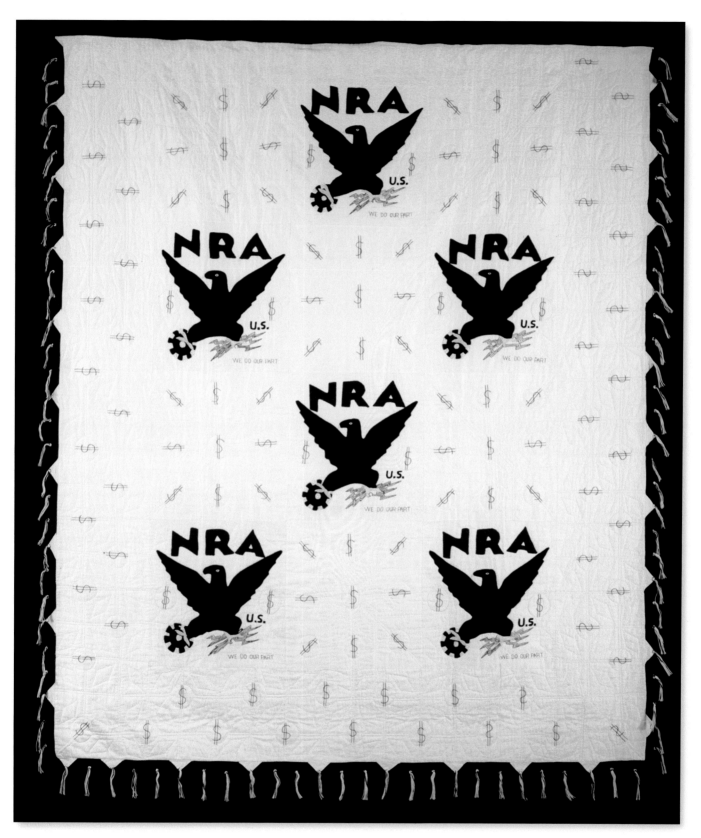

Fig. 6-7. Mrs. J.A.D. Robinson, Blue Eagle Quilt, *1933. Image courtesy of the Franklin D. Roosevelt Presidential Library and Museum, MO 1953.1091.*

in return, which was later reprinted in the *Bluefield* [West Virginia] *Daily Telegraph:*

> My dear Mrs. Martin:
>
> I received your letter of December thirteenth and want to thank you heartily for the beautiful quilt which you were good enough to send me some time ago as a present and as an expression of confidence in the National Recovery Administration.
>
> I am pleased to accept this fine piece of work made by your own hands and I appreciate the spirit which prompted you to present it to me.
>
> Very Sincerely Yours,
> (signed): FRANKLIN D. ROOSEVELT[18]

Many other quiltmakers similarly sent quilts to the White House as gifts, as discussed below. Mrs. J.A.D. Robinson of Brazos, Texas, also sent her NRA Blue Eagle quilt (fig. 6-7) to Franklin Roosevelt. As a farmwife, she may not have needed to hang a quilt in a storefront in order to proclaim her allegiance to this New Deal program. Instead, she used her quilt as a fundraiser, attaching names of donors who contributed to a fund for a new roof for the San Antonio Mission Home and Training School prior to sending it to the White House.[19] Making a quilt as a presentation piece, or as Nancy Cabot called it, "an original 1933 contribution to the historical quilt album," suggested that Blue Eagle quilts marked allegiance and also were intended to document the historical moment.[20] And it was a brief moment, with the Supreme Court rendering all of NIRA unconstitutional in May 1935, less than two years from its origination.[21]

The NRA was a defining feature of what became known as the "First New Deal," the initial legislation the Roosevelt administration pushed through during 1933-1934. The Works Progress Administration, the wide-reaching program that from 1935 through 1943 employed eight and half million Americans, became the defining feature of the Roosevelt administration's second phase. The WPA programs that trained and employed women to make quilts, as discussed in chapter 3, primarily produced quilts distributed for relief or for use in state facilities like hospitals and orphanages. In addition, WPA participants made quilts celebrating this federal program. Similar to the array of quilt styles created to mark the NRA, WPA quilts shared no unifying pattern or particular design characteristics, and instead were a grassroots outpouring of gratitude and loyalty toward this massive government agency.

For example, WPA workers in Oklahoma created a friendship quilt highlighting twenty work crews based geographically across the state (fig. 6-8). By 1940, Oklahomans employed in WPA sewing rooms had produced and distributed 500,000 comforters and 14,399 quilts.[22] Yet, it's unclear if this friendship-style sampler quilt from central Oklahoma was created in a WPA sewing room similar to those described in chapter 3 or if it was an auxiliary project created in conjunction with work crews employing men to build roads, buildings, and parks. Each block features either a geographic designation or a number that corresponds to a work crew—the groups of workers, typically men, employed by the WPA to work on a given task. Friendship quilts marking organizational affiliation rather than individual ties were a common practice during this era, and this quilt demonstrates the presumed pride those associated with the WPA felt from belonging to a group that came with membership in a work crew.

Fig. 6-8. Unidentified makers, Oklahoma WPA Quilt, *Michigan State University Museum, 2011.140.1.*

Fig. 6-9. Members of the Royal Neighbors of America, Nine Patch, made in Detroit, Michigan, 1930-1932. International Quilt Museum, Gift of the Royal Neighbors of America, Rock Island, Illinois, 2016.057.0001.

Fig. 6-10. *Members of the Royal Neighbors of America, Album, made in Alliance, Nebraska, 1920-1932. International Quilt Museum, Gift of the Royal Neighbors of America, Rock Island, Illinois, 2016.057.0002.*

Groups of grassroots citizens also made quilts during the Great Depression that exemplified sentiments of mutual aid that stemmed from private coalitions rather than ones organized through governmental entities like the WPA. Created by eight women in 1890 in the Quad Cities area of Iowa and Illinois, the Royal Neighbors of America was a fraternal benefit society—a mutual aid organization that provides life, disability, and medical benefits to its members, as did other male-organized fraternal societies such as the Oddfellows and Freemasons. Although the Royal Neighbors predates the Great Depression, its programming became more essential at the onset of the Depression, with members of the society relying on each other for support, establishing a home for elderly and disabled members, and other activities. The quilts in figures 6-9 and 6-10, along with several other examples created by local chapters of the organization, showcase the symbolic ways quiltmaking united community members. In the quilt shown in figure 6-9, members' names alternate with Nine Patch blocks pieced from fabrics common to the era. The members from Alliance, Nebraska, assembled a friendship quilt with embroidered blocks, each seemingly made by a different hand, commemorating a Royal Neighbors Camp, what the organization called its annual regional meetings.[23]

Quilts like these suggested allegiance to group identity, as did ones made by a group of African American women who accompanied their husbands to the Muscle Shoals region in Alabama to work for the Tennessee Valley Authority (TVA). The Tennessee Valley Authority Act of 1933 created this federally owned corporation designed to provide electricity and expertise to rural communities throughout the Tennessee River Valley region. These women created decorative objects now known as the TVA quilts that showcased their support for the agency and for racial empowerment. Designed by Ruth Clement Bond (1904-2005), the wife of the personnel director of the African American workers at the TVA Dam project in Muscle Shoals, this series of quilts communicates the pride these women felt specifically in regard to their families' contributions as Black Americans, celebrating the jobs—and power, both electrical and societal—offered by the TVA.[24]

Like most of the South, the TVA project workforce was segregated, as was the village of workers building the Wheeler Dam and other sites. Despite its location in the rural South, where most African Americans still lived, the TVA had one of the worst records on race compared to other New Deal initiatives; it became the largest employer in the region yet placed most of its Black employees in menial and temporary jobs, and it struggled to live up to its 1934 promise of employing African Americans in proportion to their population percentages in the region. Many former sharecroppers found work with the TVA, sometimes earning cash for the first time. Yet the structural racism that defined the era and this agency in particular resulted in segregated and often substandard housing for African American workers, with Black residents not benefitting from the amenities such as a power grid and recreational facilities that were issued to white communities.[25] Further, the quarter million rural African Americans living in the region did not benefit from the social planning promised by the TVA in the form of a "planned and rational economy," with many white landlords initially refusing to wire Black tenants' homes despite the newly implemented policies of rural electrification.[26] Further, the TVA's process of creating reservoirs where families lived displaced disproportionally more African American families than

white residents.[27] As the *Crisis*, the magazine of the NAACP, reported in 1935, "These men are used to segregation and to prejudice. But they are not used to it at the hands of the federal government."[28]

Although Ruth and her husband Max were well-educated, from affluent families, and had lived in the North and Los Angeles, they relocated to Jim Crow Alabama when Max went to work as an administrator for the TVA. Here the Bonds lived in government-issued housing. Ruth Bond conceived of a "home beautification" initiative aimed at sprucing up the segregated governmental housing where African American TVA workers lived. She wanted the project to provide an intentional alternative to papering the walls of one's cottage with pages of Sears catalogs, as many rural southern women did. She proposed that each cottage have a "TVA room" that the women could decorate with furnishings made from local resources, including curtains made from flour sacks donated by the TVA commissary cook, rugs woven from dyed corn husks, furniture made from local willow trees, and quilts celebrating the TVA.[29]

As Bond traveled from TVA village to TVA village, visiting the homes of workers, she became fascinated by the quilts the wives worked on. In a 1992 interview, she noted that these sharecropper women, now transplanted to the TVA workers' villages, had learned quiltmaking from their enslaved ancestors, who told stories through their quiltmaking.[30] Bond herself had never made a quilt, but she had the idea that quilts could represent the story of rural electrification and African American empowerment. In an internal report dated November 1, 1934, Max Bond explained that "the ladies in our village have struck upon the idea of developing Negro art. They are securing the services of some of the Negro women who know rug and quilt making. The designs on the quilts are depicting different phases of Negro life.... It is modernistic, ... it will be something to indicate that we are proud of the art of the Negro."[31]

Bond's imagery in the quilts speaks to the dual purposes of the New Deal programs—reliance on government programs and self-reliance. Quilts already had a clear connection to self-reliance, widely celebrated in popular culture, and these figurative designs conveyed that quality. Her first design, of which the location of any extant quilts is unknown, featured a full-length Black worker holding a lightning bolt in one hand. Bond gave the women who made quilts the pattern, drawn on brown paper, and suggested the colors for the design. Supposedly some of the quiltmakers as well as interns from Historically Black Colleges working for the TVA called it the "Black Power Quilt," with late twentieth-century observers speculating that these quilts may have introduced the phrase "Black Power" into the American lexicon.[32]

There are five known full-size versions of the quilt that some of the TVA workers' wives called *Lazy Man* (fig. 6-11), featuring a man holding an instrument in one hand and the white hand of the government pulling him in the other direction. Ruth Bond, the quilt's designer, explained the symbolism much later, stating that "it represents the Black man moving away from the hand of the law ... he is moving to become independent and to become an important part of society." Rose Thomas (born c. 1902) characterized the imagery in slightly different terms, perceiving the conflicting lure of leisure life and the pull of a steady government job offered by the TVA. "He is between the hand of the government and the hand of a woman. He must choose between

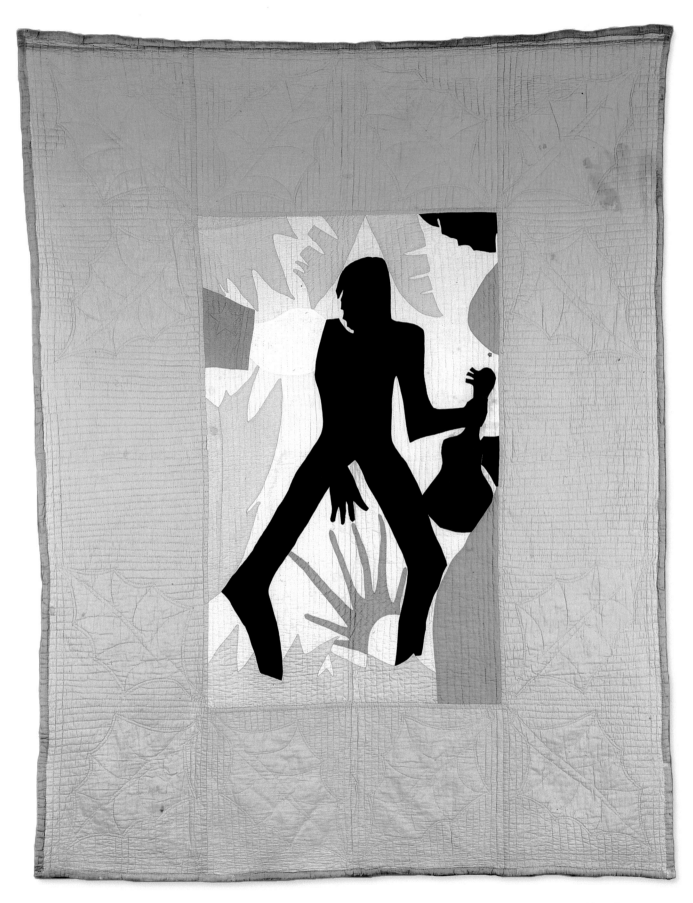

Fig. 6-11. Lazy Man *by Rose Thomas, designed by Ruth Clement Bond, 1934. Michigan State University Museum, 2011:147.1.*

the government job and the life he has known," Thomas recalled.[33] Quiltmakers Rose Lee Cooper and Grace Tyler also executed renditions of this pattern, which are now in museum collections.[34] Ruth Clement Bond did not use the *Lazy Man* title when she recalled this design decades later, and when the TVA acquired one of the quilts to display in its corporate offices, it called it "Uncle Sam's Helping Hand," a name that placed the government's interventions in a positive light.[35] Another of the quilts similarly portrayed the symbolic power of electricity through a lightning bolt,

this one with a fist reaching out of the ground (fig. 6-12). Of the symbolism of this one, Bond said, "we were pushing up through the obstacles—through objections. We were coming up out of the Depression, and we were going to live a better life through our efforts. The opposition wasn't going to stop us."[36] The final design of the series, of which there is only one known extant piece, depicted a man working with a crane overhead, quite literally representing African American workers building a dam (fig. 6-13).[37]

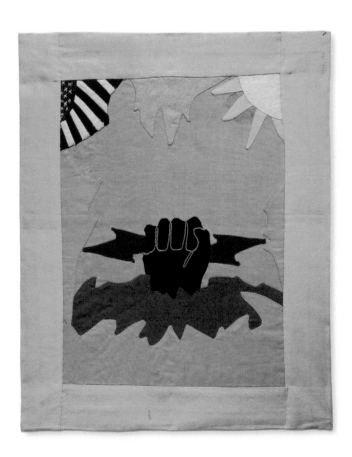

Fig. 6-12. Rose Marie Thomas, designed by Ruth Clement Bond, Tennessee Valley Authority Appliqué Quilt Design of a Black Fist, 1934. Museum of Arts and Design, New York; gift of Mrs. Rosa Philips Thomas, 1994.

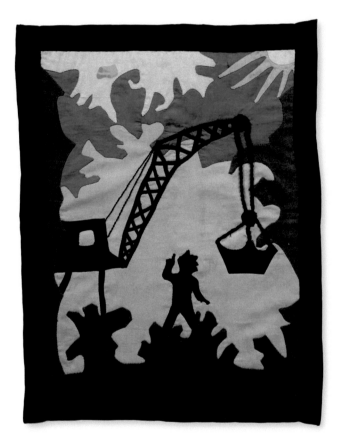

Fig. 6-13. Rose Marie Thomas, designed by Ruth Clement Bond, Tennessee Valley Authority Appliqué Quilt Design of Man with Crane, 1934. Museum of Arts and Design, New York; gift of Mrs. Rosa Philips Thomas, 1994.

In design, content, and construction, these quilts seem more akin to contemporary paintings by Harlem Renaissance artist Aaron Douglas (1899-1979) than the quilts made with the numerous commercially available patterns. Grace Tyler recalled that Ruth Bond drew the design with inspiration from a painting by an African American artist that hung at Fisk University, likely part of Douglas's mural series, and a caption accompanying a photo of one of the quilts printed in the *Crisis* similarly said, "Motif from Aaron Douglas."[38] Despite these similarities, in her interview with Merikay Waldvogel, Bond did not recall using Douglas's work as a model, although she admitted that "the man with the banjo does have certain Douglasesque elements," including the treatment of his silhouette and slits for his eyes. Bond noted that her quilt designs also share similarity with Henri Matisse's human figures.[39] Perhaps this was the outcome of quilts designed by a civil rights activist and educator familiar with early twentieth-century art rather than someone well-versed in needle and thread. Bond wanted the quilts to be prime objects for home beautification *and* be statements about the empowering effects of the TVA on African Americans.

Grace Tyler (1910-1994) was a skilled and prolific quiltmaker who participated in the home beautification initiative. When Merikay Waldvogel interviewed her in the late 1980s, she showed her other examples of quilts she executed in conventional patterns of the era, including Grandmother's Flower Garden and Dresden Plates. Married to TVA employee Harry Winston Tyler, Grace recalled liking the *Lazy Man* pattern immediately and eagerly making it, despite its dissimilarity with the popular quilts of the era.[40] Harry Winston Tyler was originally assigned as a janitor, but was later promoted by Max Bond to serve as the junior personnel representative, and he was eventually responsible for hiring African American janitorial and mailroom staff. Grace recalled that in 1934 her husband took her iteration of the quilt with the fist holding a lightning bolt to a TVA meeting with visiting dignitaries, and Harry gave the quilt away to an administrator, perhaps David E. Lilienthal, one of three TVA codirectors, who later served as Chair of the TVA board. This was one of three likely instances—two documented in letters, one only orally—in which TVA administrators received quilts as gifts.[41]

Max Bond perceived the quilts as symbolizing the huge potential for the TVA to transform the lives of African Americans in the region and, as such, in 1935 gave one of Ruth's quilts depicting an African American figure holding a lightning bolt to TVA Chairman Arthur E. Morgan, noting that quilting was one of several handicraft projects undertaken by Wheeler Dam wives.[42] He said in presenting the gift: "As you know, the wives of the workers in the Muscle Shoals area are organized into clubs, into what we call TVA clubs, seven in number. One of their projects is an attempt to revive the arts and crafts that were known to the Negro race during slavery. They further are attempting to use their handicraft to express the part that the Negro is playing in changing the South."[43]

Max Bond's motivations for giving this quilt to Morgan are unclear, but during that same year, the NAACP's *Crisis* magazine published an article quite critical of Morgan's administration of the TVA, complaining that he "is suffering from myopia" in his "policy of 'inching along,' a policy of cautious procedure so as not to raise to its highest pitch the anti-Negro sentiment in the Tennessee Valley."[44] Perhaps Max Bond intended the quilt as a peace offering that demonstrated the great potential for African American empowerment, as he saw it. "This program that we are establishing is going to set a precedent in the South. Wages have

been raised, standards of living have been changed, men are having a new opportunity and seeing new visions," he wrote.[45]

Another TVA executive received a quilt not from one of the male administrators but directly from the women who made the quilts. In 1937 the Negro Women's Association of Pickwick Dam Village in northeastern Mississippi presented Maurice Seay, the director of educational programs of the TVA, with a quilt in the pattern known as *Lazy Man*. In a letter Seay wrote in 1976, he recalled that the Association president presented him with the quilt to mark that "for the first time in the history of Mississippi, so far as she knew... black people and white people had studied and played together in an integrated educational and recreational program built and supported by public money." Seay recalled that although workers lived in segregated villages on opposite sides of a ridge, the integrated facilities were a novel and unifying feature of the Pickwick community. "The gratitude of the Negro women for this lively integrated program led them to recognize its director with their gift of this specially designed, homemade quilt," he wrote.[46] Yet with the NAACP's critique of TVA administrators for upholding the agency's discriminatory policies, we can interpret these quilts not as gifts of gratitude but as gifts intended to influence policy and practice, given the unequal conditions of Black life in the dam villages.[47]

As objects presented to white governmental TVA officials, these quilts were part of a challenging conversation about the limits and potential of federal intervention when it came to race. Despite white officials' idealistic visions about how the TVA's "social planning for the future" could transform African American life in the Tennessee Valley, Jim Crow remained an overwhelming force in the region,

including in the federally created villages. The NAACP reported in 1935 that Pickwick had a "Jim Crow" section to its movie theatre and doors to the personnel office marked "white" and "colored." TVA officials stated that there would be "racial outbreaks" if African Americans and whites lived together at Pickwick.[48] The "Negro Village" was inferior in a number of ways, with only temporary houses, rather than the larger mix of permanent and temporary in the white village. A segregated combined cafeteria and community center was available for Black workers' families, although the food was prepared in the white cafeteria and delivered to the Black village. The hospital had a separate ward for Black patients. A Pickwick resident recalled that upon Eleanor Roosevelt's 1937 visit to Pickwick Dam, she was overheard saying, "The signs on these rest rooms will surely be changed soon," in response to the "colored" and "white" labels.[49] White residents could participate in a variety of recreational activities in the white community building—including basketball, chess, volleyball, and boxing—and join various clubs and attend weekly dances. Residents in the Black village had a few similar options, like ping-pong, checkers, and dominos, but did not participate in team sports as white residents did because there were too few of them to field teams and they were not allowed to play with their white counterparts. As was the custom in this region, Pickwick schools remained segregated, with the school for Black children ending at eighth grade, while white children could attend through high school.[50] "We have the tragic picture of officials of the federal government, sworn to uphold the Constitution, teaching white citizens that Negroes are unfit to live in any but segregated communities," wrote African American journalist and activist John Davis of TVA's segregationist policies in the NAACP's *Crisis*.[51]

QUILTS FOR THE ROOSEVELTS

While the wives of TVA workers who stitched those quilts may not have originally intended them as gifts for federal officials, other individuals and groups of quilters made quilts designed as thank-you gifts. Quiltmakers have long deemed their cloth expressions as appropriate gifts to commemorate relationships and mark special occasions. Americans sent thousands of gifts to Franklin and Eleanor Roosevelt in gratitude for their efforts at fighting the Depression and uplifting the spirits of Americans.[52] Among the gifts were many quilts, like the one sent by the Romeo sisters from California in May of 1933, or the NRA quilts presented to the Roosevelts by Ella Martin and Mrs. J.A.D. Robinson. Quilt scholar Kyra Hicks has documented additional quilt gifts, and local newspaper accounts suggest that there were many more. It's impossible to know how many quiltmakers sent quilts as gifts to the Roosevelts, as Hicks has doggedly gone to extensive efforts to determine.[53]

Eleanor Roosevelt was known to have a deep appreciation for quilts, although she was likely not one of the nation's foremost collectors of old-fashioned quilts, as the newspaper article highlighting the Romeo sisters' quilt suggested. Eleanor's evident enthusiasm for quilts—whether based in fact or exaggerated—was widely circulated through a wire news story in which she called "to stimulate among women with leisure the revival of quilt-making."[54] Notably, she called for women with "leisure" to take up the craft, despite the fact that the WPA and National Youth Administration were training women and girls to quilt for vocational, rather than hobbyist, purposes.

Given the many documented quilt gifts, it's easy to surmise that a significant number of Americans made quilts to honor the Roosevelts and other elected officials. Quiltmakers have a long history of generosity, giving quilts as gifts of commemoration or to comfort those in need. But what was the symbolic heft of these quilts? Some were overtly concerned with electoral politics; others were more commemorative as they attempted to honor and celebrate the Roosevelts in imagery. Although these quilts were likely not created merely as bedcovers and indeed likely never saw everyday use, within American society quilts were understood as objects tied to cherished life milestones, such as birth, marriage, and death. As such, quilts were intimate gifts made by hand and often with love, rather than formal, sterile objects. To the makers, they likely were an outlet to feel closely connected to the President and First Lady, and a comfort to the maker more so than to the recipient.

The FDR Library has nine quilts in its collection, some of which were given as gifts, including this Donkey Quilt, commemorating Roosevelt's victory in the 1936 election over Republican Alfred M. Landon of Kansas (fig. 6-14). Embroidered on the stars are the names of the forty-eight states and the number of electoral votes each cast. The total number won by the President is embroidered in the center, along with the words, "In Honor of Franklin D. Roosevelt," while the number won by Landon appears in the bottom border, between the stars for the only two states that went Republican. Sadly, the maker is unknown, yet their allegiance to the Democratic Party and Roosevelt Administration is clear, since the quilt commemorates FDR's sweeping

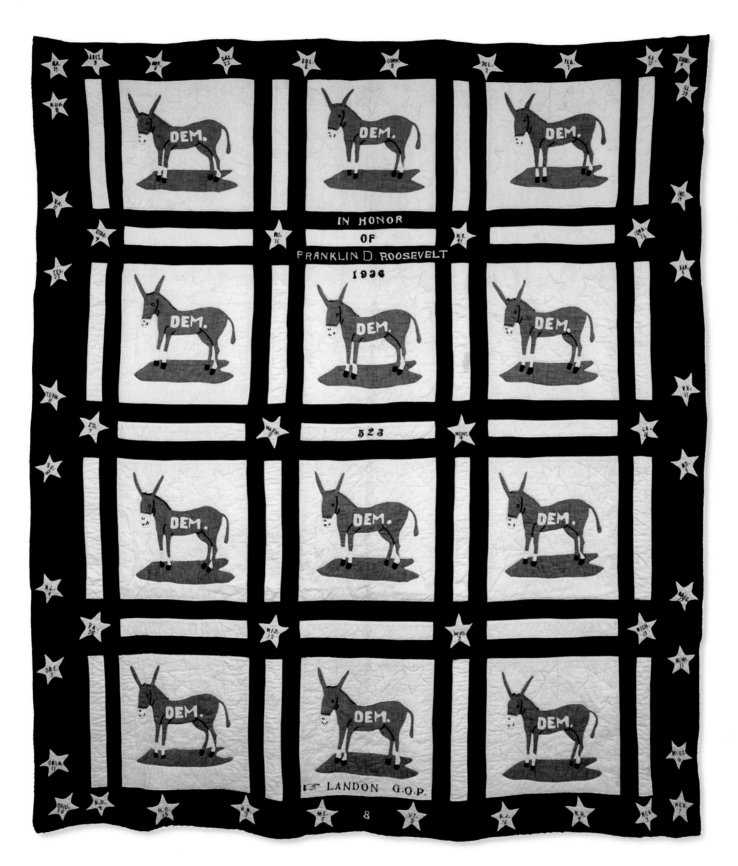

Fig. 6-14. Unidentified maker, Democratic Donkey Quilt, 1936. Image courtesy of the Franklin D. Roosevelt Presidential Library and Museum, MO 1941.10.53.

Fig. 6-15. Maker unidentified, Giddap, A Very Democratic Donkey, *possibly made in Illinois, 1940-1950. International Quilt Museum, Ardis and Robert James Collection, 1997.007.0476.*

Fig. 6-16. Maker unidentified, Original design, possibly made in Kansas, c. 1936. International Quilt Museum, Ardis and Robert James Collection, 1997.007.0488. The purple cloth features the logo of the Landon/Knox 1936 presidential campaign, shown in the detail in Fig. 6-17.

Fig. 6-17. Detail, original quilt in Fig. 6-16. International Quilt Museum, Ardis and Robert James Collection, 1997.007.0488.

reelection and the presumed continuation of New Deal policies. Politically inspired donkey quilts first appeared prior to the 1932 election, with the *Kansas City Star* publishing the pattern, "Giddap, A Very Democratic Donkey," (fig. 6-15), as well as Ararat the Swope Park elephant, in its pages in the year leading up to the election.[55] Quiltmakers also supported Republicans, including Landon. A piece of fabric with the sunflower logo of the Landon/Knox campaign from 1936 peeks out of a modernist quilt attributed to a Kansas maker (fig. 6-16 and 6-17).

Fig. 6-18. Callie Jeffress Fanning Smith, Eleanor Roosevelt Portrait Quilt, 1940, Franklin D. Roosevelt Presidential Library and Museum, MO 1953.1090.

Another quilt presented to the Roosevelts in 1940 honored Eleanor, rather than the president. Callie Jeffress Fanning Smith, a prize-winning quiltmaker from Sulpher Springs, Texas, mother to four and wife to a farmer, was around fifty-five years old when she sent Eleanor the quilt (fig. 6-18). Distinct in its technique, the quilt features painted and embroidered blocks depicting scenes from Eleanor's life, from childhood to the present day.[56] In the letter Smith sent to Mrs. Roosevelt with her quilt, she began in her perfect cursive script, "I have thought for two years that I would like to make a quilt for you. I am only an amateur artist." She went on, "To say that I admire you tremendously is only saying it mildly. I will say that it is a feeling of great pride to me that I am living today during your time." After recounting to Mrs. Roosevelt details about her family and life in Texas, she continued, "Will you please accept my 'small gift'?—I know that my brush does not have the perfect touch that was in my mind and heart, but you will, some how, know that I wish that I could make something very beautiful for you." She expressed her admiration not only for Eleanor but also the President, writing, "I truly hope that President Roosevelt will be our President for another term. I see no possibility of him not being elected, if he chooses to run again... we have got so used to President Roosevelt that we would have to begin all over again—to try to believe that some one else could fill the place that he holds in our hearts and our lives. And *you* equally as much, my wonderful lady."[57]

Although Smith does not mention specific New Deal programs or ways in which her family had benefitted, she clearly felt a deep personal connection to the administration and to the Roosevelts specifically, which she expressed through her quilt. Quilts were closely associated with family, warmth, and comfort, and used in intimate domestic settings. These connotations reflected the relationship the Roosevelts had to their loyal constituents. The President's Fireside Chats delivered over the radio famously helped create this sense of community and connection, cementing himself in American minds as the ideal leader to usher them through this trying time, as citizens listened to his voice streaming into their living rooms. Public opinion polling was a new science, yet in January 1941, a year after Smith sent Eleanor her quilt, FDR's approval rating topped 70 percent. Smith was not alone in feeling a particular affinity toward the First Family.[58]

In addition to the few quilts now in the FDR Library collection, local newspapers documented examples of quilts sent to the White House now with unknown whereabouts. For example, *Palm Beach Post* published a short dispatch on a Poinsettia quilt with flower blossoms spelling "Florida" along with a matching bath mat made by the women of the Lakeland, Florida, WPA sewing room, referred to as a "work of art" by the local journalists.[59] A 1935 Associated Press account reported that "a group of women on relief in Coleman County, Texas" sent a quilt via Senator Tom Connally, Democrat of Texas, to the White House, which "graced the bedroom of President Roosevelt today."[60]

In articles circulated by the Associated Negro Press, several African American newspapers highlighted the postage stamp quilt designed by Estella Nukes of Marion, Indiana. The quilt featured the initials "F.D.R." and was stitched by a WPA sewing class. After its display at department stores in Fort Wayne and Indianapolis, Nukes sent the quilt to the White House in hopes that it would be displayed on the Roosevelt Christmas tree.[61]

Still other quilts sent as gifts to the Roosevelts are known only through the correspondence related to them. This is the case for a quilt made by African American women working with the WPA in Snow Hill, Florida. Although the quilt is not in the Roosevelt Library collection, the archive has a letter from the chair of the local advisory committee of the WPA on behalf of the Negro Homemaking Class, presenting a bedcover "as a token of deep gratitude and appreciation for the timely help and the new hope which your practical social and economic program has brought to many of your people." In addition to documenting this quilt's existence, this letter offers a rare glimpse of the motivation for sending quilts to the Roosevelts. The president's private secretary sent a thank-you note in return, acknowledging "your courtesy in the presentation of that beautiful quilt" and the Roosevelts' "cordial appreciation of the kind thought which prompted them to send this fine product of their work."[62] The text of the letter accompanying the quilt listed Melissa Bacon as the teacher of the homemaking class. According to federal census records, at the time of this quilt's presentation, Bacon was fifty-six. She was not formally educated beyond the second grade, and was listed as without an occupation in both the 1930 and 1940 censuses, yet in 1936 she worked as a federally employed teacher for the WPA.[63] Although New Deal programs were far from colorblind amid the entrenched racism of the era, particularly in the Jim Crow South where few Black citizens could even exercise their right to vote, such opportunities and governmental support were an essential factor leading many African Americans to switch political allegiance from the Republican Party of Lincoln to the Democratic Party of the New Deal coalition.[64] As the letter to the Roosevelts suggests, Bacon and her group of WPA

quiltmakers—disenfranchised Black women—may have considered this gift of a quilt as symbolic support for Roosevelt's reelection effort in 1936.

Other correspondence from the White House reveals how such gifts were received, particularly from the perspective of the First Lady. While we know nothing of another quilt that generated a thank-you letter in response, Eleanor Roosevelt's signature closes a 1935 note addressed to Mrs. Jules Joseph Fischer (likely Agnes, a forty-five-year-old from Mountain View, California, according to 1940 census records). Mrs. Roosevelt wrote, "I was very much delighted to receive from Mrs. McGrath the quilt which you and all the other women so generously made for me."[65]

Quiltmakers also sent their stitched creations as gifts to other federal officials during the New Deal. Roosevelt's first vice president, John Nance Garner of Texas, received quilts honoring his elevation to the executive branch. Minnie Weeden Rucker of Franklin, Texas, a widow aged sixty-two, who in 1930 was a hotel proprietor, made her Texas Star quilt in 1932 (fig. 6-19), fittingly in the Lone Star quilt pattern. Embroidered around the blazing red, blue, and cream diamonds pulsating to form the star are the words "THE EYES OF TEXAS ARE UPON YOU," and "GARNER 1932 ROOSEVELT DEMOCRATS." Rucker sent the quilt to Vice President Elect Garner the day after the presidential election.[66] In 1936, in the midst of a reelection campaign, Garner received another quilt, this one created and presented by workers from the Nolan County WPA sewing room. It, and an identical Texas Centennial quilt given to John M. Hendrix, assistant director of the local branch of the WPA, featured a scale map of Texas depicting each county,

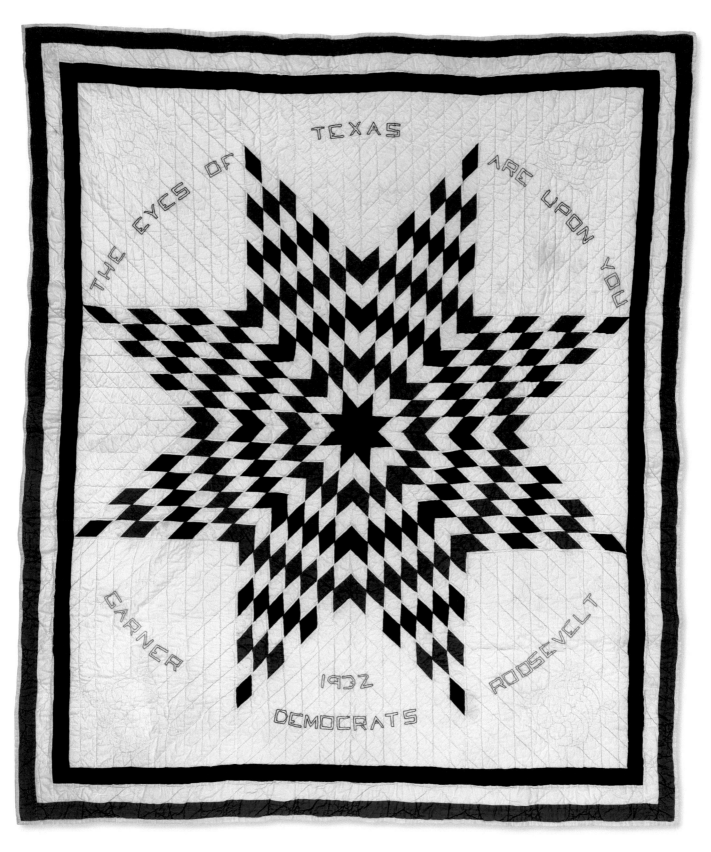

Fig. 6-19. Minnie Weeden Rucker, Texas Star, 1932. Winedale Quilt Collection, e_wqh_0468, The Dolph Briscoe Center for American History, The University of Texas at Austin.

Fig. 6-20. Mary Clara Milligan Kindler Moore, Rooster Quilt, *Huntington, Indiana, 1932-1933. Metropolitan Museum of Art.*

with appliqués of the Texas state seal, a longhorn, the Alamo, and the six flags of Texas.[67]

The symbolism of quilts with Eleanor or Franklin's face, or explicit references to electoral politics, is easy to decipher. Much less recognizable today as a political symbol than the elephant or the donkey is the rooster featured in the quilt crafted by Mary Clara Milligan Kindler Moore of Huntington, Indiana, to mark the 1932 election (fig. 6-20). The Democratic Party had adopted the rooster as its symbol in the nineteenth century, although it never became as standard as the donkey popularized by Thomas Nast beginning in 1870; the Party used the Rooster as a symbol on ballots in the Midwest, including in Indiana where Moore lived. Moore designed the quilt using a technique of piecing together small squares to form the figurative design, reminiscent of cross-stitch patterns that quilt designer and entrepreneur Anne Orr popularized in the late 1920s and early 1930s. Orr's designs, however, tended toward floral arrangements rather than political symbolism or farmyard animals. Moore added a large "X" above the single rooster, evidently indicating her desire to vote a straight democratic ticket.[68] Other more obscure animal references similarly signaled allegiance to Roosevelt, including ones featuring Scottie dogs, the favorite family pet.

Another quiltmaker executed a very cheery pastel hexagon quilt, using many of the Easter egg shades of fabric that were popular during the 1930s. At first glance, there is nothing political about this quilt's style. But its maker embroidered stitches compiling the election results for each of Roosevelt's victories in her bedcover, with each block featuring a state that voted to elect Roosevelt in 1932, 1936, and 1940 (fig. 6-21). The North Carolina Museum of History's object records state that the quilt was constructed at a craft shop in

Fig. 6-21. Detail, Unidentified maker, States That Elected Franklin Delano Roosevelt President in 1932, 1936 1940 Elections. *Photo Courtesy of North Carolina Museum of History.*

Pinehurst, North Carolina, rather than a homemade, domestic quilt, and was eventually given to Senator Kerr Scott (governor of North Carolina 1949-1953, Senator 1954-1958).[69]

EYES ON THE PRIZE

Some of the most innovative and novel quilts related to the politics and culture of the New Deal were created as submissions for the Sears National Quilt Contest in 1933 in conjunction with the Chicago Century of Progress World's Fair. Held in the midst of the Great Depression, novice, skilled, and professional quiltmakers entered over 25,000 quilts in the contest in hopes of winning the $1,000 grand prize (worth over $23,000 in 2023). Some makers submitted ordinary, everyday quilts using tried and true traditional patterns. Others entered original pictorial and abstract designs that innovatively fit the theme of

"Century of Progress," as described below. The grand prize-winning submission was entered by Margaret Rogers Caden of Lexington, Kentucky, who did not make the quilt herself.

Caden entered an exquisitely pieced, intricately stuffed and quilted, and otherwise very ordinary star design she called "Star of the Bluegrass." Caden and her sisters ran a quilt shop in Lexington that sold finished quilts and arranged for rural women to quilt customers' tops. Despite entering the winning submission in the contest, Caden did not make quilts herself. However, her name was on the contest submission for "Star of the Bluegrass," and following the contest her shop sold the pattern and the fabrics from the quilt. As later research revealed, Ida Atchison Rohrer pieced part of the quilt, Mattie Clark Black and her daughter-in-law Helen Black stuffed the quilt, and Allie Taylor Price and her daughters finished the piece with crosshatch quilting. Each of these women helped support their impoverished families by taking

in sewing during the Depression. Yet none of these rural Kentucky women received recognition, credit, or any of Caden's prize money, although two of them saved remnants of the quilt as evidence of their contributions. To top this story of deception, when Sears presented the prize-winning quilt to Eleanor Roosevelt as stipulated by the contest, Caden was not pleased, for unlike many quilters who sent quilts of their own labor to the White House as expressions of gratitude, Caden did not care for the First Lady.[70]

In contrast to Caden's very traditional quilt, others entered the Sears contest with highly innovative and symbolic quilts, set on winning the $200 bonus for an original design, equivalent to $4,500 in today's currency. Exemplary of these innovatively designed quilts is the entry (fig. 6-22) by Lillian Smith Fordyce, the forty-five-year-old daughter of Swedish immigrants, then a farmwife living in rural Gilmore Township in the corner of southwestern Pennsylvania near the West Virginia border. Fordyce's quilt

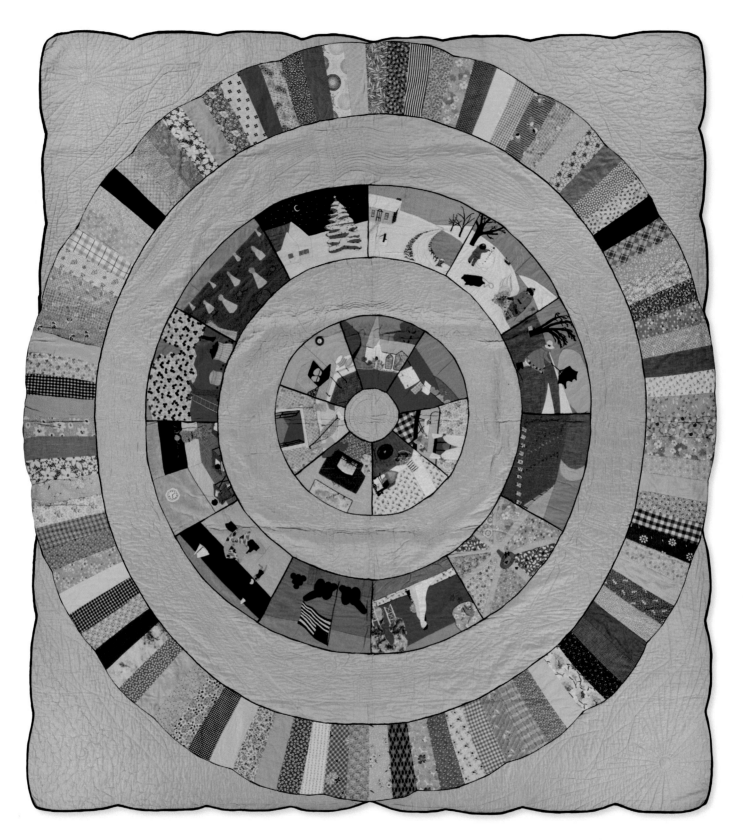

Fig. 6-22. Lillian Smith Fordyce, Calendar, Sears Century of Progress Quilt Contest Entry, probably made in Greene County, Pennsylvania, 1933, International Quilt Museum, Ardis and Robert James Collection, 1997.007.0915.

features a circular calendar that resembles a wheel of fortune. With three concentric rings, the smallest inner circle includes appliquéd and embroidered scenes from everyday life, including bread baking in an oven, an ironing board, and laundry hanging on a clothesline. The next ring features twelve keystones, one representing each month of the year, depicting seasonal vignettes, like a child building a snowman and an autumnal apple harvest. The outer ring resembles the popular Dresden Plate or Double Wedding Ring pattern, executed in cheery calico fabric strips in a charm quilt format with no piece of fabric repeated. Although we know little about Fordyce's life, we can assume she drew inspiration from the world around her, stitching what was familiar into the commemorative quilt.

Among the many originally designed quilts were several honoring President Roosevelt—inaugurated on March 4, 1933—indicative of Americans' admiration for the new president and their optimism for his administration. One featured blue embroidery celebrating some of the inventions of the prior century, with "FRANKLIN D. ROOSEVELT 1933" and "ANDREW JACKSON 1833" framing the composition. Another quilt made by Fanny and Charles (Stegan) Normann of Texas featured an elaborate appliquéd and embroidered reproduction of John Trumbell's painting *Declaration of Independence* featuring Founding Fathers gathered in Philadelphia. Flanking the scene is an oval comprised of individual portraits of each president. Almost as an appendix, the couple created a portrait of FDR, positioned directly below George Washington at the top of the oval. According to a letter Fanny wrote in 1986, her husband Charles worked as an artist in Austin, teaching art and making Old Master

painting reproductions that he sold for three dollars each in the years prior to the market crashing. The Normanns stitched away at their quilt for eighteen hours a day for three months, while caring for a baby daughter, finishing the piece six weeks after FDR's inauguration. Although the couple did not win the Sears contest—Mrs. Normann noted that "somehow our quilt was barred from entering the contest we'd made it for"—their quilt eventually won second prize at the Dallas fair. When the *Austin American-Statesman* reported on the quilt, the journalist quipped, "Normann may received [sic] a 'new deal' in his art ambitions."[71] For quiltmakers like the Normanns, entering the Sears contest with its potential of winning $1,000 plus the $200 creativity bonus was indeed taking a chance on their own new deal and ticket out of the Depression.

Another couple similarly collaborated on a historically minded quilt, researching at their local library to find images of notable figures including Thomas Edison, Abraham Lincoln, Charles Lindbergh, and FDR. Linda Rebenstorff, who designed and executed the quilt along with her husband Clarence, recalled that Roosevelt's face was easy to recreate in cloth because he had few wrinkles, in contrast to Edison. The overall composition of the quilt featured inventions spanning the "century of progress" leading up to 1933, including innovations in home appliances, lighting, transportation, and architecture (fig. 6-23).[72] Although the Rebenstorffs' perspective on FDR and the New Deal is unknown, by adding the president's portrait to the commemorative quilt they signaled their admiration and support.

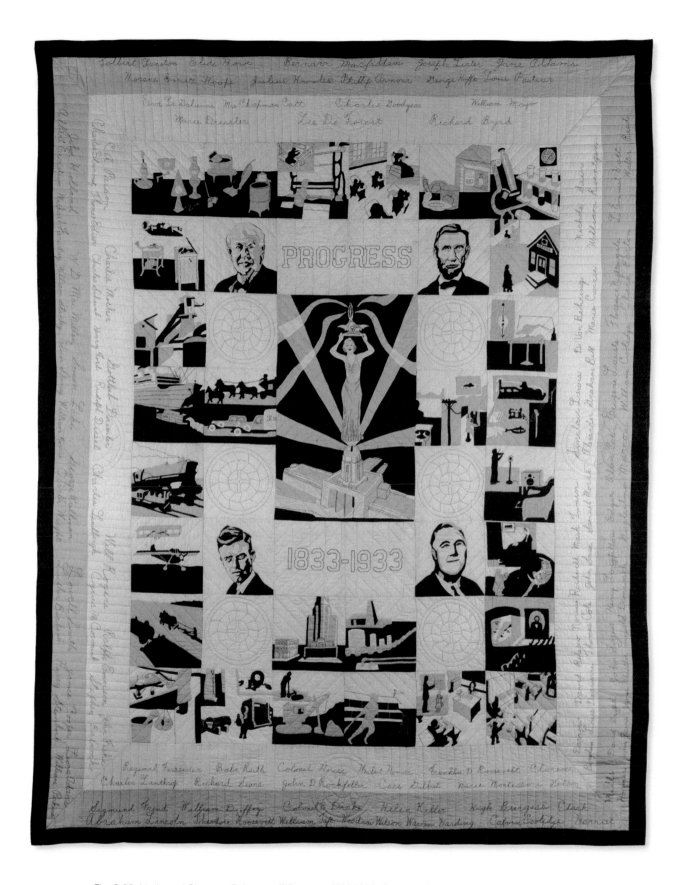

Fig. 6-23. Linda and Clarence Rebenstorff, *Progress 1833-1933, Century of Progress contest submission, 1933.* Image courtesy of Merikay Waldvogel. FDR's appliquéd face appears to the right of "1833-1933."

COMMERCIAL PATTERNS

As these examples of quilts suggest—some commonplace, some wildly innovative, some with clear symbolism—making quilts to support the efforts of New Deal programs and as expressions of support and gratitude for the Roosevelt Administration was a widespread, grassroots effort rather than a coordinated and uniform one. Yet the vast quilt industry that published thousands of patterns and sold thousands of kits, also resulted in quilts celebrating the Roosevelts and the New Deal. Perhaps the most widely disseminated of these was the Roosevelt Rose quilt pattern designed by Ruth Finley, despite its lack of an overtly political message.

By the early 1930s, Ruth Finley had already established her reputation as an expert on American quilts. When she published *Old Patchwork Quilts and The Women Who Made Them* in 1929, she solidified her status as a leader of the Colonial Revival, the architecture and decorative arts movement that celebrated—and attempted to mimic—the United States' colonial past. Like other enthusiasts of historical American quilts, Finley was intrigued with quilt pattern names, and she wrote extensively about how these pattern names related to American history.[73] This was a common Colonial Revival practice that likely included some imaginative inventing of patterns names. In a 1934 article in *Good Housekeeping*, Finley noted patterns purported to recognize presidential politics from decades earlier, including "Washington's Own," "Jackson's Victory," and "The Dolly Madison Star."[74]

In 1933 Finley designed the pattern, Roosevelt Rose (fig. 6-24), even though she was not a quiltmaker, and instead promoted old quilts and their history to audiences across the country. Newspapers celebrated

Fig. 6-24. *"The Roosevelt Rose—A New Historical Quilt Pattern," by Ruth Finley, published in* Good Housekeeping, *January 1934.*

Finley's quilt pattern as the first one named after a president since Lincoln, no doubt a message that Finley encouraged herself, and a detail that was not accurate.[75] The quilt had no figurative connection to the Roosevelts, nor did it relate to any specific aspects of FDR's policies or politics. Rather, it was a simple feel-good message that harkened back to the patriotic pattern names that Finley loved to lecture and write about that connected the cheery design to the popular president in an effort to sell more patterns. Finley stated that she designed the quilt as a means of reviving the handiwork traditions she perceived to have originated in the colonial and pioneer eras, aiming "to capture ... something of the atmosphere of colorful simplicity that was the charm of the old-time quilts" and reviving a "peculiar and paramount tradition—the creation and naming of new designs in honor of events

political, economic, and social."[76] To further promote the pattern, *Good Housekeeping*'s editor, Helen Koues, presented a Roosevelt Rose quilt to Eleanor Roosevelt in a ceremony written about by the International News Service and the Associated Press."[77]

Like many Colonial Revivalists, Finley's understanding of the colonial era was not entirely accurate, but those details did not matter when it came to a quilt's power to communicate symbolically. Finley wrote that her inspiration for the design was the "peak of quiltmaking art ... the stuffed and padded quilts of the eighteenth century." However, such stuffed quilts, which featured stitching to outline motifs that were stuffed with cotton to appear three-dimensional, used an excessive amount of thread and only became common once industrial processes enabled the production of inexpensive cotton thread around 1810. Most padded and stuffed quilts date from around 1800 to the 1860s, with a revival of the technique occurring among some of Finley's Colonial Revival quilting contemporaries in the 1920s and 1930s.[78] Unlike the nineteenth-century stuffed quilts with white backgrounds and printed floral chintz cut into appliqué motifs, Finley's modern variation featured a black ground with a playful wreath and stuffed appliqué flowers. *Good Housekeeping* described the quilt as "a rectangular wreath of fantasy flowers appliquéd in gorgeous bas-relief. A great variety of brilliant calicoes were used for the flowers of the wreath against a background of black sateen. The quilt was lined and corded with lipstick red."[79] With Finley's finger on the pulse of contemporary quilting trends while simultaneously drawing inspiration from both the politically themed quilts and the techniques of the nineteenth century (despite her inaccuracies), the resulting Roosevelt Rose had a modern aesthetic and historical flavor.

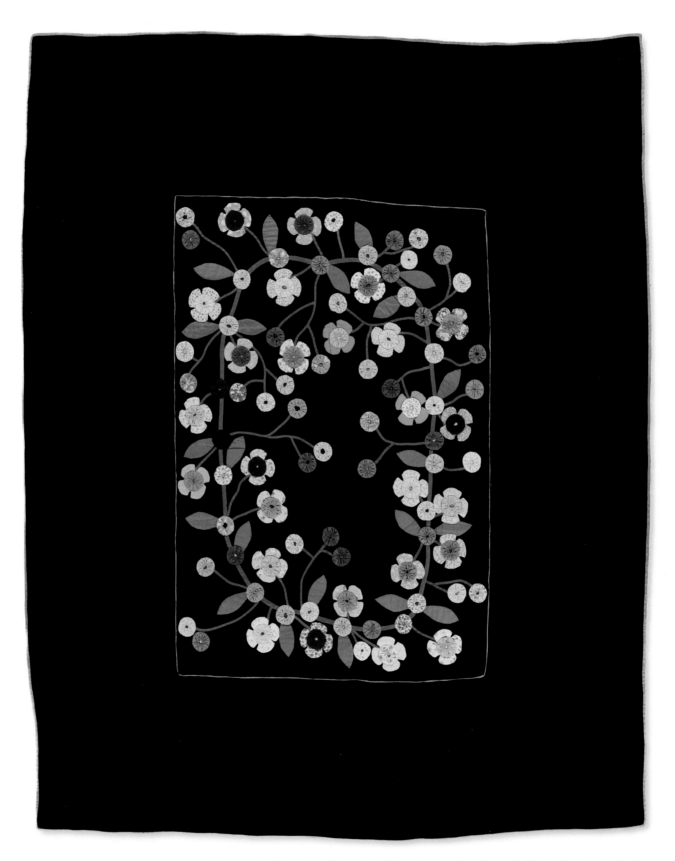

Fig. 6-25. Maker unidentified, Roosevelt Rose, *probably made in Missouri, c. 1934, pattern designed by Ruth Finley. International Quilt Museum, Given in memory of Sharon Lea Hicks Newman, 2005.048.0001.*

Fig. 6-26. Unidentified maker, Franklin D. Roosevelt, *pattern published in "Mark Current Events in Your Quilts,"* Kansas City Star, *January 27, 1934. Courtesy Roosevelt's Little White House State Historic Site.*

With both Eleanor Roosevelt and Ruth Finley calling for a quilt revival amid the Depression, women heeded their call and made quilts in the *Roosevelt Rose* pattern (fig. 6-25). *Good Housekeeping* sold copies of the pattern for twenty-five cents each, and in April 1934, *The Chicago Daily Tribune* published the pattern in its Nancy Cabot quilt column, offering, as it typically did for its published patterns, to send it to readers who mailed in five cents in stamps or coin. Girl Scouts in Washington, D.C., welcomed the First Lady to a meeting at which they executed their version of the pattern.[80] Extant versions of this historically influenced quilt pattern have ended up in museum and private collections. Minnie Pearl Barrett of Bristol, Connecticut, won a first place ribbon for her variation of the *Roosevelt Rose* and eventually passed it down to her granddaughter who registered

with the Connecticut Quilt Search Project.[81] Others are housed in the Illinois State Museum, the International Quilt Museum, and at the FDR Presidential Library Museum.[82] And just as Finley called for, still other publishers offered patterns in names that evoked the First Family, including a *Kansas City Star* pattern called Franklin D. Roosevelt (1934) and another called Roosevelt's Bow Tie (unknown date). The *Star*'s 1934 pattern in honor of FDR's birthday on January 30 called on quilters to "Mark Current Events in Your Quilts" and featured a block commemorating Warm Springs (fig. 6-26), the natural springs site in Georgia, home to the "Little White House," where Roosevelt frequently spent time to treat his paralysis from polio. A month after FDR's death in 1944, the *Star* published a pattern to memorialize him called Pres Roosevelt.[83]

EMPOWERED BY QUILTS

It's no surprise given quiltmaking's popularity during the 1930s that so many quilts celebrate various aspects of the New Deal and the Roosevelt administration. But how did this material outpouring of quilts ultimately empower the makers, who each experienced the Great Depression from their own distinct vantage point? Quilts certainly were a solace amid trying times, but the act of making a commemorative or political quilt or, taking it a step further, sending it to the White House, was more than just a cozy balm for the hard times Americans faced.[84] Making a quilt takes real time or, in the words of Ella Martin, the West Virginia maker of the Blue Eagle quilt described above, "real sacrifice from the hands." The physical labor of quiltmaking was part of the balm itself, a necessary distraction from burdens of the exterior world. In addition to labor, quilts, particularly some of the elaborate original designs described above, require creativity and planning; these are time-consuming tasks that doubled as an outlet for pent-up energy and excess leisure time. Ultimately many quiltmakers may have shared Martin's desire to make a "cover for the nation."[85] With these intentionally communicative objects, quilts' symbolism as a physical comfort extended beyond warming one's own family to an attempt to warm and comfort the collective suffering of a nation.

hal

Ruth ~
Flag B

Mabel Beckwell
Oracle

ASST.
MARSHAL

RE

H. Nix

m. J.

Independent Camp 10559
Alliance
Nebr.

Amy Broich
Dist. Deputy

RO

Ruth Seh

Lou Wythenf

Fig. 7-1. Maker unidentified, Album, *made in the United States, 1920-1940. International Quilt Museum, Ardis and Robert James Collection, 1997.007.0196.*

CONCLUSION
NEW DEALS FOR QUILTS?

What, if anything, was new about quilts during the New Deal? Did the New Deal, in fact, transform American quilts and quiltmaking the way it transformed so many other aspects of American life? Quiltmaking undeniably changed during the Great Depression, and the federal government's relief, recovery, and reform efforts no doubt shaped a number of aspects of how Americans understood quilts and how they participated in the craft of quiltmaking. Although the "Revival of the Patchwork Quilt" was already underway in 1929 when the stock market crashed, the Great Depression and ensuing New Deal led to a transformation in American quiltmaking and its symbolic meaning, making a new deal for quilts.[1]

Prior to the economic downturn of the 1930s, quilts were predominantly a product of thrift in the American imagination, with some exceptions, rather than a true salvage art. Once fabric became affordable, quiltmakers preferred to use abundant new factory-produced cloth to make their bedcoverings (and the quilts of colonial America were true luxury items, as were most precious textiles).[2] But because many Americans perceived quilts as the ideal old-fashioned make-do craft—that seed had already been firmly planted via the popular press, including by quilt experts like Ruth Finley—they embraced it with a new drive and mission during the New Deal. Now, the thrifty scrap bag made very good sense, and making quilts from recycled cotton sacks, leftover commodity cotton provided by the government, or other bits and pieces became a moral imperative, a means to keep one's family warm at night as well as a symbolic act that demonstrated one was doing their part to persevere during these trying times (see fig. 7-1). Government-funded initiatives, including Works Progress Administration (WPA) sewing rooms, home economists that staffed community centers at migratory labor camps, and the Tennessee Valley Authority's "home beautification" project each aimed to instill in women a pride in thriftiness by encouraging the production of quilts, making the myth of the make-do assemblage quilt a reality. During the Great Depression, quilts became the salvage craft imagined by the Colonial Revivalists.

During this era quiltmaking also transformed into a vocational aspiration for many poor American women. Aspects of American quiltmaking have long related to business and industry, as the nineteenth-century

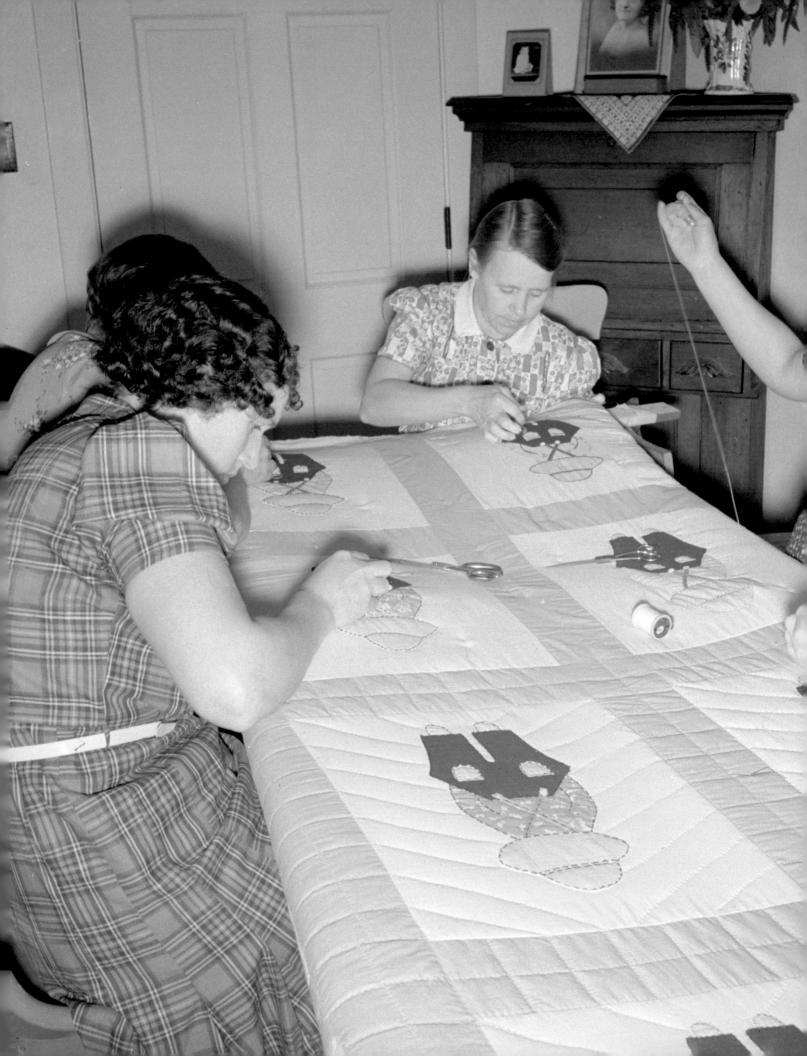

popularity of quilts—the "democratic art"—was made possible due to factory-produced cloth and commercially published patterns.[3] Yet during the New Deal, American women who had few other means of getting by turned to quiltmaking as a potential livelihood. For some, this meant attempting to sell the quilts they made at home. For women who qualified, it meant wage labor in a WPA sewing room or handicraft project, venturing perhaps for the first time into a workplace outside the home. And still others pinned their hopes for striking big on contests, like the ones Mary Gasperik, the maker of the *Road to Recovery* quilt (fig. 0-4), entered, hoping for both prize money and recognition for skilled needlework. Although few quiltmakers may have been able to achieve the dream of quilt entrepreneurship—especially those who attempted to transfer their WPA sewing room skills to private industry—some did find success by designing the ubiquitous patterns published in syndicated newspaper columns, and others living in Appalachia were able to find work in quilt cottage industries. Quilts became commodities during the New Deal as well; women laboring to make quilts to sell needed consumers. The home economist in charge of marketing handicrafts in Tennessee stated, "You don't have to make it like you like it—you have to make it like the person who buys it likes it."[4]

In addition to their status as commodities, quilts also became directly associated with relief efforts during the Great Depression. Newspapers reported on the great volume of quilts and comforters sent by WPA sewing rooms to flood victims. And on a smaller scale, women like the members of the Helping Hand Club pictured in figure 7-2 worked together to make quilts to support one another, while Farm Security Administration (FSA) Migratory Labor Camp residents made sure each new family had quilts to

Fig. 7-2. Dorothea Lange, Farm women working on quilt. Near West Carlton, *Yamhill County, Oregon, 1939, Farm Security Administration, Library of Congress.*

cover their beds upon their arrival at camp. Giving quilts as gifts was not new in and of itself, but the needs of Americans were far greater during the Great Depression and thus so were the benefits of mutual aid. No longer were quilts merely beautiful gifts that symbolically marked community ties; they were necessary and comforting covers that provided both warmth and solidarity.

For African Americans living in the rural South, a new deal for quilts certainly transpired. In small communities like Gee's Bend, Alabama, communities of quilters had been making quilts, often in relative isolation from the outside world, and often reusing bits and pieces of old clothing, even while many other quiltmakers relished using new factory-produced fabric. When FSA supervisors, home demonstration agents, and other home economics experts arrived in sharecropping enclaves and other rural areas with African American residents, they brought with them commercially circulating quilt patterns and gave advice about ways to standardize quilt design and production. These government employees also introduced new supplies and technologies, like the sewing machines National Youth Association girls learned how to use in Gee's Bend (Fig. 4-16), the tulip pattern Minnie Benberry and some of her neighbors received to make quilts (fig. 4-1), and perhaps the factory printed "cheater cloth" quilted by the woman stitching in Jack Delano's smokehouse photograph (fig. 2-15). It's difficult to assess the exact ways in which African American quilts changed as a result of the New Deal, but the presence of governmental workers and their advice added to the swirl of influences that individual quiltmakers adopted and adapted.

It would be decades later that quilt enthusiasts began to fully appreciate the creative outpouring from

African American quiltmakers, but it is through FSA photographs and Federal Writers' Project narratives that the world outside communities like Gee's Bend had some of their first glimpses of these quilt traditions. Although the Index of American Design (IAD) may not have resulted in the widely distributed portfolios of screen prints the WPA intended to serve as a design resource, the IAD did elevate the status of quilts and other folk art through its exhibitions and publicity, which typically featured examples of painted renderings of historical quilts. These records of individual quilts today serve as important sources for quilt history. The IAD also served as direct inspiration for the Quilt Index, an online database of individual quilts held by public and private collections, developed in the 1990s and launched in 2003.[5] Even if the Colonial Revivalists of the 1930s did not nail all the details of quilt history as they romanticized and guessed at aspects of it, the individuals who paid attention to old quilts during this era—Eleanor Roosevelt, Ruth Finley, Florence Peto, and the many IAD and FWP staff members who believed it was worth preserving the stories of quilts—continue to shape our contemporary appreciation and understanding of these objects. And how can we forget about the WPA employees who the federal government paid to create silk-screened prints of old quilt patterns, a prospect that seems completely foreign at the time of this writing in 2023?

As chapter 1 recounts, by the 1930s, Americans used the notion of a quilt to describe all sorts of haphazard, makeshift, or thrifty concepts. The New Deal's Soil Conservation Service sponsored a contest dubbed "crazy quilt farming" in which so-called dirt farmers who tended poor land without the help of hired labor showcased their skills in plowing curved furrows through Wisconsin farmland.[6] Many of the

resonant ideas we hold about the worth of quilts, and the related quilt metaphors we readily apply to non-patchwork concepts—otherwise worthless bits and pieces stitched together to form a harmonious whole—were solidified by the necessity of, societal and governmental pressure toward, and individual pride in thriftiness during the New Deal era.

Such a government-sponsored farming contest, as well as so many of the other New Deal programs and initiatives that aimed to uplift and inspire Americans with both low income and low morale, seem like impossibilities today. Despite the great outpouring of federal funding leveraged by 2020's Coronavirus Aid, Relief, and Economic Security (CARES) Act and 2021's subsequent American Rescue Plan Act to support Americans in the face of the COVID-19 pandemic, these allocations did not fund the kinds of programming the New Deal sponsored as part of the Federal Art Project, the WPA Handicraft Project, or the FSA's photography efforts. Artists, writers, and other cultural workers have called for such initiatives, with noted African American author Clint Smith suggesting a modern-day oral history project inspired by the FWP's ex-slave narratives that would document the lives of Black Americans.[7] Eventually a few elected officials concurred.

In May 2021 California Representative Ted Lieu (D, CA-33) and New Mexico Representative Teresa Leger Fernández (D, NM- 3) introduced the 21st Century Federal Writers' Project Act, a piece of legislation that, if passed, would have created a Department of Labor "grant program to provide eligible entities with funds to assist individuals who are unemployed or under employed in order to document in writing and images American society and the broad impacts and effects of the COVID-19 pandemic in the United States." It explicitly modeled itself on the New Deal, with the bill's introductory text explaining that "in 1935, during the Great Depression, President Franklin Delano Roosevelt established The Federal Writers' Project of the New Deal Era. This program was organized to employ writers, editors, historians, researchers, journalists, librarians, broadcasters, photographers, and others to document American society."[8] As Scott Borchert noted in *The New York Times*, in this proposed project out-of-work cultural workers would "assemble, at the grass-roots level, a collective, national self-portrait, with an emphasis on the impact of the pandemic," with an aim to "revitalize and repurpose portions of our existing cultural infrastructure." The resulting cultural products, in whatever form they took, would be archived at the Library of Congress, just like many of the New Deal primary sources to which I have turned to write this manuscript. As Borchert imagined, "The project's documentary work would make an invaluable contribution to the nation's understanding of itself. Think of the vast treasury that would accrue ... forming an indelible record of how ordinary Americans live: not only how we've weathered the ordeal of the pandemic and mourned the dead, but also how we work and relax, how we think about the burdens and triumphs of our pasts, how we envision the future."[9] After its introduction, the 21st Century Federal Writers' Project Act went nowhere. Notwithstanding the upheaval of the moment, there was no political will to create the kinds of big projects that were miraculously possible during the 1930s, with its own version of turbulent politics.

Despite the lack of a large-scale program like the FWP, the federal government has stepped in to fund projects through its arts and cultural agencies. The Quilt Alliance, a national nonprofit that documents

and preserves the stories of quilts and quiltmakers, received a 2022 Grants for Art Projects from the National Endowment for the Arts that includes funds earmarked to record interviews with African American and Native American quiltmakers, a project that harkens back to the FWP's Folklore Project, which asked narrators to recount cultural traditions. Although such initiatives are not created or administered by governmental employees directly, non-profits such as the Quilt Alliance have benefited from the federal government's continued—albeit often endangered—commitment to support arts and cultural programming.[10]

During the COVID crisis, when many American workers in industries where "working from home" was not an option lost their jobs, either temporarily or permanently, they received unemployment insurance only if they met particular qualifications and always at a fraction of the wages they had been earning. No Federal Emergency Relief Act or Works Progress Administration swooped in to create jobs to sustain those who experienced the brunt of the sudden economic crash. Performing artists were among those who faced some of the hardest prospects because not only were they unemployed but due to social distancing mandates, initiatives like the New Deal's Federal Theater Project or Federal Dance Project were not possible. There were no in-person audiences to be found.

With the federal government providing only limited indirect support to artists and writers through funds earmarked for distribution by the National Endowment for the Arts and National Endowment for the Humanities, unemployed cultural and service workers turned to nonprofits and other entities outside of government to create opportunities for

uplift and wages.[11] Unsurprisingly, the mishmash of proposed solutions prompted continued use of enduring quilt metaphors. CNN referred to the network of nongovernmental safety nets as a "patchwork of civil society programs that weren't available in the Depression."[12] Critic and educator David Kipen, one of the driving forces behind the stalled 21st Century Federal Writers' Project legislation, predicted that if passed it "might just begin to unify our astonishing, divided, crazy-quilt country."[13] With the economic void left by the U.S. government's unwillingness to financially support furloughed workers in the ways that many European countries successfully did, arts and culture nonprofits stepped in to piece together a "cover for the nation," as Ella Martin described her National Recovery Act quilt.[14] Entities, including a coalition of arts and culture nonprofits, proposed a Cultural New Deal for cultural and racial justice while numerous other groups rallied to provide outlets for arts and culture to continue to thrive.[15]

In the face of COVID-19, quiltmakers responded. Many Americans—whether they have been at it for decades or learned how to make quilts during the pandemic—turned to their own scrap bags, or to use the vernacular of the twenty-first century's contemporary quiltmakers, their "stash."[16] With personal protective equipment, including masks, in high demand and low supply, quiltmakers turned their home sewing rooms into mask-producing factories, creating cotton masks from that stash for their own use, to give away, or sell over Etsy to raise money for COVID relief. Some, like Jayne Bentley Gaskins, used scraps from mask making in turn in their quilts (fig. 7-3). She wrote of her piece, *Remnants of Care,* which she submitted to an online auction sponsored by the Studio Art Quilt Associates (SAQA), a professional organization for quilt artists: "I organized a local group to make masks, and this

Fig. 7-3. Jayne Bentley Gaskins (Reston, Virginia), Remnants of Care, 2020. International Quilt Museum, Gift of the Robert and Ardis James Foundation, 2020.072.0003.

Fig. 7-4. Kathy Menzie, Something Wicked This Way Comes, *2020. International Quilt Museum, From the collection of Sandra Sider and donated by her, 2022.049.0001. Menzie's piece was juried into* Quarantine Quilts.

piece is constructed mostly of the remnants from that effort, plus a great deal of love and gratitude."[17] Here too, we see reflections of the past, as during the New Deal, National Youth Administration workers assigned to sewing projects similarly produced "all types of medical and surgical supplies."[18]

In addition to making masks, beginning during spring 2020, many quiltmakers began to make quilts that specifically addressed the challenges of the pandemic. In a juried exhibition called *Quarantine Quilts,* artists shared statements that only three years later reflect 2020's simplified collective understanding of the coronavirus and unawareness of what we would face in the subsequent COVID years. Among the quilts juried into the exhibit were some that figuratively resembled the ubiquitous graphical representations of the virus itself (fig. 7-4). Others embedded imagery that evoked the loneliness and uncertainty of those months, like the last roll of toilet paper at the supermarket, faces with eyes peering above masks (fig. 7-3), food deliveries to quarantining families, and various depictions of home—the spot where so many of us spent the bulk of our time.[19]

Over the course of months confined to home, others began making quilts for the first time. Such was the case for Sarah Steiner, who picked up quilting in 2020, learning from YouTube tutorials and advice doled out from experienced quiltmakers over Instagram, just as other confined citizens learned to bake bread or speak Italian. By the end of summer 2020, Steiner, who adopted the Instagram handle @pandemicquilter, had completed twenty quilts.[20] Art historian Jess Bailey also took up quiltmaking during the pandemic, because she was "spending a lot of time at home and really was looking for something to do that would kind of shake up my

relationship with art and making and how I wanted to think about the role of art in my life." Bailey, who goes by the online name @publiclibraryquilts, has made quilts on commission, although she has had less bandwidth for this as we collectively emerged from the dark years of the pandemic. She has developed several fundraisers involving quilts, including ones supporting gardening and food justice, school library book purchases on queer and trans subjects, and community arts and textiles groups. Along the way, she became a quilt celebrity, amassing over thirty-five thousand followers on Instagram, as have other quilting experts who have forged significant online communities during the remote COVID years.[21] Within the quilt industry, an ad-hoc online lecture series called Textile Talks developed, which has outlived social distancing mandates and continues to provide a home for remote public programming centered on quilts and textiles, producing live and recorded events interpreting quilts and quiltmaking while establishing a virtual community that has started each Zoom event with participants shouting out hellos from their international geographic locations.[22]

The motivations spurring pandemic quilters mirror those that women shared during the Great Depression. In the twenty-first century, quilts are decidedly not utilitarian objects; there was little necessity to supply quilts as warm bedcoverings to those suffering from COVID-19 other than as objects to provide beauty and comfort, soft covers for hard times, so to speak.[23] Particularly after the immediate urgency of supplying masks to alleviate the shortage, quilters turned to their craft for meditation, distraction, and to channel their energy into positivity amid crisis. Quiltmaker Lenny van Eijk recalled feeling like the news of the pandemic was "all consuming" and she felt "powerless about the chaos the world seemed

to sink into." In addition to journaling, she used quiltmaking to redirect her feelings and find "complete focus." She describes her piece *Pandemonium* from the *Quarantine Quilts* exhibition as reflecting "lessons in patience, accepting imperfections, and coping with anxiety."[24] Another artist, Natalie Skinner, notes that she "would meditate on every single line of stitching," taking "anxiety and stitch[ing] it out on this quilt."[25] While working from home, quilt artist Teresa Barkley opted to use the time she would normally spend on her commute on quiltmaking; she recalls that quilting helped her "mental health a great deal," echoing sentiments of Depression-era quiltmakers who also turned to quilts for consolation.[26]

In addressing another ongoing crisis, cultural and political movers, led by environmentalists, have called for a Green New Deal to confront impending climate change by expanding employment and economic opportunities within the renewable energy and related sectors, particularly among underrepresented minorities.[27] Its name alone is a direct reference to the sweeping actions the U.S. federal government took on during the 1930s and is indicative of the New Deal's enduring impact and position as a cultural and political touchstone. Many of the initiatives described in the framework outlining the form a Green New Deal might take have focused on improved infrastructure that would require training for new jobs aimed at mitigating damage to a warming planet. While no legislation has been codified in the United States or elsewhere under the Green New Deal moniker, in the years prior to the sweeping changes COVID-19 brought, the concept of a broad, multifaceted campaign backed by real dollars resonated with many Americans eager to see a transformed society, economy, and government centered on protecting the planet from the worst possible outcomes of climate change.

Within these conversations and calls to action were pleas to include the needs of the arts and cultural sectors in a Green New Deal. Among the voices advocating for this route was Ashley Dawson, a literary scholar and environmental humanist, whose essay "A Green New Deal for the Arts" draws on the successes of FDR's New Deal. Dawson asserts that a future Green New Deal "needs a cultural wing to change people's minds about where power should originate, to imagine a 'just transition' for workers and affected communities, and to rethink what constitutes a good life."[28] He looks to the Federal Theater Project (FTP), a division of the WPA's Federal Art Project, as a model for changing the hearts and minds of Americans in order to conjure the political will to carry out necessary policies. Theater historian Elizabeth Osborne similarly calls for a Green New Deal to adopt programs like the FTP, because "this level of social change requires the nation's extraordinarily diverse citizenry to buy in to such an enterprise. Theatre can help build empathy and understanding by sharing human stories."[29] As the preceding chapters demonstrate, quilts, too, can convey stories and elicit social change. Think about Fannie Shaw's *Prosperity is Just Around the Corner* quilt, or the empowering TVA quilts designed by Ruth Clement Bond, or the quilts made in various planned communities that showcased resilience and mutual aid. Could making quilts be part of the Green New Deal that critics like Dawson and Osborne envision?

With quilts no longer serving as direct forms of mutual aid in terms of utilitarian bedcovers, yet continuing to have heightened symbolic value, some quilt artists have positioned their work as activism. Somewhat ironically, quilts have become an apt vehicle for activists addressing hot-button and difficult issues, including climate change, police brutality, gun control,

immigration, and other current challenges.[30] Multiple artist-activists have described quilts as a quiet and comforting means to address these hard topics, because at first glance—or touch—quilts embody comfort and warmth, which can ease viewers in with a sort of calico revolution. This is what Alexis Deise has executed with her art; she describes her *American Quilts* series as "a meditation on the epidemic of gun violence in America," with quilts inspired by traditional American repeat block designs but carrying a weighted message through appliquéd silhouettes of firearms.[31] Renowned quiltmaker and curator Carolyn Mazloomi has long used quilts to tell stories, specifically accounts of African American experiences. These stories are often difficult to hear, and as such she asserts that a quilt is a "soft place to land when you have to tell a story. It's much more palatable to have a story sewn into the cloth of a quilt."[32] I imagine that Ruth Clement Bond, the designer of the powerful TVA quilts, likely felt the same. Although the women who stitched TVA, NRA, and WPA quilts may not have called themselves activists, the contemporary work of "craftivists" stands on the shoulders of these earlier generations of quiltmakers.

The current American political climate makes it difficult to envision a Green New Deal coming to fruition in the near term. Nevertheless, it's interesting and perhaps useful to imagine how quilts and quiltmaking could contribute to a set of legislation and initiatives aiming to slow down and mitigate the effects of climate change. Some quiltmakers, including Sherri Lynn Wood and Zak Foster explicitly view their art as an environmentally sustainable practice, choosing to use few newly manufactured products to make quilts and instead recycling clothing and other fabric. The Quilt Alliance focused its 2022 annual event "Quilters Take a Moment" on sustainability and quiltmaking, recognizing the impact quiltmaking and the larger quilt industry have on the environment and providing a forum for its discussion.[33] In contrast to the 1930s thrifty impulse toward reusing cloth to make quilts as a make-do practice in response to the economic situation, many contemporary quiltmakers do so as a deliberate artistic choice that also serves as an environmental practice responding to the impacts of twenty-first-century overconsumption.[34] Today's thriving quilt industry— with thirty-five billion dollars in sales in products such as quilting fabrics and threads, sewing machines, tools and notions, books and courses—has sustained the craft of quiltmaking, yet it also has a significant environmental impact due to cotton production's high use of chemical pesticides and fresh water.[35] With quiltmaking as part of a future potential Green New Deal, quilters and the quilt industry could help transition toward more sustainable practices, finding alternative production methods and using quilts to help create the cultural changes necessary to adapt to living amid climate change.

A Green New Deal could also adopt many of the 1930s New Deal practices of providing citizens with outlets to learn new skills and enjoy the company of neighbors. As the preceding chapters demonstrate, quiltmaking has the ability to help sustain community. It's no surprise that many of the federal programs' photographs of quilts include groups of people interacting over quilt frames or with individual sewing projects in laps. Throughout the Great Depression, people gathered over fabric and quilting frames, not merely to create bedcovers, but to lift morale by engaging with friends, family members, coworkers, and neighbors. We can practically hear the conversation of the three women around the table in the Los Angeles sewing room shown in figure 7-5 as their hands collectively touch the cloth

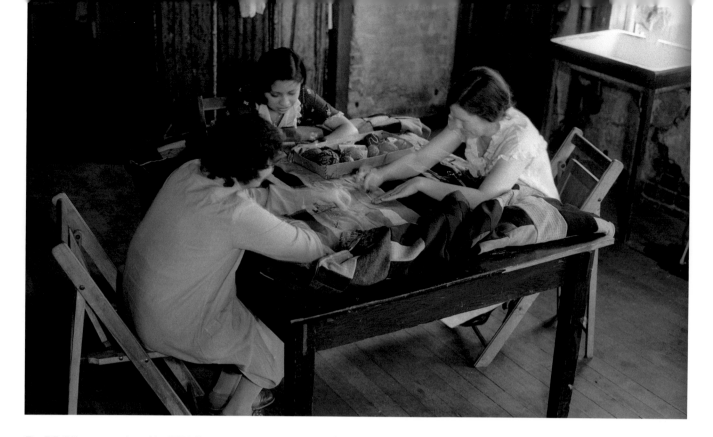

Fig. 7-5. *"Women employed by SERA [State Emergency Relief Administration] sew a quilt, Los Angeles"* c. 1934, Los Angeles Daily News. *Image courtesy of a Creative Commons CC BY 4.0 license, UCLA Charles E. Young Research Library, Department of Special Collections.*

in front of them. Similar scenes occurred around the country and throughout the Great Depression: in official governmental sewing rooms like this one, in home demonstration clubs, within specific groups like the Negro Women's Association at TVA's Pickwick Village or the Good Neighbors Club at the Marysville Migratory Labor Camp, at the Chicago municipal park where Mary Gasperik met regularly with the Tuley Park Quilting Club, in private homes like the one where Flora Colbox and her mother stitched quilts to sell for three dollars apiece, and in WPA classes taught by home economists.[36] Any substantive changes to society—especially wide-reaching ones like the New Deal ushered in and proponents of the Green New Deal aspire to—require individuals forming community to work together to improve the public good.

In the scheme of the New Deal as a whole, quilts only played a small role. But just as the quilts in temporary migrant housing softened the harsh experience of displacement and upheaval, so did quilts help ease in some governmental programs and policies that may have otherwise felt heavy-handed or intrusive. Quilts made life more comfortable, more beautiful, and more communal while allowing individuals and groups to express their frustrations, joys, loyalties, hopes, and aspirations in the face of tumult and strife. In this sense, it was not a new deal for quilts at all, as quilts—much more than mere bedcovers—have long empowered their makers and recipients in the face of adversity, in both myth and reality. Whether in our collective romanticized memory, covering our bodies as we sleep, or hanging on museum gallery walls, quilts are potent objects, and the U.S. government harnessed that power to relieve the impact of the Great Depression.

EXHIBITION
CHECKLIST

The following pieces, identified by their figure numbers, were included in the International Quilt Museum's exhibition, *A New Deal for Quilts*, October 6, 2023 – April 20, 2024.

Fig. 0-4

Mary Gasperik, *Road to Recovery*, made in Chicago, Illinois, 1939

Courtesy of the grandchildren of Mary Gasperik

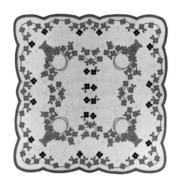

Fig. 1-2

Sarah Laughlin, Pink Dogwood, probably made in Guernsey County, Ohio, dated 1927

International Quilt Museum, Ardis and Robert James Collection, 1997.007.0737

Fig. 1-4

Maker unidentified, Grandmother's Fan, possibly made in the Midwestern United States, 1920-1940

International Quilt Museum, Ardis and Robert James Collection, 1997.007.0036

Fig. 1-7

Catherine Somerville, Britchy Quilt, made in Pickinsville, Alabama, 1930-1950

International Quilt Museum, Robert and Helen Cargo Collection, 2000.004.0116

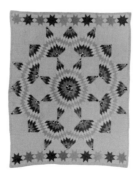

Fig. 1-8

Maker unidentified, Broken Star, possibly made in Arkansas, 1930-1950

International Quilt Museum, Ardis and Robert James Collection, 1997.007.0672.

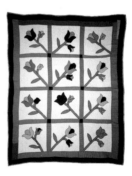

Fig. 4-1

Minnie Benberry, *WPA Tulip Quilt*, made in Kentucky, c. 1936

Cuesta Benberry Collection, Michigan State University Museum, 2008:119.3

Fig. 4-3, 4-6

Flour Sacks, 1930-1940

International Quilt Museum, Paul Pugsley Collection, Gift of the Robert and Ardis James Foundation, 2016.074.0078, 2010.042.0021

Fig. 6-8

Makers unidentified, *Oklahoma WPA Quilt*, made in Oklahoma, 1936

Michigan State University Museum, 2011.140.1

Fig. 6-10

Royal Neighbors of America, Album, made in Alliance, Nebraska, 1920-1932

International Quilt Museum, Gift of the Royal Neighbors of America, Rock Island, Illinois, 2016.057.0002

Fig. 6-11

Rose Marie Thomas, *Lazy Man*, designed by Ruth Clement Bond, 1934

Michigan State University Museum, 2011.147.1

Fig. 6-15

Maker unidentified, *Giddap, A Very Democratic Donkey*, possibly made in Illinois, 1940-1950

International Quilt Museum, Ardis and Robert James Collection, 1997.007.0476

Fig. 6-22

Lillian Smith Fordyce, *Calendar*, probably made in Greene County, Pennsylvania, 1933

International Quilt Museum, Ardis and Robert James Collection, 1997.007.0915

Fig. 6-24

Maker unidentified, Roosevelt Rose, probably made in Missouri, c. 1934,

International Quilt Museum, Given in memory of Sharon Lea Hicks Newman, 2005.048.0001

Fig. 7-1

Maker unidentified, Album, made in the United States, 1920-1940

International Quilt Museum, Ardis and Robert James Collection, 1997.007.0196

Fig. 7-3

Jayne Bentley Gaskins (Reston, Virginia), *Remnants of Care*, 2020

International Quilt Museum, Gift of the Robert and Ardis James Foundation, 2020.072.0003

ENDNOTES

PREFACE & ACKNOWLEDGEMENTS

1. L. P. Hartley, *The Go-Between*, Penguin Twentieth-Century Classics (Harmondsworth: Penguin Books in association with Hamish Hamilton, 1958), 1.

INTRODUCTION

1. Fannie B. Shaw, *Prosperity Is Just Around the Corner*, 1930-32, Dallas Museum of Art, https://www.dma.org/object/artwork/5320301/; Norma Bradley Buferd and Patricia Cooper, "Prosperity Is Just Around the Corner," *McCall's Needlework and Crafts*, Spring 1978; Virginia Avery, "Fannie B. Shaw Sews a History Lesson," *Quilter's Newsletter Magazine*, October 2002.

2. This and preceding Shaw quotations from Buferd and Cooper, "Prosperity Is Just Around the Corner," 104–6.

3. Thomas K. Woodard and Blanche Greenstein, *Twentieth Century Quilts, 1900-1950* (New York: E.P. Dutton, 1988), iv.

4. Lila MacLellan, "Adding a Layer of Nylon Stocking Could Make DIY Coronavirus Masks More Protective," *Quartz* (blog), April 25, 2020, https://qz.com/1845741/diy-coronavirus-masks-more-protective-if-enhanced-with-pantyhose/.

5. Taylor Dafoe, "The Famed Quilters of Gee's Bend Are Using Their Sewing Skills to Make a Face Mask for Every Citizen in Their Small Alabama Town," *Artnet News*, April 13, 2020, https://news.artnet.com/art-world/gees-bend-masks-1831854; Linda Hunter, "Quilters Are Cottoning to Face Mask Production," *The Buffalo News*, April 14, 2020, https://buffalonews.com/2020/04/14/quilters-are-cottoning-to-face-mask-production/.

6. *Final Report of the National Youth Administration, Fiscal Years 1936-1943* (Washington, 1944), 144, http://hdl.handle.net/2027/mdp.39015028687716.

7. "National Endowment for the Arts on COVID-19," National Endowment for the Arts, March 2021, https://www.arts.gov/about/nea-on-covid-19.

8. Merikay Waldvogel, "Mary Gasperik (1888-1969): Her Life and Her Quilts," The Quilt Index, 2008, https://quiltindex.org//view/?type=essays&kid=18-121-41; Merikay Waldvogel, "Mary Gasperik and the Tuley Park Quilting Club," The Quilt Index, 2005, https://quiltindex.org//view/?type=essays&kid=18-121-3.

9. Mary Gasperik, *Road to Recovery*, 1939, https://quiltindex.org//view/?type=fullrec&kid=18-14-98.

10. Susan Salser, "American Quilts Empowered Immigrant Women," The Quilt Index, 2011, https://quiltindex.org/view/?type=essays&kid=18-121-1.

CHAPTER 1

1. Carrie A Hall and Rose Kretsinger, *The Romance of the Patchwork Quilt in America* (New York: Bonanza Books, 1935), 28.

2. Sybil Lanigan, "Revival of the Patchwork Quilt," *The Ladies' Home Journal*, October 1894; Cuesta Benberry, "The 20th Century's First Quilt Revival (Part 1)," *Quilter's Newsletter Magazine*, August 1979; Cuesta Benberry, "The 20th Century's First Quilt Revival (Part 2)," *Quilter's Newsletter Magazine*, September 1979; Cuesta Benberry, "The 20th Century's First Quilt Revival (Part 3)," *Quilter's Newsletter Magazine*, October 1979.

3. Nancy Cabot, "Time Honored Art of Quilting Is a Rage of the Hour: Tribune Inaugurates New Pattern Service for Patchwork Devotees, 1933 Heirlooms Are Now Being Made Ready for Generations of Future," *Chicago Daily Tribune*, January 22, 1933, sec. PART 6.

4. Hall and Kretsinger, *Romance,* 28

5. "New WPA Projects Forbidden by Bell: Budget Chief Limits Relief Jobs to Those Which Can Be Completed by July 1," *New York Times*, March 14, 1936; Stephen Vincent Benet, "Patchwork Quilt of These United States: At Last We Have Guidebooks to All Our Commonwealths," *New York Herald Tribune*, December 28, 1941; John Drebinger, "String Run to No. 7 as Giants Top Cubs," *New York Times*, June 16, 1939, sec. Sports. Special thanks to my colleague Joe Navistsky for helping describe the language of quilting as part of the American vernacular.

6. *A Patch Work Quilt of Favorite Tales* (M.A. Donohue and Co., 1933), http://hdl.handle.net/2027/mdp.39015056467841.

7. *Source Material for the Industries of Colonial People to Accompany the Course of Study in Industrial Arts - Grades One to Four* (Philadelphia: School District of Philadelphia Department of Superintendence, Division of Industrial Arts, 1937), 35, http://hdl.handle.net/2027/uiug.30112105710500.

8. Robinson Godfrey Jones and Horace Mann Buckley, *Arithmetic Activities; Description of Arithmetic Activities Conducted at Gordon School, Formerly Curriculum Center for Arithmetic,* (Cleveland: [Cleveland] Division of Publication, Board of Education, 1931), 123–26, http://hdl.handle.net/2027/osu.32435016222200.

9. Marie D. Webster, *Quilts, Their Story and How to Make Them* (Garden City, N.Y.: Doubleday, Page & company, 1915); Ruth E. Finley, *Old Patchwork Quilts and the Women Who Made Them* (Philadelphia; London: J.B. Lippincott Co., 1929); Hall and Kretsinger, *Romance*.

10. See Virginia Gunn, "Perfecting the Past: Colonial Revival Quilts," in *American Quilts in the Modern Age, 1870-1940: The International Quilt Study Center Collections*, ed. Marin F. Hanson and Patricia Cox Crews (Lincoln: University of Nebraska Press, 2009), 228–86.

11. Merikay Waldvogel, "Marie Webster: The 20th Century's First Trendsetting Quilt Designer," *Vintage Quilts*, Spring 2001, https://web.archive.org/web/20060522230734/http://mccallsquilting.com/legacy/va04_article.pdf.

12. Webster, *Quilts*, 65–66.

13. Webster, 80.

14. Finley, *Old Patchwork Quilts*, 21, 22–23.

15. Finley, 21; Sally Garoutte, "Early Colonial Quilts in a Bedding Context," *Uncoverings* 1 (1980): 25; for more on early quilts and how they belie the myth of utilitarian scrap quilts see Carolyn Ducey, Christine Humphrey, and Patricia Cox Crews, "Introduction: American Quilts in the Industrial Age, 1760-1870," in *American Quilts in the Industrial Age, 1760-1870: The International Quilt Study Center and Museum Collections*, ed. Patricia Cox Crews and Carolyn Ducey (Lincoln: University of Nebraska Press, 2018), 1.

16. For more on this discussion see Robert Shaw, *American Quilts: The Democratic Art, 1780-2007* (New York, NY: Sterling, 2009), 20–23; Rachel Maines, "Paradigms of Scarcity and Abundance: The Quilt as an Artifact of the Industrial Revolution," in *In the Heart of Pennsylvania*, ed. Jeannette Lasansky (Lewisburg, PA: Union County Historical Society, 1986), 84–88.

17. For more on this and other myths see Virginia Gunn, "From Myth to Maturity: The Evolution of Quilt Scholarship," *Uncoverings* 13 (1992): 192–205, especially pages 195-96; Barbara Brackman et al., "Quilting Myths and Nostalgia," in *"Workt by Hand": Hidden Labor and Historical Quilts*, ed. Catherine Morris (Brooklyn, N.Y.: Brooklyn Museum, 2012), 26–30.

18. Marjorie Lawrence, "The Revival of an American Craft," *The American Home*, July 1929, 486.

19. Lydia Le Baron Walker, "Revival of Old-Fashioned Thrift," *Evening Star*, April 12, 1933.

20. Merikay Waldvogel, "Repackaging Tradition: Pattern and Kit Quilts," in *American Quilts in the Modern Age, 1870-1940: The International Quilt Study Center Collections*, ed. Marin F. Hanson and Patricia Cox Crews (Lincoln: University of Nebraska Press, 2009), 309.

21. "Quilt-Making Has a Revival: Farm Women of Midwest Busy With Patchwork," *New York Times*, October 17, 1937.

22. Barbara Brackman, "Nancy Cabot/Loretta Leitner: A Short History," *Material Culture* (blog), October 4, 2022, https://barbarabrackman.blogspot.com/2022/10/nancy-cabotloretta-leitner-short-history.html. The numbers for "scrap" and "colonial" quilts are based on a search of the ProQuest Historical Newspapers database.

23. Merikay Waldvogel, *Soft Covers for Hard Times: Quiltmaking and the Great Depression* (Nashville, TN: Rutledge Hill, 1990), 16. According to Barbara Brackman, Laura Wheeler patterns were published and marketed by a New York City company called Needlecraft Service and appeared in dozens of newspapers beginning in 1932. Wheeler was a fictional name, and the actual pattern designer remains unknown. "Laura Wheeler Patterns," *Material Culture* (blog), August 30, 2009, http://barbarabrackman.blogspot.com/2009/08/laura-wheeler-patterns.html. Research conducted by Wilene Smith determined that the Laura Wheeler quilt feature was syndicated by King Features Syndicate, a division of the Hearst Corporation. See Wilene Smith, "Laura Wheeler and Alice Brooks," *Quilt History Tidbits -- Old & Newly Discovered* (blog), January 6, 2015, http://quilthistorytidbits--oldnewlydiscovered.yolasite.com/laura-wheeler-and-alice-brooks.php.

24. "Here's Thrift--Scottie Quilt in Easy Laura Wheeler Applique," *The Daily Independent* (Elizabeth City, N.C.), June 30, 1937.

25. "Scrap-Bag Yield Makes Lovely Laura Wheeler Piece Quilt," *The Daily Independent* (Elizabeth City, N.C.), July 17, 1937.

26. "Be Gay--Get Out Your Scraps for This Laura Wheeler Quilt," *The Daily Independent* (Elizabeth City, N.C.), May 17, 1937.

27. "A Scrap Quilt by Laura Wheeler Glows with Room-Filling Beauty," *The Daily Independent* (Elizabeth City, N.C.), January 5, 1937.

28. "This Laura Wheeler Quilt Is Economical to Make," *The Shreveport Journal*, September 10, 1936.

29. Russell Lee, *Southeast Missouri Farms. Customers Examining Yard Goods in Cooperative Store. La Forge Project, Missouri*, 1938, https://www.loc.gov/item/2017781101/; United States Farm Security Administration, *La Forge Farms* (Washington: Farm Security Administration, 1940), http://archive.org/details/laforgefarms00unit.

30. While it is impossible to estimate with any certainty the number of quilts made during the Great Depression/ New Deal era, the Quilt Index, quiltindex.org, a multi-institutional database of quilts surveyed as part of state and regional quilt documentation projects and quilts held by cultural heritage organizations has 13,082 quilts dated between 1929 and 1940. The International Quilt Museum, home to the world's largest publicly held collection of quilts has over 250 from this era. And the well-documented 1933 Sears Century of Progress quilt contest had 25,000 quilts entered. Quilting was popular.

31. Waldvogel cites these patterns as ones that became "classic quilt designs" during the Depression because of the patterns' wide distribution. *Soft Covers for Hard Times*, 23.

32. Barbara Brackman, "Frugal and Fashionable: Quiltmaking During the Great Depression," *The Quilt Index*, 2011, http://www.quiltindex.org/essay.php?kid=3-98-6; Barbara Brackman, "Factory Cutaways and Quilts," *Material Culture* (blog), October 28, 2013, https://barbarabrackman.blogspot.com/2013/10/factory-cutaways-and-quilts.html; Barbara Brackman, "Fabric Retailing: Factory Cut-Aways," *Material Culture* (blog), October 15, 2013, https://barbarabrackman.blogspot.com/2013/10/fabric-retailing-factory-cut-aways.html.

33. Joanne Cubbs, "A History of the Work-Clothes Quilt," in *Gee's Bend: The Architecture of the Quilt*, (Atlanta, GA: Tinwood Books, 2006); Lisa Gail Collins, *Stitching Love and Loss: A Gee's Bend Quilt* (Seattle: University of Washington Press, 2023).

34. For more on African American quilts, including debates about distinct design characteristics of improvisational scrap quilts and other styles of quiltmaking often attributed to African American makers, see Cuesta Benberry, *Always There: The African-American Presence in American Quilts* (Louisville, KY: Kentucky Quilt Project, 1992); Teri Klassen, "Representations of African American Quiltmaking: From Omission to High Art," *The Journal of American Folklore* 122, no. 485 (2009): 297–334; Kyra E Hicks, *Black Threads: An African American Quilting Sourcebook* (Jefferson, N.C.: McFarland & Co., 2003); Bets Ramsey, "The Land of Cotton: Quiltmaking by African-American Women in Three Southern States," *Uncoverings* 9 (1988): 9–28; Margaret Susan Roach, "The Traditional Quiltmaking of North Louisiana Women: Form, Function, and Meaning" (PhD dissertation, Austin, University of Texas, 1986); Shelly Zegart, "Myth and Methodology," *Selvedge*, February 2008, http://www.shellyquilts.com/go/resources/read.php?article=myth-and-methodology.

35. Waldvogel, "Repackaging Tradition," 310; Barbara Brackman, "A Few Broken Stars," *Material Culture* (blog), June 5, 2014, http://barbarabrackman.blogspot.com/2014/06/a-few-broken-stars.html; Stearns & Foster Company, *Stearns & Foster Catalogue of Quilt Pattern Designs and Needle Craft Supplies.* (Cincinnati, Ohio: Stearns & Foster Co., 1900s); Waldvogel, *Soft Covers for Hard Times*, 4.

36. International Quilt Museum, "Class," World Quilts: The America Story | International Quilt Museum, 2013, http://worldquilts.quiltstudy.org/americanstory/identity/class.

37. Susan Strasser, *Waste and Want: A Social History of Trash* (New York: Holt Paperbacks, 1999), 211–15; Lu Ann Jones and Sunae Park, "From Feed Bags to Fashion," *Textile History* 24, no. 1 (1993): 91–103; Shaw, *American Quilts*, 234.

38. Waldvogel, *Soft Covers for Hard Times*, 10–11; Hall and Kretsinger, *Romance*, 241; for more on the role of periodicals in disseminating quilt patterns see Wilene Smith, "Quilt History in Old Periodicals: A New Interpretation," *Uncoverings* 11 (1990): 188–214; Waldvogel, "Repackaging Tradition."

39. Gunn, "American Quilts in the Modern Age," 245–47, 271–73.

40. The FSA offered sewing machines in its catalog of goods available for purchase by FSA client families using low-interest governmental loans United States and Farm Security Administration. Resettlement Division, *Household Furniture and Domestic Equipment* (Washington, DC: Farm Security Administration, 1940), http://books.google.com/books?id=xuN6HttQNKQC.

41. Waldvogel, "Repackaging Tradition," 309.

CHAPTER 2

1. Cabot, "Time Honored Art of Quilting."

2. For discussion of viewers' responses to FSA photographs in various settings during the New Deal era, see Cara A Finnegan, "Managing the Magnitude of the Great Depression: Viewers Respond to FSA Photography," in *Making Photography Matter: A Viewer's History from the Civil War to the Great Depression* (Urbana: University of Illinois Press, 2015), 125–26; for an analysis of how public history projects have used FSA photographs since that time, see Meighen Katz, "A Paradigm of Resilience: The Pros and Cons of Using the FSA Photographic Collection in Public History Interpretations of the Great Depression," *The Public Historian* 36, no. 4 (2014): 8–25, https://doi.org/10.1525/tph.2014.36.4.8; for further discussion of use of FSA images in other capacities see Martha A. Sandweiss, "Image and Artifact: The Photograph as Evidence in the Digital Age," *The Journal of American History* 94, no. 1 (2007): 193–202, https://doi.org/10.2307/25094789; Colleen McDannell, "Religious History and Visual Culture," *The Journal of American History* 94, no. 1 (June 1, 2007): 112–21, https://doi.org/10.2307/25094780.

3. Jason Reblando, "Farm Security Administration Photographs of Greenbelt Towns: Selling Utopia During the Great Depression," *Utopian Studies* 25, no. 1 (April 22, 2014): 60–62.

4. Interview with Marion Post Wolcott, interview by Richard Doud, January 18, 1965, Archives of American Art, https://www.aaa.si.edu/collections/interviews/oral-history-interview-marion-post-wolcott-12262.

5. Cara A. Finnegan, "FSA Photography and New Deal Visual Culture," in *American Rhetoric in the New Deal Era, 1932-1945*, ed. Thomas W Benson, A Rhetorical History of the United States, vol VII (East Lansing: Michigan State University Press, 2006), 120, 126–44.

6. Will W. Alexander, "Rural Resettlement," *The Southern Review* 1, no. 3 (Winter 1936): 529, 532.

7. Charles Kenneth Roberts, *The Farm Security Administration and Rural Rehabilitation in the South* (Knoxville: University of Tennessee Press, 2015), xix–xx.

8. Michael L. Carlebach, "Documentary and Propaganda: The Photographs of the Farm Security Administration," *The Journal of Decorative and Propaganda Arts* 8 (1988): 19, https://doi.org/10.2307/1503967; Finnegan, "FSA Photography," 129.

9. See for examples James C. Curtis, "Dorothea Lange, Migrant Mother, and the Culture of the Great Depression," *Winterthur Portfolio* 21, no. 1 (April 1, 1986): 1–20, https://doi.org/10.2307/1181013; Cara A. Finnegan, *Picturing Poverty: Print Culture and FSA Photographs* (Washington, D.C.: Smithsonian Institution Press, 2003); Reblando, "Farm Security Administration Photographs of Greenbelt Towns"; Pete Daniel et al., *Official Images: New Deal Photography* (Washington, D.C.: Smithsonian Institution Press, 1987).

10. Finnegan, "FSA Photography," 142.

11. Linda Gordon, "Dorothea Lange's Oregon Photography: Assumptions Challenged," *Oregon Historical Quarterly* 110, no. 4 (December 1, 2009): 574.

12. Russell Lee, *Mrs. Shotbang with Her Four Children She Delivered Herself. Husband Broke His Foot Early This Spring. About Time Baby Was to Be Born They Ran Short of Coal and Bed Clothing, Mrs. Shotbang Had to Take Care of the Newly-Born Baby and the Rest of the Family, Cutting Fence Posts for Fuel. The Family Almost Froze; No Mattresses on the Beds This Past Winter, Only Quilts over the Hard Springs*, 1937, Farm Security Administration, Library of Congress http://www.loc.gov/pictures/item/fsa2000011976/PP/. See interview with Russell Lee and Jean Lee, interview by Richard K. Doud. June 2, 1964. Archives of American Art. Throughout this chapter, the figure captions use the titles of the photographs as recorded by the photographers and FSA staff, and as such use antiquated terms such as "Negro" and "Mulatto."

13. Jack Delano, *Mulatto Ex-Slave in Her House near Greensboro, Alabama*, 1941, https://www.loc.gov/pictures/resource/fsa.8c29053.

14. For a discussion of some of the impulses and ideas informing Black quiltmakers post-emancipation, see Anna Arabindan-Kesson, *Black Bodies, White Gold: Art, Cotton, and Commerce in the Atlantic World* (Durham: Duke University Press, 2021), 196–202.

15. Roberts, *The Farm Security Administration*, 140–42; Farm Security Administration. Resettlement Division, *Household Furniture and Domestic Equipment* (Washington, D.C.: The Department, 1940), http://books.google.com/books?id=xuN6HttQNKQC; Marion Post Wolcott, *Pressure Cooker on Mrs. L.L. LeCompt's New Stove Bought through FSA (Farm Security Administration) Loan. Coffee County, Alabama*, March 1939. https://www.loc.gov/resource/fsa.8c35757/.

16. Farm Security Administration, *Household Furniture*; United States, "Report of the Administrator of the Farm Security Administration." (Washington: U.S. G.P.O., 1938), https://catalog.hathitrust.org/Record/102215409.

17. Marion Post Wolcott, *Mrs. L.L. LeCompt Stitching Quilt Squares Together. She Does All Her Family Sewing. Coffee County, Alabama*, 1939, Farm Security Administration, Library of Congress, http://www.loc.gov/pictures/item/fsa2000031834/PP/; Farm Security Administration, *Household Furniture*.

18. Sidney Baldwin, *Poverty and Politics: The Rise and Decline of the Farm Security Administration* (Chapel Hill: University of North Carolina Press, 1968), 200; Roberts, *The Farm Security Administration*, xi, 129–55.

19. Marion Post Wolcott, *Mr. & Mrs. Peacock, RR (Rural Rehabilitation) Family (Four Years) and Children in Front of Their Home. Coffee County, Alabama*, 1939, https://www.loc.gov/item/2017800669/.

20. Marion Post Wolcott, *Through Help and Supervision of Home and Field Supervisors, Diet and Health of Many RR (Rural Rehabilitation) Families Have Been Greatly Improved. The Peacock Family (RR Four Years) Had for Dinner (Noon Meal): Sausage, Cabbages, Carrots, Rice, Tomatoes, Cornbread, Canned Figs, Bread Pudding and Milk. They Did Not Know That a Picture Would Be Made. Coffee County, Alabama*, 1939, https://www.loc.gov/item/2017800686/.

21. "The Farm Security Photographer Covers the American Small Town," June 13, 1940, Library of Congress, https://www.loc.gov/rr/print/coll/fsawr/12024-3-Ex41-D1-2p.pdf.

22. Drawing on correspondence between Lee and Stryker, art historian James Curtis summarized it as such. See *Mind's Eye, Mind's Truth: FSA Photography Reconsidered* (Philadelphia: Temple University Press, 1989), 93.

23. Russell Lee, *Mrs. Bill Stagg Exhibiting a Quilt Made from Tobacco Sacks Which She Ripped up, Dyed, and Pierced. Nothing Is Wasted on These Homesteading Farms. Pie Town, New Mexico*, 1940, http://www.loc.gov/pictures/item/fsa2000018005/PP/. It's unclear if Lee's use of the word "pierce" is a typo of "piece" or if it is used here as a synonym for stabbing with a needle, as in the act of quilting. While not common vernacular for "quilting," this language has appeared elsewhere.

24. Curtis, *Mind's Eye*, 112–13.

25. Rose Marie Werner, *State Bird and State Flower Quilts: Identification Guide*, (CreateSpace Independent Publishing Platform, 2013), 6–7.

26. Curtis, "Dorothea Lange," 4–11.

27. Russell Lee, *Figure in a Square Dance. Pie Town, New Mexico. Notice the Quilting Frame Overhead*, 1940, http://www.loc.gov/pictures/item/fsa2000018194/PP/.

28. Finnegan, "FSA Photography," 140–44.

29. Maren Stange makes this point in her analysis of FSA photographs within the context of rural displacement, writing, "In some images the pieced quilt, now doing duty in tents, trailers,

and shacks, is a nostalgic remainder of displacement." See "'The Record Itself': Farm Security Administration Photography and the Transformation of Rural Life," in *Official Images: New Deal Photography* (Washington, DC: Smithsonian Institution Press, 1987), 3.

30. Interview with Jack Delano and Irene Delano, interview by Richard K. Doud, June 12, 1965, Archives of American Art, https://www.aaa.si.edu/collections/interviews/oral-history-interview-jack-and-irene-delano-13026.

31. Wolcott interview.

32. Craig S. Pascoe and John Rieken, "Fort Stewart," in *New Georgia Encyclopedia*, December 10, 2019, https://www.georgiaencyclopedia.org/articles/government-politics/fort-stewart. See other photos by Jack Delano in Lot 1574, Library of Congress, Farm Security Administration Collection.

33. Nicholas Natanson, *The Black Image in the New Deal: The Politics of FSA Photography* (Knoxville: University of Tennessee Press, 1992), 188–89.

34. Natanson, 189.

35. Quilt historian Barbara Brackman helped me confirm my suspicion during a conversation on November 15, 2019. Also see "Quilt Pictures: Tossing Out Some Basic Assumptions," *Material Culture* (blog), August 24, 2018, http://barbarabrackman.blogspot.com/2018/08/quilt-pictures-tossing-out-some-basic.html.

36. For more on printed patchwork see Deborah E. Kraak, "Patchwork Prints in America: 1878-1900," *Uncoverings*, 2011, 153–73; Barbara Brackman, "Cheater Cloth - Geometrical Chintz," *Material Culture* (blog), April 12, 2017, http://barbarabrackman.blogspot.com/2017/04/cheater-cloth-geometrical-chintz.html; Barbara Brackman, *Clues in the Calico: A Guide to Identifying and Dating Antique Quilts* (Charlottesville, Va.: Howell Press, 1989), 94–95.

37. Brackman, *Clues in the Calico*, 95.

38. Delano and Delano interview; Jack Delano, *Woman Who Has Not Yet Found a Place to Move out of the Hinesville Army Camp Area Working on a Quilt in Her Smokehouse. Near Hinesville, Georgia*, 1941, http://www.loc.gov/pictures/item/fsa2000025315/PP/; Brackman, "Quilt Pictures."

39. Brian Q. Cannon, "'Keep on A-Goin': Life and Social Interaction in a New Deal Farm Labor Camp," *Agricultural History* 70, no. 1 (1996): 1–2.

40. The Library of Congress has 270 digitized photos by Dorothea Lange from Kern County, California. See https://www.loc.gov/photos/?q=lange+kern+county.

41. According to Brian Cannon's study of the Arvin camp, it typically attracted residents who had just moved to California, whereas others who had arrived earlier had found shelter in such cabins. See Cannon, "Keep on A-Goin," 5-6, 7-8.

42. Quoted in Finnegan, "FSA Photography," 140.

43. Dorothea Lange, *Camps of Migrant Pea Workers. California*, 1936, https://www.loc.gov/pictures/resource/fsa.8b27084.

44. Finnegan, "FSA Photography," 143.

45. Roberts, *Farm Security Administration*, 36–37, 97, 109–28.

46. See for example Timothy Kelly, Margaret Power, and Michael D Cary, *Hope in Hard Times: Norvelt and the Struggle for Community during the Great Depression* (University Park, PA: Pennsylvania State University Press, 2016), 76.

47. Lynn Zacek Bassett, "'A Dull Business Alone': Cooperative Quilting in New England, 1750-1850," in *Textiles in New England II: Four Centuries of Material Life*, ed. Peter Benes, Annual Proceedings of the Dublin Seminar for New England Folklife 24 (Boston: Boston University, 1999), 27–43; Brackman et al., "Quilting Myths and Nostalgia," 28–29.

48. Hall and Kretsinger, *Romance*, 21.

49. Marjory Collins, *The Moravian Sewing Circle Quilts for Anyone at One Cent a Yard of Thread and Donates the Money to the Church*, Lititz, Pennsylvania, 1942, http://www.loc.gov/pictures/item/owi2001014419/PP/.

50. John Vachon, *Making a Quilt in Scranton, Iowa, Home. The Ladies Will Give the Quilt to a Needy Family*, 1940, https://www.loc.gov/item/2017810133/.

51. John Vachon, *Ladies of the Helping Hand Society Working on Quilt. Gage County, Nebraska*, 1938, http://www.loc.gov/pictures/item/fsa1998021274/PP/; Dorothea Lange, *Farm Women of the "Helping Hand" Club Display a Pieced Quilt Which They Are Making for the Benefit of One of Their Numbers. Near West Carlton, Yamhill County, Oregon. General Caption Number 58-11*, 1939, http://www.loc.gov/pictures/item/fsa2000004638/PP/.

52. John Vachon, *Members of the Women's Club Making Quilt. Granger Homesteads, Iowa*, 1940, http://www.loc.gov/pictures/item/fsa2000041543/PP/; Paul Keith Conkin, *Tomorrow a New World: The New Deal Community Program*, Reprint; First published 1959 by Cornell University Press (Miami, FL: Hardpress Publishing, 2012), 301–2.

53. For a discussion of the challenges to the collectivism of the New Deal see Kelly, et al, *Hope in Hard Times*, 111–28.

54. Lange, *Farm Women of the "Helping Hand" Club*; Dorothea Lange, *Farm Women, Members of the "Helping Hand" Club, Carefully Roll up the Quilt upon Which They Are Working. Near West Carlton, Yamhill County, Oregon. General Caption Number 58-11*, 1939, http://www.loc.gov/pictures/item/fsa2000004649/PP/; Dorothea Lange, *Farm Women Working on Quilt. Near West Carlton, Yamhill County, Oregon. General Caption Number 58-11*, 1939, http://www.loc.gov/pictures/item/fsa2000004689/PP/; Dorothea Lange, *Farm Women Working on Quilt. Near West Carlton, Yamhill County, Oregon. See General Caption Number 58*, 1939, http://www.loc.gov/pictures/item/fsa2000004690/PP/.

55. Anne Whiston Spirn and Dorothea Lange, "General Caption No. 58, October 3, 1939," in *Daring to Look: Dorothea Lange's Photographs and Reports from the Field* (Chicago: University of Chicago Press, 2008), 192.

56. Dorothea Lange, *Here Are the Farmers Who Have Bought Machinery Cooperatively. Photographed Just before They Go to Dinner on the Miller Farm Where They Are Working. West Carlton, Yamhill County, Oregon,* 1939, http://www.loc.gov/pictures/item/fsa2000004635/PP/.

57. Gordon, "Dorothea Lange's Oregon Photography," 586.

58. Finnegan, *Picturing Poverty,* 20–21.

59. Webster, *Quilts,* 81.

60. "Tenant Farmers," Documenting America, 1988, www.loc.gov/pictures/collection/fsa/docchap5.html; Beardsley, "River Island," 24.

61. Arthur Rothstein, *Inhabitants of Gees Bend, Alabama,* April 1937, https://www.loc.gov/resource/fsa.8b35970/; Arthur Rothstein, *Negroes at Gees Bend, Alabama. Descendants of Slaves of the Pettway Plantation. They Are Still Living Very Primitively on the Plantation,* February 1937, https://www.loc.gov/item/2017775814/; Arthur Rothstein, *Sewing a Quilt. Gees Bend, Alabama,* 1937, http://www.loc.gov/pictures/item/fsa2000006962/PP/.

62. John Temple Graves, "The Big World at Last Reaches Gee's Bend: Amid Changes Wrought by the RA, a Picturesque Community of Negroes in Alabama Seeks to Keep Its Own Way of Life," *New York Times,* Aug 22, 1937; "Tenant Farmers."

63. Graves, "Big World"; Beardsley, "River Island," 26–27; M. G. Trend and W. L. Lett, "Government Capital and Minority Enterprise: An Evaluation of a Depression-Era Social Program," *American Anthropologist* 88, no. 3 (1986): 596–97.

64. Wolcott interview.

65. Marion Post Wolcott, *NYA (National Youth Administration) Girls Making Bedspreads under Supervision of Juanita Coleman, NYA Leader, in School Home Economics Room. Gee's Bend, Alabama,* May 1939, https://www.loc.gov/resource/fsa.8c10045/; Marion Post Wolcott, *A Display of Sewing and Needle Work Made by NYA (National Youth Administration) Girls in School Home Economics Room. Gee's Bend, Alabama,* May 1939, https://www.loc.gov/resource/fsa.8c10057/; Marion Post Wolcott, *Thelma Shamburg and Mrs. Spragg (or Sprague), NYA (National Youth Administration) State Supervisor, Helping Catherine Plumer and Sallie Titus at Sewing Machines in School Economics Room. Gee's Bend, Alabama,* May 1939, https://www.loc.gov/item/2017800775/.

66. Lisa Gail Collins recounts how the new "Roosevelt Houses" in Gee's Bend transformed the community in *Stitching Love and Loss,* 71–73.

67. Trend and Lett, "Government Capital and Minority Enterprise," 601.

68. Marion Post Wolcott, *Jorena Pettway and Her Daughter Making Chair Cover out of Bleached Flour Sacks and Flower Decorations from Paper. She Also Made the Chairs and Practically All the Furniture in the House. Gees Bend, Alabama,* May 1939, https://www.loc.gov/item/2017753782/; Marion Post Wolcott, *Jorena Pettway Making Flower Decorations for Her Home. She Has Made Practically All Her Own Furniture and Her Own Bedspreads and Chair Covers from Flour Sacks, Etc. Gee's Bend, Alabama,* May 1939, https://www.loc.gov/item/2017800760/.

CHAPTER 3

1. Unnamed WPA official quoted in Elna C. Green, "Relief from Relief: The Tampa Sewing-Room Strike of 1937 and the Right to Welfare," *The Journal of American History* 95, no. 4 (2009): 1022, https://doi.org/10.2307/27694558.

2. *Mrs. Lizzie Chambers and Mrs. Mary Collier Piecing Quilts While Mrs. Octa Self, Forelady of the Quilting Project Directs the Pattern They Are to Follow,* 1936, Records of the Work Projects Administration, National Archives.

3. Sara B. Marcketti, "The Sewing-Room Projects of the Works Progress Administration," *Textile History* 41, no. 1 (May 2010): 31, https://doi.org/10.1179/174329510x12670196126566; details of Octa Self's life from Ancestry.com query including 1930 and 1940 United States Federal Census records.

4. Quoted in Green, "Relief from Relief," 1022.

5. Pollye Braswell, "But Woman's Work Is Never Done," *The Tennessean,* November 10, 1935, http://www.newspapers.com/image/161077130/.

6. "Quilting Project, Starting Monday, Will Employ 50," *The Daily Times,* November 8, 1935, http://www.newspapers.com/image/302482408.

7. Margaret Leonard, "Revival of Women's Arts," *The Times Dispatch,* February 27, 1938.

8. Marcketti, "Sewing-Room Projects," 34, 39–40.

9. Marcketti, 34.

10. United States, *W.P.A.: [Invitation to an Exhibition],* WPA (Chicago, IL: Works Progress Administration, 1938), https://catalog.hathitrust.org/Record/102193465.

11. Sewing rooms were in fact the first work projects created by FERA. Marcketti, "Sewing-Room Projects," 28–31; See for example "FERA to Operate Quilt Factory," *The Tampa Times,* December 18, 1934; "Start Making Quilts in FERA Sewing Room," *The Post-Crescent,* November 16, 1934.

12. Marcketti, "Sewing-Room Projects," 28–32; Green, "Relief from Relief," 1033.

13. Marcketti, "Sewing-Room Projects," 37.

14. "NYA May Take Over Work on Used Clothes," *Fort Worth Star-Telegram*, March 26, 1941, http://www.newspapers.com/image/636379491/.

15. "72 WPA Women Sew and Quilt," *The Post-Register*, March 22, 1936, http://www.newspapers.com/image/74553027/.

16. "Quilt-Making Jobs Found for Elderly," *New York Daily News*, October 27, 1935, http://www.newspapers.com/image/418205802/; "WPA Making Quilts For Needy, Homeless," *New York Daily News*, December 10, 1935, http://www.newspapers.com/image/418460784/.

17. Works Progress Administration, New Jersey, *Report of the Division of Women's and Professional Projects : For the Period Ending July 31, 1936* ([Newark, N.J. : Works Progress Administration, New Jersey], 1936), http://archive.org/details/reportofdivision00unit; total count manually derived from totalling numbers from individual sewing rooms reports; for details on the Neptune Sewing Room, see page 38n.

18. "Eight WPA Projects Are Active in City at Present," *Marshfield News-Herald*, February 8, 1941.

19. Works Progress Administration, New Jersey, *Report of the Division of Women's and Professional Projects*, 95.

20. "Local WPA Unit Makes One Quilt Every Two Hours," *The Frederick Press*, September 27, 1940, http://www.newspapers.com/image/631567737/.

21. "District Supervisor Visits Sewing Room," *The Clinton Eye*, March 12, 1936.

22. "WPA Sewing Rooms Prepare for Camden Pageant April 15," *Courier-Post*, April 8, 1936, http://www.newspapers.com/image/479903849/; "72 WPA Women Sew and Quilt."

23. "WPA Fair Exhibit Viewed by 550,000," *Courier-Post*, September 30, 1936, 000, http://www.newspapers.com/image/479282969/.

24. United States, *WPA and the Negro* (New York, N.Y.: New York State Works Progress Administration, 1936), 3, https://catalog.hathitrust.org/Record/009127852.

25. "Sewing Center Producing 6,000 Garments for Poor," *Scottsbluff Daily Star-Herald*, November 10, 1939, http://www.newspapers.com/image/750203625.

26. Waldvogel, *Soft Covers for Hard Times*, 57–58.

27. Martha H. Swain, "'The Forgotten Woman': Ellen S. Woodward and Women's Relief in the New Deal," in *Women and Politics*, ed. Nancy F. Cott, article reprinted from 1983 issue of *Prologue*, vol. 18/2, History of Women in the United States (Berlin, Boston: K. G. Saur, 2012), 732, https://doi.org/10.1515/9783110971071.716.

28. Works Progress Administration, New Jersey, *Report of the Division of Women's and Professional Projects*, 5.

29. Mary Northrup, "[Ex-WPA Workers]" (U.S. Work Projects Administration, Federal Writers' Project, October 28, 1938), Library of Congress, Folklore Project, Life Histories, 1936-39, Library of Congress, https://www.loc.gov/resource/wpalh2.28030127.

30. Janie Solomon, "Janie Solomon," interview by Muriel L. Wolf, September 7, 1938, Library of Congress, Folklore Project, Life Histories, 1936-39, Library Of Congress, https://www.loc.gov/item/wpalh001919/.

31. Anne Win Stevens, "The Farlows" (U.S. Work Projects Administration, Federal Writers' Project, December 16, 1938), Folklore Project, Life Histories, 1936-39, Library of Congress, https://www.loc.gov/resource/wpalh2.28091516/.

32. Works Progress Administration, New Jersey, *Report of the Division of Women's and Professional Projects*, 6.

33. "WPA Sewing Room Pupils Now Are Apt Needlewomen," *Courier-Post*, August 1, 1936, http://www.newspapers.com/image/479256955/; Works Progress Administration, New Jersey, *Report of the Division of Women's and Professional Projects*, 145. The merit books were such a staple in the New Jersey sewing rooms that one worker altered lyrics to a popular 1936 Tommy Dorsey song: "I took my merit book / I looked it through and through / ho, ho, ho, me oh my, what shall I do? / I took my piece of goods / My pattern came out next...."

34. Works Progress Administration, New Jersey, *Report of the Division of Women's and Professional Projects*, 9a.

35. "Quilt-Making Jobs Found for Elderly."

36. Works Progress Administration, New Jersey, *Report of the Division of Women's and Professional Projects*, 71.

37. Works Progress Administration, New Jersey, 5.

38. Green, "Relief from Relief," 1025; "WPA Women Workers Use Jobs as Stepping Stones to Better Places in Business or Professional Fields," *The Atlanta Constitution*, November 1, 1936.

39. Marcketti, "Sewing-Room Projects," 39–40.

40. Quoted in Marcketti, 41.

41. "WPA Women Workers Use Jobs."

42. Swain, "'The Forgotten Woman,'" 732.

43. Leonard, "Revival of Women's Arts."

44. Edward N. Jones, *One Year of W.P.A. in Pennsylvania, July 1, 1935-June 30, 1936* (Works Progress Administration for Pennsylvania, 1936), http://archive.org/details/oneyearofwpainpe00jone_0.

45. "Worries of at Least One Girl Put at Rest," *Blackwell Journal-Tribune*, April 30, 1936.

46. "WPA Quilts and Comforts for Missouri Flood Sufferers," *The Kansas City Star*, January 25, 1937, http://www.newspapers.com/image/656917842.

47. "48,458 Garments Given Refugees," *The Tennessean*, February 28, 1937, http://www.newspapers.com/image/160952593.

48. "$308,080 Surplus Foodstuffs Distributed to Home Relief Families in January," *The Brooklyn Citizen*, February 20, 1936, http://www.newspapers.com/image/543780460.

49. Hopkins to Ellen Woodward in a letter dated Dec. 1936, quoted in Marcketti, "Sewing-Room Projects," 42.

50. Works Progress Administration, New Jersey, *Report of the Division of Women's and Professional Projects*, 6-f.

51. Works Progress Administration, New Jersey, 9b.

52. Catherine Cleveland, "The W.P.A. Sewing Program," *Journal of Home Economics* 33, no. 8 (1941): 588.

53. "First Lady Sees WPA at Work: Sewing room spirit wins praise," *Work: A Journal of Progress*, September 1936, 2.

54. Barbara Berry Darsey, "[Mr. and Mrs. Fredrick Goethe]" (WPA Federal Writers' Project, c 1938), Folklore Project, Life Histories, 1936-39, Library of Congress, https://www.loc.gov/resource/wpalh1.10130722.

55. Green, "Relief from Relief," 1026–27.

56. Narrative Report, July 1938, page 14, quoted in Green, 1026.

57. "Protest WPA Cuts, Sewing Job Conditions," *The Capital Times*, August 16, 1937; on labor organizing in sewing rooms see Green, "Relief from Relief"; on mutual aid and morale see page 1025-26.

58. Green, "Relief from Relief," 1022.

59. Eugenia Martin, "I Managed to Carry On," interview by Geneva Tonsill, November 1939, U.S. Work Projects Administration, Federal Writers' Project, Library Of Congress, https://www.loc.gov/resource/wpalh1.13070112/?sp=6.

60. Quoted in Green, "Relief from Relief," 1023.

61. Andy Leon Harney, "WPA Handicrafts Rediscovered," *Historic Preservation*, September 1973, 14.

62. "Former Ziegfeld Follies Girl Employs Old Hobby in WPA Handicraft Work," *The Minneapolis Journal*, August 9, 1936.

63. For more on the various WPA handicraft projects nationwide see Harney, "WPA Handicrafts Rediscovered." Harney provide the figure of 43 states and 35,000 workers. Previous studies of the Milwaukee Handicraft Project include Valerie J. Davis and Jackie Schweitzer, "The Policy of Good Design: Quilt Designs and Designers from the WPA Milwaukee Handicrafts Project, 1935-1942," *Uncoverings* 32 (2011): 103–21; Merikay Waldvogel, "Quilts in the WPA Milwaukee Handicraft Project, 1935-1943," *Uncoverings* 5 (1984): 153–67; firsthand accounts of the project include Elsa Ulbricht, "The Story of the Milwaukee Handicraft Project," *Design for Arts in Education*, February 1944, 6-7, 10-11; Mary Kellogg Rice, "The Policy of Good Design," *Design for Arts in Education*, February 1944, 15-23; Mary Kellogg Rice, *Useful Work for Unskilled Women: A Unique Milwaukee WPA Project* (Milwaukee, Wis.: Milwaukee County Historical Society, 2003). I am grateful to Merikay Waldvogel for rediscovering this project in the 1980s and for generously sharing her research files on this topic with me.

64. Rhea Talley, "WPA Project Gives Future to Handicrafts," *The Times Dispatch*, September 15, 1940, http://www.newspapers.com/image/828018258.

65. For more on Eleanor Roosevelt's involvement in handicraft industries see Victoria M. Grieve, "'Work That Satisfies the Creative Instinct': Eleanor Roosevelt and the Arts and Crafts," *Winterthur Portfolio* 42, no. 2/3 (Summer 2008): 159–82, https://doi.org/10.1086/589595; Walter Rendell Storey, "The Home Craft Movement Grows: A League Carries on the Project That Mrs. Roosevelt Inaugurated," *New York Times*, April 15, 1934, sec. Magazine.

66. Grieve, "'Work That Satisfies the Creative Instinct,'" 166–67.

67. Rice, *Useful Work for Unskilled Women*, 2; Davis and Schweitzer, "The Policy of Good Design," 104.

68. Rice, *Useful Work for Unskilled Women*, 7–8; Waldvogel, "Quilts in the WPA," 154; Davis and Schweitzer, "The Policy of Good Design," 104-05.

69. Ulbricht, "The Story of the Milwaukee Handicraft Project," 10.

70. For an overview of the American Arts and Crafts movement see Monica Obniski, "The Arts and Crafts Movement in America," The Metropolitan Museum of Art's Heilbrunn Timeline of Art History, June 2008, https://www.metmuseum.org/toah/hd/acam/hd_acam.htm; for the relationship of the Milwaukee Handicraft Project to Arts and Crafts see Kathryn E. Maier, *A New Deal for Local Crafts: Textiles from the Milwaukee Handicrafts Project* (Milwaukee: University of Wisconsin -- Milwaukee Art History Gallery, 1994), 7–10.

71. Davis and Schweitzer, "The Policy of Good Design," 104.

72. "What Is the W.P.A. Handicraft Project?," undated, Merikay Waldvogel Collection on WPA Projects; Davis and Schweitzer, "The Policy of Good Design," 107–08.

73. Elsa Ulbricht, "Tape Recorded Interview with Elsa Ulbricht," interview by Hayward Ehrlich, June 1964, Merikay Waldvogel Collection on WPA Projects.

74. Rice, *Useful Work for Unskilled Women*, 17; Waldvogel, "Quilts in the WPA," 161–62.

75. For more on emergency nursery schools, another initiative of the New Deal, see Lynn Matthew Burlbaw, "An Early Start: WPA Emergency Nursery Schools in Texas, 1934-1943," *American Educational History Journal* 36, no. 2 (January 1, 2009): 269–98; Rice, *Useful Work for Unskilled Women*, 25–29.

76. Rice, *Useful Work for Unskilled Women*, 29–34; Harriet Clinton quoted in same, page 35.

77. Quoted in Waldvogel, "Quilts in the WPA," 162.

78. Davis and Schweitzer have identified between 25 and 28 MHP applique and patchwork designs made from over the run of the project. "The Policy of Good Design," 110.

79. Davis and Schweitzer, 108–09.

80. This analysis is based on research photographs from the Milwaukee Public Museum made available to me by Jackie Schweitzer.

81. Waldvogel, "Quilts in the WPA," 160–61; Davis and Schweitzer, "The Policy of Good Design," 112.

82. Waldvogel, "Quilts in the WPA," 162.

83. Quoted in Waldvogel, 162.

84. Rice, "The Policy of Good Design," 18.

85. Waldvogel, "Quilts in the WPA," 162.

86. Davis and Schweitzer, "The Policy of Good Design," 109-10.

87. Milwaukee WPA Handicraft Project, *Material Cost List* (Milwaukee: Milwaukee WPA Handicraft Project, 1939), 24–24a, https://content.wisconsinhistory.org/digital/collection/tp/id/72454/.

88. Waldvogel, "Quilts in the WPA," 162–64.

89. Ellen Kort, *Wisconsin Quilts: Stories in the Stitches* (Charlottesville, VA: Howell Press, 2001), 159–60; Milwaukee WPA Handicraft Project, *Material Cost List*, 14.

90. Davis and Schweitzer, "The Policy of Good Design," 112–13.

91. Alberta Redenbaugh quoted in Waldvogel, "Quilts in the WPA," 157.

92. Ulbricht interview; Rice, *Useful Work for Unskilled Women*, 60–61.

93. Rice, *Useful Work for Unskilled Women*, 60–61.

94. Rice, 62.

95. Davis and Schweitzer, "The Policy of Good Design," 106; Harney, "WPA Handicrafts Rediscovered," 15; Rice, *Useful Work for Unskilled Women*, 23–24.

96. Jane Betsey Welling quoted in Waldvogel, "Quilts in the WPA," 158.

97. Ulbricht, "The Story of the Milwaukee Handicraft Project," 6.

98. Ulbricht, 6.

99. Ulbricht interview.

100. Rice, *Useful Work for Unskilled Women*, 21.

101. "What Is the W.P.A. Handicraft Project?"

102. Ulbricht interview; Elsa Ulbricht to Eleanor Roosevelt, September 20, 1941, Merikay Waldvogel Collection on WPA Projects.

103. Quoted in Rice, *Useful Work for Unskilled Women*, 35.

104. Elna Green shares some of this anecdotal evidence of social bonds and mutual aid that stemmed from women's experiences in Tampa's WPA sewing rooms, yet notes that reports of morale building were "filtered through the perspective of the supervisors." See "Relief from Relief," 1025–26.

105. Waldvogel, *Soft Covers for Hard Times*.

CHAPTER 4

1. Cuesta Benberry, "W.P.A. & Quilt Research Survey" (c 1985), 2.3.b4.f8, Cuesta Benberry Papers, Michigan State University Museum; Mary Worrall, "Unpacking Collections: the Legacy of Cuesta Benberry, An African American Quilt Scholar," Quilt Index, https://quiltindex.org//view/?type=fullrec&kid=12-8-5242. Accessed March 18, 2022.

2. On the close association of the New Deal with the WPA specifically, see Ron Elving, "In The 1930s, Works Program Spelled HOPE For Millions Of Jobless Americans," *NPR*, April 4, 2020, sec. The Coronavirus Crisis, https://www.npr.org/2020/04/04/826909516/in-the-1930s-works-program-spelled-hope-for-millions-of-jobless-americans.

3. Russell Lord and Paul Howard Johnstone, *A Place on Earth, a Critical Appraisal of Subsistence Homesteads* (Washington, D.C.: U.S. Bureau of Agricultural Economics, 1942), 78, http://archive.org/details/placeonearthcrit00unit; Ann Elizabeth McCleary, "Shaping a New Role for the Rural Woman: Home Demonstration Work in Augusta County, Virginia, 1917-1940" (PhD diss., Brown University, 1996); Elizabeth Griffin Hill, "Home Demonstration Clubs," in *Encyclopedia of Arkansas*, July 23, 2018, https://encyclopediaofarkansas.net/entries/home-demonstration-clubs-5387/; quotation from Lucile W. Reynolds, "The Home Economists' Part in the Rehabilitation Program," *Journal of Home Economics* 29, no. 4 (April 1937): 217.

4. Carolyn M. Goldstein, *Creating Consumers: Home Economists in Twentieth-Century America* (Chapel Hill: University of North Carolina Press, 2012), 17.

5. Kathleen R. Babbitt, "The Productive Farm Woman and the Extension Home Economist in New York State, 1920-1940," *Agricultural History* 67, no. 2 (1993): 88; Ann McCleary, "Negotiating the Urban Marketplace: Farm Women's Curb Markets in the 1930s," *Perspectives in Vernacular Architecture* 13, no. 1 (2006): 87.

6. Rena B. Maycock, "Home Economics Work in the Resettlement Administration," *Journal of Home Economics* 28, no. 8 (October 1936): 561.

7. McCleary, "Shaping a New Role for the Rural Woman," 154–57; Ted Ownby, *American Dreams in Mississippi: Consumers, Poverty & Culture, 1830-1998* (Chapel Hill: University of North Carolina Press, 2002), 99–103.

8. Erna E. Proctor, "Home Economics in a Rural Rehabilitation Program," *Journal of Home Economics* 27, no. 8 (October 1935): 503–4.

9. Katherine Jellison, *Entitled to Power: Farm Women and Technology, 1913-1963* (Chapel Hill: University of North Carolina Press, 1993), 17. The bill's co-sponsor, Asbury Lever, quoted in same, page 17.

10. See Franklin M. Reck, *The 4-H Story: A History of 4-H Club Work* (Ames: Iowa State University Press, 1963), http://catalog.hathitrust.org/api/volumes/oclc/7985378.html.

11. "Home Demonstration Work in My Home and Community," *Home Demonstration Radio Program* (National Broadcasting Company, June 6, 1934), http://archive.org/details/CAT31378806; Abby L. Marlatt, "'New Deal' in Home Economics," *Journal of Home Economics* 28, no. 8 (October 1936): 523; Melissa Walker, "Home Extension Work among African American Farm Women in East Tennessee, 1920-1939," *Agricultural History* 70, no. 3 (1996): 496.

12. Danielle Dreilinger, *The Secret History of Home Economics: How Trailblazing Women Harnessed the Power of Home and Changed the Way We Live* (New York, NY: W. W. Norton & Company, Inc., 2021), 67–68.

13. Walker, "Home Extension Work," 496.

14. Ownby, *American Dreams in Mississippi*, 99–100; Dickens quoted in same, page 100.

15. Ownby, 99–103.

16. McCleary, "Shaping a New Role for the Rural Woman," 159.

17. McCleary, 160, 192–95, 200–205.

18. Marion Rebecca Spear, *Textiles*, vol. 2, Waste Material Series (Kalamazoo, Mich., 1939), 28, http://hdl.handle.net/2027/mdp.39015013516375.

19. Marian Ann J Montgomery, *Cotton & Thrift: Feed Sacks and the Fabric of American Households* (Lubbock, TX: Texas Tech University Press, 2019), 9–10.

20. Gilbert C. Fite, "The Great Depression Strikes," in *Cotton Fields No More: Southern Agriculture, 1865-1980* (University Press of Kentucky, 1984), 130–31, 135.

21. O. C. Stine, "Future of Cotton in the Economy of the South," *Journal of Farm Economics* 23, no. 1 (1941): 112–21, https://doi.org/10.2307/1231843.

22. Amy Manor, "4-H and Home Demonstration during the Great Depression," Special Collections Research Center | Green "N" Growing - The History of Home Demonstration and 4-H Youth Development in North Carolina, https://www.lib.ncsu.edu/specialcollections/greenngrowing/essay_great_depression.html; Virgil W. Dean and Ramon Powers, "'In No Way a Relief Set Up': The County Cotton Mattress Program in Kansas, 1940-1941," *Kansas History: A Journal of the Central Plains* 37, no. Winter (2014): 244, 251.

23. Melissa Walker interviewed Lane (b. 1912) in 1994. See Melissa Walker, ed., *Country Women Cope with Hard Times: A Collection of Oral Histories* (Columbia: University of South Carolina Press, 2004), 85–86.

24. Montgomery, *Cotton & Thrift*, 13.

25. Ruth Rhoades, "Feed Sacks in Georgia: Their Manufacture, Marketing, and Consumer Use," *Uncoverings* 18 (1997): 129.

26. Rhoades, 129.

27. Rhoades, 130; Montgomery, *Cotton & Thrift*, 13.

28. Ownby, *American Dreams in Mississippi*, 104; Walker, "Home Extension Work," 497.

29. Carmen V. Harris, "'Well I Just Generally Bes the President of Everything': Rural Black Women's Empowerment through South Carolina Home Demonstration Activities," *Black Women, Gender & Families* 3, no. 1 (May 20, 2009): 103, https://doi.org/10.1353/bwg.0.0001.

30. *Entry in the Home Demonstration Quilt and Bedspread Show - Jefferson County, Florida*, April 1937, State Archives of Florida, Florida Memory, https://www.floridamemory.com/items/show/146637; "Club Members Piecing Quilt," *Miami News-Record*, April 19, 1937; "To Make, Sell Quilt," *The Knoxville Journal*, March 8, 1942; Linda D. Wilson, "Home Demonstration Clubs," in *The Encyclopedia of Oklahoma History and Culture*, accessed July 27, 2022, https://www.okhistory.org/publications/enc/entry.php?entry=HO020. A fundraiser quilt made by the Jay Bird Home Demonstration club is in the collection of the Siloam Springs Museum in Siloam Springs, Arkansas.

31. Multiple quilts documented in the Quilt Index have patterns with such origin stories. See for example Ethel F. Ball, Nelly Bly, c. 1930, https://quiltindex.org/view/?type=fullrec&kid=9-6-141; Toledo Ohio Willingtam Glenn, Double Wedding Ring, 1937-39, https://quiltindex.org//view/?type=fullrec&kid=54-159-327.

32. Gladys Baker, *The County Agent* (Chicago: University of Chicago Press, 1939), 205, https://digital.library.cornell.edu/catalog/chla2838768.

33. Brackman, "Quilt Pictures"; Brackman, "Frugal and Fashionable."

34. Jane S. Becker, *Selling Tradition: Appalachia and the Construction of an American Folk, 1930-1940* (Chapel Hill: University of North Carolina Press, 1998), 101–2.

35. Stevens, "The Farlows."

36. Elna C. Green, *Looking for the New Deal: Florida Women's Letters During the Great Depression* (Univ of South Carolina Press, 2007), 116.

37. Green, 86.

38. McCleary, "Shaping a New Role for the Rural Woman," 236–37; Babbitt, "Productive Farm Woman."

39. Babbitt, "Productive Farm Woman," 92–94; Becker, *Selling Tradition*, 76–77.

40. Quoted from the Annual Report of Extension Work in Home Economics in New York State, Babbitt, "Productive Farm Woman," 94.

41. For more on the Milwaukee Handicraft Project see Chapter 3. Quotation on good design from Annual Report of Extension Work in Home Economics in New York State, 1931, quoted in Babbitt, 94–95.

42. Babbitt, 96; McCleary, "Negotiating the Urban Marketplace," 88–90.

43. Walker, "Home Extension Work," 498–99.

44. Conkin, *Tomorrow a New World*, 6.

45. Robert M. Carriker, *Urban Farming in the West: A New Deal Experiment in Subsistence Homesteads* (Tucson, Ariz: Univ. of Arizona Press, 2010), 3.

46. Conkin, *Tomorrow a New World*, 5–6, 193–94, 205–6; USDA National Agricultural Library, "Homestead Project Timeline," Small Agriculture: A National Agricultural Library Digital Exhibit, accessed June 29, 2022, https://www.nal.usda.gov/exhibits/ipd/small/homestead-timeline.

47. Division of Subsistence Homesteads, *A Homestead and Hope* (Washington DC: United States Governmental Printing Office, 1935), 10, http://archive.org/details/CAT31355383.

48. Division of Subsistence Homesteads, 6; Conkin, *Tomorrow a New World*, 333.

49. Division of Subsistence Homesteads, *A Homestead and Hope*, 10.

50. Division of Subsistence Homesteads, 10–11; Conkin, *Tomorrow a New World*, 108.

51. Conkin, *Tomorrow a New World*, 137–40, 332–37; USDA National Agricultural Library, "Homestead Project Timeline."

52. Conkin, *Tomorrow a New World*, 193–94.

53. Marlatt, "'New Deal' in Home Economics," 526.

54. Grieve, "'Work That Satisfies the Creative Instinct,'" 170.

55. Conkin, *Tomorrow a New World*, 193–95.

56. Conkin, 189; Maycock, "Home Economics Work," 561.

57. Lord and Johnstone, *A Place on Earth, a Critical Appraisal of Subsistence Homesteads*, 78.

58. Lord and Johnstone, 100; Maycock, "Home Economics Work," 560.

59. Marion Post Wolcott, *Housewives in Tygart Valley, West Virginia, Have Weekly Group Meetings in Home Economics. Here They Are Quilting*, 1938, http://www.loc.gov/pictures/item/fsa2000030514/PP/.

60. Kathy Roberts, "Tygart Valley Homestead: New Deal Communities in Randolph County," *Goldenseal*, Summer 2005, 11.

61. On the Special Skills Division that furnished teachers in fine and applied arts to homestead communities see Conkin, *Tomorrow a New World*, 195; Merikay Waldvogel conducted interviews with some of the women and their descendants associated with Cumberland Homesteads; see *Soft Covers for Hard Times*, 88.

62. "Custer's Last Stand, Vol 4 Number 26," *Greenbelt Cooperator*, August 1, 1940.

63. Clifford Kuhn notes that FSA Supervisors helped women establish "home demonstration clubs" among FSA client families and encouraged friendly competition to see who had canned the most vegetables. "'It Was a Long Way from Perfect, but It Was Working': The Canning and Home Production Initiatives in Greene County, Georgia, 1940–1942," *Agricultural History* 86, no. 2 (2012): 80, https://doi.org/10.3098/ah.2012.86.2.68.

64. Roberts, "Tygart Valley Homestead," 15.

65. This was the case in the subsistence homestead in Arthurdale which had a specific focus on craft making. See Grieve, "'Work That Satisfies the Creative Instinct,'" 169.

66. On the New Deal's policies on equal opportunity for African Americans see Cheryl Lynn Greenberg, *To Ask for an Equal Chance: African Americans in the Great Depression* (Lanham, Md.: Rowman & Littlefield Publishers, 2009), 43–64.

67. Tasha M. Hargrove, Robert Zabawa, and Michelle Pace, "Twice Born: The Death and Rebirth of Resettlement in Georgia," Flint River Farms, http://www.flintriverfarms.org/the-story.html.

68. Tasha M. Hargrove, Robert Zabawa, and Michelle Pace, "School & Community," Flint River Farms, http://www.flintriverfarms.org/school--community.html; Marion Post Wolcott, *Home Economics and Home Management Class for Adults, under Supervision of Miss Evelyn M. Driver (Standing in White Uniform). Everything They Make Including the Small Handmade Looms, Utilizes Materials of Local Origin as Cornshucks, Cane, Flour and Meal and Feed Sacks, Etc*, May 1939, https://www.loc.gov/item/2017800828/.

69. Arthur Rothstein, *The FSA (Farm Security Administration) Home Supervisor Has Helped This Woman Make Her Dress of Flour Sacks and Decorate Her Curtain with Splatter Work. Osage Farms, Missouri*, November 1939, https://www.loc.gov/resource/fsa.8b19178/; "Osage Farms - Pettis Co. Mo.," *Living New Deal* (blog), n.d., https://livingnewdeal.org/projects/osage-farms-pettis-co-mo/.

70. Veronica Martinez-Matsuda, *Migrant Citizenship: Race, Rights, and Reform in the U.S. Farm Labor Camp Program* (Philadelphia: University of Pennsylvania Press, 2020), 5–7, 253.

71. Martinez-Matsuda, 76.

72. Quoted in Cannon, "'Keep on A-Goin'," 10–11.

73. "Sewing Room News," *Tow Sack Tattler, Arvin Farm Workers Community*, September 19, 1941, 3, MLC Box 1, California State University Northridge, Special Collection & Archives.

74. Quoted in Sylvan Jacob Ginsburgh, "The Migrant Camp Program of the F.S.A. in California: A Critical Examination of Operations at the Yuba City and Thornton Camps" (MA Thesis, San Francisco State College, 1943), 64.

75. Mrs. Becker, "Sewing Room News," *Covered Wagon News (Shafter Farm Workers Community)*, July 20, 1940, 9, MLC Box 1, California State University Northridge, Special Collection & Archives.

76. Luke Widener, "Dusting the Peach Bowl: Agricultural Migrants, Camp Managers, and Life in the Marysville and Yuba City Resettlement Administration and Farm Security Administration Camps, 1935-1943" (PhD diss, California State University, Chico, 2013), 98; Jeanette Gardener Betts, "Women's Role in Migration, Settlement, and Community Building: A Case Study of 'Okies' in the Migrant Farm Workers' Camp, Marysville, California" (Master's, California State University, Chico, 1997), 48; Ginsburgh, "Migrant Camp Program," 48, 71, 82.

77. Minnie Becker, "Art and Craft," *Covered Wagon News (Shafter Farm Workers Community)*, March 24, 1940, 6, MLC Box 1, California State University Northridge, Special Collection & Archives.

78. Betts, "Women's Role in Migration," ix.

79. "Women's Sewing Club," *Brawley Migratory Camp Newsletter*, December 13, 1940, 2, MLC Box 1, California State University Northridge, Special Collection & Archives; Lucy Baker,

"Announcement," *Covered Wagon News (Shafter Farm Workers Community)*, April 14, 1940, MLC Box 1, California State University Northridge, Special Collection & Archives.

80. Lucy Baker, "Welfare Minutes," *Covered Wagon News (Shafter Farm Workers Community)*, March 24, 1940, 7, MLC Box 1, California State University Northridge, Special Collection & Archives; "Notice to Our Campers," *Covered Wagon News (Shafter Farm Workers Community)*, February 25, 1940, 9, MLC Box 1, California State University Northridge, Special Collection & Archives.

81. May Wilson, "Sewing Room Items," *The Woodville Community News (Woodville Farm Workers Community)*, March 21, 1942, 4, MLC Box 1, California State University Northridge, Special Collection & Archives.

82. Ginsburgh, "Migrant Camp Program," 49.

83. John Vachon, *Farm Security Administration Home Supervisor Helping Rehabilitation Client with Sewing. Otoe County, Nebraska*, Oct. 1938, https://www.loc.gov/item/2017762710/.

84. Kuhn, "'It Was a Long Way from Perfect,'" 74.

85. Kuhn, 76.

86. Proctor, "Rural Rehabilitation Program," 503–4.

87. Dreilinger, *The Secret History of Home Economics*, 95.

88. Walker, "Home Extension Work," 489, 500.

89. Carmen V. Harris, "The South Carolina Home in Black and White: Race, Gender, and Power in Home Demonstration Work," *Agricultural History* 93, no. 3 (Summer 2019): 491, https://doi.org/10.3098/ah.2019.093.3.477.

90. Harris, 489.

91. Greenberg, *To Ask for an Equal Chance*, 43–64; on "Negro" advisors and divisions see page 47.

92. *Resettlement Administration; Rural Rehabilitation; "Quilting Project"; Rock Crest School, Chambersburg TWP., Iredell Co., N.C.*, May 30, 1935, Franklin D. Roosevelt Presidential Library and Museum, http://www.fdrlibrary.marist.edu/archives/collections/franklin/?p=digitallibrary/digitalcontent&id=3121.

93. Conkin, *Tomorrow a New World*, 133–36, 332–37.

94. Kuhn, "'It Was a Long Way from Perfect,'" 75.

95. Ohio Federal Writers' Project, *Butler County Emergency School Homemaking Class*, September 19, 1936, Ohio Guide Collection, Ohio Memory Connection, https://www.ohiomemory.org/digital/collection/p267401coll34/id/2895.

96. For summaries of these debates see Klassen, "Representations of African American Quiltmaking"; Zegart, "Myth and Methodology."

97. Benberry, *Always There,* 1992.

CHAPTER 5

1. Mayme Reese, "Interview with Mayme Reese," interview by Dorothy West, September 21, 1938, American Life Histories: Manuscripts from the Federal Writers' Project, 1936 to 1940, Library of Congress, https://memory.loc.gov/mss/wpa/lh2/25/2506/25060506/25060506.pdf; "Dorothy West, Harlem Renaissance Writer Born," African American Registry, https://aaregistry.org/story/dorothy-west-a-renaissance-woman/; "Dorothy West," in Encyclopedia Britannica, https://www.britannica.com/biography/Dorothy-West.

2. Reese interview; 1930 United States Federal Census.

3. For more on the concept of "romantic nationalism" in the context of WPA cultural programs, see Jerrold Hirsch, *Portrait of America: A Cultural History of the Federal Writers' Project* (Chapel Hill: University of North Carolina Press, 2004); for a historiographic examination of romantic nationalism see Joep Leerssen, "Notes toward a Definition of Romantic Nationalism," *Romantik: Journal for the Study of Romanticisms* 2, no. 1 (February 3, 2013): 9–35, https://doi.org/10.7146/rom.v2i1.20191.

4. Robert Cogswell, "Introduction: From Making Do to How-To," in *Soft Covers for Hard Times*, by Merikay Waldvogel (Nashville, TN: Rutledge Hill Press, 1990), xii.

5. Finley, *Old Patchwork Quilts.*

6. Victoria Grieve, *The Federal Art Project and the Creation of Middlebrow Culture* (Urbana: University of Illinois Press, 2009), 112.

7. Ann Banks, "Introduction | American Life Histories: Manuscripts from the Federal Writers' Project, 1936 to 1940," Library of Congress, https://www.loc.gov/collections/federal-writers-project/articles-and-essays/introduction/.

8. On some of this criticism see Jerre Mangione, *The Dream and the Deal; the Federal Writers' Project, 1935-1943* (Boston: Little, Brown, 1972), 266.

9. Catherine A. Stewart, *Long Past Slavery : Representing Race in the Federal Writers' Project* (Chapel Hill: The University of North Carolina Press, 2016), 62–64.

10. Norman R. Yetman, "An Introduction to the WPA Slave Narratives," Library of Congress, 2001, https://www.loc.gov/collections/slave-narratives-from-the-federal-writers-project-1936-to-1938/articles-and-essays/introduction-to-the-wpa-slave-narratives/.

11. Banks, "Introduction."

12. Norman R. Yetman, "The Limitations of the Slave Narrative Collection: Problems of Memory," web page, Born in Slavery: Slave Narratives from the Federal Writers' Project, 1936 to 1938 | Library of Congress, 2001, https://www.loc.gov/collections/slave-narratives-from-the-federal-writers-project-1936-to-1938/articles-and-essays/introduction-to-the-wpa-slave-narratives/limitations-of-the-slave-narrative-collection/.

13. William F. McDonald, *Federal Relief Administration and the Arts: The Origins and Administrative History of the Arts Projects of the Works Progress Administration* (Columbus: Ohio State University Press, 1969), 721–22.

14. McDonald, 722.

15. For an analysis and critique of the practices of using dialect in the Ex-Slave Narratives see Lauren Tilton, "Race and Place: Dialect and the Construction of Southern Identity in the Ex-Slave Narratives," *Current Research in Digital History* 2 (2019), https://doi.org/10.31835/crdh.2019.14; Stewart, *Long Past Slavery*, 65–89; Also see "A Note on the Language of the Narratives | Born in Slavery: Slave Narratives from the Federal Writers' Project, 1936-1938," Library of Congress, https://www.loc.gov/collections/slave-narratives-from-the-federal-writers-project-1936-to-1938/articles-and-essays/note-on-the-language-of-the-narratives/.

16. Tilton, "Race and Place."

17. Georgia Baker, "Georgia Baker, Ex-Slave - Age 87," interview by Sadie B. Hornsby, August 4, 1938, Federal Writers' Project: Slave Narrative Project, Vol. 4, Georgia, Part 1, Adams-Furr, Library of Congress, https://www.loc.gov/resource/mesn.041/?sp=41.

18. I translated this dialect style of writing from the original into natural language without the stylistic choices imposed by the project during the 1930s.

19. Fannie Moore, "Interview with Fannie Moore, Ex-Slave," interview by Marjorie Jones, September 21, 1937, Slave Narratives: A Folk History of Slavery in the United States from Interviews with Former Slaves, Vol XI, North Carolina Narratives, Library of Congress.

20. James Bolton, "James Bolton, Athens, Georgia," interview by Sarah H. Hall, n.d., Federal Writers' Project: Slave Narrative Project, Vol. 4, Georgia, Part 1, Adams-Furr, Library of Congress.

21. On quiltmaking by enslaved individuals, see Brackman's work that draws on the Federal Writers' Project archive. Barbara Brackman, *Facts & Fabrications-Unraveling the History of Quilts & Slavery: 8 Projects 20 Blocks First-Person Accounts* (Lafayette, CA: C&T Publishing, 2006).

22. Banks, "Introduction."

23. Lolly Bleu, "Lolly Bleu--Florida Squatter," interview by Barbara Berry Darsey, November 29, 1938, Folklore Project, Life Histories, 1936-39, Library of Congress, https://www.loc.gov/resource/wpalh1.10131210/.

24. Sarah M. Bonds, "Mrs. Sarah M. Bonds," interview by Ivey G. Warren, November 22, 1936, Folklore Project, Life Histories, 1936-39, Library of Congress, https://www.loc.gov/item/wpalh002597/.

25. Ella Bartlett, "Living Lore," interview by Louise Bassett, December 19, 1938, Folklore Project, Life Histories, 1936-39, Library of Congress, https://www.loc.gov/resource/wpalh1.14020913/.

26. Lula Bowers, "Mrs. Lula Bowers," interview by Phoebe Faucette, June 28, 1938, Folklore Project, Life Histories, 1936-39, Library of Congress, https://www.loc.gov/resource/wpalh3.30110205.

27. Kate Flenniken, "Kate Flenniken," interview by W.W. Dixon, June 6, 1938, Folklore Project, Life Histories, 1936-39, Library of Congress, https://www.loc.gov/resource/wpalh3.30081005.

28. Library of Congress, "About This Collection," Digital Collection, American Life Histories: Manuscripts from the Federal Writers' Project, 1936-1940 | Library of Congress, www.loc.gov/collections/federal-writers-project/about-this-collection/.

29. David Taylor, *Soul of a People: The WPA Writers' Project Uncovers Depression America* (Hoboken, N.J.: John Wiley & Sons, 2009), 77.

30. For historical context and background on the project see National Gallery of Art, Gallery Archives, "Finding Aid for the Records of the Index of American Design, 1929-2018 (Bulk 1936-1942)," December 2020, https://www.nga.gov/content/dam/ngaweb/research/gallery-archives/pdf/nga-ga-44-iad.pdf; Virginia Tuttle Clayton et al., *Drawing on America's Past : Folk Art, Modernism, and the Index of American Design* (Washington, DC: National Gallery of Art, 2002).

31. Virginia Tuttle Clayton, "Picturing a 'Usable Past,'" in *Drawing on America's Past: Folk Art, Modernism, and the Index of American Design* (Washington, DC: National Gallery of Art, 2002), 10; Grieve, *The Federal Art Project*, 127.

32. See Hirsch, "Kentucky Folk Art," 29–44; Erika Doss, "American Folk Art's 'Distinctive Character': The Index of American Design and New Deal Notions of Cultural Nationalism," in *Drawing on America's Past: Folk Art, Modernism, and the Index of American Design* (Washington, DC: National Gallery of Art, 2002), 61–73; Cogswell, "Introduction: From Making Do to How-To," 4.

33. For examples of publications see Holger Cahill and Rita Wellman, "American Design: From the Heritage of Our Styles Designers Are Drawing Inspiration to Mold a National Taste," *House and Garden,* 74 (July 1938), 15-16; Constance Rourke, "The Index of American Design," *The Magazine of Art* (April 1937), 207-211, 260; Erwin O. Christensen, *The Index of American Design* (New York: Macmillan, 1950). The full collection of paintings are reproduced in the National Gallery of Art's online collections database at https://www.nga.gov/collection-search-result.html?artobj_credit=Index%20of%20American%20Design.

34. For insights into the early twentieth-century fascination with folk art see Beatrix T. Rumford, "Uncommon Art of the Common People: A Review of Trends in the Collecting and Exhibiting of American Folk Art," in *Perspectives on American Folk Art*, ed. Ian M. G. Quimby and Scott T Swank (Winterthur, DE: The Henry Francis du Pont Winterthur Museum, 1980), 13–53; Elizabeth Stillinger, "From Attics, Sheds, and Secondhand Shops: Collecting Folk Art in America, 1880-1940," in *Drawing on*

America's Past: Folk Art, Modernism, and the Index of American Design (Washington DC: National Gallery of Art, 2002), 45–60; Eugene W. Metcalf, "The Politics of the Past in American Folk Art History," in *Folk Art and Art Worlds*, ed. John Michael Vlach and Simon J. Bronner (Ann Arbor, MI: UMI Research Press, 1986).

35. Grieve, *The Federal Art Project*, 125.

36. Hirsch, *Portrait of America*, 11 in ebook.

37. Doss, "American Folk Art's 'Distinctive Character,'" 61–62.

38. Clayton, "Picturing a 'Usable Past,'" 5–6.

39. Clayton, 8; for examples of press coverage see Preston A. Barba, "Folk Art," *The Morning Call (Allentown)*, June 20, 1936; A.D. Emmart, "Art Notes," *The Baltimore Sun*, February 11, 1940; Dorothy Kantner, "Design Artists Compile Painted Records of Old-Fashioned Objects," *Pittsburgh Sun-Telegraph*, March 31, 1940; "California Relics Recorded for American Design Index," *The Los Angeles Times*, August 30, 1936; "Native Kentucky Art Preserved Through W.P.A. Indexing Project," *The Courier-Journal*, February 15, 1939; "Utah's Early Handicraft Recorded in Index Through Silk Screen Process," *The Salt Lake Tribune*, September 14, 1940.

40. I derived this and other data below from my examination of over 1000 datasheets of various textiles, including many woven coverlets (numbers I do not use in my total of quilts). National Gallery of Art archivists generously compiled the datasheets for my review along with a concordance to assist in matching the datasheets with digitized images of the renderings available through the Gallery's online collection database. See National Gallery of Art, Gallery Archives, "Finding Aid for the Records of the Index of American Design, 1929-2018 (Bulk 1936-1942)." Also see NGA's online database at https://www.nga.gov/collection.html where users can conduct a keyword search for "Index of American Design."

41. See Archives of the National Gallery of Art, Index of American Design Datasheets.

42. Clayton, "Picturing a 'Usable Past,'" 19.

43. Clayton, 7.

44. Clayton, 7 and n50.

45. Clayton, 6, 9, n31.

46. Clayton, n60.

47. Constance Rourke, "What Is American Design?" in *Art for the Millions: Essays from the 1930s by Artists and Administrators of the WPA Federal Art Project*, ed. Francis V O'Connor (Boston: New York Graphic Society, 1975), 165–66, https://historymatters.gmu.edu/d/5102/; Clayton, "Picturing a 'Usable Past,'" 10.

48. Clayton, "Picturing a 'Usable Past,'" 10.

49. The IAD datasheets from the Archives of the National Gallery of Art corresponding with the Westerfield quilts are: ME-TE-14, ME-TE-16, ME-TE-17, ME-TE-18, ME-TE-19. The renderings of the quilts are NGA objects 1943.8.386, 1943.8.3353, 1943.8.387, 1943.8.2568, 1943.8.2569. Barbara Brackman, "Peggy

Westerfield: Textile Collector," *Material Culture* (blog), June 16, 2018, http://barbarabrackman.blogspot.com/2018/06/peggy-westerfield-textile-collector.html; Julia Ott, "The 'Free and Open' 'People's Market': Public Relations at the New York Stock Exchange, 1913-1929," *Business and Economic History Online*, 2004, 25.

50. See 1930 U.S. Census record for Claud L. Pemberton. The IAD datasheets from the Archives of the National Gallery of Art corresponding with the Pemberton quilts are: KY-TE-13, KY-TE-18, KY-TE-19, KY-TE-20, KY-TE-23. The renderings of the quilts are NGA objects 1943.8.2901, 1943.8.364, 1943.8.362, 1943.8.2866, 1943.8.2927.

51. Barbara Schaffer, *A Passion for Quilts: The Story of Florence Peto 1881-1970* (Livingston, NJ: Heritage Quilt Project of New Jersey, Inc., 2011), 30, 37; Deborah Clem, "Florence Peto," Quilters Hall of Fame, https://quiltershalloffame.net/florence-peto/. Lewittes, who later became a noted architectural photographer, is listed as the researcher on at least 16 IAD datasheets for quilts. Judith Hibbard-Mipaas and Nicole Krup Oest, "About Esther Mipaas," Esther Lewittes Mipaas, https://www.esthermipaas.com/bio.

52. IAD rendered quilts that appear in Peto's *Historic Quilts* include frontis, Plate 5, Plate 7, and Plate 46. Peto sold the Sunflower quilt to the Farmers' Museum in Cooperstown, New York in 1944. See Schaffer, *A Passion for Quilts,* 127.

53. Clem, "Florence Peto"; Schaffer, *A Passion for Quilts*, 32–39.

54. Peto, *Historic Quilts*, frontis; Mary Betsy Totten, *Betsy Totten's "Rising Sun" Quilt*, c. 1825-1835, Smithsonian National Museum of American History, https://www.si.edu/object/1825-1835-betsy-tottens-rising-sun-quilt%3Anmah_556331. The IAD datasheet is NYC-TE-65a-b-c-d and the National Gallery of Art object records are 1943.8.2579, 1943.8.17511, 1943.8.886, 1943.8.418. NGA also has a black-and-white photo of the quilt from the IAD: 1943.8.17732.

55. Schaffer, *A Passion for Quilts*, 16; for more on these quilts see Barbara Brackman, "Tottenville Sisters #1: Mary or Betsey?," *Material Culture* (blog), April 11, 2018, https://barbarabrackman.blogspot.com/2018/04/tottenville-sisters-1-mary-or-betsey.html; Barbara Brackman, "Tottenville Sisters #2: A Second & Third Rising Sun," *Material Culture* (blog), April 12, 2018, https://barbarabrackman.blogspot.com/2018/04/tottenville-sisters-2-second-third.html; Barbara Brackman, "Tottenville Sisters # 3: The Sunflower/Sunburst Quilt," *Material Culture* (blog), April 13, 2018, http://barbarabrackman.blogspot.com/2018/04/tottenville-sisters-3-sunflowersunburst.html; Barbara Brackman, "Tottenville Sisters #4: Dating the Quilts," *Material Culture* (blog), April 14, 2018, https://barbarabrackman.blogspot.com/2018/04/tottenville-sisters-4-dating-quilts.html.

56. Catherine Morris, "Historical Quilts and the Elizabeth A. Sackler Center for Feminist Art," in *"Workt by Hand": Hidden Labor and Historical Quilts* (Brooklyn, N.Y.: Brooklyn Museum, 2012), 13–14.

57. Ray Price, *Patchwork Quilt*, 1935, Archives of National Gallery of Art, 1943.8.2903, https://www.nga.gov/collection/art-object-page.15112.html.

58. Marian Curtis Foster, *Applique Quilt*, 1935, National Gallery of Art, 1943.8.2913, https://www.nga.gov/collection/art-object-page.15122.html. See IAD datasheet NYC-TE-123.

59. Brackman, *Clues in the Calico*, 63, 142–43, 155–56.

60. Ed Klimuska, *Lancaster County: Quilt Capital U.S.A.* (Lancaster, PA: Lancaster New Era, 1987).

61. Clayton et al., *Drawing on America's Past*, 166–67; Arlene Perkins, *Applique Bedspread*, c. 1941, National Gallery of Art, 1943.8.2589, https://www.nga.gov/collection/art-object-page.14798.html; Barbara Brackman, "Quintuplets with a Scalloped Edge: New York Style," *Material Culture* (blog), December 25, 2017, https://barbarabrackman.blogspot.com/2017/12/quintuplets-with-scalloped-edge-new.html; Sarah Ann Wilson, *Album Quilt*, 1854, https://www.artic.edu/artworks/153633/album-quilt.

62. Robert A McKnight, "Data Report Sheet Index of American Design," July 22, 1940, Archives of the National Gallery of Art.

63. Clayton, "Picturing a 'Usable Past,'" 7, 9–10, n60.

64. For an extended critique of the limitations of object selection and contextualization in the IAD see Hirsch, "Kentucky by Design."

65. Hirsch, 32–33.

66. Hirsch, 34–35; Cogswell, "Introduction: From Making Do to How-To," xiii; Becker, *Selling Tradition*.

67. Clayton et al., *Drawing on America's Past* , 245.

68. Alois Ulrich, "The Point of View: Hot Against the Raise," *The Courier-Journal*, October 6, 1929; "Today's Radio Programmes," *The Courier-Journal*, March 17, 1928; "Berea Man to Paint Postoffice Murals," *The Courier-Journal*, December 15, 1935; A. E Ulrich, Samuel Gfroerer, and C.T. Dearing Printing Co, *Money Mad: An American Novel by an American Citizen* (Louisville, Kentucky: Press of C.T. Dearing Printing Company, 1924). See the U.S. Federal Census for 1900, 1910, 1920, and 1930, each of which lists Ulrich as a resident of Louisville.

69. See datasheet KY 9912-TE-23 for the painting Alois E. Ulrich, *Patchwork Quilt*, c. 1935, National Gallery of Art, 1943.8.2901, https://www.nga.gov/collection/art-object-page.15110.html; also see U.S. Federal Census for Ora Pemberton.

70. *Index of American Design: Reference Bibliography of Illustrated Books* (Washington D.C.:, 1936), http://hdl.handle.net/2027/ien.35556043273408; Hall and Kretsinger, *Romance*; Finley, *Old Patchwork Quilts*; Webster, *Quilts*; Sexton, *Old Fashioned Quilts*; Eliza Calvert Hall, *A Book of Hand-Woven Coverlets* (Boston: Little, Brown, 1931).

71. Index of American Design Datasheet NYC-Te-100, Archives of the National Gallery of Art.

72. According to Brackman, the oldest example of a dated pieced baskets quilt block is from 1855. She estimates a date range of 1850 to the present for this pattern. *Clues in the Calico*, 168.

73. Chris Miner, "Art with a Purpose: Pennsylvania's Museum Extension Project, 1935–1943," *Pennsylvania Heritage*, Spring 2008, http://paheritage.wpengine.com/article/art-with-purpose-pennsylvanias-museum-extension-project-1935-1943/.

74. Miner.

75. Quoted in Miner.

76. Pennsylvania Museum Extension Project, *1938 Catalogue: Visual Education Material for Distribution to Public Schools and Institutions in Pennsylvania* (Harrisburg, PA: Pennsylvania WPA, 1938), 5, https://digitalarchives.broward.org/digital/collection/wpa/id/2697/rec/143.

77. Lillian Perricone, "The WPA Museum Project in Context: Historical Precedents in Visual Education," in *WPA Museum Extension Project, 1935-1943: Government Created Visual Aids for Children from the Collections of the Bienes Museum of the Modern Book*, by James A Findlay and Lillian Perricone (Fort Lauderdale, FL: Bienes Museum of the Modern Book, 2009), 12–14.

78. Pennsylvania Museum Extension Project, *State-Wide Museum Extension Project Catalog Number Three* (Harrisburg, PA: Pennsylvania Work Projects Administration, 1940), 35–36, https://digitalarchives.broward.org/digital/collection/wpa/id/107/rec/38. Also see Pennsylvania Museum Extension Project, *1938 Catalogue*.

79. Miner, "Art with a Purpose."

80. Lillian Perricone, "The Pennsylvania Museum Extension Project (1935-1943): The First WPA Visual Education Project," in *WPA Museum Extension Project, 1935-1943: Government Created Visual Aids for Children from the Collections of the Bienes Museum of the Modern Book*, by James A Findlay and Lillian Perricone (Fort Lauderdale, FL: Bienes Museum of the Modern Book, 2009), 39.

81. Pennsylvania Museum Extension Project, *State-Wide Museum Extension*, 34–35. To see each of the plates, visit Shippensburg University Special Collections Digital Archives, "Museum Extension Project," https://harbor.klnpa.org/shippensburg/islandora/object/ship%3Amep.

82. For an array of visual aids created by MEPs around the country, see the collection checklist in James A Findlay and Lillian Perricone, *WPA Museum Extension Project, 1935-1943: Government Created Visual Aids for Children from the Collections of the Bienes Museum of the Modern Book* (Fort Lauderdale, FL: Bienes Museum of the Modern Book, 2009), 57–91.

83. Finley, *Old Patchwork Quilts*. See chapter 1 and chapter 6 herein for more on Finley's significant role in disseminating ideas about quilts during this era.

84. Author conversation with Barbara Garrett, April 29, 2021; Beatta Peck Little, Nancy F. Roan, and Variable Star Quilters, *W.P.A. Museum Extension Quilt Project* (Souderton, PA: Variable Star

Quilters and Generational Resources Exchange, 1990).

85. Little, Roan, and Variable Star Quilters.

86. Little, Roan, and Variable Star Quilters, 11.

87. Beatta Peck Little, Nancy F. Roan, and Variable Star Quilters, "History and Romance in Quilts," in *W.P.A. Museum Extension Quilt Project* (Souderton, PA: Variable Star Quilters and Generational Resources Exchange, 1990), 15. This is from the reprinted version, "a facsimile of the original which was type written and mimeographed," page 11.

88. Little, Roan, and Variable Star Quilters, *W.P.A. Museum Extension Quilt Project*, 9, 11.

89. Finley, *Old Patchwork Quilts*.

90. Little, Roan, and Variable Star Quilters, *W.P.A. Museum Extension Quilt Project*, 11; Finley, *Old Patchwork Quilts*, plate 72; Pennsylvania Museum Extension Project, *Chimney Sweep*, c. 1939, Shippensburg University Library Special Collections, https://harbor.klnpa.org/shippensburg/islandora/object/ship%3A516.

91. Little, Roan, and Variable Star Quilters, "History and Romance in Quilts," 35; for comparison see Finley, *Old Patchwork Quilts*, 132.

92. Little, Roan, and Variable Star Quilters, "History and Romance in Quilts," 19; see Finley, *Old Patchwork Quilts*, Plate 38; Pennsylvania Museum Extension Project, *Basket of Tulips*, c 1939, Shippensburg University Library Special Collections, https://harbor.klnpa.org/shippensburg/islandora/object/ship%3A502.

93. Little, Roan, and Variable Star Quilters, *W.P.A. Museum Extension Quilt Project*, 7; Perricone, "WPA Museum Project in Context," 40.

94. "About Bucks Co.," *The Central News*, October 5, 1939.

95. Little, Roan, and Variable Star Quilters, *W.P.A. Museum Extension Quilt Project*, 8–9.

96. Names on the silkscreened plates in this set include: Frank W. Hultelander, Wayne W. Kinsey, Phyllis [Irene] Light, Roy Singleton, Cathy Marchee, Donna Baesman, Karen Montalban__, John Carlo, Jim Seeton, Jean Adlman, Lewis Clark, Kathy J. Dutlinger, Sandra Ludwig, Rocci A. Pignoli, Martin Spitko, and Vernon R. Drey.

97. R.V. Rogers, "Supervisor Defends WPA's Museum Extension Project," *The Pittsburgh Press*, June 29, 1940.

98. "Visual Education Aids at Salisbury Twp. H.S," *Sunday News*, September 22, 1940.

99. Miner, "Art with a Purpose."

100. For example, see Brackman, *Facts & Fabrications*, 13–15.

101. Shelly Zegart, "Since Kentucky: Surveying State Quilts," The Quilt Index, accessed February 25, 2022, https://quiltindex.org/view/?type=essays&kid=8-109-1.

102. Perricone, "WPA Museum Project in Context," 49.

CHAPTER 6

1. "Roosevelt Quilt," *The Pasadena Post*, May 22, 1933.

2. "Old Fashioned Quilt for White House" (International News Photos, March 17, 1933).

3. Hall and Kretsinger, *Romance*, 28.

4. Jason E. Taylor, "Buy Now! But Here!: The Rise and Fall of the Patriotic Blue Eagle Emblem, 1933-1935," *Essays in Economic & Business History* 25 (2007): 118–21, https://www.ebhsoc.org/journal/index.php/ebhs/article/view/172/153.

5. Quoted in Taylor, 122.

6. "NRA Inspired This Quilt," *Lancaster New Era*, September 4, 1933; Taylor, "Buy Now!" 125. I am grateful for the expertise and generosity of Susan Wildemuth, who has conducted extensive research on known NRA Blue Eagle quilts. She shared her research notes with me which were invaluable for this portion of my study.

7. Nancy Cabot, "Quiltmakers Get 'New Deal' in Blue Eagle Coverlet Design," *Chicago Daily Tribune*, October 8, 1933, sec. PART 6.

8. "Blue Eagle Quilt Is Made Here," *The Pantagraph*, March 6, 1934, 1.

9. Taylor, "Buy Now!" 120–21.

10. Quoted in Charles Epting, "Roosevelt's Blue Eagle: The NRA and Mass Culture," *The Ephemera Journal* 19, no. 1 (2016): 11.

11. "Even the Men Quilt," *The Cincinnati Enquirer*, February 23, 1934; *Cincinnati City Directory*, 1933, https://www.ancestrylibrary.com/imageviewer/collections/2469/s/4225745?treeid=&person-id=&rc=&usePUB=true&_phsrc=SAF23&_phstart=successSource&pld=1105809957; see 1910 U.S. Census.

12. "Blue Eagle Quilt: Mrs. A.J. Bridgeman Designs Unique Pattern," *The Herald Statesman*, March 9, 1935.

13. Taylor, "Buy Now!" 125–26.

14. "Blue Eagle Quilt: Mrs. A.J. Bridgemand Designs Unique Pattern."

15. Susan Wildemuth has done an extraordinary job identifying Blue Eagle quilts. She knows of at least 22 quilts, based on her research in historical newspaper records, extant quilts, and other primary sources. For a summary of some of her preliminary findings, see her blog post, "NRA Eagle Quilt Research," Eye of the Needle, Oct 21, 2019, https://sew-eyeoftheneedlequilthistory.blogspot.com/2009/10/nra-eagle-quilt-research.html. Author's correspondence with Wildemuth, 2020-2021.

16. Quoted in Michael M. Meador, "'A Cover for the Nation': Ella Martin's Quilt Comes Home," *Quilter's Newsletter Magazine*, August 1989, 17.

17. Meador, "'A Cover for the Nation'" 16.

18. "The N.R.A. Quilt," *Bluefield Daily Telegraph*, May 10, 1936, http://www.newspapers.com/image/14974176.

19. "New Deal for Wintry Nights," *The San Antonio Light*, September 10, 1933; Susan Wildemuth to Janneken Smucker, "NRA Quilt Robinson NRA Quilt Texas," November 16, 2020.

20. Cabot, "Quiltmakers Get 'New Deal' in Blue Eagle Coverlet Design."

21. Epting, "Roosevelt's Blue Eagle," 13.

22. Marjorie Barton, *Leaning on a Legacy: The WPA in Oklahoma* (Oklahoma City, OK: Oklahoma Heritage Association, 2008), 61.

23. "Timeline," Digital Museum: Royal Neighbors of America, accessed May 5, 2023, https://rna.historyit.com/public-sites/home/digital-museum; Marie Young, "Quilts Accepted by the International Quilt Study Center & Museum," Royal Neighbors of America, October 18, 2016, https://www.royalneighbors.org/must-reads/newsroom/2016/10/18/depression-era-quilts.

24. For an extended discussion of these quilts and their makers' motivations, see Janneken Smucker, "Quilts, Social Engineering, and Black Power in the Tennessee Valley," *Southern Cultures*, Spring 2022, 25–39.

25. Greenberg, *To Ask for an Equal Chance*, 52–53; John P. Davis, "The Plight of the Negro in the Tennessee Valley," *Crisis*, October 1935, 294.

26. Davis, "The Plight of the Negro," 314.

27. Melissa Walker, "African Americans and TVA Reservoir Property Removal: Race in a New Deal Program," *Agricultural History* 72, no. 2 (1998): 417–28.

28. Davis, 315.

29. Waldvogel, *Soft Covers for Hard Times,* 78; Ruth Clement Bond, interview by Jewell Fenzi, November 12, 1992, Foreign Service Spouse Series, Association for Diplomatic Studies and Training | Foreign Affairs Oral History Program.

30. Bond interview

31. Max Bond, "Tennessee Valley Authority Office Memorandum," November 1, 1934, Personal collection of Merikay Waldvogel.

32. Angelik Vizcarrondo-Laboy, "Fabric of Change: The Quilt Art of Ruth Clement Bond," Museum of Arts and Design, February 22, 2017, https://madmuseum.org/views/fabric-change-quilt-art-ruth-clement-bond; Waldvogel, *Soft Covers for Hard Times*, 78; Bond interview.

33. Waldvogel, *Soft Covers for Hard Times*, 80-1. Waldvogel interviewed both Ruth Clement Bond and Rose Thomas for her book.

34. Michigan State University Museum owns the version made by Rose Thomas. In summer 2020, a previously unidentified version which was given to TVA administrator Maurice Seay came up for public auction and is now in the collection of the High Museum of Art. See Maurice Seay, "TVA Quilt Correspondence," September 10, 1976, https://quiltindex.org//view/?type=correspondence&kid=45-124-6. The location of the version made by Grace Tyler, pictured in Waldvogel, *Soft Covers for Hard Times,* 79, is currently unknown. Another copy, made by Rose Lee Cooper, was purchased by the Tennessee Valley Authority. See "The TVA Quilt," Tennessee Valley Authority | Built for the People, https://www.tva.com/about-tva/our-history/built-for-the-people/the-tva-quilt. A 5th version is pictured in black and white in Davis, "The Plight of the Negro," *Crisis*, October 1935.

35. For more discussion of the quilt's name and symbolism, see Smucker, "Quilts, Social Engineering, and Black Power," 26–7, 37.

36. Quoted in Vizcarrondo-Laboy, "Fabric of Change."

37. See Vizcarrondo-Laboy.

38. Merikay Waldvogel, "Regarding Quilts Made at Wheeler Dam Village (1930s)," undated, 9.1.b2.f38 Tennessee Valley Authority (TVA) Quilts, WPA, Michigan State University Museum, Cuesta Benberry Papers.

39. Waldvogel, *Soft Covers for Hard Times*, 82.

40. Nancy L. Grant, *TVA and Black Americans: Planning for the Status Quo* (Philadelphia: Temple University Press, 1990), 42–44. Also see the 1940 United States Census record for Tyler, which lists him as working at Watts Bar Dam, part of the TVA.

41. Waldvogel, "Regarding Quilts"; James R. Mapp, *Chance or Circumstance?: A Memoir and Journey Through the Struggle for Civil Rights* (Bloomington, IN: iUniverse, 2016). Some of these details were clarified during author's conversation with Waldvogel, April 15, 2021. For more on the cultural context of the TVA quilts within the segregated communities of the TVA, see Smucker, "Quilts, Social Engineering, and Black Power."

42. Waldvogel has a letter from Max Bond to Arthur Morgan that accompanied the quilt. This document indicates that the quilt featured an African American figure holding a lightning bolt, which is the quilt design with no known extant versions. The TVA quotes from this same letter on its web page discussing the TVA quilts. See https://www.tva.com/about-tva/our-history/built-for-the-people/the-tva-quilt.

43. "The TVA Quilt."

44. Davis, "The Plight of the Negro," 315.

45. Max Bond, "Tennessee Valley Authority Office Memorandum," November 1, 1934, Personal collection of Merikay Waldvogel.

46. Maurice Seay, "TVA Quilt Correspondence," September 10, 1976, https://quiltindex.org//view/?type=correspondence&kid=45-124-6.

47. On critiques of the TVA's racial practices and Morgan's and Lilienthal's perspectives on race see Davis, "The Plight of the Negro," 314; Grant, *TVA and Black Americans*, 33–35, 42–43.

48. Davis, "The Plight of the Negro," 295.

49. Russell Roberts, *Pickwick People and TVA, 1935-1985* (Pickwick Dam, Tennessee: R.R. Roberts, 1985), 53.

50. Killingsworth, "Regional Planning on a Local Scale," 54–57; Roberts, *Pickwick People and TVA, 1935-1985*, 50.

51. Davis, "The Plight of the Negro," 295.

52. For more on quilts given to or commemorating American presidents see Sue Reich, *Quilts Presidential and Patriotic* (Atlgen, PA: Schiffer Publishing, 2016).

53. Kyra E. Hicks, *Franklin Roosevelt's Postage Stamp Quilt: The Story of Estella Weaver Nukes' Presidential Gift* (Arlington, Va.: Black Threads Press, 2012).

54. "Quilt Given Mrs. Roosevelt," *St. Louis Post-Dispatch*, December 30, 1933, http://www.newspapers.com/image/138915726/.

55. International Quilt Museum, "Giddap," World Quilts: The American Story, 2013, https://worldquilts.quiltstudy.org/americanstory/node/5732; "Here Is 'Giddap,' A Very Democratic Donkey," *Kansas City Star*, July 22, 1931, http://www.newspapers.com/image/655486523.

56. Another quilt attributed to Fanning is in the collection of the Briscoe Center for American History at the University of Texas at Austin, similarly featuring painted and embroidered figures, in this case characters from children's storybooks. See Callie Elizabeth Jeffress Fanning, *Storybook Quilt* (Dolph Briscoe Center for American History, 1934), AR 2010-303-2], Briscoe Center for American History, Winedale Quilt History Collection, https://www.cah.utexas.edu/db/dmr/image_lg.php?variable=e_wqh_0262.

57. Callie Jeffress Fanning Smith to Eleanor Roosevelt, March 28, 1940, Franklin D. Roosevelt Presidential Library and Museum. For the museum record of the quilt see Callie Jeffress Fanning Smith, *Eleanor Roosevelt Portrait Quilt*, 1940, Franklin D. Roosevelt Presidential Library and Museum, https://fdr.artifacts.archives.gov/objects/6699/eleanor-roosevelt-portrait-quilt.

58. For details on public opinion of FDR, see Helmut Norpoth, *Unsurpassed: The Popular Appeal of Franklin Roosevelt* (London and New York: Oxford University Press, 2018).

59. "A Fitting Gift," *The Palm Beach Post*, January 9, 1937, http://www.newspapers.com/image/133411004.

60. "President Gets Quilt," *Lubbock Morning Avalanche*, January 3, 1935.

61. For more on this quilt and others sent to the Roosevelts see Hicks, *Franklin Roosevelt's Postage Stamp Quilt*.

62. I am grateful to Kyra Hicks for uncovering this correspondence. See Hicks, 24; R.L. Glenn to Franklin D. Roosevelt and Eleanor Roosevelt, March 20, 1936, FDR Gift File, Franklin D. Roosevelt Presidential Library and Museum; M.A. LeHand to R.L. Glenn, March 28, 1936, FDR Gift File, Franklin D. Roosevelt Presidential Library and Museum.

63. See 1940 United States Federal Census for Melissa Bacon.

64. For an overview of the political realignment that occurred among African Americans during the Great Depression, see Office of the House Historian, "The 'Fulfillment of White's Prophecy,'" History, Art & Archives, U.S. House of Representatives, accessed February 12, 2021, https://history.house.gov/Exhibitions-and-Publications/BAIC/Historical-Essays/Exile-Migration-Struggle/Fulfillment-of-Prophecy/; also see Eric Schickler, *Racial Realignment: The Transformation of American Liberalism, 1932-1965* (Princeton N.J.: Princeton University Press, 2016).

65. Eleanor Roosevelt to Mrs. Jules Joseph Fischer, February 9, 1935, Personal collection of Susan Wildemuth; 1940 United States Federal Census.

66. Kate Adams, "A Quilt for John Nance Garner," *The Texas Story Project* (blog), October 2, 2014, https://www.thestoryoftexas.com/discover/texas-story-project/garnerquilt-uvalde-county; Minnie Lee Holton Weeden Rucker, *Texas Star*, 1932, QB 326, Briscoe-Garner Museum Quilt Collection, Winedale Quilt History Collection, https://www.cah.utexas.edu/db/dmr/image_lg.php?variable=e_wqh_0468; 1930 United States Federal Census.

67. "Texas Map in Vivid Color Is Center Feature of Centennial Quilt-Gift to John M. Hendrix, Official of W.P.A.," *Abilene Reporter-News*, June 21, 1936.

68. Mary Clara Milligan Kindler Moore, *Rooster Quilt*, 1932, The Metropolitan Museum of Art, https://www.metmuseum.org/art/collection/search/645328; "Party Symbols," National Museum of American History, May 15, 2017, https://americanhistory.si.edu/democracy-exhibition/machinery-democracy/enduring-popular-images-and-party-symbols-0; Merikay Waldvogel, "Anne Orr," *The Quilters Hall of Fame* (blog), https://quiltershalloffame.net/anne-orr/.

69. *States That Elected Franklin Delano Roosevelt President in 1932, 1936 and 1940*, 1941, North Carolina Museum of History, http://collections.ncdcr.gov/RediscoveryProficioPublicSearch/ShowItem.aspx?19487+.

70. This account and many others of the 1933 Sears Quilt Contest are known thanks to the remarkable research of Barbara Brackman and Merikay Waldvogel. *Patchwork Souvenirs of the 1933 World's Fair: The Sears National Quilt Contest and Chicago's Century of Progress Exposition* (Nashville, TN: Rutledge Hill, 1993), 46–61.

71. Lorriane Barnes, "Painting in Thread Stitched by Artist," *Austin American-Statesman*, May 9, 1933; "Club Celebrates Achievement Day," *Austin American-Statesman*, December 1, 1933; "Faculty Member of School of Fine Arts Creates 'Oil Painting' by Use of Threads," *Austin American-Statesman*, November 12, 1939; Waldvogel and Brackman, *Patchwork Souvenirs*, 72–74.

72. Waldvogel and Brackman, *Patchwork Souvenirs*, 65–69.

73. Ricky Clark, "Ruth Finley and the Colonial Revival Era," *Uncoverings* 16 (1995): 51.

74. Ruth E. Finley, "The Roosevelt Rose—A New Historical Quilt Pattern," *Good Housekeeping*, January 1934.

75. For further analysis of this pattern and Finley's efforts to market it see Barbara Brackman, "The Roosevelt Rose Quilt," *Material Culture* (blog), November 3, 2022, https://barbarabrackman.blogspot.com/2022/11/the-roosevelt-rose-quilt.html.

76. Finley, "The Roosevelt Rose."

77. "First Lady Given Quilt: Interest Expressed in Revival of Folk Art," *The Nebraska State Journal*, December 30, 1933, http://www.newspapers.com/image/314354104/.

78. Brackman, *Clues in the Calico,* 112–13.

79. Finley, "The Roosevelt Rose."

80. "Girl Scouts' 'Little House' Will Open Better Homes Week," *Evening Star*, April 25, 1934.

81. See record for Barrett's quilt in the Quilt Index, https://quiltindex.org//view/?type=fullrec&kid=17-13-466

82. In addition to the International Quilt Museum example pictured, see the Illinois State Museum example at https://quiltindex.org//view/?type=fullrec&kid=5-2-34. Brackman lists the FDR Library and Museum example in her "F.D.R. Era in Quilts," *Quilters' Journal*, n.d.

83. Brackman, "F.D.R. Era in Quilts"; "Mark Current Events in Your Quilts," *Kansas City Star*, January 27, 1934.

84. Waldvogel, *Soft Covers for Hard Times.*

85. Meador, "'A Cover for the Nation,'" 17.

CONCLUSION

1. Lanigan, "Revival of the Patchwork Quilt," 19.

2. Lynn Z. Bassett, "Whole Cloth Quilts," in *American Quilts in the Industrial Age, 1760-1870: The International Quilt Study Center and Museum Collections*, ed. Patricia Cox Crews and Carolyn Ducey (Lincoln: University of Nebraska Press, 2018), 60.

3. For more on quilts as a distinctly American small-D democratic phenomenon, see Shaw, especially chapter 4 "The Rise of the Pieced Quilt, 1840-80," *American Quilts*; also see Maines, "Paradigms of Scarcity and Abundance," 84–88.

4. Isadora Williams quoted in Becker, *Selling Tradition*, 76–77.

5. "Our History," *Quilt Index*, November 2018, https://quiltindex.org/about/our-history/.

6. Neil Maher, "'Crazy Quilt Farming on Round Land': The Great Depression, the Soil Conservation Service, and the Politics of Landscape Change on the Great Plains during the New Deal Era," *The Western Historical Quarterly* 31, no. 3 (2000): 319–39, https://doi.org/10.2307/969963.

7. Clint Smith, "The Value of the Federal Writers' Project Slave Narratives," *The Atlantic*, March 2021, https://www.theatlantic.com/magazine/archive/2021/03/federal-writers-project/617790/.

8. Ted Lieu, "21st Century Federal Writers' Project Act," Pub. L. No. H.R.3054 (2021), http://www.congress.gov/.

9. Scott Borchert, "Opinion | A New Deal for Writers in America," *The New York Times*, July 6, 2021, sec. Opinion, https://www.nytimes.com/2021/07/06/opinion/federal-writers-project.html.

10. National Endowment for the Arts, "National Endowment for the Arts Grant Announcement—FY 2023," May 16, 2023, https://www.arts.gov/sites/default/files/Spring2023_DisciplineListReport_05.23.23.pdf; personal communication with Amy Milne,

Executive Director of the Quilt Alliance, August 15, 2023.

11. On federal funding see "National Endowment for the Arts on COVID-19," National Endowment for the Arts, March 2021, https://www.arts.gov/about/nea-on-covid-19; "Updates From NEH on COVID-19 And The CARES Act," The National Endowment for the Humanities, October 2014, https://www.neh.gov/coronavirus.

12. Ryan Prior, "Artists May Need a Depression-Era Jobs Program Today," *CNN*, April 11, 2020, https://www.cnn.com/style/article/coronavirus-recession-wpa-arts-programs-wellness-style/index.html.

13. Quoted in Borchert, "Opinion | A New Deal for Writers in America."

14. Meador, "'A Cover for the Nation.'"

15. "A Cultural New Deal for Cultural and Racial Justice," Cultural New Deal, 2020, https://culturalnewdeal.com/.

16. On collecting a "stash" of fabric see Marybeth C. Stalp, *Quilting: The Fabric of Everyday Life* (Oxford: Berg, 2007) especially chapter 4, "The Guilty Pleasures of the Fabric Stash"; on using one's stash to make PPE during COVID see Marybeth C. Stalp, "Who Ya Gonna Call? Quilters," *Contexts* 19, no. 3 (2020): 67.

17. Janneken Smucker, "Quilting and Difficult Times with Melanie Testa," July 16, 2020, in *Running Stitch, A QSOS Podcast,* https://quiltalliance.org/runningstitch/#episode-3; Stalp, "Who Ya Gonna Call?"; Sandra Sider, *Quarantine Quilts: Creativity in the Midst of Chaos* (Atglen, PA: Schiffer Publishing, 2021), 93.

18. *Final Report of the National Youth Administration.*

19. See examples from Nadine Pédusseau (page 53), Patti Louise Pasteur (page 30), Mary Wilson Kerr (page 75), Penny Howard (97), Anna Tufankjian (page 101) in Sider, *Quarantine Quilts.*

20. Janneken Smucker, "Learning to Quilt with Sarah Steiner," Nov 10, 2021, in *Running Stitch, A QSOS Podcast*, https://quiltalliance.org/runningstitch/.

21. Janneken Smucker, "Radical Quilt Histories with Jess Bailey," Dec 16, 2021, in *Running Stitch, A QSOS Podcast*, https://quiltalliance.org/runningstitch/; Jess Bailey, "Public Library Quilts," https://www.publiclibraryquilts.com/.

22. Textile Talks features weekly presentations and panel discussions from the International Quilt Museum, Modern Quilt Guild, Quilt Alliance, San Jose Museum of Quilts & Textiles, Studio Art Quilt Associates, and Surface Design Association. For details see https://www.internationalquiltmuseum.org/textile-talks, 2020-2023. To access all recordings of past Textile Talks see https://www.youtube.com/playlist?list=PLXsBpWjk3xVCTzucHkrU3ly5N-lLa7mW3f.

23. Waldvogel, *Soft Covers for Hard Times.*

24. Lenny van Eijk quoted in Sider, *Quarantine Quilts*, 38.

25. Natalie Skinner quoted in Sider, 34.

26. Teresa Barkley quoted in Sider, 42.

27. For more details about a proposed Green New Deal see Ray Galvin and Noel Healy, "The Green New Deal in the United

States: What It Is and How to Pay for It," *Energy Research & Social Science* 67 (September 1, 2020): 101529, https://doi.org/10.1016/j.erss.2020.101529; Kate Aronoff et al., *A Planet to Win: Why We Need a Green New Deal* (London: Verso Books, 2019).

28. Ashley Dawson, "A Green New Deal for the Arts," in *The World We Need: Stories and Lessons From America's Unsung Environmental Movement* (New York: New Press, 2021), 114.

29. Elizabeth A. Osborne, "The Promise of the Green New Deal: A 21st-Century Federal Theatre Project," *TDR: The Drama Review* 65, no. 4 (2021): 19.

30. For examples of this sentiment see interviews I conducted for *Running Stitch, A QSOS Podcast:* Janneken Smucker, "Sewing with Purpose with Sara Trail," Dec 10, 2021, in *Running Stitch, A QSOS Podcast*, https://quiltalliance.org/runningstitch/#episode-15; Janneken Smucker, "Quilts and Activism with Thomas Knauer," *Running Stitch, A QSOS Podcast*, accessed June 6, 2023, https://quiltalliance.org/runningstitch/#episode-2; Janneken Smucker, "Quilting and Civil Rights with Carolyn Mazloomi," July 16, 2020, in *Running Stitch, A QSOS Podcast,* https://quiltalliance.org/runningstitch/#episode-4; also see Thomas Knauer, *Why We Quilt: Contemporary Makers Speak Out: The Power of Art, Activism, Community, and Creativity* (North Adams, MA: Storey Publishing, 2019).

31. See Alexis Deise's quilts including "Comfort Quilt for a Lockdown Drill," "American Album Quilt," and "Family Fire." Alexis Deise, "Work," https://www.alexisdeise.com/work.

32. Smucker, "Quilting and Civil Rights"; Carolyn L. Mazloomi, *And Still We Rise: Race, Culture and Visual Conversations*, (Atglen, PA: Schiffer, 2015); Carolyn Mazloomi, "About," Carolyn Mazloomi, accessed June 12, 2023, https://carolynlmazloomi.com/about/.

33. For two prominent examples, see the work and teaching practices of Zak Foster (https://www.zakfoster.com/about) and Sherrie Lynn Wood (https://www.sherrilynnwood.com/improv-quilting-blog/2023/02/10/sustainable-quilting-with-mens-shirts). See the full program for Quilt Alliance, "QTM 2022: Sustainability Stories!" https://www.qtm2022.org/.

34. See Quilt Alliance, "Sustainable Stitching: Making Quilts with the Earth in Mind," September 16, 2022, https://www.youtube.com/watch?v=K3BlkToxLzE; Thomas Knauer, "Go Tell it at the Quilt Show! Interview with Thomas Knauer," Feb 23, 2013, Quilt Alliance, https://www.youtube.com/watch?v=mtTF0FDHyc4.

35. "2022 Quilters' Survey Results," *American Quilt Retailer* (blog), January 5, 2023, https://www.americanquiltretailer.com/news/2022-quilters-survey-results/; "Environmental Impact of Cotton Production," The World Counts, https://www.theworldcounts.com/challenges/consumption/clothing/environmental-impact-of-cotton-production, accessed June 13, 2023.

36. Seay, "TVA Quilt Correspondence," September 9, 1976; Waldvogel, "Tuley Park"; Stevens, "The Farlows"; Betts, "Women's Role in Migration," ix.

BIBLIOGRAPHY

ARCHIVAL COLLECTIONS AND ONLINE RESOURCES

American Life Histories: Manuscripts from the Federal Writers' Project, 1936 to 1940, loc.gov/collections/federal-writers-project/

Born in Slavery: Slave Narratives from the Federal Writers' Project, 1936 to 1938, loc.gov/collections/slave-narratives-from-the-federal-writers-project-1936-to-1938/

Chronicling America, chroniclingamerica.loc.gov/

Farm Security Administration/Office of War Information Black-and-White Negatives. Library of Congress. loc.gov/collections/fsa-owi-black-and-white-negatives/

Migratory Labor Camp Newsletters Collection, Special Collection & Archives, California State University Northridge

HathiTrust Digital Library, hathitrust.org

Index of American Design, National Gallery of Art, www.nga.gov/

International Quilt Museum, internationalquiltmuseum.org/collections/search

International Quilt Museum, *World Quilts: The American Story* 2013. worldquilts.quiltstudy.org/american story.

A New Deal for Quilts primary source collection, newdealquilts.janneken.org/

The Living New Deal, livingnewdeal.org

Newspapers.com, a division of Ancestry.com

The Quilt Index, quiltindex.org

SELECTED BIBLIOGRAPHY

Adams, Kate. "A Quilt for John Nance Garner." *The Texas Story Project* (blog), October 2, 2014. https://www.thestoryoftexas.com/discover/texas-story-project/garnerquilt-uvalde-county.

African American Registry. "Dorothy West, Harlem Renaissance Writer Born." Accessed November 5, 2021. https://aaregistry.org/story/dorothy-west-a-renaissance-woman/.

Alexander, Will W. "Rural Resettlement." *The Southern Review* 1, no. 3 (Winter 1936): 528–39.

Arabindan-Kesson, Anna. *Black Bodies, White Gold: Art, Cotton, and Commerce in the Atlantic World.* Durham, NC: Duke University Press, 2021.

Aronoff, Kate, Alyssa Battistoni, Daniel Aldana Cohen, and Thea Riofrancos. *A Planet to Win: Why We Need a Green New Deal.* London: Verso Books, 2019.

Avery, Virginia. "Fannie B. Shaw Sews a History Lesson." *Quilter's Newsletter Magazine*, October 2002, 36-37.

Babbitt, Kathleen R. "The Productive Farm Woman and the Extension Home Economist in New York State, 1920-1940." *Agricultural History* 67, no. 2 (1993): 83–101.

Baldwin, Sidney. *Poverty and Politics: The Rise and Decline of the Farm Security Administration.* Chapel Hill: University of North Carolina Press, 1968.

Baker, Georgia. "Georgia Baker, Ex-Slave - Age 87." Interview by Sadie B. Hornsby, August 4, 1938. Federal Writers' Project: Slave Narrative Project, Vol. 4, Georgia, Part 1, Adams-Furr. Library Of Congress. https://www.loc.gov/resource/mesn.041/?sp=41.

Baker, Gladys. *The County Agent.* Chicago: University of Chicago Press, 1939. https://digital.library.cornell.edu/catalog/chla2838768.

Banks, Ann. "Introduction | American Life Histories: Manuscripts from the Federal Writers' Project, 1936 to 1940." Library of Congress. https://www.loc.gov/collections/federal-writers-project/articles-and-essays/introduction/.

Bartlett, Ella. "Living Lore." Interview by Louise Bassett, December 19, 1938. Folklore Project, Life Histories, 1936-39. Library Of Congress. https://www.loc.gov/resource/wpalh1.14020913/.

Barton, Marjorie. *Leaning on a Legacy: The WPA in Oklahoma*. Oklahoma City, OK: Oklahoma Heritage Association, 2008.

Bassett, Lynn Zacek. "'A Dull Business Alone': Cooperative Quilting in New England, 1750-1850." In *Textiles in New England II: Four Centuries of Material Life*, edited by Peter Benes, 27–43. Annual Proceedings of the Dublin Seminar for New England Folklife 24. Boston: Boston University, 1999.

———. "Whole Cloth Quilts." In *American Quilts in the Industrial Age, 1760-1870: The International Quilt Study Center and Museum Collections*, edited by Patricia Cox Crews and Carolyn Ducey, 60–63. Lincoln: University of Nebraska Press, 2018.

Beardsley, John. "River Island." In *The Quilts of Gee's Bend: Masterpieces from a Lost Place*. Atlanta: Tinwood Books in association with the Museum of Fine Arts, Houston, 2002.

Becker, Jane S. *Selling Tradition: Appalachia and the Construction of an American Folk, 1930-1940*. Chapel Hill: University of North Carolina Press, 1998.

Benberry, Cuesta. "The 20th Century's First Quilt Revival (Part 1)." *Quilter's Newsletter Magazine*, August 1979.

———. "The 20th Century's First Quilt Revival (Part 2)." *Quilter's Newsletter Magazine*, September 1979.

———. "The 20th Century's First Quilt Revival (Part 3)." *Quilter's Newsletter Magazine*, October 1979.

———. *Always There: The African-American Presence in American Quilts*. Louisville, Ky: Kentucky Quilt Project, 1992.

———. "W.P.A. & Quilt Research Survey," c 1985. 2.3.b4.f8. Cuesta Benberry Papers, Michigan State University Museum.

Betts, Jeanette Gardener. "Women's Role in Migration, Settlement, and Community Building: A Case Study of 'Okies' in the Migrant Farm Workers' Camp, Marysville, California." Master's thesis, California State University, Chico, 1997.

Bleu, Lolly. "Lolly Bleu--Florida Squatter." Interview by Barbara Berry Darsey, November 29, 1938. Folklore Project, Life Histories, 1936-39. Library Of Congress. https://doi.org/10.

Bolton, James. James Bolton, Athens, Georgia. Interview by Sarah H. Hall, n.d. Federal Writers' Project: Slave Narrative Project, Vol. 4, Georgia, Part 1, Adams-Furr. Library Of Congress.

Bond, Max. "Tennessee Valley Authority Office Memorandum," November 1, 1934. Personal collection of Merikay Waldvogel.

Bond, Ruth Clement. Interview by Jewell Fenzi, November 12, 1992. Foreign Service Spouse Series. Association for Diplomatic Studies and Training | Foreign Affairs Oral History Program.

Bonds, Sarah M. "Mrs. Sarah M. Bonds." Interview by Ivey G. Warren, November 22, 1936. Folklore Project, Life Histories, 1936-39. Library of Congress. https://www.loc.gov/item/wpalh002597/.

Borchert, Scott. "Opinion | A New Deal for Writers in America." *The New York Times*, July 6, 2021, sec. Opinion. https://www.nytimes.com/2021/07/06/opinion/federal-writers-project.html.

Bowers, Lula. "Mrs. Lula Bowers I." Interview by Phoebe Faucette, June 28, 1938. Folklore Project, Life Histories, 1936-39. Library of Congress. https://www.loc.gov/resource/wpalh3.30110205/.

Brackman, Barbara, Maria Elena Buszek, Beverly Gordon, and Janneken Smucker. "Quilting Myths and Nostalgia." In *"Workt by Hand": Hidden Labor and Historical Quilts*, edited by Catherine Morris, 26–30. Brooklyn, NY: Brooklyn Museum, 2012.

Brackman, Barbara. "A Few Broken Stars." *Material Culture* (blog), June 5, 2014. http://barbarabrackman.blogspot.com/2014/06/a-few-broken-stars.html.

———. "Cheater Cloth - Geometrical Chintz." *Material Culture* (blog), April 12, 2017. http://barbarabrackman.blogspot.com/2017/04/cheater-cloth-geometrical-chintz.html.

———. *Clues in the Calico: A Guide to Identifying and Dating Antique Quilts*. Charlottesville, VA: Howell Press, 1989.

———. "Fabric Retailing: Factory Cut-Aways." *Material Culture* (blog), October 15, 2013. https://barbarabrackman.blogspot.com/2013/10/fabric-retailing-factory-cut-aways.html.

———. "Factory Cutaways and Quilts." *Material Culture* (blog), October 28, 2013. https://barbarabrackman.blogspot.com/2013/10/factory-cutaways-and-quilts.html.

———. *Facts & Fabrications-Unraveling the History of Quilts & Slavery: 8 Projects 20 Blocks First-Person Accounts.* Lafayette, CA: C&T Publishing, 2006.

———. "Frugal and Fashionable: Quiltmaking During the Great Depression." *The Quilt Index*, 2011. https://quiltindex. org/view/?type=essays&kid=7-108-1.

———. "F.D.R. Era in Quilts." *Quilters' Journal*, n.d.

———. "Laura Wheeler Patterns." *Material Culture* (blog), August 30, 2009. http://barbarabrackman.blogspot. com/2009/08/laura-wheeler-patterns.html.

———. "Nancy Cabot/Loretta Leitner: A Short History." *Material Culture* (blog), October 4, 2022. https:// barbarabrackman.blogspot.com/2022/10/nancy-cabotloretta-leitner-short-history.html.

———. "Peggy Westerfield: Textile Collector." *Material Culture* (blog), June 16, 2018. http://barbarabrackman. blogspot.com/2018/06/peggy-westerfield-textile-collector. html.

———. "Quilt Pictures: Tossing Out Some Basic Assumptions." *Material Culture* (blog), August 24, 2018. http://barbarabrackman.blogspot.com/2018/08/quilt-pictures-tossing-out-some-basic.html.

———. "Quintuplets with a Scalloped Edge: New York Style." *Material Culture* (blog), December 25, 2017. https:// barbarabrackman.blogspot.com/2017/12/quintuplets-with-scalloped-edge-new.html.

———. "The Roosevelt Rose Quilt." *Material Culture* (blog), November 3, 2022. https://barbarabrackman.blogspot. com/2022/11/the-roosevelt-rose-quilt.html.

———. "Tottenville Sisters # 3: The Sunflower/Sunburst Quilt." *Material Culture* (blog), April 13, 2018. http:// barbarabrackman.blogspot.com/2018/04/tottenville-sisters-3-sunflowersunburst.html.

———. "Tottenville Sisters #1: Mary or Betsey?" *Material Culture* (blog), April 11, 2018. https://barbarabrackman. blogspot.com/2018/04/tottenville-sisters-1-mary-or-betsey. html.

———. "Tottenville Sisters #2: A Second & Third Rising Sun." *Material Culture* (blog), April 12, 2018. https:// barbarabrackman.blogspot.com/2018/04/tottenville-sisters-2-second-third.html.

———. "Tottenville Sisters #4: Dating the Quilts." *Material Culture* (blog), April 14, 2018. https://barbarabrackman. blogspot.com/2018/04/tottenville-sisters-4-dating-quilts. html.

Buferd, Norma Bradley, and Patricia Cooper. "Prosperity Is Just Around the Corner." *McCall's Needlework and Crafts*, Spring 1978.

Burlbaw, Lynn Matthew. "An Early Start: WPA Emergency Nursery Schools in Texas, 1934-1943." *American Educational History Journal* 36, no. 2 (January 1, 2009): 269–98.

Cannon, Brian Q. "'Keep on A-Goin': Life and Social Interaction in a New Deal Farm Labor Camp." *Agricultural History* 70, no. 1 (1996): 1–32.

Carlebach, Michael L. "Documentary and Propaganda: The Photographs of the Farm Security Administration." *The Journal of Decorative and Propaganda Arts* 8 (1988): 6–25. https://doi.org/10.2307/1503967.

Carriker, Robert M. *Urban Farming in the West: A New Deal Experiment in Subsistence Homesteads.* Tucson: University of Arizona Press, 2010.

Clark, Ricky. "Ruth Finley and the Colonial Revival Era." *Uncoverings* 16 (1995): 33–66.

Clayton, Virginia Tuttle. "Picturing a 'Usable Past.'" In *Drawing on America's Past: Folk Art, Modernism, and the Index of American Design*, 1–43. Washington, DC: National Gallery of Art, 2002.

Clayton, Virginia Tuttle, Elizabeth Stillinger, Erika Doss, and Deborah Chotner. *Drawing on America's Past: Folk Art, Modernism, and the Index of American Design.* Washington, DC]: National Gallery of Art, 2002

Clem, Deborah. "Florence Peto." Quilters Hall of Fame. Accessed November 30, 2021. https://quiltershalloffame.net/ florence-peto/.

Cleveland, Catherine. "The W.P.A. Sewing Program." *Journal of Home Economics* 33, no. 8 (1941): 587–88.

Cogswell, Robert. "Introduction: From Making Do to How-To." In *Soft Covers for Hard Times*, by Merikay Waldvogel, xi–xv. Nashville, TN: Rutledge Hill Press, 1990.

Collins, Lisa Gail. *Stitching Love and Loss: A Gee's Bend Quilt.* Seattle: University of Washington Press, 2023.

Conkin, Paul Keith. *Tomorrow a New World: The New Deal Community Program.* Miami, FL: Hardpress Publishing, 2012. First published 1959 by Cornell University Press.

Cubbs, Joanne. "A History of the Work-Clothes Quilt." In *Gee's Bend: The Architecture of the Quilt.* Atlanta, GA: Tinwood Books, 2006.

Cultural New Deal. "A Cultural New Deal for Cultural and Racial Justice," 2020. https://culturalnewdeal.com/.

Curtis, James C. "Dorothea Lange, Migrant Mother, and the Culture of the Great Depression." *Winterthur Portfolio* 21, no. 1 (April 1, 1986): 1–20.

———. *Mind's Eye, Mind's Truth: FSA Photography Reconsidered*. Philadelphia: Temple University Press, 1989.

Dafoe, Taylor. "The Famed Quilters of Gee's Bend Are Using Their Sewing Skills to Make a Face Mask for Every Citizen in Their Small Alabama Town." *Artnet News*, April 13, 2020. https://news.artnet.com/art-world/gees-bend-masks-1831854.

Daniel, Pete, Maren Strange, Sally Stein, and Merry A Foresta. *Official Images: New Deal Photography*. Washington, DC: Smithsonian Institution Press, 1987.

Darsey, Barbara Berry. "[Mr. and Mrs. Fredrick Goethe]." WPA Federal Writers' Project, c 1938. Folklore Project, Life Histories, 1936-39. Library of Congress. https://www.loc.gov/resource/wpalh1.10130722.

Davis, John P. "The Plight of the Negro in the Tennessee Valley." *Crisis*, October 1935.

Davis, Valerie J., and Jackie Schweitzer. "The Policy of Good Design: Quilt Designs and Designers from the WPA Milwaukee Handicrafts Project, 1935-1942." *Uncoverings* 32 (2011): 103–21.

Dawson, Ashley. "A Green New Deal for the Arts." In *The World We Need: Stories and Lessons From America's Unsung Environmental Movement*, 114–23. New York: New Press, 2021.

Dean, Virgil W., and Ramon Powers. "'In No Way a Relief Set Up': The County Cotton Mattress Program in Kansas, 1940-1941." *Kansas History: A Journal of the Central Plains* 37, no. 4 (Winter 2014): 242–55.

Division of Subsistence Homesteads. *A Homestead and Hope*. Washington DC: United States Governmental Printing Office, 1935. http://archive.org/details/CAT31355383.

Documenting America. "Tenant Farmers," 1988. www.loc.gov/pictures/collection/fsa/docchap5.html.

Doss, Erika. "American Folk Art's 'Distinctive Character': The Index of American Design and New Deal Notions of Cultural Nationalism." In *Drawing on America's Past: Folk Art, Modernism, and the Index of American Design*, 61–73. Washington, DC: National Gallery of Art, 2002.

Dreilinger, Danielle. *The Secret History of Home Economics: How Trailblazing Women Harnessed the Power of Home and Changed the Way We Live*. First edition. New York: W. W. Norton, 2021.

Ducey, Carolyn, Christine Humphrey, and Patricia Cox Crews. "Introduction: *American Quilts in the Industrial Age, 1760-1870*." In *American Quilts in the Industrial Age, 1760-1870: The International Quilt Study Center and Museum Collections*, edited by Patricia Cox Crews and Carolyn Ducey, 1–24. Lincoln: University of Nebraska Press, 2018.

Elving, Ron. "In The 1930s, Works Program Spelled HOPE For Millions Of Jobless Americans." *NPR*, April 4, 2020, sec. The Coronavirus Crisis. https://www.npr.org/2020/04/04/826909516/in-the-1930s-works-program-spelled-hope-for-millions-of-jobless-americans.

Epting, Charles. "Roosevelt's Blue Eagle: The NRA and Mass Culture." *The Ephemera Journal* 19, no. 1 (2016): 11–14.

Findlay, James A, and Lillian Perricone. *WPA Museum Extension Project, 1935-1943: Government Created Visual Aids for Children from the Collections of the Bienes Museum of the Modern Book*. Fort Lauderdale, FL: Bienes Museum of the Modern Book, 2009.

Finley, Ruth E. *Old Patchwork Quilts and the Women Who Made Them*. Philadelphia, PA: J.B. Lippincott Co., 1929.

———. "The Roosevelt Rose--A New Historical Quilt Pattern." *Good Housekeeping*, January 1934.

Finnegan, Cara A. "FSA Photography and New Deal Visual Culture." In *American Rhetoric in the New Deal Era, 1932-1945*, edited by Thomas W Benson, 115–55. A Rhetorical History of the United States, vol VII. East Lansing: Michigan State University Press, 2006.

———. "Managing the Magnitude of the Great Depression: Viewers Respond to FSA Photography." In *Making Photography Matter: A Viewer's History from the Civil War to the Great Depression*, 125–68. Urbana: University of Illinois Press, 2015.

———. *Picturing Poverty: Print Culture and FSA Photographs*. Washington, DC: Smithsonian Institution Press, 2003.

Fite, Gilbert C. "The Great Depression Strikes." In *Cotton Fields No More: Southern Agriculture, 1865-1980*, 120–38. Lexington: University Press of Kentucky, 1984.

Flenniken, Kate. "Kate Flenniken." Interview by W.W. Dixon, June 6, 1938. Folklore Project, Life Histories, 1936-39. Library of Congress. https://www.loc.gov/resource/wpalh3.30081005/.

Galvin, Ray, and Noel Healy. "The Green New Deal in the United States: What It Is and How to Pay for It." *Energy Research & Social Science* 67 (September 1, 2020): 101529. https://doi.org/10.1016/j.erss.2020.101529.

Garoutte, Sally. "Early Colonial Quilts in a Bedding Context." *Uncoverings* 1 (1980): 18–25.

Ginsburgh, Sylvan Jacob. "The Migrant Camp Program of the F.S.A. in California: A Critical Examination of Operations at the Yuba City and Thornton Camps." MA thesis, San Francisco State College, 1943.

Glenn, R.L. Letter to Franklin D. Roosevelt and Eleanor Roosevelt, March 20, 1936. FDR Gift File. Franklin D. Roosevelt Library.

Goldstein, Carolyn M. *Creating Consumers: Home Economists in Twentieth-Century America.* Chapel Hill: University of North Carolina Press, 2012.

Gordon, Linda. "Dorothea Lange's Oregon Photography: Assumptions Challenged." *Oregon Historical Quarterly* 110, no. 4 (December 1, 2009): 570–97.

Grant, Nancy L. *TVA and Black Americans: Planning for the Status Quo.* Philadelphia: Temple University Press, 1990.

Graves, John Temple. "The Big World At Last Reaches Gee's Bend: Amid Changes Wrought by the RA, a Picturesque Community Of Negroes in Alabama Seeks to Keep Its Own Way of Life." *The New York Times*, Aug. 22, 1937, sec. The New York Times Magazine.

Green, Elna C. *Looking for the New Deal: Florida Women's Letters During the Great Depression.* Columbia: University of South Carolina Press, 2007.

———. "Relief from Relief: The Tampa Sewing-Room Strike of 1937 and the Right to Welfare." *The Journal of American History* 95, no. 4 (2009): 1012–37. https://doi.org/10.2307/27694558.

Greenberg, Cheryl Lynn. *To Ask for an Equal Chance: African Americans in the Great Depression.* Lanham, MD: Rowman & Littlefield Publishers, 2009.

Grieve, Victoria M. *The Federal Art Project and the Creation of Middlebrow Culture.* Urbana: University of Illinois Press, 2009.

———. "'Work That Satisfies the Creative Instinct': Eleanor Roosevelt and the Arts and Crafts." *Winterthur Portfolio* 42, no. 2/3 (Summer 2008): 159–82. https://doi.org/10.1086/589595.

Gunn, Virginia. "From Myth to Maturity: The Evolution of Quilt Scholarship." *Uncoverings* 13 (1992): 192–205.

———. "Perfecting the Past: Colonial Revival Quilts." In *American Quilts in the Modern Age, 1870-1940: The International Quilt Study Center Collections,* edited by Marin F. Hanson and Patricia Cox Crews, 228–86. Lincoln: University of Nebraska Press, 2009.

Hall, Carrie A., and Rose Kretsinger. *The Romance of the Patchwork Quilt in America.* New York: Bonanza Books, 1935.

Hall, Eliza Calvert. *A Book of Hand-Woven Coverlets.* Boston: Little, Brown, 1931.

Hargrove, Tasha M., Robert Zabawa, and Michelle Pace. "School & Community." Flint River Farms. http://www.flintriverfarms.org/school--community.html.

———. "Twice Born: The Death and Rebirth of Resettlement in Georgia." Flint River Farms. http://www.flintriverfarms.org/the-story.html.

Harney, Andy Leon. "WPA Handicrafts Rediscovered." *Historic Preservation*, September 1973, 10–15.

Harris, Carmen V. "The South Carolina Home in Black and White: Race, Gender, and Power in Home Demonstration Work." *Agricultural History* 93, no. 3 (Summer 2019): 477–501. https://doi.org/10.3098/ah.2019.093.3.477.

———. "'Well I Just Generally Bes the President of Everything': Rural Black Women's Empowerment through South Carolina Home Demonstration Activities." *Black Women, Gender & Families* 3, no. 1 (May 20, 2009): 91–112. https://doi.org/10.1353/bwg.0.0001.

Hibbard-Mipaas, Judith, and Nicole Krup Oest. "About Esther Mipaas." Esther Lewittes Mipaas. Accessed January 5, 2022. https://www.esthermipaas.com/bio.

Hicks, Kyra E. *Black Threads: An African American Quilting Sourcebook.* Jefferson, N.C.: McFarland & Co., 2003.

———. *Franklin Roosevelt's Postage Stamp Quilt: The Story of Estella Weaver Nukes' Presidential Gift.* Arlington, Va.: Black Threads Press, 2012.

Hill, Elizabeth Griffin. "Home Demonstration Clubs." In *Encyclopedia of Arkansas*, July 23, 2018. https://encyclopediaofarkansas.net/entries/home-demonstration-clubs-5387/.

Hirsch, Jerrold. "Kentucky Folk Art: New Deal Approaches." In *Kentucky by Design: The Decorative Arts and American Culture,* edited by Andrew Kelly, 29–44. Lexington: University of Kentucky Press, 2015.

———. *Portrait of America: A Cultural History of the Federal Writers' Project.* Chapel Hill: University of North Carolina Press, 2004.

Hise, Greg. "From Roadside Camps to Garden Homes: Housing and Community Planning for California's Migrant Work Force, 1935-1941." *Perspectives in Vernacular Architecture* 5 (1995): 243–58. https://doi.org/10.2307/3514258.

"Home Demonstration Work in My Home and Community." *Home Demonstration Radio Program.* National Broadcasting Company, June 6, 1934. http://archive.org/details/CAT31378806.

Index of American Design: Reference Bibliography of Illustrated Books. Washington DC: Federal Art Project, 1936. http://hdl.handle.net/2027/ien.35556043273408.

Jellison, Katherine. *Entitled to Power: Farm Women and Technology, 1913-1963.* Chapel Hill: University of North Carolina Press, 1993.

Jones, Lu Ann, and Sunae Park. "From Feed Bags to Fashion." *Textile History* 24, no. 1 (1993): 91–103.

Jones, Edward N. *One Year of W.P.A. in Pennsylvania, July 1, 1935-June 30, 1936.* Works Progress Administration for Pennsylvania, 1936. http://archive.org/details/oneyearofwpainpe00jone_0.

Jones, Robinson Godfrey, and Horace Mann Buckley. *Arithmetic Activities; Description of Arithmetic Activities Conducted at Gordon School, Formerly Curriculum Center for Arithmetic.* Cleveland: [Cleveland] Division of Publication, Board of Education, 1931. http://hdl.handle.net/2027/osu.32435016222200.

Katz, Meighen. "A Paradigm of Resilience: The Pros and Cons of Using the FSA Photographic Collection in Public History Interpretations of the Great Depression." *The Public Historian* 36, no. 4 (2014): 8–25. https://doi.org/10.1525/tph.2014.36.4.8.

Kelly, Timothy, Margaret Power, and Michael D Cary. *Hope in Hard Times: Norvelt and the Struggle for Community during the Great Depression.* University Park, PA: Pennsylvania State University Press, 2016.

Killingsworth, Steve. "Regional Planning on a Local Scale: The Brief Life of Pickwick Village." *West Tennessee Historical Society Papers* 51 (January 1997): 48–63.

Klassen, Teri. "Representations of African American Quiltmaking: From Omission to High Art." *The Journal of American Folklore* 122, no. 485 (2009): 297–334.

Klimuska, Ed. *Lancaster County: Quilt Capital U.S.A.* Lancaster, PA: Lancaster New Era, 1987.

Knauer, Thomas. *Why We Quilt: Contemporary Makers Speak Out: The Power of Art, Activism, Community, and Creativity.* North Adams, MA: Storey Publishing, 2019.

Kort, Ellen. *Wisconsin Quilts: Stories in the Stitches.* Charlottesville, VA: Howell Press, 2001.

Kraak, Deborah E. "Patchwork Prints in America: 1878-1900." *Uncoverings* 32, (2011): 153–73.

Kuhn, Clifford M. "'It Was a Long Way from Perfect, but It Was Working': The Canning and Home Production Initiatives in Greene County, Georgia, 1940–1942." *Agricultural History* 86, no. 2 (2012): 68–90. https://doi.org/10.3098/ah.2012.86.2.68.

Lanigan, Sybil. "Revival of the Patchwork Quilt." *Ladies' Home Journal*, October 1894.

Lawrence, Marjorie. "The Revival of an American Craft." *The American Home*, July 1929.

Leerssen, Joep. "Notes toward a Definition of Romantic Nationalism." *Romantik: Journal for the Study of Romanticisms* 2, no. 1 (February 3, 2013): 9–35. https://doi.org/10.7146/rom.v2i1.20191.

LeHand, M.A. Letter to R.L. Glenn, March 28, 1936. FDR Gift File. Franklin D. Roosevelt Library.

Library of Congress. "A Note on the Language of the Narratives | Born in Slavery: Slave Narratives from the Federal Writers' Project, 1936-1938." Accessed November 11, 2021. https://www.loc.gov/collections/slave-narratives-from-the-federal-writers-project-1936-to-1938/articles-and-essays/note-on-the-language-of-the-narratives/.

———. "About This Collection." American Life Histories: Manuscripts from the Federal Writers' Project, 1936-1940 | Library of Congress. Accessed January 26, 2022. https://www.loc.gov/collections/federal-writers-project/about-this-collection/.

Lieu, Ted. 21st Century Federal Writers' Project Act, Pub. L. No. H.R.3054 (2021).

Little, Beatta Peck, Nancy F. Roan, and Variable Star Quilters. "History and Romance in Quilts." In *W.P.A. Museum Extension Quilt Project.* Souderton, PA: Variable Star Quilters and Generational Resources Exchange, 1990.

———. *W.P.A. Museum Extension Quilt Project.* Souderton, PA: Variable Star Quilters and Generational Resources Exchange, 1990.

Living New Deal. "Osage Farms - Pettis Co. Mo.," https://livingnewdeal.org/projects/osage-farms-pettis-co-mo/.

Lord, Russell, and Paul Howard Johnstone. *A Place on Earth, a Critical Appraisal of Subsistence Homesteads*. Washington, DC: U.S. Bureau of Agricultural Economics, 1942. http://archive.org/details/placeonearthcrit00unit.

M.A. Donohue and Co. *A Patch Work Quilt of Favorite Tales*. M.A. Donohue and Co. 1933. http://hdl.handle.net/2027/mdp.39015056467841.

MacLellan, Lila. "Adding a Layer of Nylon Stocking Could Make DIY Coronavirus Masks More Protective." *Quartz* (blog), April 25, 2020. https://qz.com/1845741/diy-coronavirus-masks-more-protective-if-enhanced-with-pantyhose/.

Maher, Neil. "'Crazy Quilt Farming on Round Land': The Great Depression, the Soil Conservation Service, and the Politics of Landscape Change on the Great Plains during the New Deal Era." *The Western Historical Quarterly* 31, no. 3 (2000): 319–39. https://doi.org/10.2307/969963.

Maines, Rachel. "Paradigms of Scarcity and Abundance: The Quilt as an Artifact of the Industrial Revolution." In *In the Heart of Pennsylvania*, edited by Jeannette Lasansky, 84–88. Lewisburg, PA: Union County Historical Society, 1986.

Maier, Kathryn E. *A New Deal for Local Crafts: Textiles from the Milwaukee Handicrafts Project*. Milwaukee: University of Wisconsin Milwaukee Art History Gallery, 1994.

Mangione, Jerre. *The Dream and the Deal: the Federal Writers' Project, 1935-1943*. Boston: Little, Brown, 1972.

Manor, Amy. "4-H and Home Demonstration during the Great Depression." Special Collections Research Center, Green "N" Growing: The History of Home Demonstration and 4-H Youth Development in North Carolina. https://www.lib.ncsu.edu/specialcollections/greenngrowing/essay_great_depression.html.

Mapp, James R. *Chance or Circumstance?: A Memoir and Journey Through the Struggle for Civil Rights*. Bloomington, IN: iUniverse, 2016.

Marcketti, Sara B. "The Sewing-Room Projects of the Works Progress Administration." *Textile History* 41, no. 1 (May 2010): 28–49. https://doi.org/10.1179/174329510x12670196126566.

Marlatt, Abby L. "'New Deal' in Home Economics." *Journal of Home Economics* 28, no. 8 (October 1936): 522–26.

Martin, Eugenia. "I Managed to Carry On." Interview by Geneva Tonsill, November 1939. U.S. Work Projects Administration, Federal Writers' Project. Library Of Congress. https://www.loc.gov/resource/wpalh1.13070112.

Martinez-Matsuda, Veronica. *Migrant Citizenship: Race, Rights, and Reform in the U.S. Farm Labor Camp Program*. Philadelphia: University of Pennsylvania Press, 2020.

Maycock, Rena B. "Home Economics Work in the Resettlement Administration." *Journal of Home Economics* 28, no. 8 (October 1936): 560–62.

Mazloomi, Carolyn L. "About." *Carolyn Mazloomi*. Accessed June 12, 2023. https://carolynlmazloomi.com/about/.

———. *And Still We Rise: Race, Culture and Visual Conversations*. Atglen, PA: Schiffer, 2015.

McCleary, Ann. "Negotiating the Urban Marketplace: Farm Women's Curb Markets in the 1930s." *Perspectives in Vernacular Architecture* 13, no. 1 (2006): 86–105.

———. "Shaping a New Role for the Rural Woman: Home Demonstration Work in Augusta County, Virginia, 1917-1940." PhD diss., Brown University, 1996.

McDannell, Colleen. "Religious History and Visual Culture." *The Journal of American History* 94, no. 1 (June 1, 2007): 112–21. https://doi.org/10.2307/25094780.

McDonald, William F. *Federal Relief Administration and the Arts: The Origins and Administrative History of the Arts Projects of the Works Progress Administration*. Columbus: Ohio State University Press, 1969.

McKnight, Robert A. Datasheet for Index of American Design object Tenn-Te-2. July 22, 1940, Archives of the National Gallery of Art.

Meador, Michael M. "'A Cover for the Nation': Ella Martin's Quilt Comes Home." *Quilter's Newsletter Magazine*, August 1989.

Metcalf, Eugene W. "The Politics of the Past in American Folk Art History." In *Folk Art and Art Worlds*, edited by John Michael Vlach and Simon J. Bronner. Ann Arbor, MI: UMI Research Press, 1986.

Milwaukee WPA Handicraft Project. *Material Cost List*. Milwaukee, WI: Milwaukee WPA Handicraft Project, 1939. https://content.wisconsinhistory.org/digital/collection/tp/id/72454/.

Miner, Chris. "Art with a Purpose: Pennsylvania's Museum Extension Project, 1935–1943." *Pennsylvania Heritage*, Spring 2008. http://paheritage.wpengine.com/article/art-with-purpose-pennsylvanias-museum-extension-project-1935-1943/.

Montgomery, Marian Ann J. *Cotton & Thrift: Feed Sacks and the Fabric of American Households.* Lubbock: Texas Tech University Press, 2019.

Moore, Fannie. Interview with Fannie Moore, Ex-Slave. Interview by Marjorie Jones, September 21, 1937. Slave Narratives: A Folk History of Slavery in the United States from Interviews with Former Slaves, Vol XI, North Carolina Narratives. Library Of Congress.

Morris, Catherine. "Historical Quilts and the Elizabeth A. Sackler Center for Feminist Art." In *"Workt by Hand": Hidden Labor and Historical Quilts*, 11–15. Brooklyn, N.Y.: Brooklyn Museum, 2012.

Natanson, Nicholas. *The Black Image in the New Deal: The Politics of FSA Photography.* Knoxville: University of Tennessee Press, 1992.

National Museum of American History. "Party Symbols," May 15, 2017. https://americanhistory.si.edu/democracy-exhibition/machinery-democracy/enduring-popular-images-and-party-symbols-0.

Norpoth, Helmut. *Unsurpassed: The Popular Appeal of Franklin Roosevelt.* London and New York: Oxford University Press, 2018.

Northrup, Mary. "[Ex-WPA Workers]." U.S. Work Projects Administration, Federal Writers' Project, October 28, 1938. Library of Congress, Folklore Project, Life Histories, 1936-39. Library of Congress. https://www.loc.gov/resource/wpalh2.28030127.

Obniski, Monica. "The Arts and Crafts Movement in America." The Metropolitan Museum of Art's Heilbrunn Timeline of Art History, June 2008. https://www.metmuseum.org/toah/hd/acam/hd_acam.htm.

Office of the House Historian. "The Fulfillment of White's Prophecy." History, Art & Archives, U.S. House of Representatives. Accessed February 12, 2021. https://history.house.gov/Exhibitions-and-Publications/BAIC/Historical-Essays/Exile-Migration-Struggle/Fulfillment-of-Prophecy/.

Osborne, Elizabeth A. "The Promise of the Green New Deal: A 21st-Century Federal Theatre Project." *TDR: The Drama Review* 65, no. 4 (2021): 11–28.

Ownby, Ted. *American Dreams in Mississippi: Consumers, Poverty & Culture, 1830-1998.* Chapel Hill: University of North Carolina Press, 2002.

Pascoe, Craig S., and John Rieken. "Fort Stewart." In *New Georgia Encyclopedia*, December 10, 2019. https://www.georgiaencyclopedia.org/articles/government-politics/fort-stewart.

Pennsylvania Museum Extension Project. *1938 Catalogue: Visual Education Material for Distribution to Public Schools and Institutions in Pennsylvania.* Harrisburg, PA: Pennsylvania WPA, 1938. https://digitalarchives.broward.org/digital/collection/wpa/id/2697/rec/143.

———. *State-Wide Museum Extension Project Catalog Number Three.* Harrisburg, PA: Pennsylvania Work Projects Administration, 1940. https://digitalarchives.broward.org/digital/collection/wpa/id/107/rec/38.

Perricone, Lillian. "The Pennsylvania Museum Extension Project (1935-1943): The First WPA Visual Education Project." In *WPA Museum Extension Project, 1935-1943: Government Created Visual Aids for Children from the Collections of the Bienes Museum of the Modern Book*, by James A Findlay and Lillian Perricone, 38–56. Fort Lauderdale, Fla.: Bienes Museum of the Modern Book, 2009.

———. "The WPA Museum Project in Context: Historical Precedents in Visual Education." In *WPA Museum Extension Project, 1935-1943: Government Created Visual Aids for Children from the Collections of the Bienes Museum of the Modern Book*, by James A Findlay and Lillian Perricone, 8–26. Fort Lauderdale, Fla.: Bienes Museum of the Modern Book, 2009.

Peto, Florence. *Historic Quilts.* New York: American Historical Company, 1939.

Prior, Ryan. "Artists May Need a Depression-Era Jobs Program Today." CNN, April 11, 2020. https://www.cnn.com/style/article/coronavirus-recession-wpa-arts-programs-wellness-style/index.html.

Proctor, Erna E. "Home Economics in a Rural Rehabilitation Program." *Journal of Home Economics* 27, no. 8 (October 1935): 501–5.

Quilt Index. "Our History." November 2018. https://quiltindex.org/about/our-history/.

Ramsey, Bets. "The Land of Cotton: Quiltmaking by African-American Women in Three Southern States." *Uncoverings* 9 (1988): 9–28.

Reblando, Jason. "Farm Security Administration Photographs of Greenbelt Towns: Selling Utopia During the Great Depression." *Utopian Studies* 25, no. 1 (April 22, 2014): 52–86.

Reck, Franklin M. *The 4-H Story: A History of 4-H Club Work.* Chicago: National 4-H Service Committee, 1963. http://catalog.hathitrust.org/api/volumes/oclc/7985378.html.

Reese, Mayme. Interview with Mayme Reese. Interview by Dorothy West, September 21, 1938. American Life Histories: Manuscripts from the Federal Writers' Project, 1936 to 1940. Library of Congress. https://memory.loc.gov/mss/wpa lh2/25/2506/25060506/25060506.pdf.

Reich, Sue. *Quilts Presidential and Patriotic.* Atlgen, PA: Schiffer Publishing, 2016.

Reynolds, Lucile W. "The Home Economists' Part in the Rehabilitation Program." *Journal of Home Economics* 29, no. 4 (April 1937): 217–22.

Rhoades, Ruth. "Feed Sacks in Georgia: Their Manufacture, Marketing, and Consumer Use." *Uncoverings* 18 (1997): 121–52.

Rice, Mary Kellogg. "The Policy of Good Design." *Design for Arts in Education*, February 1944.

———. *Useful Work for Unskilled Women: A Unique Milwaukee WPA Project.* Milwaukee, WI: Milwaukee County Historical Society, 2003.

Roach, Margaret Susan. "The Traditional Quiltmaking of North Louisiana Women: Form, Function, and Meaning." PhD dissertation, University of Texas, 1986.

Roberts, Charles Kenneth. *The Farm Security Administration and Rural Rehabilitation in the South.* Knoxville: University of Tennessee Press, 2015.

Roberts, Kathy. "Tygart Valley Homestead: New Deal Communities in Randolph County." *Goldenseal* 31, no. 2 (Summer 2005): 10.

Roberts, Russell. *Pickwick People and TVA, 1935-1985.* Pickwick Dam, Tennessee: R.R. Roberts, 1985.

Roosevelt, Eleanor. Letter to Mrs. Jules Joseph Fischer, February 9, 1935. Personal collection of Susan Wildemuth.

Rourke, Constance. "What Is American Design?" In *Art for the Millions: Essays from the 1930s by Artists and Administrators of the WPA Federal Art Project*, edited by Francis V O'Connor, 165–66. Boston: New York Graphic Society, 1975. https://historymatters.gmu.edu/d/5102/.

Rumford, Beatrix T. "Uncommon Art of the Common People: A Review of Trends in the Collecting and Exhibiting of American Folk Art." In *Perspectives on American Folk Art*, edited by Ian M. G. Quimby and Scott T. Swank, 13–53. Winterthur, DE: The Henry Francis du Pont Winterthur Museum, 1980.

Salser, Susan. "American Quilts Empowered Immigrant Women." *The Quilt Index*, 2011. https://quiltindex.org/view/?type=essays&kid=18-121-1.

Sandweiss, Martha A. "Image and Artifact: The Photograph as Evidence in the Digital Age." *The Journal of American History* 94, no. 1 (2007): 193–202. https://doi.org/10.2307/25094789.

Schaffer, Barbara. *A Passion for Quilts: The Story of Florence Peto 1881-1970.* Livingston, NJ: Heritage Quilt Project of New Jersey, Inc., 2011.

Schickler, Eric. *Racial Realignment: The Transformation of American Liberalism, 1932-1965.* Princeton N.J.: Princeton University Press, 2016.

School District of Philadelphia, PA. *Source Material for the Industries of Colonial People to Accompany the Course of Study in Industrial Arts - Grades One to Four.* Philadelphia: School District of Philadelphia Department of Superintendence, Division of Industrial Arts, 1937. http://hdl.handle.net/2027/uiug.30112105710500.

Seay, Maurice. "TVA Quilt Correspondence," *The Quilt Index*, September 9, 1976. https://quiltindex.org/view/?type=correspondence&kid=45-124-4.

Seay, Maurice. "TVA Quilt Correspondence," *The Quilt Index*, September 10, 1976. https://quiltindex.org//view/?type=correspondence&kid=45-124-6.

Sexton, Carlie. *Old Fashioned Quilts.* Wheaton, IL, 1928.

Shaw, Robert. *American Quilts: The Democratic Art, 1780-2007.* New York, NY: Sterling, 2009.

Sider, Sandra. *Quarantine Quilts: Creativity in the Midst of Chaos.* Atglen, PA: Schiffer Publishing, 2021.

Smith, Callie Jeffress Fanning. Letter to Eleanor Roosevelt, March 28, 1940. Franklin D. Roosevelt Library.

Smith, Clint. "Stories of Slavery, From Those Who Survived It," *The Atlantic*, March 2021. https://www.theatlantic.com/magazine/archive/2021/03/federal-writers-project/617790/.

Smith, Wilene. "Laura Wheeler and Alice Brooks." *Quilt History Tidbits — Old & Newly Discovered* (blog), January 6, 2015. http://quilthistorytidbits--oldnewlydiscovered.yolasite. com/laura-wheeler-and-alice-brooks.php.

———. "Quilt History in Old Periodicals: A New Interpretation." *Uncoverings* 11 (1990): 188–214.

Smucker, Janneken. "Learning to Quilt with Sarah Steiner." *Running Stitch, A QSOS Podcast.* Nov 10, 2021. https://quiltalliance.org/runningstitch/.

———. "Quilting and Civil Rights." *Running Stitch, A QSOS Podcast.* July 16, 2020. https://quiltalliance.org/runningstitch/.

———. "Quilting and Difficult Times with Melanie Testa." *Running Stitch, A QSOS Podcast.* July 9, 2020. https://quiltalliance.org/runningstitch/.

———. "Quilts and Activism." *Running Stitch, A QSOS Podcast.* July 2, 2020. https://quiltalliance.org/runningstitch/.

———. "Quilts, Social Engineering, and Black Power in the Tennessee Valley." *Southern Cultures*, Spring 2022, 25–39.

———. "Radical Quilt Histories with Jess Bailey." *Running Stitch, A QSOS Podcast.* Dec 16, 2021. https://quiltalliance. org/runningstitch/.

———. "Sewing with Purpose with Sara Trail." *Running Stitch, A QSOS Podcast.* Dec 10, 2021. https://quiltalliance.org/ runningstitch/.

Solomon, Janie. "Janie Solomon." Interview by Muriel L. Wolf, September 7, 1938. Library of Congress, Folklore Project, Life Histories, 1936-39. Library Of Congress. https://www.loc.gov/ item/wpalh001919/.

Soltys, Hanna. "Dorothea Lange's 'Migrant Mother' Photographs in the Farm Security Administration Collection: Introduction." Library of Congress, 1998, updated 2019. guides.loc.gov/migrant-mother/introduction.

Spear, Marion Rebecca. *Textiles.* Vol. 2. Waste Material Series. Kalamazoo, MI, 1939. http://hdl.handle.net/2027/ mdp.39015013516375.

Spirn, Anne Whiston, and Dorothea Lange. "General Caption No. 58, October 3, 1939." In *Daring to Look: Dorothea Lange's Photographs and Reports from the Field*, 192. Chicago: University of Chicago Press, 2008.

Stalp, Marybeth C. *Quilting: The Fabric of Everyday Life.* Oxford: Berg, 2007.

———. "Who Ya Gonna Call? Quilters." *Contexts* 19, no. 3 (2020): 66–67.

Stange, Maren. "'The Record Itself': Farm Security Administration Photography and the Transformation of Rural Life." In *Official Images: New Deal Photography*, 1–5. Washington, DC: Smithsonian Institution Press, 1987.

Stearns & Foster Company. *Stearns & Foster Catalogue of Quilt Pattern Designs and Needle Craft Supplies.* Cincinnati, OH: Stearns & Foster Co., 1900s.

Stevens, Anne Win. "The Farlows." U.S. Work Projects Administration, Federal Writers' Project, December 16, 1938. Folklore Project, Life Histories, 1936-39. Library of Congress. https://www.loc.gov/resource/wpalh2.28091516.

Stewart, Catherine A. *Long Past Slavery: Representing Race in the Federal Writers' Project.* Chapel Hill: The University of North Carolina Press, 2016.

Stillinger, Elizabeth. "From Attics, Sheds, and Secondhand Shops: Collecting Folk Art in America, 1880-1940." In *Drawing on America's Past: Folk Art, Modernism, and the Index of American Design*, 45–60. Washington [D.C.]: National Gallery of Art, 2002.

Stine, O. C. "Future of Cotton in the Economy of the South." *Journal of Farm Economics* 23, no. 1 (1941): 112–21. https://doi.org/10.2307/1231843.

Strasser, Susan. *Never Done: A History of American Housework.* New York: Pantheon Books, 1982.

———. *Waste and Want: A Social History of Trash.* New York: Metropolitan Books, 2000.

Swain, Martha H. "'The Forgotten Woman': Ellen S. Woodward and Women's Relief in the New Deal." In *Women and Politics*, edited by Nancy F. Cott. Article reprinted from 1983 issue of *Prologue*. 18/2:716–44. History of Women in the United States. Berlin: K. G. Saur, 2012. https://doi. org/10.1515/9783110971071.716.

Taylor, David. *Soul of a People: The WPA Writers' Project Uncovers Depression America.* John Wiley & Sons, 2009.

Taylor, Jason E. "Buy Now! But Here!: The Rise and Fall of the Patriotic Blue Eagle Emblem, 1933-1935." *Essays in Economic & Business History* 25 (2007). https://www.ebhsoc.org/ journal/index.php/ebhs/article/view/172/153.

Tennessee Valley Authority | Built for the People. "The TVA Quilt." https://www.tva.com/about-tva/our-history/built-for-the-people/the-tva-quilt.

Tilton, Lauren. "Race and Place: Dialect and the Construction of Southern Identity in the Ex-Slave Narratives." *Current Research in Digital History* 2 (2019). https://doi.org/10.31835/crdh.2019.14.

"The Farm Security Photographer Covers the American Small Town," June 13, 1940. Library of Congress. http://www.loc.gov/rr/print/coll/fsawr/fsawr.html#shooting.

Tow Sack Tattler, Arvin Farm Workers Community. "Sewing Room News." September 19, 1941. MLC Box 1. California State University Northridge, Special Collection & Archives.

Trend, M. G., and W. L. Lett. "Government Capital and Minority Enterprise: An Evaluation of a Depression-Era Social Program." *American Anthropologist* 88, no. 3 (1986): 595–609.

Ulbricht, Elsa. Tape Recorded Interview with Elsa Ulbricht. Interview by Hayward Ehrlich, June 1964. Merikay Waldvogel Collection on WPA Projects.

———. "The Story of the Milwaukee Handicraft Project." *Design for Arts in Education*, February 1944.

———. Letter to Eleanor Roosevelt, September 20, 1941. Merikay Waldvogel Collection on WPA Projects.

United States Farm Security Administration. *La Forge Farms.* Washington, DC: Farm Security Administration, 1940. http://archive.org/details/laforgefarms00unit.

United States Farm Security Administration. Resettlement Division. *Household Furniture and Domestic Equipment.* Washington, DC: The Department, 1940. http://books.google.com/books?id=xuN6HttQNKQC.

United States National Youth Administration. *Final Report of the National Youth Administration, Fiscal Years 1936-1943.* Washington DC: United States Government Printing Office, 1944. http://hdl.handle.net/2027/mdp.39015028687716.

USDA National Agricultural Library. "Homestead Project Timeline." Small Agriculture: A National Agricultural Library Digital Exhibit. Accessed June 29, 2022. https://www.nal.usda.gov/exhibits/ipd/small/homestead-timeline.

Vizcarrondo-Laboy, Angelik. "Fabric of Change: The Quilt Art of Ruth Clement Bond." Museum of Arts and Design. February 22, 2017. https://madmuseum.org/views/fabric-change-quilt-art-ruth-clement-bond.

Waldvogel, Merikay. "Marie Webster: The 20th Century's First Trendsetting Quilt Designer." *Vintage Quilts*, Spring 2001. https://web.archive.org/web/20060522230734/http://mccallsquilting.com/legacy/va04_article.pdf.

———. "Mary Gasperik (1888-1969): Her Life and Her Quilts." *The Quilt Index*, 2008. https://quiltindex.org//view/?type=essays&kid=18-121-41.

———. "Mary Gasperik and the Tuley Park Quilting Club." *The Quilt Index*, 2005. https://quiltindex.org//view/?type=essays&kid=18-121-3.

———. "Quilts in the WPA Milwaukee Handicraft Project, 1935-1943." *Uncoverings* 5 (1984): 153–67.

———. "Regarding Quilts Made at Wheeler Dam Village (1930s)," undated. 9.1.b2.f38 Tennessee Valley Authority (TVA) Quilts, WPA. Michigan State University Museum, Cuesta Benberry Papers.

———. "Repackaging Tradition: Pattern and Kit Quilts." In *American Quilts in the Modern Age, 1870-1940: The International Quilt Study Center Collections*, edited by Marin F. Hanson and Patricia Cox Crews, 305–64. Lincoln: University of Nebraska Press, 2009.

———. S*oft Covers for Hard Times: Quiltmaking and the Great Depression.* Nashville, TN: Rutledge Hill, 1990.

Waldvogel, Merikay, and Barbara Brackman. *Patchwork Souvenirs of the 1933 World's Fair: The Sears National Quilt Contest and Chicago's Century of Progress Exposition.* Nashville, Tenn.: Rutledge Hill, 1993.

Walker, Melissa, ed. *Country Women Cope with Hard Times: A Collection of Oral Histories.* Columbia: University of South Carolina Press, 2004.

———. "Home Extension Work among African American Farm Women in East Tennessee, 1920-1939." *Agricultural History* 70, no. 3 (1996): 487–502.

Webster, Marie D. *Quilts, Their Story and How to Make Them.* Garden City, NY: Doubleday, Page & Company, 1915.

"What Is the W.P.A. Handicraft Project?" n.d. Merikay Waldvogel Collection on WPA Projects.

Widener, Luke. "Dusting the Peach Bowl: Agricultural Migrants, Camp Managers, and Life in the Marysville and Yuba City Resettlement Administration and Farm Security Administration Camps, 1935-1943." PhD diss., California State University, 2013.

Wilson, Linda D. "Home Demonstration Clubs." In *The Encyclopedia of Oklahoma History and Culture.* Accessed July 27, 2022. https://www.okhistory.org/publications/enc/entry.php?entry=HO020.

Wolcott, Marion Post. "Oral history interview with Marion Post Wolcott." Interview by Richard Doud, January 18, 1965. Archives of American Art. https://www.aaa.si.edu/collections/interviews/oral-history-interview-marion-post-wolcott-12262.

Woodard, Thomas K., and Blanche Greenstein. *Twentieth Century Quilts, 1900-1950*. New York: E.P. Dutton, 1988.

Works Progress Administration, New Jersey. *Report of the Division of Women's and Professional Projects: For the Period Ending July 31, 1936*. Newark, NJ: Works Progress Administration, New Jersey, 1936. http://archive.org/details/reportofdivision00unit.

WPA and the Negro. New York, NY: New York State Works Progress Administration, 1936. https://catalog.hathitrust.org/Record/009127852.

W.P.A.: [Invitation to an Exhibition]. Chicago, IL: Works Progress Administration, 1938. https://catalog.hathitrust.org/Record/102193465.

Yetman, Norman R. "An Introduction to the WPA Slave Narratives." Born in Slavery: Slave Narratives from the Federal Writers' Project, 1936 to 1938 | Library of Congress, 2001. https://www.loc.gov/collections/slave-narratives-from-the-federal-writers-project-1936-to-1938/articles-and-essays/introduction-to-the-wpa-slave-narratives/wpa-and-the-slave-narrative-collection/.

———. "The Limitations of the Slave Narrative Collection: Problems of Memory." Born in Slavery: Slave Narratives from the Federal Writers' Project, 1936 to 1938 | Library of Congress, 2001. https://www.loc.gov/collections/slave-narratives-from-the-federal-writers-project-1936-to-1938/articles-and-essays/introduction-to-the-wpa-slave-narratives/limitations-of-the-slave-narrative-collection/.

Zegart, Shelly. "Myth and Methodology." *Selvedge*, February 2008. http://www.shellyquilts.com/go/resources/read.php?article=myth-and-methodology.

———. "Since Kentucky: Surveying State Quilts." *The Quilt Index*. Accessed February 25, 2022. https://quiltindex.org/view/?type=essays&kid=8-109-1.

INDEX